A documentary history of taste in Britain

The Late Victorians
Art, design and society, 1852–1910

Bernard Denvir

Longman
London and New York

Longman Group Limited
Longman House, Burnt Mill, Harlow
Essex CM20 2JE, England
Associated companies throughout the world

Published in the United States of America
by Longman Inc., New York

© Longman Group Limited 1986

First published 1986

British Library Cataloguing in Publication Data

Denvir, Bernard
 The late Victorians: art, design and society,
 1852–1910.——(A Documentary history of taste
 in Britain; 4)
 1. Arts and society——Great Britain
 I. Title II. Series
 700'. 941 NX543

ISBN 0 582 49137 1

Library of Congress in Publication Data

Denvir, Bernard, 1917–
 The late Victorians.

 (A documentary history of taste in Britain)
 Bibliography; p.
 Includes index.
 1. Art, Victorian——Great Britain. 2. Design——
Great Britain——History——19th century. 3. Aesthetics, British.
4. Art and society——Great Britain. I. Title.
II. Series: Denvir, Bernard, 1917– . Documentary
history of taste in Britain.
N6767.5.V52D46 1986 709'.41 85–4289
ISBN 0–582–49137–1

Set in 10/12 Linotron 202 Bembo
Produced by Longman Singapore Publishers (Pte) Ltd.
Printed in Singapore

Contents

2.1 A permanent and unalterable constitution: William Michael Rossetti chronicles the constitution of the Pre-Raphaelite Brotherhood *24* **2.2 Art and morality**: John Orchard writes in *The Germ* about art and morality *26* **2.3 Art as an exponent of virtues**: some fifty years later the same theme is taken up by Lord Leighton and others *28* **2.4 Devoid of unnecessary delicacy**: in 1855 Richard Redgrave expresses doubts about the morality of French art, especially that of Courbet *32* **2.5 The decline of subject pictures**: a historian of the Royal Academy records the changing subject-matter of painting *33* **2.6 Portrait of an Artist**: at the end of the century the art critic Philip Hamerton remembers his old teacher *36* **2.7 A painter in his studio**: in describing Whistler's studio in 1886, a writer in the *Court and Society Review* indicates how artists' attitudes influenced their surroundings *39* **2.8 A society artist**: in 1932 William Rothenstein remembers one of the luminaries of the Edwardian art scene *ooo* **2.9 Artists' models**: the author of *Life and Labour of the People of London* analyses the economic position of one occupation *44* **2.10 The misdeeds of a model**: the painter of *Derby Day* records his experience with one particular model *44* **2.11 Perplexities and doubts**: Lord Leighton reassures budding artists *49* **2.12 Advice to elementary art students**: a successful Academician gives practical advice to the students of Sutton Coldfield Art School *51* **2.13 Female students at the RA Schools**: G. D. Leslie descibes the effects of a new phenomenon in the Royal Academy Schools *54* **2.14 A striking personality**: a first-hand account of a Ruskin lecture *55* **2.15 The critic as artist**: Oscar Wilde examines the role of the critic *59* **2.16 The Slade**: *The Magazine of Art* describes teaching methods at a famous art school *61* **2.17 Master class**: one of Whistler's pupils des-

3. Buying and selling
The state of the art market 98

4. Architectural alternatives
Stylistic pressures on architects 132

5. Virtuous design
Design and ornament take on a new complexion 157

List of plates

List of plates

1. Introduction

By the second half of the nineteenth century an interest in art had reached epidemic proportions in Britain. It possessed more art schools than any other country in Europe, as well as a multitude of institutions destined to improve the taste of adult members of the working classes and other sections of the population. Museums and art galleries proliferated, monuments, often enough to the munificence of some local industrialist, whose name would be enshrined forever in the foundation which he had created; Tate, Leverhulme, Cartwright, Russell-Cotes, Herbert, Towner, Graves, Mappin and many others are known today for their cultural rather than for their more worldly achievements. Art was taught at all educational levels; often not very imaginatively, but at least thoroughly. An ability to sketch, to dabble in water-colours was considered essential for females, and was not considered reprehensible in males. The Queen herself, who had received lessons from Landseer and Henry Graves, was an active, and not untalented painter, and an assiduous sketcher. Albert too had not only been the most enlightened royal collector since Charles I, but also a painter and an engraver, as well as a bit of an architect and interior designer, his main achievement in these fields being at Balmoral. The Queen had consulted Ruskin about the art education of her children, and received the rather pompous reply that 'Art should not be regarded as a mere means of luxury and pride, but one of the main duties of princes is to provide for the preservation of perishing frescos and monuments.'

The Queen may not have done a great deal about preserving perishing frescos, but she did ensure that her children were taught to paint and draw. History has not recorded what the Prince of Wales thought about the decay of monuments, but there were those who praised his aesthetic susceptibilities, one of them being the rather tarnished widow of Lord Cardigan of Crimean fame, who in her mildly scabrous autobiography recorded of the future Edward VII, 'We often discussed art together, and those that say a taste for high

art can only be acquired are quite wrong, for the prince is a born artist.' Little has survived of his actual creations, but he did once buy a drawing by Leech of two girls on the beach at Dieppe, and acquired a set of Whistler etchings. His most lasting and, in a sense typical, contribution to English culture was that he was mainly responsible for ensuring that public museums and art galleries were allowed to open on Sundays, an idea which aroused immense opposition among the more vociferous Sabbatarians. The Princess Royal, as her father's favourite daughter, was an active and gifted painter, a pursuit which she continued when Empress of Germany, but it was Princess Louise, the Queen's fourth daughter, who achieved most. Working at Kensington Palace, she produced a great deal of sculpture, including a bust of her mother which was shown at the Royal Academy in 1882, a full-length statue of the same subject in Kensington, a medal for the Abyssinian War of 1868, and a monument for her brother Henry's tomb at Osborne. Her home (she married the Marquess of Lorne, who became the ninth Duke of Argyll in 1871) became a centre of 'artistic' gatherings, and under the pseudonym of 'Myra Fontenoy' she wrote articles about art and matters of taste in a number of magazines. She was also the first President of the National Union for the Higher Education of Women.

Although no woman had become a member of the Royal Academy since its early days, the position of women in the world of art had become widely accepted. One of the most popular artists of the latter half of the century was that redoubtable painter of battle and martial subjects, Lady Elizabeth Butler, and one of the best known foreign artists of the time was the animal painter Rosa Bonheur. Kate Greenaway's was a household name, and the paintings by women such as Mary Fortesque-Brickdale, Florence Lewis, Agnes Raeburn, Mary Watts and Margaret Macdonald appeared regularly at the Royal Academy or the Royal Water-Colour Society exhibitions. In the arts and crafts, too, women were especially prominent, possibly for ideological reasons – feminism grew at a steady rate during the period; partly because the peculiar temper of the age in England applauded a type of activity for women which would keep them economically productive, and unsullied by the potential impurities of art itself. A whole legion of women participated in both the education and commercial activities of the Arts and Crafts movement; May Morris (who died in 1938) took over the departments of her father's firm which dealt with embroidery and jewellery, and taught these subjects at the Central

School; many of the leading designers at the Doulton factory at Lambeth, Hannah Barlow, Eliza Banks, Florence Barlow, Esther Lewis and Eliza (she preferred to be called Élise) Simmance were women.

In more general matters of taste women were almost obliged to have a dominant voice. In 1872 *The Art Journal* devoted a series to the subject of 'Art Work for Women', and one of its major conclusions was:

> To whom should we so confidently apply for all that concerns the beautifying of home-life as to the presiding spirit of the home? Why should not the instinctive taste and natural grace of woman be reflected in the hues and harmonies of colour and form on the walls of her rooms, on the curtains arranged by her deft fingers, on the soft carpet beneath her feet, and in the thousand forms of comfort, convenience or elegance which surround her?

The expanding interest in matters of art and taste were catered for by a flood of periodical literature dealing with everything from household taste to Florentine painters of the fifteenth century. Much of it appeared in general magazines ranging from influential periodicals such as *The Westminster Gazette* to popular women's journals. The national daily papers such as *The Times* gave over whole columns to the review of current art exhibitions, as well as to articles of more general artistic interest. Then there were the more specialised magazines. *The Art Journal*, which had been founded in 1839, continued throughout the most of the period to have a large circulation among the 'middling' classes, captivated by its popular, slightly didactic style, its emphasis on personalities and 'human' interest stories, and its extensive illustrations. More specialised areas of art and design were catered for by publications such as *The Builder* (1843–1966) *The Cabinet-maker* (1880–1936) and *The Artworker's Quarterly* (1902–6). The changing temper of the times, however, was suggested by the phenomenal prestige and success of *The Studio* which achieved an international reputation, largely through its early identification with the Arts and Crafts movement, and its support of more advanced art forms. Of similar significance was the appearance in 1903 of *The Burlington Magazine*, the first in England to be devoted to the serious study of art history, but it was significant too, because it afforded an outlet for a more progressive group of art critics, which included Roger Fry, D. S. MacColl, C. J. Holmes and Martin Conway. The discovery in the last quarter of the nineteenth century of the half-tone plate process, which involved combining the camera with a screen to produce a series of dots which allowed

accurate reproduction of photographic prints to be published, added a whole new dimension to the visual experience of the general public, and this was further enhanced by the gradual development of colour photography.

Art critics had gradually assumed something of the charisma and popularity of theologians. Ruskin was regarded as a prophet, and his complete works were published in 1903 in thirty-nine volumes. William Morris, whose collected works numbered a mere twenty-four volumes, was equally well known. Books on art and design by writers such as Julia Cartwright, Walter Crane, Christopher Dresser, Richard Redgrave, C. R. Ashbee and others poured from the presses. Extensive biographies of artists such as Leighton, Rossetti, Morris, Ford Madox Brown, Whistler, Millais, Frank Holl and Watts commanded a large market. Nor were artists themselves reticent about recording their personal impressions. Frith, Holman-Hunt, Burne-Jones, Horsley, Walter Crane, Henry Holiday and William Rothenstein (much of whose working life as an artist falls within the period of this book) lavished their reminiscences on an avid readership. Nor were art critics and artists the sole arbiters of aesthetic taste. Indeed many of the most influential figures, among them Thackeray, Matthew Arnold, Walter Pater, Oscar Wilde and George Moore, were known mainly as writers in other literary forms, even though they had a deep interest in matters of visual interest.

Both reflecting and encouraging this widespread interest in art, writers were doing no more than reacting to a general air of artistic euphoria.

> Looking at the histories of the various schools of painting since the revival of Art, it may be affirmed, without fear of contradiction, that not one presents a case of rapid improvement parallel to our own. It occupied the Italians three centuries from the thirteenth to the fifteenth to develop their school, and another century firmly to establish it. Fifty years have sufficed to place England on a level with the best Art-epoch of the continent.

Thus a contributor to *The Art Journal* in 1856, and this almost engaging mixture of cultural jingoism, sheer nonsense and justifiable pride should not blind us to the fact that England was indeed enjoying a kind of artistic renaissance. Collectors such as Sheepshanks, Vernon and Gillott were paying what seemed at the time fantastic sums for works by living British painters, just as dealers such as Gambart were making fortunes out of the process. Nearly every

month a new record price for a work by a contemporary artist was realised at one of the major auction houses.

High prices reflected great popularity. The private view day of the Royal Academy Summer Exhibition, usually held on 1 May, was one of the great social events of the London season, and the exhibition was visited on average by a quarter of a million people each year. Provincial cities such as Liverpool, Bristol and Manchester staged similar events, and there were also several other institutions, such as the Royal Water-Colour Society, the Royal Portrait Society and several others which held annual exhibitions. In addition, the number of commercial art galleries increased rapidly, some of them such as the Grosvenor Gallery, founded in the 1870s by Sir Coutts Lindsay, and the New Gallery becoming identified with specific styles. Dealers such as Agnew, Gambart and Flatow broke new ground in methods of presentation and marketing.

Nor was this interest in art confined to the upper and middle classes. The Great Exhibition of 1851, and that of 1862, contained large and popular sections devoted to painting, sculpture and the decorative arts. In the latter, for instance, there was a 'Medieval Court' devoted to the works of the recently founded firm of craftsmen and decorators presided over by William Morris. In 1857 Manchester had seen the most important historic exhibition to have been held in England, devoted to the art of the Middle Ages, and emphasising its sense of continuity with the art of the nineteenth century. There were other less prestigious, but equally popular opportunities for seeing art. The Canterbury Music Hall in Lambeth, which opened in 1858, had a picture gallery containing £10,000 worth of contemporary paintings, and the annual exhibitions held first at St Jude's School House in Whitechapel, and then at the Whitechapel Art Gallery, which opened in 1901, attracted as many as 36,000 visitors in 20 days to see work by living artists. In south London the art gallery at Camberwell had its origins in the efforts of William Rossiter, who began to exhibit paintings at his shop in Camberwell Road in 1868, and public reaction had been so enthusiastic (Ruskin had lived at nearby Denmark Hill) that with the encouragement of Lord Leighton, G. F. Watts and Sir Henry Irving the building was opened to the general public in 1891, becoming the property of the Camberwell Vestry, and later of the successive borough councils.

The Great Exhibition had been indirectly responsible for the creation of design museums. In 1852 a Museum of Manufactures, under Sir Henry Cole, was opened on the first floor of Marlborough

House with the dual objects of 'the improvement of taste in design, and the application of fine art to objects of utility'. The nucleus consisted of objects bought from the Great Exhibition with the aid of a grant of £5,000 and collections from the Government School of Design. In 1857 the museum, now renamed the Museum of Ornamental Art, was moved to South Kensington as part of the Prince Consort's plan to set up there a cultural centre of museums and colleges. The building, and what was by then known as the Victoria and Albert Museum, was opened by the Queen in 1857. The present structure designed by Sir Aston Webb was begun in 1899 and formally opened by Edward VII in 1909. The influence of this institution was obvious from its very commencement, and it had no rival either here or in Europe. Other museums could not rival its resources nor compete with its proximity to what in the course of this century became the Royal College of Art. In a way too, the Victoria and Albert, despite its original goal of improving 'industrial' art and making this one of the prime goals of all art education, came to be partly responsible for the change which came over teaching, and which transformed it into a more general way of improving the individual, a change which was embodied in the Board of Education's acceptance of 'the alternative syllabus' in 1896, and the revised handbook for teachers in 1905.

There was great prestige to be acquired by having works exhibited in public exhibitions, hung in public art galleries – the provincial ones having to start from scratch from the middle of the century onwards, were omnivorous buyers – or purchased by prestige-conferring funds such as the Chantrey bequest – the income deriving from a bequest made by the sculptor Sir Francis Chantrey of £105,000 which was spent annually by the Royal Academy for 'works of Fine Art of the highest merit executed within the shores of Great Britain'. (The accumulated Chantrey Bequest, consisting, understandably enough, mostly of works by Royal Academicians, is now housed in the Tate Gallery.) This meant that artists were more honoured than ever they had been; knighthoods and baronetcies showered on painters and sculptors of repute as they had never done before, nor, for that matter since. For the first, and probably the last time in English history, a painter, Leighton, was raised to the peerage, though the impact of the honour was slightly diminished by his dying before he could even take his seat in the House. However, he had had earlier consolations; in addition to having been President of the Royal Academy, he had received honorary degrees from Oxford, Cambridge, Dublin and Durham; he had been made a

Commander of the Légion d'Honneur, a knight of both Belgium and Coburg, a knight of the German Order of Art and Science, and a gold medallist of the Royal Institute of British Architects, as well as an honorary member of the Academies of Antwerp, Berlin, Brussels, Rome, Perugia, Turin and Vienna.

The recognition given to art and artists was, however, expressed in terms more tangible than the merely honorific. Alma-Tadema thought of himself as virtually impoverished because he was only making £10,000 a year (multiply by twenty to get late-twentieth-century equivalents); Rossetti was making £3,000 a year by the time he was forty – and he was not a 'popular' artist in the sense that Leighton or Millais were. Holman-Hunt received 5,500 guineas for *The Finding of Christ in the Temple* and Frith was paid £9,187 for *The Railway Station*, out of which the dealer Flatow is reputed to have made £30,000 in reproduction fees, public showings (at 2s. 6d. a head) and the eventual sale. Artists and art dealers were, on the whole, very rich indeed, dispensing lavish hospitality in their great houses, or at institutions such as the Arts Club in Dover Street, constantly travelling abroad, sometimes to Europe, sometimes to the Middle East or even further afield, often in the quest for appropriate subject-matter. The houses which they had built for themselves in Brompton, Kensington or St John's Wood were designed with a strong instinct for publicity. Melbury Road was the location of the so-called Leighton Settlement, dominated by the master's house, designed for him in 1866 by George Aitchinson, mostly to his own specifications. The hub of this remarkable building was its Arabian Court, based on the Saracenic palace of La Zisa at Palermo, with its black marble fountain, its fretted woodwork made by Egyptian craftsmen, its mother-of-pearl fixtures, its mosaics by Walter Crane and its tiles by William de Morgan, which was declared by an over-enthusiastic director of the Victoria and Albert Museum as being 'the most beautiful structure which has been erected since the sixteenth century'.

William Gaunt's description of the rest of the interior (*Victorian Olympus*, 1952, pp. 106 *et seq.*) gives a more vivid impression even than contemporary accounts, of this Victorian dream palace:

> The house was immensely copious in its reflection of the owner's grand scale of taste. In the study to the left of the entrance hall, over the low bookshelves, the orderly writing-desk, hung choice drawings by Alphonse Legros and Alfred Stevens. On the opposite side of the Court were more objects of art in the drawing and dining rooms, both of which looked out on the cloistered garden – 'so

quiet' said Leighton 'that not a sound reaches me here save the singing of the birds'. On the Pompeian walls of the dining room, Rhodian and Damascus plates were arranged in circular patterns, and vertical tiles from floor to ceiling; over the substantial oak fireplace hung the painting of the female figure by Gregorio Schiavone, fifteenth century master of the Paduan school; on each side of the hearth stood seats of oriental design with mirror glass fitted into back and arms. Here too reposed the Satsuma plate and sword presented to Lieutenant-Colonel Leighton by the officers of the Artists' Volunteer Corps in 1878. The drawing room was filled with paintings. In the ceiling of the covered porch which led to the garden, set in a frame of gold, was a study by Delacroix for the ceiling in the Palais-Royal. On the walls of nut-brown were the four great Corots, *Sunrise, Sunset, Noon* and *Night* which had once belonged to Daubigny; a silver-grey river scene, also by Corot, which was one of the Leighton's favourites; two Constables, one of Hampstead Heath, the other the sketch for *The Haywain*; a David Cox, a Daubigny, and a landscape by Leighton's unfortunate friend, George Mason.

Still there was an experience to come. You went up the stairs to the studio, always surrounded, as you went, by works of art; a copy of Michelangelo's *Creation of Adam*, an unfinished portrait of Lord Rockingham and Burke by Sir Joshua Reynolds. You arrived at an antechamber, whence through a screen of mosharabiyeh, you could see the fountain playing below. Here was a further profusion of paintings; the *Girl Shelling Peas* by Sir John Millais, who presented it to Leighton, a Tintoretto portrait, a head by Bassano, *A Corner of my studio* by Alma-Tadema, *Chaucer's Dream of Fair Women* by Burne-Jones. The antechamber led to the great studio. There were a hundred things to catch the eye in this magnificent workshop. Easels stood around, each bearing its work of art. Travel sketches by the artist covered the walls; sketches of Rome and Rhodes, Athens, Venice, Seville, Algiers, the Nile; of Devonshire and Donegal, of Scotland and Wales. On the precious oriental rugs leaned mighty portfolios, stacked with innumerable drawings of fold and figure, which preceded each painting. You turned to one wall and saw a beautiful study by Gainsborough for *The Mall* painted for George III; to another and there was an engraving of the Royal Academy Exhibition in 1777, autographed by the Prince of Wales.

Alma-Tadema's home at the corner of Abbey and Grove End Road in St John's Wood, which cost him upwards of £1 million in the equivalent of twentieth-century money, was equally splendiferous, and seemed like a realisation of one of his own paintings. The previous occupant had been Tissot, who had constructed in the garden a classical colonnade and other Graeco-Roman

adornments. Alma-Tadema took up this architectural theme with enthusiasm, adding to the house Pompeian bronze doors, walls of sea-green marble, a mosaic atrium, the now almost obligatory fountain, and marble floors, so highly polished, that visitors were provided with slippers to avoid accidents. As a patriotic gesture to his original Dutch homeland, he had a studio in the seventeenth-century Dutch style for his wife Laura, and his own which had a dome covered with aluminium to provide him with the appropriate silvery light, 'conjured up' according to one visitor 'all the luxury, the ivory, apes and peacocks of the Roman civilisation with which his art was largely preoccupied'.

These sumptuous houses were, of course, not merely exercises in conspicuous expenditure, they were shrewd investments in salesmanship, designed to impress potential patrons and attract attention in the general press, but they were often also affirmations of stylistic intent. This was so with Whistler, and even more so with Alma-Tadema, whose predilection for classical subjects was reinforced by an extraordinary archaeological accuracy, historical realism and an attention to detail, which led him to comment on his *Caracalla and Geta*:

> I have from the outset counted the number of spectators as I painted them, and have now reached a number approximating to 2,500. Allowing that the columns and garlands hide as many more, this would give us a total of 5,000 figures for that seventh part of the Coliseum which is shown and for the whole building 35,000, the number actually believed to have found accommodation in the auditorium.

Greece and Rome had in effect by the second half of the century taken over from the Middle Ages as a dominant source of iconography and style – notably in the works of Poynter, Leighton, Watts, Albert Moore, Richmond and of course Alma-Tadema himself. It is interesting in fact that in the 1860s so seemingly committed a medievalist as Burne-Jones turned increasingly to classical themes.

Not all artists however, whatever their resources, were able to find such perfect architectural expressions of their own stylistic preferences. Many relied on the gifts of that eminently 'picturesque' architect Richard Norman Shaw, who designed buildings as though they were paintings, and found many of his clients among his fellow Royal Academicians. Shaw, who had started off as a medievalist working in the offices of George Edmund Street, went on to practise

a kind of Tudoresque style which was then supplanted by variations on the William and Mary style which became extremely popular. Some of his homes for artists were in Melbury Road; No. 8 for Marcus Stone, No. 11 for Luke Fildes; then there were Frederick Goodall's great house at Harrow, and those of Kate Greenaway, Edwin Long and Frank Holl in Hampstead.

On the whole public architecture, like painting, tended towards some version of the classical, typical examples being Aston Webb's Admiralty Arch, Thomas Edward Collcut's Imperial Institute, Brydon's Treasury Building and Frank Atkinson's Selfridges in Oxford Street. Imperial style architecture suited the mood of a Britain which had become almost hysterically conscious of its Imperial mission, one which was based very largely on the wealth of a comparatively small number of people, whose affluence, derived either from manufacture, or the possession of land in urban areas, or land rich in mineral wealth, was for the most of the period undiminished by any serious taxation. Compared with these people, even the richest artist was a comparative pauper, and many of them spent part of that wealth on architectural fantasies more splendiferous than anything which had existed before. As Gilbert Scott hopefully observed in his *Secular and Domestic Architecture* (1857)

> Providence has ordained the different orders and gradations into which the human family is divided, and it is right and necessary that it should be maintained. The position of a landed proprietor, be he squire or nobleman, is one of dignity. Wealth must always bring its responsibilities, but a landed proprietor is especially in a responsible position. He is the natural head of his parish or district – in which he should be looked up to as the bond of union between the classes. . . . He has been placed by Providence in a position of dignity, and authority, and no false modesty should deter him from expressing this quietly and gravely in the character of his house.

False modesty was not a major Victorian vice, and quietness and gravity were often eschewed by the rich as they erected all over the country immense mansions in the style of baronial castles, Renaissance palaces, Flemish town halls and French châteaux. It is indeed a remarkable comment on the range and extent of country-house building during this period that one of the most brilliant art historical studies published in the late twentieth century, by Mark Girouard (*The Victorian Country House*, Oxford, 1971), should be entirely devoted to the subject, without exhausting it. Accommodation for droves of servants – at Eaton Hall there were 50 indoor servants, 40 gardeners and a resident ducal family of 17 – clock

towers 183 feet high with carillons of 28 bells – galleries, libraries, chapels, conservatories, Turkish baths, billiard rooms; the profusion of comfort and extravagance of display was endless. Nor was this architectural frenzy confined to the active homes of landed proprietors. During the life of Hugh Lupus, first Duke of Westminster, whose income by the 1890s was some £300,000 a year, he built on his Cheshire estate 48 farmhouses, 360 cottages, 8 schools, 7 village halls and 3 churches.

The demand for buildings was insatiable; public architecture had become a boom industry; town halls, libraries, museums, churches, cathedrals (Truro and Westminster being the outstanding instances), post offices, administrative palaces such as those devoted to the Whitehall ministries, sprang into existence, borrowing their appearances from a whole gamut of historical styles, the only rough guide being that secular buildings tended to be classical, religious vaguely medieval. Brisk commercial competitiveness stimulated still further new forms of ostentation. When King's Cross Station was opened in 1852 in a modest, functional Italian style, the company which ran a competing line to the east of England decided to create a station and a hotel which would far outshine it, and in 1878 the complex of St Pancras was finally opened (the station itself, a more restrained affair than the façade would suggest, had been functioning for some ten years) with its 500 rooms, its fretted fanciful skyline, its sheer overpowering architectural presence. Other London and provincial stations followed suit according to their varying ambitions and house styles; the Grosvenor Hotel at Victoria, the first to have a French pavilion roof; Philip Hardwick's Great Western Hotel at Paddington and the Italianate Charing Cross Station Hotel. Even when no hotel was built, the façades of stations were tricked out with ostentatious accessories to create a sense of grandeur; J. R. Scott's grandiose treatment of Waterloo, the baroque façade which Sir Charles Morgan, the chief engineer of the South East Railway, provided for Victoria 'The Gateway to the Continent', or the battlements and turrets behind which the Great Western hid the more mundane activities which went on in its station at Exeter, are typical.

Hotels were a new phenomenon in their Victorian guise, catering for a more mobile commercial class, demonstrating the opulence of those who had made or were making their fortunes. The Parisian-styled Ritz, built in Norwegian granite; the Savoy built in 1903–4, and claiming, to the vast astonishment of even polite society, that each room contained its own bathroom and lavatory; the imaginative

baronial brick of the Russell Hotel were the London prototypes of scores of provincial equivalents from Brighton to Aberdeen, from Bristol to Glasgow. Towns too saw a proliferation of often extensive combinations of pubs and hotels, usually in what we now call the inner suburbs, areas such as Camberwell, Islington and Clapham, which catered for stage people, commercial travellers and often more or less permanent residents. The emergence of the department store opened up another field of architectural competitiveness just as much as it tended towards stimulating a certain standardisation of taste. Harrods, founded in small premises in 1849, changed into its present red brick palatial grandeur at the turn of the century; Selfridges appeared in 1908 and the Bayswater complex of shops around Whiteleys at the same time. If it did nothing else, the need to design department stores expanded architectural horizons, and stimulated that new approach to building problems which was beginning to make such spectacular headway in the United States.

But despite cathedrals, public buildings, churches and the like, the main activity of most architects was in the area of house design. Whereas the most ambitious eighteenth-century developers and architects had, at their most sanguine, thought in terms of streets, the Victorians, following the precedent of Nash in Regent's Park, visualised and created whole areas such as Brompton, Belgravia and Pimlico. It has been observed that London as we know it today owes more to Thomas Cubitt than to any other man, with the possible exception of Wren. A ship's carpenter from Norfolk, he had become a speculative builder in Holborn by 1815, and securing the patronage of Lord Grosvenor and the Lowndes family, created a whole town of elegant Italianate houses for the well-to-do which was named after Belgrave in Cheshire, part of the Grosvenor estate. Adjacent to this 'select' area Cubitt created Pimlico, rows of porticoed houses ranging in size from five to two stories, set in grids at about forty-five degrees to the river, intersected by long shopping streets. The social distinction between the two was noted by Trollope when the about-to-be-married Lady Alexandrina is warned against the intentions of her future husband, who wants to live in Pimlico, 'For heaven's sake, my dear, don't let him take you anywhere beyond Eccleston Square.'

Belgravia, Pimlico and their equivalents in Liverpool, Birmingham and other cities were composed of town houses, but though country houses were for the aristocracy and the very rich, the suburbs of these cities, places such as Sydenham, Aigburth, Edgbaston and the like proliferated with large, diversely styled,

extensively gardened houses, bristling with miniature towers, marble-pillared porticoes and dormer roofs, where lived the affluent who drove into the neighbouring city every day, collected the occasional work of art, and added a rich diversity to the social pattern of the island race.

One cannot, however, think of large developments purely in terms of South Kensington, Belgravia or Pimlico. A new concept had arisen, adding to Cubitt's pragmatic town planning an ideological approach to carefully planned, stylistically coherent, and socially homogeneous housing estates. The first of these was Bedford Park in west London, planned by Jonathan T. Carr, the brother of the art dealer and critic, J. Comyns Carr, who was connected with both the Grosvenor and the New Galleries. It was designed especially for those with an artistic taste, as a place where, in the words of a *St James's Gazette* parodist, 'Men may lead a chaste, correct, Aesthetical existence' in modest-sized terrace, detached and semi-detached houses, each with its own garden, and with an adjacent church, inn (appropriately named 'The Tabard') and bank. Chesterton in his *The Man Who was Thursday* (1906), written more than quarter of a century after its foundation, was less than fair to its stylistic quality: 'It was built of bright brick throughout; its skyline was fantastic, and even its ground plan was wild . . . the outburst of a speculative builder, faintly tinged with art, who called its architecture sometimes Elizabethan, and sometimes Queen Anne, apparently under the impression that the two sovereigns were identical.'

The notion of town planning had emerged before the end of the century, and Ebenezer Howard's *Garden Cities of Tomorrow* was first published in 1898 with its emphasis on attracting people back to the country (or the near-country) to relieve the terrible congestion in towns and cities. Howard's ideas of combining socialist planning with free enterprise found their expression in Letchworth and Welwyn Garden Cities, while at Hampstead in a similar venture the balance of social class, commerce and industry was lost right from the start.

The main beneficiaries of these developments, with their admixture of social and aesthetic idealism, were basically intended to be the professional middle classes, ranging from doctors and lawyers in the larger units, to schoolteachers and the like in the smaller . There had, however, been significant efforts made towards providing suitable accommodation for the industrious working class. The pioneer workers' housing estate was Sir Titus Salt's Saltaire near Bradford, which was begun in 1852, but more spectacular efforts

involving conscious 'artistic' effort – which usually meant archi-
tectural styles in a roughly traditionalist farmhouse, Elizabethan, a
Jacobean, Merrie-England idiom – took place at Port Sunlight on
Merseyside, where in 1889 William Hesketh Lever, himself an ardent
art collector, inaugurated the felicitously named Port Sunlight, pro-
vided with its own art gallery, and at Birmingham where George
Cadbury created the model village of Bournville.

The one factor with which everybody had to deal in the latter half
of the nineteenth century was of course the problems attendant upon
the extraordinary increase in population; between 1800 and 1900 the
population of the United Kingdom rose from 1.12 to 16 million; that
of London was quadrupled, and Manchester's increased from 75,000
in 1800 to 720,000 in 1900. To accommodate these millions a
building programme on a vast scale, whether consciously planned or
not, was inevitable. The urban face of Britain, as we know it today,
was largely created in the nineteenth century, and it was composed
not of the great edifices of city centres, but of the countless two-up
two-down homes built radiating outwards from the centre. Plain in
style, basic in their facilities, invariably equipped with outside
lavatories, often back to back, owned by landlords, rented to tenants
for sums between 2s. 6d. and 5s. a week, they seldom presented any
stylistic quality beyond the occasional Gothic revival pillars on either
side of the front door, or the occasional splash of ornamental stucco
on the façade. But it was in this period too that housing was trans-
formed, as far as the poor were concerned, from an entrepreneurial
hazard into a public duty. In 1865 the City of London opened its
Corporation Buildings in Farringdon Street, and twenty-five years
later Parliament passed the Housing of the Working Class Act. The
newly formed London County Council became active in this area,
and so did a number of other organisations such as the Peabody
Trust – whose tenement buildings were bleakly functional in con-
trast to the bright neo-Georgian façades of the LCC flats – and the
Artisans', Labourers and General Dwelling Company.

Conscious efforts were made to make these buildings not only
hygienic and comfortable, but aesthetically pleasing. This was an age
when everybody, from proprietor to artisans (a now largely defunct
word), was concerned not only with exteriors, but with interiors,
with the design and shape of household goods, and with design –
though the word was only beginning to assume the wider im-
plications it later attracted. In part this was due to the consistant
propaganda and educational activities which had been flowing in a
steady stream from central government since the 1840s, and had

culminated in that most remarkable public relations exercise, the Great Exhibition. A constant stream of books on how to furnish your home, how to choose wallpapers, carpets and everything else was reinforced by copious articles on this theme in the ever-expanding magazine market.

In 1880 *The Practical Carver's and Gilder's Guide* noted, 'There is now scarcely a cottage where the inmates do not look with pride and pleasure upon some humble effort of art that adorns the walls of their home, and from the artisan to the titled nobility of our land the work of the artist and engraver is admired and valued.' At the upper end of the scale, expenditure on art and antiques was lavish. In the Duke of Westminster's extended Eaton Hall, the glass and mosaics in the chapel were by Frederic Shields, who spent eleven years working on them; the walls of the drawing room were adorned with huge paintings of the Canterbury Pilgrims by Stacy Marks RA, and in another room there was a series of bird paintings by the same artist in a setting conceived by Gertrude Jekyll, the famous garden designer. In Scotland the shipowner Richard Marks Burrell adorned his various houses with paintings by Steer and Chardin, by Degas (the first bought in 1901), by Crowhall and by Bellini, by Whistler and by Daumier. In Cheshire, Leverhulme's magpie tastes led him into collecting eighteenth-century French furniture, Chinese porcelain, paintings by Reynolds, Gainsborough and Burne-Jones, while at the same time the poor of Birkenhead adorned their homes with prints cut out from magazines, for to them the possession of any objec seemed a talisman against destitution.

But taste generally was being beset with forms of sectarianism which took on an almost fanatical intensity. Some of these had their origins in the past. There was that strong sense of social snobbery which had been apparent in the eighteenth century (cf. *The Eighteenth Century, 1698–1789* in this series, pp. 83–7). The right taste was what distinguished people from their social or intellectual inferiors, and the comments made, for instance, about the Rothschild mansion at Waddesdon, or the Italianate Brompton Oratory, or the design of Selfridges, all had a common denominator of condescension similar to that lavished on the 'cits' in the previous century, tinctured often enough with more than a hint of chauvinism or worse. Superimposed on this was that medievalism which, since the time of Pugin, had taken on a more strident note, in reaction in part to the increasing dominance of the machine. Whereas, for instance, in the past, complexity of design and ornament had implied luxury and expensiveness, because they involved the effort of skilled

craftsmen, the new machinery involved in furniture-making had made them not only accessible, but desirable for cheap mass-produced furniture, which writhed with rococo lines and shapes. Comparative simplicity of design and an emphasis on the handmade became therefore hallmarks of 'good taste', contrasting with the vulgar exhibitionism of mass-produced, and often foreign, domestic furnishings.

It would be a gross exaggeration to suggest that it was these social considerations which created the Arts and Crafts movement, but they definitely played a role in it. Other factors were the natural reaction of the taste of one generaion to its predecessor, often enough bound up with hostility towards successful and 'vulgar' parents, and a whole complex of social, political and religious beliefs which could uncomfortably be linked together under the name of Socialism. Ruskin was the great preceptor in all this, his luscious prose arousing the emotions of his readers, and guiding them to a kind of design Utopia the achievement of which he wrote could be attained by following three simple rules:

1. Never encourage the manufacture of any object not absolutely necessary, in the production of which *Invention* has no share.
2. Never demand an exact finish for its own sake, but only for some practical or noble end.
3. Never encourage imitation or copying of any kind, except for the sake of preserving records of great works (*The Nature of Gothic*, 1854).

This was heady stuff for young Oxford graduates such as William Morris to read, and it was he who by his business ability, his articulate prose, his creative energy and his missionary-like zeal, transformed the often muddled, Rousseauesque thinking of Ruskin into a coherent style and attitude which were to revolutionise design in Britain. 'Art furniture' – the term was first used by Charles Locke Eastlake in his *Hints on Household Taste* (1871) – was marked by its simplicity of design, its dependence on medieval or English traditional prototypes, and its 'honesty'. Pattern design was to be marked by its dependence on organic forms; printing should be integrated with the whole concept of a book; pottery should be true not only to its function, but to its method of production. 'Don't try for instance', Morris told an audience at Burslem in 1881, 'to make a printed plate look like a hand-painted one. . . . If you have to design for machine work, at least let your design show clearly what it is. Make it mechanical with a vengeance, at the same time as simple as possible.' Morris was in far closer contact with the spirit of his time

in that for Ruskin's religiosity which, by the 1880s was going out of fashion, he substituted a belief in Socialism which, he believed, would produce as a by-product an awareness among the population as a whole of the principles of true design. This was the greatest innovation of the time, the notion that taste in fields other than fine art could be determined by a canon of pragmatic rules, and not just by a kind of vague instinct.

The influence of Morris was paramount in creating a body of men and women, who, devoted to his principles, saw themelves primarily as craftworkers, but who were in effect largely designers. Among these the most prominent were the illustrator Walter Crane, and the architects and designers Charles Robert Ashbee and William Richard Lethaby. But in addition to these individuals, there were institutions which had as their aim the organisation and publicising of this new aesthetic gospel. Chief of these were the Art Workers' Guild, founded in 1884, the Arts and Crafts Exhibition Society, which held its first exhibition at the New Gallery in Regent Street in 1888, and perhaps most important of all the Central School of Arts and Crafts, first established by Lethaby in 1896, and moving to its present Southampton Row premises in 1908. Working towards the realisation of the ideal of the Arts and Crafts movement it consisted of five major departments dealing with furniture, stained glass, printing, dress design and embroidery, and metal-work. Drawing and painting were taught not only as professions, but as aids to craftsmanship, and all the members of the staff were themselves practitioners in their individual fields. The pre-eminence of the Central School was admitted not only in Britain, but in most European countries, and it was not supplanted in this position until the appearance of the Weimar Bauhaus in the 1920s.

The Arts and Crafts movement cannot be seen in isolation as a mere propounder of new ideals in design. It was part of a much larger phenomenon, which had started to become apparent almost as soon as the Pre-Raphaelites had established what was originally an anti-establishment aesthetic in the late 1840s. Till then, although there had been many individual artists who had protested against the Academy and traditionalist attitudes to art, there had never existed what might be called an official oppositon. From the late 1850s onwards, however, it became apparent that both art and design no longer possessed a unified ideology, a fact signalised by the emergence first of the so-called 'aesthetic movement' – largely publicised through Du Maurier's cartoons in *Punch*, Gilbert and Sullivan's *Patience*, first produced at the Opéra Comique in London

on 23 April 1881, and the career of Oscar Wilde; and then of Art Nouveau. On the whole it may be said that the former involved an attitude to life and art; the latter an attitude to art and design. But so clear-cut a distinction cannot always be sustained; both contained elements of each other.

The aesthetic movement involved almost every aspect of life; dress, furniture, art, literature, even pronunciation. It was based essentially on the notion of art for art's sake, with the additonal implications, much publicised by Walter Pater, that life should be experienced to the full without too many religious or moral implications or restraints, that beauty itself is a religion, and that 'to burn always with this hard gem-like flame, to maintain this ecstasy is success in life'. In actual practice this involved a host of subsidiary experiences, some of which may have appeared marginal. There was, for instance, a new interest in the Orient of a kind which had not been seen since the eighteenth century. But now Japan had taken over from China as the main source of influence. When Whistler returned to London in 1859 he brought with him examples of that blue and white china of the kind originally associated with the seventeenth-century potter Kang Hsi, but more usually of actual Japanese manufacture, which had already become popular in Paris. Rossetti was as impressed as Whistler with the product, and both became avid collectors, mainly relying on the dealer and general man-about-Bohemia Murray Marks, who made frequent trips to Holland, where it was still comparatively cheap. There was a shop near London Bridge where a piece of this china was given away free with every pound of tea bought, and in 1875 Arthur Lazenby Liberty opened his own shop in Regent Street. He had previously been manager of Farmer and Roger's Oriental Warehouse, which had set up trading in the late 1860s, with the stock of Japanese objects remaindered from the International Exhibition of 1862, and Liberty's new shop soon became a centre of the new oriental taste, providing at the same time machine-made products such as textiles and furniture which reproduced some of the qualities of their handmade equivalents.

In July 1880 Du Maurier was approached by the playwright Frank Burnand for advice on a general 'aesthetic' interior for a set for his satirical play *The Colonel*. Du Maurier replied:

> Try and have a room papered with Morris' green daisy, with a dado
> six feet high of green-blue serge in folds – and a matting with rugs
> for floor (Indian red matting if possible) spider-legged black tables &
> side-board – black rush-bottom chairs & armchairs; blue china plates

on the wall with plenty of space between – here and there a blue
china vase with an enormous hawthorn or almond blossom
sprig . . . also on mantelpiece pots with lilies and peacock feathers –
plain dull yellow curtains lined with dull blue for windows if
wanted. Japanese sixpenny fans now and then on the wall in
picturesque unexpectedness. (From a MS in the Yale University
Library quoted by Leonée Ormonde, *George Du Maurier*, London,
1969)

The aesthetic movement as a unity which affected the whole lives of
people owed as much to its enemies as to its friends. This is
especially so of Du Maurier, if indeed he can be regarded as an
enemy – his constant satire appearing in the pages of *Punch* had a note
almost of affection about it. At various times he attacked aesthetic
dress, aesthetic conversation, Burne-Jones, the idol of the
movement, Japanese furniture, intensity, passionate Brompton, the
aesthetic tendency to substitute 'ah' instead of 'er' or 'ure' at the end
of a word, and Oscar Wilde. In the process he invented characters
such as Cimabue Brown, Jellaby Postlethwaite, Maudle, Algernon,
Peter Pilcox (a sculptor who had started his career as a chemist's
assistant), Milkington Sopley and Miss Mariana Bilderbogie. Du
Maurier was not the only one to satirise the aesthetes; W. H.
Mallock's *The New Republic* of 1877 picks on Pater's prose and
conversational style; Vernon Lee (herself an art critic of no mean
ability) wrote a novel *Miss Brown*, published in 1884, which features
Walter Hamlin, a 'fleshy' poet, and has extensive descriptions of
'aesthetic' London, and there were many less familiar writers, who
found in the movement an outlet for expressing a whole range of
emotions in which intolerance, chauvinism, suspicion of
homosexuality, philistinism and a healthy distaste for affectation all
played their part.

The aesthetic movement, whether it involved ebonized furniture
or Japanese fans, intense living or high-waisted, long loose dresses, a
passion for Botticelli or Sussex chairs, presented a complete
alternative style of living, taste and decoration. It went beyond those
mere fancies for Gothic or Grecian furniture which had differentiated
stylistic wars in the past, and its characteristics were disseminated
not only through the critical pages of *Punch* but through the host of
'good taste' articles which appeared in the ever-increasing number of
illustrated women's magazines.

Art Nouveau, with which the aesthetic movement was, and still is,
often confused, was indeed closely linked with it, but it is on the
whole to be seen as a style rather than an attitude, and was largely

concentrated in the decorative arts, where its main exponents in Britain were architects and designers such as Charles Rennie Mackintosh and Arthur Mackmurdo, and illustrators and artists such as Aubrey Beardsley, Charles Ricketts and Walter Crane. Significantly, however, although it did not possess the elaborate philosophical substructure which writers such as Pater, Wilde and John Addington Symonds had provided for the aesthetes, it was even more emphatically an anti-establishment movement, setting out alternative art forms, and emphasising the fact that unlike the past, the late nineteenth century in England was no longer a unity, but a sectarian *mélange* of aesthetic beliefs. Disraeli's remark about two nations was now as true in the field of taste as it was in that of economics. On the one hand there was the Royal Academy, romanticised realism in painting, elaborate heavy decoration and conformist attitudes; on the other were a variety of painterly styles, light, elegant traditional decoration and furniture, and a slightly rebellious, frequently socialist stance. This was emphasised still further by the appearance of a whole series of 'little magazines' polemical in tone, innovatory in content and layout. Mackmurdo's *The Hobby Horse* (1884), Rickett's *The Dial* (1889), Beardsley's *The Yellow Book* (1894–95) and *The Savoy* (1896–98) were intended to present the viewpoint of the opposition in all the arts, but were especially effective as far as the fine and decorative arts were concerned.

However vaguely defined, the concept of the avant-garde had arrived, and there soon existed a considerable apparatus to support it. In 1877 Sir Coutts Lindsay had opened the Grosvenor Gallery as an alternative to the Royal Academy, though some idea of the amorphous nature of the 'rebels', if indeed they could be described by so emphatic a word, is suggested by the fact that the gallery exhibited the works of Burne-Jones, Albert Moore, Whistler and Walter Crane. As W. S. Gilbert's famous lines,

> A greenery-yallery, Grosvenor Gallery,
> Foot-in-the-grave young man

suggest, the Grosvenor Gallery was definitely identified with what was increasingly coming to be called 'modern art'. In actual fact it very soon followed a pattern of development which was to become increasingly apparent throughout the world of art, becoming more conservative, and by the end of the 1880s it was supplanted by the New Gallery in Regent Street. It had been, however, at the Grosvenor Gallery's first exhibition that Whistler had exhibited his

Nocturne in Black and Gold; The Falling Rocket which provoked the famous lawsuit with Ruskin in 1878, an event which neatly polarised tradition and innovation in England, with Burne-Jones, Tom Taylor, the art critic of *The Times* and Frith of *Derby Day* fame supporting Ruskin; William Michael Rossetti, Albert Moore and William Gorman Wills, an Irish playwright and portrait painter, supporting Whistler, and questions being asked such as 'Does it show finish?' and 'How soon did you knock it off?' (Laughter.)

If painters such as Whistler, Albert Moore and even Burne-Jones were thought of as representative of the opposition to the Royal Academy and its works, this was a superficial view. The mainstream of modern art was flowing in very different directions. By the middle of the century English art students who wished to pursue their studies on the Continent had ceased going to Rome, Florence or Antwerp as before, and were now going to Paris, though even by the 1870s not all of them had fully realised the implications of Impressionism. Manet had visited England in 1868 and Monet and Pissarro both stayed here during the period of the Franco-Prussian War and the Commune. From December 1870 till the end of the 1875 the Paris dealer Durand-Ruel held an annual exhibition of works by artists belonging to his own creation, 'The Society of Friends of French Artists', at his gallery in New Bond Street. This included works by several Impressionists, including Alphonse Legros, who, having exhibited at the second Impressionist exhibition in 1876, became, in that year, Principal of the Slade School of Art, teaching on French principles and encouraging his students to visit Paris.

In 1883 Durand-Ruel held an exhibition of sixty-five works by Degas, Manet, Monet, Renoir, Sisley, Boudin, Pissarro, Mary Cassatt and John Lewis Brown (a student and later a teacher at the Slade) which aroused more comment than any other exhibition of its kind. Most was unfavourable, but there was a group of critics including D. S. MacColl who came to be known as practitioners of the 'New Criticism', who were distinctly favourable. Even a magazine such as *The Art Journal*, reporting in April of that year on an exhibition which Monet had been having in Paris, wrote, 'This collection may not please everyone, and certain people accuse them of being *impressionisme* as if that were something to be ashamed. Yet nevertheless they are excellent in treatment, with much feeling, and combine fresh and original talents with an artistic temperament of the first order. 'Impressionism was in fact confronting the British with an alternative art different not only in its themes, but in its very approach to the nature of visual reality.

The creation of the New English Art Club was a significant step in the consolidation of this dichotomy, and from the moment of its creation on 22 April 1886 attracted all the best artistic talent in England – a Scottish contingent including John Lavery and James Guthrie formed a rough equivalent in Scotland, the Glasgow School. Within the Club there were several variations of belief and techniques, and Pissarro, having given a lecture to the members, commented afterwards, 'They talk about the subject as Englishmen who know not the first thing about Impressionism, young men who paint smoothly, and have black on their palette.' Eventually the New English Art Club was to become closely linked with the Academy, and the pattern, to be so familiar during the coming century, had been established whereby the rebellious tastes of one generation were to become the accepted clichés of conformity in the next. Those who found Steer and Sickert hard to understand, and despised all Impressionist painting as 'rough and untutored' had little idea what was in store for them in the next few years.

During the first decade of the century it had become apparent in Paris and elsewhere on the Continent, that probably the greatest revolutions in visual expression since the Renaissance had been taking place, and one of the few people in England who was fully cognisant of this was Roger Fry, who, almost accidentally arranged in November 1910 an exhibition of Post-Impressionist painting at the Grafton Gallery off Bond Street. 'On or about December 1910 human character changed', Virginia Woolf was later to say, and it is certain that the world of art and of taste altered profoundly, becoming embedded, as it was to be for most of the century, in a bitter conflict between the traditional and the innovatory, the new and the old. Ethical preoccupations inherited from the Victorians added to judgements about art and design an almost biblical intensity. Visitors to the Grafton Gallery exhibition were heard by Desmond MacCarthy to keep using phrases like 'pure pornography', 'grossly indecent'. The popular idea took root that the artists whose works were on show, men such as Cézanne, Van Gogh, Gauguin, were charlatans, concerned mainly with 'pulling our legs'. A fear of the new took on dimensions of pure pathological hatred, of the kind which was later to lead to the disfigurement of Epstein statues and other forms of vandalism. On the other hand the notion had also been born that what was new was *ipsissimo facto* superior to what was not; that taste was pure, its canons obligatory. A new intolerance had been born of a kind which made that which had divided the Pre-Raphelites from their contemporaries seem like an exercise in critical

ecumenicism. As Clive Bell pointed out, 'The first Post-Impressionist exhibition was a prodigious success. It set all England talking about contemporary painting, and sent the more alert not only to Paris, but to museums and galleries where they could have a look at primitive, oriental and savage art. The attendance was a record for the gallery; the sales were more than satisfactory.' (*Art News*, October 1950.) A later generation would look wryly at Bell's concept of 'all England', and be sceptical about the actual increase in cross-Channel traffic occasioned by the goings-on in Grafton Street. But the sociological dimensions of taste and art criticism had not become apparent in 1910. What had become so, however, was the fact that taste and fashion, not only in art and architecture, but in all the arts would never again have the simple outlines they had possessed over the past ten centuries.

2. The state of art

The relationship between art and High Victorian life

2.1 A permanent and unalterable constitution

How seriously the young members of the Pre-Raphaelite Brotherhood took themselves can be gauged from the elaborate constitution which they devised for themselves, and which was solemnly recorded by William Michael Rossetti.

P.R.B. – Present, at Hunt's, himself, Millais, Stephens, and W. M. Rossetti, 13 January 1851.

In consideration of the unsettled and unwritten state of the Rules guiding the P.R.B., it is deemed necessary to determine and adopt a recognized system.

The P.R.B. origianlly consisted of seven members – Hunt, Millais, Dante and William Rossetti, Stephens, Woolner, and another; and has been reduced to six by the withdrawal of the last. It was at first positively understood that the P.R.B. is to consist of these persons and no others – secession of any original member not being contemplated; and the principle that neither this highly important rule nor any other affecting the P.R.B. can be repealed or modified, nor any finally adopted, unless on unanimous consent of the members, is hereby declared permanent and unalterable.

Rule 1. That William Michael Rossetti, not being an artist, be Secretary of the P.R.B.

2. Considering the unforeseen vacancy as above stated, Resolved that the question of the election of a successor be postponed until after the opening of the year's art-exhibitions. This Rule to be acted on as a precedent in case of any future similar contingency.

3. That, in case a new election be voted, the person named as eligible be on probation for one year, enjoying meanwhile all the advantages of full membership, except as to voting.

4. That, on the first Friday of every month, a P.R.B. meeting, such as has hitherto been customary, be held.

5. That the present meeting be deemed the first in rotation under the preceding Rule; and that the future meetings be

held at the abodes of the several members, in order as follows – Millais, Dante Rossetti, William Rossetti, Stephens, Woolner.

6. That, in the event of the absence of the Member at whose house any meeting falls due, or other obstacle – to be allowed as valid by the others – the Secretary be made aware of the fact; and that the Member next in rotation act for the absent Member: the ensuing meetings to follow as before provided.

7. That unjustified absence under such circumstances subject the defaulter to a fine of 5s.

8. That a Probationary Member be not required to take his turn in this rotation.

9. That at each monthly meeting the Secretary introduce any business that may require consideration – to the exclusion of other topics until such business shall have been dispatched.

10. That any Member unavoidably absent be entitled to send his written opinion on any subject fixed for consideration.

11. That, failing full attendance at a meeting, or unanimously expressed opinion, the members present may adopt Resolutions, – to remain in force until a dissenting opinion shall be made known.

12. That any member absent from a meeting without valid excuse – to be allowed by the others – shall forfeit 2s. 6d.; and that no engagement with any other person whatever be held to supersede the obligation of a P.R.B. meeting.

13. That the January meeting of each year be deemed the Anniversary Meeting.

14. That the application of fines accruing as before specified be determined, by majority of votes, at each such annual meeting.

15. That at each annual meeting the conduct and position of each P.R.B. during the past year, in respect of his membership, be reviewed; it being understood that any member who shall not appear to have acted up to the best of his opportunities in furtherance of the objects of the Brotherhood is expected, by tacit consent, to exert himself more actively in future.

16. That the Secretary be required, as one chief part of his duty, to keep a Journal of the P.R.B.

17. That the Journal remain the property of the Brotherhood

collectively, and not of the Secretary or any other individual member; that it be considered expedient in ordinary cases to read the Journal at each meeting at the Secretary's residence; and that any member have the power to require its production whenever he may think fit.

18. That any election which may be hereafter proposed be determined by ballot.

19. That any such election be renewable annually by vote of the six original members.

20. That any member considered unworthy to continue in the Brotherhood cease to be a P.R.B. on the unanimous vote of his peers – i.e., of those in the same class, as regards date of election, as himself.

21. That the fines be received by the Secretary.

22. That the 23rd of April be kept sacred annually to Shakespeare, as an obligation equally binding as that of a P.R.B. meeting.

23. That, in case any P.R.B. should feel disposed to adopt publicly any course of action affecting the Brotherhood, the subject be in the first instance brought before the other members.'

2.2 Art and morality

The debate about the ethics of art was interminable, and it seemed at one point that any aesthetic which did not involve a discussion about the morality of creative activity was meaningless. In the last issue of the Pre-Raphaelite magazine *The Germ*, John Orchard, a young artist who died a week after he had written the piece, published a dialogue between four fictitious characters, each presenting a different approach to the question.

Christian. I do. Without he has a didactic aim; like as Hogarth had. A picture, poem, or statue, unless it speaks some purpose, is mere paint, paper, or stone. A work of art must have a purpose, or it is not a work of *fine* art: thus, then, if it be a work of fine art, it has a purpose; and having purpose, it has either a good or an evil one: there is no alternative.

Sophon. Suffer me to extend the just conclusions of Christian. Art – true art – fine art – cannot be either coarse or low. Innocent-like, no taint will cling to it, and a smock frock is as pure as 'virginal-chaste

robes'. And – sensualism, indecency, and brutality, excepted – sin is not sin, if not in the act; and, in satire, with the same exceptions, even sin in the act is tolerated when used to point forcibly a moral crime, or to warn society of a crying shame which it can remedy.

Kalon. But my dear Sophon, and you, Christian, – you do not condemn the oak because of its apples; and, like them, the sin in the poem, picture, or statue, may be a wormy accretion grafted from without. The spectator often makes sin where the artist intended none. For instance, in the nude, – where perhaps, the poet, painter, or sculptor, imagines he has embodied only the purest and chastest ideas and forms, the sensualist sees – what he wills to see; and, serpent-like, previous to devouring his prey, he covers it with his saliva.

Christian. The Circean poison, whether drunk from the clearest crystal or the coarsest clay, alike intoxicates and makes beasts of men. Be assured that every nude figure or nudity introduced into a poem, picture, or piece of sculpture, merely on physical grounds, and only for effect, is vicious. And, where it is boldly introduced and forms the central idea, it ought never to have a sense of its condition: it is not nudity that is sinful, but the figure's knowledge of its nudity (too surely communicated by it to the spectator), that makes it so. Eve and Adam before their fall were not more utterly shameless than the artist ought to make his inventions. The Turk believes that, at the judgement-day, every artist will be compelled to furnish, from his own soul, soul for every one of his own creations. This thought is a noble one, and should thoroughly awake poet, painter, and sculptor, to the awful responsibilities they labour under. With regard to the sensualist, – who is omnivorous, and, swine-like, assimilates indifferently pure and impure, degrading everything he hears and sees, – little can be said beyond this, that for him, if the artist *be* without sin, he is not answerable. But in this responsibility he has two rigid yet just judges, God and himself; – let him answer there before that tribunal. God will acquit or condemn him only as he can acquit or condemn himself.

Kalon. But, under any circumstance, beautiful nude flesh beautifully painted must kindle sensuality; and, described as beautifully in poetry, it will do the like, almost, if not quite, as readily. Sculpture is the only form of art in which it can be used thoroughly pure, chaste, unsullied, and unsullying. I feel, Christian, that you mean this. And see what you do! What a vast domain of art you set a Solomon's seal upon! how numberless are the poems, pictures, and statues – the most beautiful productions of their auth

ors – you put in limbo! To me, I confess, it appears the very top of prudery to condemn these lovely creations, merely because they quicken some men's pulses.

Kosmon. And to me, it appears hypercriticism to object to pictures, poems, and statues, calling them not works of art – or fine art – because they have no higher purpose than eye or ear-delight. If this law be held to be good, very few pictures called of the English school – of the English school, did I say? – very few pictures at all, of any school, are safe from condemnation: almost all the Dutch must suffer judgement, and a very large proportion of modern sculpture, poetry, and music, will not pass. Even *Christobel* and the *Eve of St Agnes* could not stand the ordeal.

Christian. Oh Kalon, you hardly need an answer! What! Shall the artist spend weeks and months, nay, sometimes years, in thought and study, contriving and perfecting some beautiful invention, – in order only that men's pulses may be quickened? What! – can he, Jesuit-like, dwell in the house of soul, only to discover where to sap her foundations? – Satan-like, does he turn his angel of light into a fiend of darkness, and use his God-delegated might against its giver, making Astartes and Molochs to draw other thousands of innocent lives into the embraces of sin? And as for you, Kosmon, I regard purpose as I regard soul; one is not more the light of the thought than the other is the light of the body; and both, soul and purpose, are necessary for a complete intellect; and intellect of the intellectual – of which the fine arts are the capital members – is not more to be expected than demanded. I believe that most of the pictures you mean are mere natural history paintings from the animal side of man. The Dutchman may, certainly, go Letheward; but for their colour, and subtleties of execution, they would not be tolerated by any man of taste.'

2.3 Art as an exponent of virtues

Time and time again the writers of the period sought justification for art in the theory that it taught moral values. In 1890 T. C. Horsfall, one of the main luminaries of the Manchester art world, wrote to Leighton including a letter he had sent to *The Manchester Courier* on the subject. Leighton's reply shows flashes of refreshing realism.

To the Editor of the *Manchester Courier*
Sir,
On the 4th and 6th inst. I published two long letters on the man-

agement of art galleries, of some part of which this is a summary: No one can intelligently and fully enjoy any picture or statue unless he has some measure of three kinds of knowledge. (1) He must know something about the subject represented, or he cannot enjoy the expression by the work of the artist's feeling and thought; (2) he must know something of the processes of the art in which the artist has worked, or he cannot know what effects the artist sought or might have sought; (3) he must know something of the history of the art, or he cannot understand what elements in the work are due to the artist himself and what to his time and place; or enjoy at all some of the finest works ever produced. For the giving of the second and third of these three kinds of knowledge there ought to be subsidiary collections in our Manchester galleries, kept distinct from the principal collection, and for the giving of the first kind there ought to be several distinct subsidiary collections, of which some should be for the purpose of giving knowledge of flowers, birds, trees, and the other beautiful objects which are 'elements of landscape'. As a very large proportion of the people of all large towns are ignorant of all that is interesting in nature, and of all that is noblest and most interesting in history and in contemporary life, and as pictures can very effectively give some knowledge both of nature and of the deeds of men while fulfilling their special function, which is to give certain kinds of aesthetic pleasure, the principal collections in our galleries ought to be used for the purpose of giving knowledge of nature and of noble human nature. A gallery of good pictues of the kind would, by reason of the interest of the subjects represented, attract so much attention that the public would to a far larger extent than now feel the influence of the artistic qualities of pictures. In order to obtain pictures of suitable subjects. the directors of art galleries, instead of only buying pictures in exhibitions and studios as they now do, should, as a rule, revert to the custom which prevailed in the ages when art influenced life deeply, and should ask artists to paint pictures of prescribed subjects. I believe that they would get thus better pictures and at lower prices. Many artists certainly would be at their best when they knew they were working to enlighten a great community, and would gladly accept a moderate price for a picture ordered for a public gallery.

I sent a copy of my letters to Sir Frederic Leighton, and asked him if he would let me have his opinion respecting the principal suggestions contained in them. With the great kindness which distinguishes him, Sir Frederic Leighton has written me the following letter, which contains advice so valuable that I am sure every person

in Manchester who cares for art will be glad to have an opportunity of reading it:

Dear Mr Horsfall,

I must apologise for my very long delay in answering your letter – a delay due in great part to lack of time, but in part also to the fact that your questions could not be answered hastily, or without due consideration. I may say at the outset that I very warmly appreciate the depth of your interest in the subject of art, and the constancy of your efforts to spread its influence in Manchester; and I am glad to be able to add that on not a few points, I find myself in harmony with your views.

It is evidently not possible for me to touch, within the compass of a letter, upon more than one or two of the matters with which you deal in your two long communications to the Manchester press; and, indeed, the question on which you mainly dilate, and in regard to which I am not wholly at one with you, would require to be dealt with at far greater length than is possible to me here. I must content myself with saying what little seems to me sufficient to indicate the grounds of my dissent from you. But first I should like to say a word in passing on the vexed subject of *copies*.

There can be no doubt that it would be an immense advantage to those who cannot travel – that is to say, to the enormous majority of men – to bring before their eyes, through reproductions – if these reproductions were absolutely faithful – the masterpieces to which distance deprives them of access. This is, in the case of sculpture and architectural detail, in a large measure achieved by the means of plaster casts, though it is needless to point out that the capacity of the material robs the reproduction of much of the life and light of the original. With pictures the case is different. The subtle and infinite charm which resides in the *handiwork* of a master, and in the absence of which half the personality of his work is lost, can hardly ever be rendered by a copyist. For this reason the overwhelming majority of even reasonable copies is to my mind worse than useless. Such copies can kindle no enthusiasm, and they virtually misinform the student. It has always seemed to me that the best way to acquaint young people with pictures which they are not able to see is to put before them photographs of the originals, which, besides giving design, form, and light and shade, with absolute fidelity, render, in a wonderful way, the executive physiognomy of the work; and by the side of these photographs free, but faithful, coloured sketches of the pictures should hang, giving the scheme, harmony, and tone of the colour, but not, like finished copies, professing an identity with the original, which is never achieved.

Turning now to what you say on the subject of the acquisition of works for a public gallery, I should at once dissuade you from any idea of giving definite commissions – I mean commission to paint specially selected subjects. I have always felt very strongly that artistic work, to be of real value, must be the outcome of entirely spontaneous impulse in an artist. I believe that in the immense majority of cases work done under any other conditions lacks vitality and sincerity, and will not show the worker at his best. A subject which does not impose itself unbidden on the artist will never elicit his full powers. I have myself on that ground for many years past invariably declined to paint under any kind of restriction.

Neither does your idea of – practically – refusing encouragement to any work which does not commemorate a noble deed, and, if possible, the noble deed of a well-known personage, commend itself to me. It seems to me, on the contrary, to be a harmful one, inasmuch as it misdirects the mind of a people, already little open to pure artistic emotion, as to the special function of Art. This can, of course, only be the doing of something which it *alone* can achieve. Now, direct ethical teaching is specially the province of the written and the spoken word. A page or two from the pen of a great and nobly-inspired moralist – a Newman say, or a Liddon, or a Martineau – can fire us more potently and definitely for good than a whole gallery of paintings. This does not, of course, mean that a moral lesson may not indirectly be conveyed by a work of art, and thereby enhance its purely moral value. *But it cannot be the highest function of any form of expression to convey that which can be more forcibly, more clearly, and more certainly brought home through another channel.* You may no more make this direct *explicit* ethical teaching a test of worth in a painted work than you may do so in the case of instrumental music; indeed by doing so you will turn the attention of those before whom you place it from the true character of its excellence – you will, so to speak, mis-focus their emotional sensibility. It is only by concentrating his attention on essentially artistic attributes that you can hope to intensify in the spectator that perception of what is beautiful in the highest, widest, and fullest sense of the word, through which he may enrich his life by the multiplication of precious moments akin to those which the noblest and most enhancing music may bestow on him through different forms of aesthetic emotion. It is in the power to lift us out of ourselves into regions of such pure and penetrating enjoyment that the privilege and greatness of art reside. If, in a fine painting, a further wholly human source of emotion is present, and if that emotion is more vividly kindled in the

spectator by the fact that he is attuned to receive it by the excitement of aesthetic perception through the beauty of the work of art as such, that work will gain no doubt in interest and in width of appeal. But it will not therefore be of a loftier order than a great work in architecture or music – than the Parthenon, for instance, or a symphony of Beethoven, neither of which preaches a direct moral lesson.

But I am being led away into undue length without the possibility, after all, of doing more than roughly indicate the grounds of my dissent from a rather vital article of your creed – a dissent which will, I am afraid, jar on you in proportion to the great sincerity with which you hold your faith. I may say, by the way, that I dwelt at rather greater length on this very subject in my first presidential address to the Royal Academy, delivered on 16th December 1879. – And, herewith, I remain, dear Mr Horsfall, yours very truly, Fred Leighton
2 Holland Park Road, Kensington,
August 18, 1890.'

2.4 Devoid of unnecessary delicacy

In 1855 that formidable Inspector of Art, cultural bureaucrat and painter Richard Redgrave went to Paris to arrange the British art section in the Great Exhibition there. On 6 April he visited the French painting section, and had what to him was the dubious pleasure of seeing for the first time Courbet's great painting of his own studio – which was subsequently removed, prompting the painter to set up his own exhibition outside the limits of the official one. His reactions were certainly typical, if not of those of his fellow countrymen and of many Frenchmen too, but especially of the kind of art he himself admired and practised. He recorded his reactions in his diary, quoted by his son in the posthumous, *Richard Redgrave, C.B. R.A. A Memoir*, compiled by his son (Cassell, 1891).

Some of the pictures here by Frenchmen of celebrity surprise me greatly. I have seen to-day, standing in one of the vast halls, a work by Courbet. He is a great man, and they hardly know how to deal with it. It has, I hear, been once rejected, but the discussion is renewed at the instance of his friends. I can hardly trust myself to say what I think of its coarseness of conception, of execution, and design. It represents an interior, I presume the painter's studio. He is sitting at his easel, on which is a large landscape, and he seems about to introduce into it a naked figure, perhaps as a bather. The studio is filled with male friends and pupils of the artist, but the principal

figure in the foreground is a strong-minded woman, amidst a group of gentlemen. I say 'strong-minded', for immediately in front of her, and standing between her and the picture, is a female model, most common in form, who holds up some drapery before her in such a way as to make her nakedness more visible. At the feet of the strong-minded female is a small boy, about fourteen years of age, lying on the ground, with a sheet of paper, on which he is sketching the model. All this is bad enough, but at the foot of the easel is another sitter, a coarse, fat, greasy beggar-woman, almost entirely without drapery, engaged in nursing a dirty little brat. All these figures are the size of life. A beggar-child in front of the easel, about eight years old, is looking at the naked bather before described. Nor is this sufficiently strong for French taste, or as a picture of 'studio doings'. Behind the easel, apparently posed for one of the pupils, is an undraped *male* model! The room, as I have said before, is full of friends, bearded and hoary, as well as the lady devoid of unnecessary delicacy. In the background is a young female model who has just, I presume, completed her toilette, upon which a pupil is complimenting her with a kiss. Dogs of various breeds complete the picture. The whole is wrought with the execution of a house-painter who has just taken up art. It is bad both in form and in colour. Truly this is a strange people! Side by side with this work, a picture of our Lord's Agony or of the Blessed Virgin will probably be hung!

One new rendering of the Annunciation I saw in close proximity to the Courbet, a really beautiful work by Jalabert, refined in drawing, in feeling, and in taste.

The picture by Courbet, after many discussions, was taken down and returned, which so nettled him, that, although he had many other pictures hung, he opened a separate exhibition in the vicinity.

2.5 The decline of subject pictures

One of the most noticeable changes which were taking place at this time was the decline in the popularity of the 'subject picture' which had dominated the first half of the century. In his *The Inner Life of the Royal Academy* (1914) G. D. Leslie, whose father C. R. Leslie had made his reputation from works of this type, analysed the factors which had brought this about.

During the Presidency of Lord Leighton a marked change gradually became manifest in the character of the annual Exhibitions at the Academy – a change principally observable in the gradual but dis-

tinct diminution of what artists term 'subject pictures'; under this head may be classed those representing scenes from domestic or rural life, humorous pictures of various sorts, those in which strong dramatic situations or scenes of sentiment or love are depicted, and pictures with subjects taken from history or from the great dramatists or novelists. In such pictures great care was usually taken in representing the backgrounds, costumes, and accessories with archaeological accuracy; the canvases were generally of moderate dimensions, and the figures introduced in them were always smaller than life.

It was a peculiarly *national* branch of the art, for though it probably owed its origin to the works of the Dutch School, its first introduction into England may be traced to such essentially British artists as Hogarth, Morland, Stothard, Smirke, James Ward, and Wheatley, followed by such equally national artists as Wilkie, Mulready, Collins, C. R. Leslie, Webster, Maclise, and others. The works of the Pre-Raphaelites, as far as the subjects and sizes of the canvas were concerned, belonged to the same category, their style and technique being the chief difference between them and those of the figure painters of the School just mentioned.

During the early years of the nineteenth century these pictures received but scanty patronage; their prices were low, and the artists had to supplement their earnings either by painting small portraits or by devoting their talents to book illustration. Even with such supplementary aids my father had a hard struggle in the early part of his career to support his wife and family; later in life he was more successful in selling his works, and the prices he got for his pictures were much higher. Towards the end of Sir Martin Shee's Presidency several patrons distinguished themselves by forming large collections of landscapes and subject pictures by living British artists; among these collectors the names of Mr Vernon and Mr Sheepshanks are the best known. From that time the figure and landscape painters enjoyed more prosperous days; purchasers were found in abundance, the moderate size of the canvases was all in their favour, for it rendered the pictures easy to place on the walls of the collectors. With the general public these pictures were extremely popular; the receipts from the shillings taken at the doors of the Academy going up by leaps and bounds. Ruskin was at the time at the zenith of his brilliancy, and devoted his most fervent energy to laudation of the works of the Pre-Raphaelites, although occasionally others of the subject painters came in for a share of his praise. Even the critics in the press began, as they say of babies, 'to take notice.'

Visitors at the Private Views in those days really looked at the pictures as well as at each other. And altogether the artists had a famous time of it during the 'fifties and 'sixties.

Thinking that the good times had come to stay, numbers of successful painters who could afford it, and, sad to say, very many other artists who could not, bought houses with gardens attached to them, in St John's Wood, Kensington, Hampstead, and other suburban districts, where they built themselves large and luxuriously fitted studios; in these on 'Show Sundays' they were visited by crowds of fashionable people, but on working days such artists at their easels, with their models, always seemed to me to be sadly out of scale with their spacious and magnificent surroundings. I can well remember, for example, John Pettie appearing to me as quite lost in his large studio. I suspect he must have felt something of this sort himself, for he had divided the place in half by a huge velvet curtain, hanging from ceiling to floor.

How far the removal, in 1869, of the Academy from Trafalgar Square to its present spacious abode at Burlington House had to do with it I cannot say, but certainly a few years after that event a gradual falling off in the annual output of 'subject pictures' was distinctly noticeable. Such paintings of this class as were still contributed were usually of far larger dimensions than those formerly sent, and possibly on this account they became less acceptable to private collectors.

Very shortly after the removal to Burlington House, the rule prohibiting whole-length and life-sized half-length portraits from places on the so-called line was abolished, and as a result the landscape painters soon found out that works of theirs under six feet in length failed to attract attention on the walls. Large pictures became the general fashion, smaller ones being only placed, here and there, to fill up awkward gaps and corners. Room No. IX., the 'Gem Room,' was henceforth the only room reserved for very small works. Some of the members themselves, however, were addicted to small canvases, and their works had to be accommodated in various ways on choice walls, and what are termed 'little nests' were formed for them in some of the larger rooms.

Coincidently with the invasion of the line by the life-sized portraits, the patronage hitherto given to subject-pictures began to fall of lamentably, and in consequence of this a great number of distinguished painters, who formerly produced important works of figure subjects, began to take to portraiture. Prominent among such painters were Millais, Holl, Orchardson, and Pettie. But numerous

other examples of men who likewise did so may be found among members of the Academy who are still living. I should have taken to portrait painting myself, but, unfortunately, I never could work well in harness, feeling miserable unless I have absolute freedom to choose my own models and my own subjects. There is still some patronage, though at a very moderate remuneration, for landscapes, and accordingly I have chiefly occupied my old age with that delightful branch of painting.

I have endeavoured above to give a few of the possible reasons for the gradual decrease in number of the subject-pictures in our annual Exhibition. There were, however, others as well, one, in my opinion, being the powerful influence which Lord Leighton possessed over the Councils of selection while he occupied the chair. He himself had little or no sympathy with works of this character, and although he undoubtedly maintained the most conscientious impartiality as a chairman, it was beyond even his marvellous powers of self-control entirely to conceal his opinion from the members of the Council.

2.6 Portrait of an artist

In 1854 Philip Gilbert Hamerton, art critic of *The Saturday Review*, founder and editor of *The Portfolio*, painter and novelist, became at the age of twenty a student of J. P. Pettitt who carried on into the nineteenth century, as many other artists did, something of the attitudes and quality of life which had characterised their eighteenth-century predecessors. In his *Autobiography* (1896) Hamerton presented an interesting portrait of Pettitt's career and artistic personality.

Mr Pettitt was a most devoted student of nature, and his best pictures had the character of faithful studies. He would sit down in some rocky dell by the side of a stream in Wales, and paint rocks and trees month after month with indefatigable perseverance; but he had no education, either literary or artistic, and very little imaginative power. His only safety was in that work from nature, and he would have stuck to it most resolutely had there been any regularity in the encouragement he received; but his income, like that of all painters who are not celebrated, was very uncertain, and he could not quietly settle down to the tranquil studies that he loved. Anxiety had made him imprudent; it had driven him to try for notoriety. The Nebuchadnezzar picture, and other mistakes of a like magnitude,

were the struggles of a disquieted mind. Pettitt had a very large family to maintain, and did nothing but paint, paint from morning till night, except for half-an-hour after his light lunch, when he read the 'Times'. As the great picture did not advance very rapidly, he worked by gaslight after the short London winter day, and often pursued his terrible task till the early hours of the morning, when exhausted nature could resist no longer, and he fell asleep on a little iron bed in the studio. There were days when he told me he had worked twenty hours out of the twenty-four. All this was a perfectly gratuitous expenditure of time and health that could not possibly lead to any advantage whatever.

Pettitt was a very kind and attentive teacher, and his method was this: He would begin a picture in my presence, give me two white canvases exactly the same size, and then tell me to copy his hour's work twice over. Whilst he painted I watched; whilst I painted he did not look over me, but went on with his own work. He was always ready to answer any question and to help me over any difficulty. In this way he soon initiated me into the processes of oil-painting so far as I required any initiation, for most of them were familiar to me already. Unfortunately, Pettitt had no conception of art. This needs a short explanation, as the reader may allowably ask how a man without any conception of art could be even a moderately successful artist.

The answer is that men like Mr Pettitt regard painting simply as a representation of nature, and their pictures are really nothing but large and laborious studies. Pettitt was a most sincere lover of nature, but that was all; he knew little or nothing of those necessities and conditions that make art a different thing from nature. The tendency of his teaching was, therefore, to lead me to nature instead of leading me to art, and this was a great misfortune for me, as my instincts were only too much in the same direction already. I could get nature in the country, and that in endless abundance; what I needed at that time was some guidance into the realm of art.

Pettitt taught me to draw in a hard, clear, scientific manner. He himself knew a little geology, and one of his sons was a well-informed geologist. I copied studies of cliffs that were entirely conceived and executed in the scientific spirit.

The ideas of artistic synthesis, of seeing a subject as a whole, of subordination of parts, of concentration of vision, of obtaining results by opposition in form, light and shade, and colour, all those ideas were foreign to my master's simple philosophy of art. In his view the artist had nothing to do but sit down to a natural subject

and copy with the utmost diligence what was before him, first one part and then another, till the whole was done. My master, therefore, only confirmed me in my own tendencies, which were to turn my back on art and go to nature as the sole authority. Mr Ruskin's influence had impelled me in the same direction. Every one is the product of his time and of his teachers. It is not my fault if the essentially artistic elements in art were hidden from me in my youth. Had I perceived them at that time they would only have seemed a kind of dishonesty.

If Mr Pettitt had written an autobiography it would have been extremely interesting. He was the twenty-fifth child of his father, and five were born after him. He began by being apprenticed to a cabinet-maker, but did not take to the work, and was put into a printing-office. Then he served an apprenticeship to a japanner, and married very early on incredibly small earnings, which, however, he increased by his rapidity in work and his incessant industry. Before the expiration of his apprenticeship he had a shop of his own, and sold japanned tea-trays and bellows. When he was able to rent a house, he made all the furniture with his own hands, and took a pride in having it very good, either solid mahogany or veneered. He saved money in the japanning business, and then on these savings undertook to teach himself painting. His earliest works were sold for anything they would fetch. Whilst I was in London he recognized one of them, a small picture that he immediately bought back for sixpence. There had been a fall in its market value, alas! for the original price was ninepence. Pettitt had a fancy for collecting his early daubs, as they confirmed his sense of progress. Having acquired some knowledge of painting, he engaged himself on weekly wages as a decorator of steamboat panels. His employers wanted quantity rather than finish, but Pettitt liked to finish as well as he could, and recommended his fellow-workmen to study from nature. This led to his dismissal.

During the time of his poverty, Pettitt made an excursion into France, and being at Paris with a companion as penniless as himself, he had to devise means for reaching England without money. The pair had nothing of any value but a flute, and the flute had silver keys, so it was a precious article. With the proceeds in their pockets the friends tramped to Boulogne on foot, and there they arrived in the last stage of poverty. They cleaned themselves as well as they could before showing their faces at the hotel they had patronized when richer, and there they stayed for some days in the hope of a remittance from an uncle. That relative was of opinion that a little

hardship would surely bring the travellers back to England, and so he sent them nothing. What was to be done? They avowed the whole case to the hotel-keeper, who not only made no attempt to detain them, but filled their empty purses. The story concludes prettily, for the obdurate uncle relented on their arrival, and at once repaid the Frenchman.

Pettitt long preceded Mr Louis Stevenson in the idea of travelling in France with a donkey. He, too, explored some mountainous districts in the centre or south of France with a donkey to carry his luggage, and the two companions slept out at nights, as Mr Stevenson did afterwards. At last Pettitt met with an old woman whose lot seemed to him particularly hard. She had to walk from a hill-village down to the valley every day, nearly twenty miles going and returning; so Pettitt made her a present of his donkey, and she prayed for him most fervently.

Another of my master's pedestrian rambles extended for fifteen hundred miles along the coast of Great Britain. During this excursion he accumulated a vast quantity of sketches, truthful memoranda, almost as accurate as the photographs which have now superseded studies of that kind.

Pettitt had made astonishing progress considering the humble position he started from; but unfortunately for me he was not a man of culture, even in art. One of his friends, a journalist, who often called at the studio, and who saw a little deeper than most people, said to me one day that the art of painting, as practised by many fairly successful men (and he referred tacitly to my master), might be most accurately described as 'a high-class industry'.

For my part I worked very steadily when in London, and made rapid progress. It was not quite in the right direction, unfortunately.

No reader of these pages will be able to imagine what a sacrifice that stay in London was for me. The studio was never cleaned, and very badly ventilated. My master did not perceive this amidst the clouds of his own tobacco smoke, but for me, who had come from perfect cleanliness and the pure air of our northern hills, it was almost unbearable.

2.7 A painter in his studio

Whistler was remarkable not only because his style of painting, with its French roots, went directly against that currently fashionable in England, but because his projection of himself as the impeccable

dandy helped to make him an arbiter of fashion. It is significant that in an article published in the *court and Society Review* for July 1886 Malcolm C. Salaman should have paid even more attention to his surroundings than to his paintings.

The plain white-washed walls, the unadorned wooden rafters, which partly form a loft for the stowing away of numerous canvases, panels, &c., the vast space unencumbered by furniture, and the large table-palette, all give the appearance of the working place where serious Art alone is tolerated, and where *dilettantism* would be an impertinence. Mr Whistler is not so feeble as to aim at theatrical effects in his costume. The velvet coat, the embroidered smoking-cap, and other accessories of the fashionable, albeit incompetent painter, find no favour in his eyes, but in the black clothes of his ordinary wear, straight from the street or the garden, he stands at work at his easel. To those accustomed to studios the completeness of the arrangement of model, background, and surroundings – exactly in accordance with the scheme of the picture that is in progress – is striking, as striking indeed as the actual personality (always remarkable) of the talented artist. For his whole body seems instinct with energy and enthusiasm for his work, his face lit up with flashes of quick and strong thought, as that of a man who sees with his brains as well as with his eyes, and his brush-hand electric in sympathy with both.

A word, by the way, about Mr Whistler's palette, just alluded to. As I saw it the other day, the colours were systematically arranged, almost with the appearance of a picture. In the centre was white and on one side were the various reds leading up to black, while on the other side were the yellows leading up to blue. . . .

And now a few words about some of the pictures which the master has almost ready for exhibition, and which I hope the public will have an opportunity of seeing. 1. A full-length figure of a girl in an out-door black dress, with a fur cape and a becoming hat trimmed with flowers. The face is daintily pretty and piquant and the grace and spontaneity of the attitude are charming. She stands against a dark background, and like all the figures that Mr Whistler paints, she actually *lives* in her frame. The painting of the head is as refined and beautiful a piece of work as I have ever seen. 2. A full-length portrait of Mr Walter Sickert, a favourite pupil of Mr. Whistler's and one of his cleverest disciples. He is in evening dress, and stands against a dark wall. The values of the black tones in this picture are wonderfully mastered. This is a picture that Velasquez himself would have delighted in – (it has vanished) – and still more so is

another – 3. A full-length portrait of a man with a very characteris-
tic, rather Spanish-looking head, painted in a manner that is surely of
the very greatest. (This may have been the portrait of Chase or of
Eldon, also disappeared) . . .

A superb portrait of Mrs Godwin, wife of the well-known archi-
tect, will rank among Mr Whistler's *chefs-d'œuvre*. The lady stands in
an ample red cloak over a black dress, against red draperies, and in
her bonnet is a red plume. Her hands rest on her hips, and her
attitude is singularly vivacious. The colour is simply wonderful, and
is another positive proof of Mr Whistler's pre-eminence as a col-
ourist. This picture has been painted in artificial light, as has also
another one of a lady seated in a graceful attitude, with one hand
leaning over the back of a chair, while the other holds a fan. She
wears a white evening dress, and is seen against a light background.
Besides these pictures, Mr Whistler showed me the other day the
sketches of three pictures he is going to paint, consisting of various
groups of several girls on the sea-shore . . . (The *Projects*, evidently.)
In addition to these sketches, I was also privileged to see a sketch of a
Venus, very lovely in colour and design, the nude figure standing
close to the sea with delicate gauze draperies being lightly lifted by
the breeze. The studio is full of canvases and pictures in more or less
advanced stages, and on one of the walls hang a number of pastel
studies of the nude and partially draped female figure, showing in
every touch the master hand. . . . A portrait sketch in black chalk of
Mr Whistler himself by M. Rajon, also hangs on the wall.'

2.8 A society artist

John Singer Sargent was the very epitome of the successful society
artist, and a painter of very real gifts. His personality and
surroundings were convincingly sketched by his contemporary
William Rothenstein in his *Men and Memories* (London, 1932, vol. ii).

I felt that something essential was lacking in Sargent. He was like a
hungry man with a superb digestion, who need not be too particular
what he eats. Sargent's unappeased appetite for work allowed him to
paint everything and anything without selection, anywhere, at any
time. It was this uncritical hunger for mere painting which distin-
guished him from the French and English painters whom he rivalled,
and often surpassed, in facility. He accepted any problem set him
with equal zest; it was for him to solve it successfully. He never
relied solely on his facility, but gave all his energies to each task.

I was touched by Sargent's generous enthusiasm for Manet and Monet, for Rodin and Whistler; for, as I said, I had heard Degas and Whistler speak disparagingly of Sargent, as a skilful portrait painter who differed little from the better Salon painters then in fashion. He was allowed to be Carolus Duran's most capable disciple, but not a markedly personal artist. With the exception of Rodin, I never heard anyone in Paris acknowledge the worth of Sargent's performance.

Even Helleu, his closest friend, whose work Sargent adulated, regarded him with a patronising eye – a worthy painter, a dear good fellow; scarcely an artist.

On the other hand, at the Royal Academy where, having settled in England, he exhibited regularly, Sargent appeared as a daring innovator. Although he had as many commissions as he could execute, they came chiefly from Americans. In London his warmest admirers were the wealthy Jews. But it would be a mistake to suppose that Sargent preferred the aristocratic to the Jewish type, that he painted Jews because they happened to be his chief clients. On the contrary, he admired, and thoroughly enjoyed painting, the energetic features of the men, and the exotic beauty of the women of Semitic race. He urged me to paint Jews, as being at once the most interesting models and the most reliable patrons. The more conservative English were at first shy of facing the cold light of Sargent's studio; the absurd legend that he brought out the worst side of his sitters' characters also helped to keep people away.

There was neither flattery nor satire in his portraits; his problem was to make his work visually convincing. Not for him any short cuts; his integrity was unquestionable. And yet in his brilliant rendering of the men and women who sat to him, he seemed to miss something of the mystery of life. I remember how this sense of the dramatic element of good portraiture came on me when looking one day at photographs of Titian's and Giorgione's portraits of young men, so proud in their bearing, and from whose death, I suddenly felt, was never far off. But what relation have Sargent's men and women to the drama of life and death? Sargent rarely succeeded in removing his figures from the model stand, from the Louis XV or Louis XVI chair or settee dear to the new rich; from pearl necklaces and glittering medals, and Worth dresses of velvet and satin. Looking, too, at his out-of-door work, so accidental in composition, at those sparkling paintings of flickering sunlight over mountains and plains, over trees and buildings, I felt as though they had sprung up before him by a sort of magic: feverish, transitory apparitions with no past and no future, that would fade away after he had folded up his easel and painting stool.

But this was, after all, the real Sargent; for the qualities I missed in his painting were qualities he did not particularly admire in others. It was not the gravity of Velazquez and Hals that he cared for so much as their perfection of handling. Similarly with his admiration for Manet; it was for Manet's brilliance of execution that he preferred him to austerer painters like Fantin-Latour and Legros. Cézanne's work he altogether disliked. Oddly enough, when later I was painting Jews in the East End, he thought I was aiming at too abstract a representation, and wanted me to paint scenes in Petticoat Lane, or the interiors of tailors' shops, as showing the more intimate side of Jewish life. Yet it was just this lack of intimacy that I missed in his portraits. But then Sargent himself had little of this intimacy in his own life. His studio was that of a cultivated cosmopolitan, filled with French, Italian and Spanish furniture and bric-à-brac; he could scarcely be expected to paint people in the middle-class interiors in which Degas, Fantin-Latour and Cézanne saw their sitters.

But herein Sargent was true, and wisely true, to himself. On the other hand, when he gave up portrait painting to devote himself solely to his Boston decorations, he showed unworldliness and a touching desire to escape from the slavery of the model-stand; but his shortcomings were at once revealed. The American element in his nature asserted itself; he approached the scene of the Divine Comedy not with the great Mantuan, not with the noble Giotto, not yet with the passionate El Greco, but with Edwin Abbey by his side. Truth to tell, Sargent's taste and judgement in painting were very unexpected. He was a keen admirer not only of Hals and Velazquez, but also of El Greco and of Tiepolo; and, what was more strange, of the early work of Rossetti. He was an ardent musician. When I was painting with him, he always improvised on the piano while the model was resting. He had many musical friends, chief among them Fauré, whom he invited to England to stay with him, taking endless trouble to introduce him to musical people in London, inviting them to his studio to hear Fauré play his own compositions.

Like Steer and myself, he was a keen chess-player, and he often asked us round to his mother's flat for a game in the evenings. He adored his mother, while her pride in him was touching to see – a quiet undemonstrative pride, as became a lady of old Bostonian lineage.

Perhaps Sargent's closest friends were Laurence Harrison, and his wife, 'Alma Strettell', the translator of Roumanian folk-songs, and also of Émile Verhaeren. I had known them both in Paris, and valued Harrison's judgement and his work more than that of most artists. It

was difficult to induce him to show his canvases, for Harrison belittled himself, and was over modest; but some of his interiors and sea-pieces reached the level of Steer at his best, I thought.

Harrison was a man of unusually fine taste, taste apparent throughout his beautiful house in Cheyne Walk. Besides Sargent, Steer, Tonks, George Moore and MacColl met constantly round his table.

Those were days of vital friendships in art, when our faith and trust in one another were as yet undimmed.

2.9 Artists' models

Never before, nor indeed since, had the services of artists' models been in such demand. But it is interesting that one of the major references to them came in Charles Booth's *Life and Labour of the People of London*, the first volume of which appeared in 1889.

Artists' models sometimes have been and often become ballet-girls. The regular pay for models whether for face or figure is 7s. for a whole day, including two meals, and 3s. 6d. or 5s. for half a day. At the Royal Academy they receive a good deal more – 54s. a week – but their engagement at these rates does not last for more than one month, because the custom is for each visiting academician to bring a model with him for his term as a lecturer.

Male models are very frequently Italians, and the profession runs in families.

Female models as such lead a pleasant life, and in the end often marry one or other of those to whom they have been sitting. Those of them who are not fortunate enough to do this not infrequently end by going on the stage.

2.10 The misdeeds of a model

In an age dominated by anecdotal and realistic art, models played a more important role than probably ever before in the history of British art. Assiduously sought after, cultivated and jealously guarded, they could help an artist to success. Many were Italians; Leighton was especially attracted to one male; others were, as in the eighteenth century, discharged soldiers, used to the strains of maintaining the same pose for lengthy periods; others were flower-girls, domestic servants and the like. Artists' autobiographical writings abounded with anecdotes of them. Typical is this account by Frith in his entertaining *My Autobiography and Reminiscences*, vol. 2, 1887.

Amongst the ignorant – and how large that class is as regards matters of art it would be impossible to calculate – the idea commonly prevails that pictures are evolved out of the painter's inner consciousness, or, in other words, are created out of nothing. The fact that nature is constantly referred to, that for the most trifling detail the artist never trusts to his memory, that he not only uses models for the human being which may fill his compositions, but that he seeks far and wide for the smallest object to be represented, will be a revelation to most people. That being so, the model becomes a most important factor, either as a human being or a detail, to all painters; and the difficulty of discovering the needful type becomes sometimes almost impossible.

If I may presume to be known as an artist, it is as the painter of large compositions, such as the 'Derby Day', the 'Railway Station', 'Ramsgate Sands', etc., etc., and it has been my fate to undergo much tribulation in my search after material in various forms. During the execution of the picture of 'Ramsgate Sands', after much search I found an individual exactly suited to my purpose. My servant announced a visitor:

'A person of the name of Bredman has called.'

'Is he a model?'

'I think so.'

'Good-looking?'

'No, sir.'

'Show him in.'

Mr Bredman was a man of about thirty, dressed in a fustian jacket and trousers much the worse for wear; a somewhat heavy countenance with strongly marked character; a serious, indeed solemn, expression – in fact, the exact type I had sought for. I engaged him immediately, and, though he had never sat before, I found him an attentive and excellent sitter.

It is obvious that an artist must talk to his models if he expects to rouse the expression necessary for his work, and it is also obvious that conversation becomes difficult or easy according to the intelligence of the model. I found Bredman far above the average of the ordinary model. He had read most of the books with which I was familiar, and with one Book, the most important of all, he showed more acquaintance, I am sorry to confess, than I enjoyed myself: indeed, he surprised me by producing a Testament, in which he seemed absorbed during the necessary intervals of rest. On one occasion, I remember, when my wife brought one of our children into the studio, Bredman's solemn face brightened pleasantly as he took the child on to his, not very satisfactory, fustian knee.

'You seem fond of children', said my wife.

'Well, mum, I should hope so', said Bredman. 'Haven't we got an example here?' tapping the Testament.

'Are you married? Have you any of your own?'

'I am married, mum, but have no children *yet*.'

The peculiar accent on the word 'yet' impressed me, and in the course of our work I asked my serious friend if he had hope in the happy direction of a family.

'Well, yes, sir, please God, before very long.'

Bredman sat to me many times, and though, as I said before, he was familiar with many subjects, his thoughts evidently dwelt most on the most serious of all; and I found that he was convinced that he was in what he called 'a state of grace' – that he was one of the elect, in fact. His conversion took place on a certain day in June at a chapel in Tottenham Court Road; at a special instant of time his sins were forgiven; from that time forward he was secure, his celestial condition was sin-proof.

'And I only wish, sir, you was in the happy frame of mind as I have felt in ever since.'

Bredman's affection for his wife seemed very strong. He took much pleasure in telling me, in reply to my inquiries after her, that 'It couldn't be very far off'; and the tears often came into his eyes, and on more than one occasion rolled down his cheeks, when he drew affecting pictures of the danger and suffering that might be in store for her. My model lived somewhere in Southwark, and on a tempestuous night in December he rang my doorbell. It was late; my servants had gone to bed, and I was about to follow, when the bell stopped me. On opening the door, I found Bredman drenched with rain, and in a terrible state of mind. The event had taken place unexpectedly; no preparation, or scarcely any, had been made; no baby-clothes. 'No nothing hardly', said the weeping man. 'Would Mrs Frith look him out something?' The doctor said the poor thing must have 'strengthening things, port wine', etc., and he had no means. I aroused my wife, and Bredman left with a bundle of small habiliments, port wine not being forgotten. Our sittings continued, and each morning I anxiously inquired after the wife and child.

'The doctor is very kind, sir, very attentive. He says she'll pull through, he thinks; but she is very bad, and he don't know if the child will live. Oh! if only *she* is saved, how truly thankful I shall be!'

I had recommended the man as a model to several of my brother artists, amongst the rest to my old friend Mr Egg, R.A.

46

About a fortnight after Mrs Bredman's confinement I met Mr Egg, who had received a call from Bredman, and an appeal for assistance in similar terms to those he had made to me. Egg was a bachelor, so baby-clothes were impossible; but money and wine were supplied abundantly.

A month elapsed, during which I had varying accounts of Mrs Bredman's condition from her husband. More port wine, and a promise – which did not seem enthusiastically received – that Mrs Frith would go to Southwark as soon as his wife was well enough to see her.

'It's such a poor place, you know, sir, for a lady to come to; and the poor thing is so weak and nervous, the doctor says it wouldn't do – not yet.'

I think six weeks had passed since Bredman had been made a happy father, when a friend of mine, a Mr Bassett, who had frequently seen Bredman sitting to me, called to tell me that he had just received a visit from my model, in great distress at the premature confinement of his wife – there were no preparations, no baby-clothes, and so on. Mr Bassett was not provided with infant habiliments, but he was with money and port wine, both of which were gratefully carried off by my pious friend.

'Did he tell you when the event took place?' asked I.

'Yes', said Bassett, 'last night between ten and eleven; and he would have come to me then if it hadn't been so late.'

What a very extraordinary woman Mrs Bredman must be! thought I. It then occurred to me that it was desirable, in the interest of myself and friends, that I should see this wonderful woman. Accordingly I lost no time in wending my way to Southwark. I easily found Mr Bredman's lodging, which, as he said, was but a poor place. There was a perpendicular row of bell-handles, and I pulled one after another till I found the door answered by a respectable-looking woman.

'Does Mr Bredman live here?'

'Yes, sir; but he is not at home: he has been out all day.'

'Is Mrs Bredman in?'

'Who, sir?'

'Mrs Bredman.'

'He ain't married; there ain't no Mrs Bredman. He has lodged here for two years and a half, and I am quite sure he is not married. Why, he is that cheerful and steady; always in, and reading of an evening, when he ain't playing with my children, and they are that fond of him!'

'Oh', said I, 'I thank you; I wish you good-evening.'

It happened that my regenerated friend was engaged to sit for me the morning after my journey to Southwark, and it certainly seemed strange that his landlady had said nothing to him about the inquirer after Mrs Bredman; that such was the case was evident by the placid unconcern with which my model fell into the attitude in which he may be seen in 'Ramsgate Sands', where he is depicted offering a 'Tombola' for sale to an old woman who will none of it.

'Well, Bredman, how's the wife?'

'I think she'll pull through, now, sir. She felt a little faint last night; I gave her some of your port wine, and she got all right. I hope I shall always remember you and Mrs Frith, and all your kindness.'

'Did you taste it yourself, Bredman?'

'Well, I won't deceive you, sir; she made me take just a drop, and it was that good!'

'And the baby – by the way, is it a boy or girl?'

'A boy, sir. He rather squints just now, and he is a little yellow, but the doctor says those things will mend themselves.'

'Doesn't kneeling like that tire you very much? Just rest awhile.'

'Thank you, sir', and the Testament was produced as usual.

'Put that book away, Bredman; I don't like to see you handling it just now.'

'Ah, sir, if only you would – '

'Bredman, do you know what the punishment is for those who obtain money by false pretences?'

'No, sir.'

'Well, then, you are very likely to know. You have no wife and no child; you have obtained clothes and money from me, from Mr Egg, Mr Bassett, and probably from others, and you richly deserve – Now, what have you got to say for yourself?'

In an instant the man was sobbing, the tears pouring down his face. He evidently couldn't speak for some moments. He then looked up with an expression on his face quite new to me, and he said:

'I am in infernal rogue, ain't I?'

'You are', said I. 'Now get out of my room, and never let me see your face again!'

The man's character became too well known in the profession for the calling of model to be any longer possible for him, and strange as

it may appear, though his career as a hypocritical knave was well known to us, a sufficient sum was subscribed by artists to enable him to go to Australia. He found his way to the diggings, which were in full swing at that time; and I received a grateful letter from him, still in my possession, in which he informed me he was prospering, and he hoped helping the good cause by the sale of religious works in a store at Ballarat.

2.11 **Perplexities and doubts**

In one of his lectures to the students at the Royal Academy Schools in 1879 Lord Leighton (as he was to become), then President of the Royal Academy, offered some answers to a problem which must have been agitating many of the ever-increasing number of artists and art students: why do it at all?

Addressing you for the first time, at some length, on the threshold of those relations which my office establishes between us, and which a deep and sympathetic interest in your artistic growth and welfare makes especially weighty in my eyes, I am impelled to set aside, for once at least, all purely practical and technical matters, and to ask you, rather to look with me for a moment into a wider and deeper question – that of the position of Art in its relation to the world at large in the present and in the past time, that we may gather if possible from this survey something of its prospects in the future.

I wish in so doing to seek with you the solution of certain perplexities and doubts which will often, in these days of restless self-questioning in which we live, arise in the minds and weigh on the hearts of students who think as well as work.

These perplexities, which few are fortunate enough wholly to escape, arise sooner in some and later in other organisations, and present themselves only at a certain stage of advancement in the artist's mental development; for the gift of artistic production man- ifests itself in the young in an impulse so spontaneous and so im- perative, and is in its origin so wholly emotional and independent of the action of the intellect, that it at first, and for some time, entirely absorbs their energies. The student's first steps on the bright paths of his working life are obscured by no shadows save those cast by the difficulties of a technical nature which lie before him; and these difficulties, which, indeed, he only half discerns, serve rather to whet his appetite than to hamper or discourage him, for his heart whispers that when he shall have brushed them aside the road will be clear

before him, and the utterance of what he feels stirring within him will be from thenceforward one long unchecked delight. This spirit of spontaneous, unquestioning rejoicing in production, which is still the privilege of youth, and which, even now, the very strong sometimes carry with them through their lives, was, indeed, when Art herself was in her prime, the normal and constant condition of the artistic temper, and shone out in all artistic work. It is this spirit which gave a perennial freshness to Athenian Art – the serenest and most spontaneous men have ever seen. And when again, after many centuries, another Art was born out of the night of the Dark Ages, and shed its gentle light over the chaos of society, this spirit once more burst through it into flame. All forms of Art were alike fired with it. Architecture first, exulting in new flights of vigorous and bold creation; then Sculpture; last Painting, virtually a new Art, looked out on to the world with the wondering delight of a child, timidly at first, but soon to fill it with the bright expression of its joy. Those were halcyon days; the questions 'Why do I paint?' 'Why do I model?' 'Why should I build beautifully?' 'What – how shall I build, model, paint?' had no existence in the mind of the artist. 'Why', he might have answered, 'does the lark soar and sing?'

We need not follow the vicissitudes of this spirit, which, born anew in every true artist, ever fights hard for its life; it is enough to say that in the days in which we live it is subjected to an ordeal of which it knew nothing in the past; the questioning spirit is now abroad, it asserts itself on all sides, and is paramount; it leaves nothing unassailed, takes nothing for granted, calls every belief to account, casts everything into the balance. I will not complain that this is so, for, of a certainty, whatever deserves to live will survive the ordeal; but the present result is this, that unconscious work has become and will be henceforth all but impossible; the critical intelligence stands by the imagination at her work, and Fancy no longer walks alone. We are the children of our time, we breathe perforce the intellectual atmosphere in which we move, we could not if we would close our hearts to the questions which arise within us; they force themselves upon us, we must face them, we must seek to answer them; and so at some period of our lives most of us will be led to ask themselves, 'What *is* Art in the world? is it a lasting, living thing, or is it an ephemeral apparition? has it still power of growth within it, and capability of further expansion? or has it reached, already, its full and final developments? If it has power of growth, what form may we expect that growth to take?'

These queries, indeed, meet us at every turn when we meditate on

the past history of civilisation; they meet us when we compare the growth and steady evolution of Art in the periods of its greatness with the eclectic instability and indefiniteness of purpose of our own day; they meet us when we consider the circumstances and surrounding conditions, material and intellectual, in the midst of which it grew and throve, noting the impulse and the impress imparted to it by those circumstances, and then compare them with the atmosphere in which it fights for life in the present time.

2.12 Advice to elementary art students

On Saturday 14 January 1888 that well-known Royal Academician, portrait painter and illustrator C. W. Cope came to Sutton Coldfield to address the students of the Sutton Coldfield Art School of which he was President. His words, reported in the local press, reflect perfectly the attitudes towards art education which informed most contemporary thinking.

In addressing students at an elementary school like this, there may be some who do not intend to study with a view to using the Arts as a profession. They may take it now with a desire to obtain some knowledge and practice in drawing, and this is always good; for although it is always quite possible for the observant eye to appreciate beauties of form and colour, yet the knowledge gained by study is the more conducive to fully understand and appreciate the beauties with which we are surrounded. Yet I hope there may be many young students here who are beginning with the strong res-olution of following it as a profession, keen with the enthusiasm of 'some day' becoming a great painter, and to these I shall principally address myself.

Schools like this are the nurseries of Art. It is here that many of the artists of the future will learn to walk. The highest eminence is only to be gained step by step, and we know that all that is best in the world is only gained by gradual formation.

The responsibility of the master therefore is very grave, for it is the early training, insignificant as it may seem, that is of the most serious importance. The earliest seeds of goodness and wrong-doing, are sown at the earliest period of training. This is acknowledged in the character and disposition of man; it is precisely the same in the vocation that man follows. And as one endeavours to instil into the minds of the young, firm and truthful principles which will be a support in the trying road of life, so it is that conscientious

and watchful care must be taken with the young student in Art. And thus to you, students, as your master has this grave charge over you, so you too must always remember to do your earnest part to be worthy of the care of your trainer. Whatever you attempt to do, do to the best of your ability. In your first study of drawing, draw as faithfully as possible; try to believe that you are breaking a truth if you have not your representation quite exact; and if you fail once, twice, or any number of times, do it until you honestly and truly believe that you cannot make it better; and know this, and believe what I tell you, that if you allow a careless representation to pass with the idea that you will do it better next time, you are only putting off, which not only wastes time, but which is far more serious, weakens your powers of determination. You should make it a rule never to put off, and under these circumstances, if you have the right mind within you, you will not be happy until you have accomplished your task. You may depend on it that present action is strength.

I have known instances of men who were always going to do something; circumstances would not allow them to do it. They had not the materials, or there was always something to stop them; but still, they were always going to do it. This arises from want of strength of will to face the difficulty at the moment – a kind of nervousness of present action – which most grievously grows, and, without a very strong will, will creep on unperceived, and eat away the foundation of strength. You cannot therefore bear in mind too strongly to form the very first stroke to your own, and your master's entire satisfaction. So, the same as you advance to more difficult stages, always work with the same care, and imperceptibly you will find the growth of interest and enthusiasm, and, unknown to you, will come an unspeakable delight – a love and interest which will always be the dawn of 'natural gifts'. . . .

To speak of the work I see here I shall not venture; but allow me to say I think it most satisfactory, especially in a school so recently formed. Some of your drawings from flowers are especially careful, and rendered with much care and industry. There is one remark I will make; I do not say that I perceive it here in your work, for I am so glad to see such painstaking here in your faithful outlines, but I have noticed in more advanced drawings in other schools, when they have to deal with light and shade to spend too much time on brilliant execution. It has a fascination, I admit, but it is simply mere gloss. The principal thing to attend to is an exact attention to the very correct outline, applying your strength to that, where the real

difficulties exist, and not by mistaken industry, wasting your time on that which is merely ornamental.

At some short period some of you will be, and possibly by now are, trying your skill on original conceptions of your own – and in so doing you enter into the period of invention. Invention, I think, is practically, observation. To make a constant practice of observing nature, studying it, and by this means acquiring a knowledge of life and character, commencing this practice from the time you begin to draw even, will serve to give you a knowledge gained by your own experience, and when called upon to use your powers of so-called 'invention' you will be far more likely to place upon canvas your own original conceptions.

Then as to selection. It is, of course, a very easy thing to talk; but I cannot help thinking that we are often inclined to take a thing in hand that really is not worthy of painting. As by constant observation our hopes are that we shall improve in our knowledge of life and character, so it is equally necessary to endeavour to cultivate and improve our taste. This can only be done by firstly, a most careful search into our own mind, scouting out all meaner thoughts, and trying to have a clear, liberal view of life and nature. The chances are that a simple, high-minded being will have high-minded thoughts, a higher taste in fact; and thus in endeavouring to improve our mind, the likelihood is that our taste will improve, so that mean, worthless things that once we might have looked at, we shall tread over and look for higher and nobler ends. Endeavour therefore to select subjects that, in your mind shall be worthy to be done. If your fancy leads you to landscape painting, choose these subjects that by their joy, beauty, or impressiveness inspire you, so that your reproductions shall impart the same impressions to others. If you lean to figure subjects, let your selections be worthy, remembering that in whatever branch you take up, you can 'through the eye correct the heart!'

Taste is, of course, greatly cultivated and improved by a most earnest attention to the works of the great masters. Not only do you see what their cultivation of taste resulted in, but to depend on one's own ideas only is narrowing and weakening, and requires the education and enthusiasm aroused by a knowledge and appreciation of the great works. Through them you see Nature in her highest mood, for it is the result of the life-long study of these great men. If one could but take up where these great men ended, and continue! Of course this would be impossible; and yet I think there is something in this thought. Sometimes young students – and old artists

too – flushed with the admiration of their kindly friends, shielded by them from the perhaps too little notice they may receive from others – and continuously told they are clever fine fellows, begin at last to believe they are wondrously clever, and that the young school is the thing, and that their seniors, after all, are quite of the old-fashioned school. What an unfortunate absurdity this is. To tell them the truth, they are only at the bottom of the ladder those of the old school are so high up, that they are far away out of sight.

2.13 Female students at the RA Schools

The emergence of the professional female artist as a force to be reckoned with was one of the artistic phenomena of the second half of the century. Rose Bonheur in France, Lady Butler in England were but two of the more outstanding instances of this tendency. In part this was due to the increase in opportunities for art education. In his *The Inner Life of the Royal Academy* (1914) G. D. Leslie RA described the effect that the introduction of female students into the RA Schools had on staff and students.

The girls, it must be confessed, work very hard and well; numbers of them have taken medals over the heads of boys, especially in later years. They are more attentive to the teaching of the Visitors than the generality of the boys, though, for the most part, they lack the self-reliant conceit which so often characterises the brightest geniuses of the male sex. Constable used to say that if you robbed an artist of his conceit you might as well hang him at once. It is, however, this self-appreciative tendency on the part of the boys which renders the Visitor's task far more difficult with them than the docile and diligent girls. Mr Calderon, when Keeper, told me of one young male student who gave him much trouble by his insubordination, and there was another who, for a time, was actually suspended for unruly behaviour; both these students, I am glad to say, have since greatly distinguished themselves.

It is very pleasant work teaching girls, especially pretty ones, who somehow always seemed to me to make the best students. Possibly I may have been biased in their favour, for all my life I have regarded good-looking girls with feelings of gratitude; but it is certainly remarkable that, as a general rule, the prettier the girl the better the study. Girls are very receptive of careful coaching, and it may be that a pretty girl, as she passes through her art training, when the teachers are men, receives decidedly more attention than falls to the lot of her plainer companions; it is not quite fair, but I am afraid it is inevitable.

When female students first found their way into the Academy Schools there were amongst them some who were well advanced in years – veterans, so to speak; they did their best and were most painstaking and diligent, but somehow or other they were not successes. For what particular reason I do not remember, let us hope it was a good one, and uninfluenced by any partiality on the part of the members, an age limit was fixed for the admission of all students, and very shortly after this the elderly female student disappeared from the Academy Schools. It was rather cruel, but I believe the Institution benefited by it.

Amongst other difficulties that a Visitor has to encounter during his month's work in the Schools, is a sort of heckling to which he is subjected from some of the students at the commencement of each sitting; one of the most frequent questions put to him being, 'What do you consider the best way to begin a painting?' For myself, as I have been experimenting all my life, never having commenced any two pictures exactly in the same way, this is a difficult question to answer. I generally get out of it by saying frankly that I have never been able to make up my mind on the subject, but that I think the best plan is, to put on the canvas, in any way the student likes, and as quickly as possible, some resemblance of the model. Sometimes the question is, 'What colour do you use, sir, for the shadows?' in which case, 'Shadow colour' is a short and obvious reply. Then there are the deaf and dumb students; there are generally one or two of these to be encountered by the Visitor on making his round. On approaching one of these unfortunates, signs are made on the fingers, and pieces of paper with pencils are produced on both sides.

I have no means of ascertaining with what feelings the male students regard the subject of mixed classes at the present day. I suppose that they have grown accustomed to the state of affairs, but I am glad that the female invasion took place after I had left the Schools, for I feel sure that my work in them would have suffered many interruptions if half of my fellow students had been young ladies.

2.14 A striking personality

It is doubtful whether anybody has left so strong a mark on English taste as John Ruskin, and it is difficult for us to realise in the late twentieth century the influence he exerted on his contemporaries, uniting as he did in his teachings aesthetic theory, moral fervour, political passion (albeit of a rather confused kind) and economic

theory. Prone to fits of psychosis, possessing a passion for female children which hovered on the verge of the reprehensible, his heightened sensibilities found expression in a luscious prose, which was the pattern for writers such as Pater and Wilde. In his *Studies in Ruskin* (George Allen, 1890), his disciple and self-appointed publicist E. T. Cook re-creates something of the atmosphere of enthusiasm which his teaching aroused, especially at Oxford, still marked by his influence.

Mr Ruskin's first professional lecture at Oxford, it may be interesting to say, was announced for the theatre in the Museum, but so great was the crowd that the Professor and his audience adjourned to the large Sheldonian Theatre. This, however, was an exception, and the usual lecture-room was in the Museum. The crowd was always very great, and it was necessary to be outside the doors an hour beforehand to secure a good seat. At the first lecture of his second Professorship there was a large sprinkling of ladies; subsequently tickets were issued, which were confined (with a few exceptions) to members of the University. On many occasions Mr Ruskin repeated his lectures twice in the week, in order to give every one who wished to hear him a chance. The attendance of undergraduates was invariably very large. This was the more remarkable as the lectures were always given in the afternoon, which is ordinarily at Oxford devoted to other purposes than the pursuit of learning. Mr Ruskin's lectures were further remarkable for the number, comparatively large, of graduates which they attracted. At the first lecture of his second Professorship the then Vice-Chancellor (Professor Jowett) attended in state with the proctors, and rose at the end to say a few graceful words of welcome and thanks, which were received with a storm of applause.

But the charm of the Living Voice in Mr Ruskin's lectures was as potent as the influence of the Living Teacher. The published volumes of these lectures are amongst the more important, as they are the most closely and carefully written, of his works. But they convey to the reader only a faint echo of the fascination they exercised over the hearer.

Mr Ruskin is, indeed, no orator. His eloquence is studied, not spontaneous – the eloquence of a writer, not of a speaker. His voice, though sympathetic, is neither strong nor penetrating. Of action he has little or none. But one quality which is essential to a successful speaker Mr Ruskin possesses to the full – the quality of a striking personality. No one who ever attended his Oxford Lectures is likely to forget the bent figure with the ample gown – discarded often

when its folds became too hopelessly involved – and the velvet college cap, one of the few remaining memorials of the 'gentleman commoner'. Mr Ruskin is a great believer in the importance of distinctive dress. The habit with him does, or should, show the man. And certainly in his own case the quaintness of his costume – the light home-spun tweed, the double-breasted waistcoat, the ill-fitting and old-fashioned frock-coat, the amplitude of inevitable blue tie – accurately reflected something of the quaintness of his mind and talk. If it were not for the peculiarly delicate hands and tapering fingers, denoting the artistic temperament, the Oxford Professor might have been taken for an old-fashioned country gentleman. In repose Mr Ruskin's face has of recent years been furrowed into sadness; but the blue eyes, piercing from beneath thick, bushy eyebrows, have never ceased to shine with the fire of genius; whilst the smile that was never long absent when he lectured, lit up his face with the radiance of a singularly gracious and gentle spirit.

Mr Ruskin has sometimes been accused of lack of humour – an accusation made of most men who are in earnest. That the Professor of Fine Art took both himself and his subjects seriously was very obvious; but not less obvious to any one who ever heard him lecture was his saving sense of humour. Just as an ever-recurring smile relieved an expression of prevailing sadness, so a play of humour relieved the sternness of teaching. 'As solid as the lecture of a University Professor' was a comparison recently applied to the discourse of some politician. Mr Ruskin's earlier Oxford Lectures had much solid stuff in them, but no lecturer knew better than he how to relieve the strain by supplying those *diverticula amœna* – those pleasant digressions – which are the salt of oral discourse. Mr Ruskin's fads and fancies have often been laughed at, but by no one more heartily than by himself. It was the frequent digressions in the form of self-deprecatory egoism that gave a peculiar charm to Mr Ruskin's Lectures, by investing them with what the French call *intimité*, with the personal note of familiar conversation. A lecture delivered some years ago, at the London Institution (December 4th, 1882), afforded at the very outset a case in point. The subect originally announced was 'Crystallography', but it had subsequently been changed to 'Cistercian Architecture', and one of the newspapers had remarked that 'no doubt either title would do equally well'. Mr Ruskin began by referring to this remark, and admitted that there was a good deal of truth in it, for 'in the proposed lecture on Crystallography' there would certainly have been allusions to Cistercian Architecture, while it had required all his powers of self-

denial to keep Crystallography out of the lecture he was actually delivering. He was not equally successful in including Cistercian Architecture, and he was amused to find that his lecture was five-parts written before any allusion to the architecture in question came in. However, stones had always been interesting to him only as expressing the minds of their builders; and the main part of the lecture was occupied with a delightful sketch of the principles and methods of the Benedictine monks, with their gospel of manual labour, and their good work in agriculture and letters. Then followed an equally charming description (illustrated by diagrams) of the Monastery of Cluny, which was contrasted, in Mr Ruskin's manner, with a picture of our modern rural economy – with a parson looking on at the 'restoration' of his church, while the squire was busy with plans for agricultural machinery, which would send the people off to America.' At Oxford, where he spoke 'among friends, with the chaff of the citizens winnowed out', Mr Ruskin permitted himself greater license in colloquial banter. He was often behindhand with the preparation of his lectures, and sometimes he could not even get through the regulation hour by Charles Lamb's expedient of making up for beginning late by ending early. I remember one occasion, during the course on 'The Pleasures of England', when he found some difficulty in eking out the time, even with the help of copious extracts from himself and Carlyle; but he kept his audience in good humour by confessing to some 'bad shots' in previous lectures; by telling them that all pretty girls were angels; by abusing 'the beastly hooter' that woke them every morning, and assuring them that, in spite of appearances, he really was not humbugging them. The digressions and interpolations in Mr Ruskin's Oxford Lectures were, however, by no means confined to pretty fooling; often they were passages of serious and telling eloquence. I re-member one such in the lecture on 'The Pleasures of Faith', when he turned aside from his manuscript notes to refer to General Gordon as a Latter-day Saint whose life still illustrates the age of faith. We are too much in the habit, Mr Ruskin had been saying, of 'supposing that temporal success is owing either to worldly chance or to worldly prudence, and is never granted in any visible relation to states of religious temper – as if the whole story of the world, read in the light of Christian faith, did not show 'a vividly real yet miraculous tenour' in the contrary direction! 'But what need', Mr Ruskin broke off to say, 'to go back to the story of the world when you can see the same evidence in the history of today – in the lives and characters of men like Havelock and Gordon?' Often, too, the

lecturer would lay aside his manuscript at some important point, and giving free play to his feelings, drive it home in burning passages of extempore irony. Hence the published lectures, printed from his manuscript, often differed greatly from the lectures as actually delivered; and therefore I have thought it might be interesting to give, in an appendix, besides some notes of unpublished lectures, my abstracts, made at the time, of a few published ones.

2.15 The critic as artist

In music, literature and art the latter half of the nineteenth century may be seen as the last splendiferous explosion of romanticism. It involved, among other things, a belief of almost theological intensity in the supremacy of the artist as an individual, as a creator, as the supreme embodiment of belief in his own inspiration. This view was promoted, in suitably gaudy prose, to a very large number of people by Oscar Wilde, whose later 'disgrace' should not blind us to his popularity as a writer during the larger part of his life. The man who went out road-making with Ruskin, and fawned on Pater in the casemented rooms of Brasenose, saw that the aura of secular sancity possessed by artists could also rub off on to critics. And, never a fool, he was aware too that critics 'make' works of art almost as effectively as their actual creators do – a viewpoint which he put with his customary facility in the first of two dialogues on *The Critic As Artist*, which appeared in 1883.

Who cares whether Mr Ruskin's views on Turner are sound or not? What does it matter? That mighty and majestic prose of his, so fervid and so fiery-coloured in its noble eloquence, so rich in its elaborate symphonic music, so sure and certain, at its best, in subtle choice of word and epithet, is at least as great a work of art as any of those wonderful sunsets that bleach or rot on their corrupted canvases in England's Gallery; greater indeed, one is apt to think at times, not merely because its equal beauty is more enduring, but on account of the fuller variety of its appeal, soul speaking to soul in those long-cadenced lines, not through form and colour alone, though through these, indeed, completely and without loss, but with intellectual and emotional utterance, with lofty passion and with loftier thought, with imaginative insight, and with poetic aim; greater, I always think, even as Literature is the greater art. Who, again, cares whether Mr Pater has put into the portrait of Monna Lisa something that Lionardo never dreamed of? The painter may have been merely the slave of an archaic smile, as some have fancied, but whenever I pass

into the cool galleries of the Palace of the Louvre, and stand before that strange figure 'set in its marble chair in that cirque of fantastic rocks, as in some faint light under sea', I murmur to myself, 'She is older than the rocks among which she sits; like the vampire, she has been dead many times, and learned the secrets of the grave; and has been a diver in deep seas, and keeps their fallen day about her: and trafficked for strange webs with Eastern merchants; and, as Leda, was the mother of Helen of Troy, and, as St Anne, the mother of Mary; and all this has been to her but as the sound of lyres and flutes, and lives only in the delicacy with which it has moulded the changing lineaments, and tinged the eyelids and the hands.' And I say to my friend, 'The presence that thus so strangely rose beside the waters is expressive of what in the ways of a thousand years man had come to desire'; and he answers me, 'Hers is the head upon which all "the ends of the world are come", and the eyelids are a little weary.'

And so the picture becomes more wonderful to us than it really is, and reveals to us a secret of which, in truth, it knows nothing, and the music of the mystical prose is as sweet in our ears as was that flute-player's music that lent to the lips of La Gioconda those subtle and poisonous curves. Do you ask me what Lionardo would have said had any one told him of this picture that 'all the thoughts and experience of the world had etched and moulded therein that which they had of power to refine and make expressive the outward form, the animalism of Greece, the lust of Rome, the reverie of the Middle Age with its spiritual ambition and imaginative loves, the return of the Pagan world, the sins of the Borgias?' He would probably have answered that he had contemplated none of these things, but had concerned himself simply with certain arrangements of lines and masses, and with new and curious colour-harmonies of blue and green. And it is for this very reason that the criticism which I have quoted is criticism of the highest kind. It treats the work of art simply as a starting-point for a new creation. It does not confine itself – let us at least suppose so for the moment – to discovering the real intention of the artist and accepting that as final. And in this it is right, for the meaning of any beautiful created thing is, at least, as much in the soul of him who looks at it, as it was in his soul who wrought it. Nay, it is rather the beholder who lends to the beautiful thing its myriad meanings, and makes it marvellous for us, and sets it in some new relation to the age, so that it becomes a vital portion of our lives, and symbol of what we pray for, or perhaps of what, having prayed for, we fear that we may receive. The longer I study, Ernest, the more closely I see that the beauty of the visible arts is, as

the beauty of music, impressive primarily, and that it may be marred, and indeed often is so, by any excess of intellectual intention on the part of the artist. For when the work is finished it has, as it were, an independent life of its own, and may deliver a message far other than that which was put into its lips to say. Sometimes, when I listen to the overture to *Tannhäuser*, I seem indeed to see that comely knight treading delicately on the flower-strewn grass, and to hear the voice of Venus calling to him from the caverned hill. But at other times it speaks to me of a thousand different things, of myself, it may be, and my own life, or of the lives of others whom one has loved and grown weary of loving, or of the passions that man has known, or of the passions that man has not known, and so has sought for. To-night it may fill one with that ΕΡΩΣ ΤΩΝ ΑΔΥΝΑΤΩΝ, that *Amour de l'Impossible*, which falls like a madness on many who think they live securely and out of reach of harm, so that they sicken suddenly with the poison of unlimited desire, and, in the infinite pursuit of what they may not obtain, grow faint and swoon or stumble. To-morrow, like the music of which Aristotle and Plato tell us, the noble Dorian music of the Greek, it may perform the office of a physician, and give us an anodyne against pain, and heal the spirit that is wounded, and 'bring the soul into harmony with all right things'. And what is true about music is true about all the arts. Beauty has as many meanings as man has moods. Beauty is the symbol of symbols. Beauty reveals everything, because it expresses nothing. When it shows us itself, it shows us the whole fiery-coloured world.

2.16 The Slade

The Slade School of Art, part of University College, soon established a name for itself as the most prolific nursery of talent in late-nineteenth-century England, largely because of the teaching of an *émigré* French artist, Alphonse Legros. His techniques, and the general life of the school, were described in *The Magazine of Art*, vol. 6, 1883.

The Slade Schools have from the first taken up an independent position as regards the method of instruction pursued. Mr Poynter, the first appointed Slade Professor at London University, came, as it were, to virgin soil. Bringing to his task a practical acquaintance with the Continental methods of teaching, as well as with those of the Royal Academy and South Kensington Schools, and having a

strong conviction of the evils existing in the latter, he set to work to graft the good of the French method on to the foundation of the English. I remember listening to Mr Poynter's inaugural address in the large life room of the new schools, in October, 1871, in which he explained the principles on which he proposed to direct the work of the students. Here, for the first time in England, indeed in Europe, a public Fine Art School was thrown open to male and female students on precisely the same terms, and giving to both sexes fair and equal opportunities. And it is to the precedent then established that ladies have since elsewhere had the necessary advantages for study placed within their reach.

In 1880 the north wing of University College was enlarged to meet the growing wants of the students, of whom there are now a hundred and forty. In Mr A. Legros an able and competent successor to Mr Poynter was found: one well fitted to carry on the intelligent system of instruction already instituted. But Professor Legros did more than this; he struck out in a line of his own, and his 'demonstrations', if they may be so called, are among the most popular and useful characteristics of his teaching. Not content with saying to his pupils, 'Do as I tell you', he occasionally takes a brush or pencil from their hand and says, 'Do as I do.' It is an exemplification of the old saying, 'An ounce of practice is worth a pound of precept.' Not only when going from easel to easel, to correct the students' work, does he sometimes pause and complete a study, the other students grouping round and watching; but on stated occasions a special model is ordered, and the Professor, standing in the centre of the life school, paints a complete study-head before those students who are sufficiently advanced to be admitted to the life class. His method of work is simple in the extreme; the canvas is grounded with a tone similar to the wall of the room, so that no background needs to be painted. With a brush containing a little thin transparent colour the leading lines and contour are touched in; with the same simple material the broad masses of shadow are put in, then gradually the flesh tones are added, the half-tones and lights laid on, the highest lights being reserved for the last consummate touches. In about an hour and a half, sometimes in less time, the study is completed, and the watchers have probably learnt more in the course of that silent lesson than during three times the amount of verbal instruction. It will perhaps be asked whether Professor Legros wishes his students to paint their studies in as short a time as himself? whether they may not be tempted to imitate the quickness and dash, rather than by patient plodding study to acquire the certain facility of the master-

hand? Against this there is no surer safeguard than the watchful eye of the Professor and his assistants. Work that aims at being pretty rather than correct, which is showy when it ought to be thorough, which is hasty when it should be careful, calls forth the unqualified blame of the master, and is, in fact, held up to public obloquy. Ever ready to recognise talent and encourage industrious, honest work, even where no great talent exists, Professor Legros wages incessant warfare against all attempts at pseudo-mastery in his students' work. On the other hand he does require a certain amount of rapidity in what they do. The system of elaborate 'stippling' and manipulation which allows the student to take a mental 'nap', whilst his hand is busy with bread and point, is not suffered. What is asked is an intelligent representation of the model or cast, with special reference to action, light and shade, tone and general correctness of drawing; and, before the student can relapse into the above-mentioned mental drowsiness, a fresh model, pose, or cast is put before him, a fresh combination of light, shade, and tone is presented to him; so that his energies are constantly being called into action and kept in exercise steadily. The fact that more is learnt in making several drawings of various figures, in various positions, than in elaborating on one drawing from the same point of view, is quite obvious.

It will be interesting to examine more closely the daily routine. Although no competitive test of proficiency is required from a new student on entering the schools, the Professor examines the previous work of the applicant for admission, and relegates her either to draw or paint from the antique or from the flat, as he considers best for her. In like manner every promotion from one stage of study to another is referred to – and controlled by – the Professor. Auto-types from drawings by the Old Masters are sometimes given to the students to copy; and this excellent practice, combined with original work from the life, refines and educates both eye and hand, enforcing the utmost simplicity of handling, together with the utmost expression of form. The life model (figure) sits daily in the two life schools from ten till three o'clock – in the large life studio exclusively for the male students, and in the life room of the ladies, or the mixed class for students of either sex. The latter is pictured in our engraving. The sketch is taken during the afternoon class, when half-hour poses are arranged to assist the students in the composition subjects. In a variety of attitudes, suitable to their work, the students are grouped round the model, and in the right-hand corner a standing figure with folded arms is easily recognised as Mr Slinger, the Professor's invaluable assistant. In this room, which is well lit

and spacious, being 40 feet by 35, and 19 feet high, the Professor paints before the students; the models are grouped to assist in the composition of subjects, given out by the Professor every three or four weeks, and afterwards criticised by him. These models sit every afternoon, except Saturdays, from half-past three till five o'clock, and every half-hour a fresh position is arranged, suggested by each student in turn, to suit his or her composition. Any student may join this class on payment of model fee of 3s. 6d. per term. Very good, rapid drawings are done during these half-hour sittings.

2.17 Master class

In 1898 Whistler opened an art school, the Académie Whistler, in the Passage Stanislas in Paris. One of his first pupils was Miss Inez Bate (Mrs Clifford Adams) whose personal account of her experiences was reproduced in E. R. and J. Pennell's *The Life of James McNeill Whistler*, vol. 2, London, 1908.

Mr Whistler's whole system lies in the complete mastery of the palette – that is to say, on the palette the work must be done and the truth obtained, before transferring one note on to the canvas.

He usually recommended the small oval palettes as being easy to hold and place his arrangement of colour upon. White was then placed at the top edge in the centre, in generous quantity, and to the left came in succession: yellow ochre, raw Sienna, raw umber, cobalt, and mineral blue, while to the right: vermilion, Venetian red, Indian red, and black. Sometimes the burnt Sienna would be placed between the Venetian and Indian red, if the harmony to be painted seemed to desire this arrangement, but generally the former placing of colours was insisted upon.

A mass of colour, giving the fairest tone of the flesh, would then be mixed and laid in the centre of the palette near the top, and a broad band of black curving downward from this mass of light flesh note to the bottom, gave the greatest depth possible in any shadow; and so, between the prepared light and the black, the colour was spread, and mingled with any of the various pure colours necessary to obtain the desired changes of note, until there appeared on the palette a tone picture of the figure that was to be painted – and at the same time a preparation for the background was made on the left in equally careful manner.

Many brushes were used, each one containing a full quantity of every dominant note, so that when the palette presented as near a

reproduction of the model and background as the worker could obtain, the colour could be put down with a generous flowing brush.

Mr Whistler also said, "I do not interfere with your individuality. – I place in your hands a sure means of expressing it, if you can learn to understand, and if you have your own sight of Nature still." Each student prepared his or her palette to suit individual taste – in some the mass of light would exceed the dark; in others, the reverse would be the case. Mr Whistler made no comments on these conditions of the students' palettes: "I do not teach Art; with that I cannot interfere; but I teach the scientific application of paint and brushes." His one insistence was, that no painting on the canvas should be begun until the student felt he could go no further on the palette; the various and harmonious collection of notes were to represent, as nearly as he could see, the model and background that he was to paint.

Mr Whistler would often refrain from looking at the students' canvas at all, but would carefully examine the palette, saying that there he could see the progress being made, and that it was really much more important that it should present a beautiful appearance, than that the canvas should be fine and the palette inharmonious. He said, "If you cannot manage your palette, how are you going to manage your canvas?"

These statements sounded like a heresy to the majority of the students, and they refused to believe the reason and purpose of such teaching, and as they had never before even received a hint to consider the palette of primary importance, they insisted in believing that this was but a peculiarity of Mr Whistler's own manner of working, and that, to adopt it, would be with fatal results!

The careful attempt to follow the subtle modellings of flesh placed in a quiet, simple light, and therefore extremely grey and intricate in its change of form, brought about, necessarily, in the commencement of each student's endeavour, a rather low-toned result. One student said to Mr Whistler that she did not wish to paint in such low tones, but wanted to keep her colour pure and brilliant; he answered, "then keep it in tubes, it is your only chance, at first".

It was taught to look upon the model as a sculptor would, using the paint as a modeller does his clay; to create on the canvas a statue, using the brush as a sculptor his chisel, following carefully each change of note, which means "form"; it being preferable that the figure should be presented in a simple manner, without an attempt to obtain the thousand changes of colour that are there in reality, and

make it, first of all, *really and truly exist in its proper atmosphere*, than that it should present a brightly coloured image, pleasing to the eye, but without solidity and non-existent on any real plane. This it will be seen was the reason of Mr Whistler's repeated and insistent commands to give the background the most complete attention, believing that by it alone the figure had a reason to exist.

In the same way, or rather in insistence of the same important principles, he pointed out the value of the absolutely true notes in the shadow, for they determine the amount of light in the figure, and therefore its correct drawing as perceived by the eye, and he said that "in the painting of depth is really seen the painter's power".

Mr Whistler would often paint for the students.

Once he modelled a figure, standing in the full, clear light of the *atelier*, against a dull, rose-coloured wall. After spending almost an hour upon the palette, he put down with swift, sure touches, the notes of which his brushes were already generously filled, so subtle that those standing close to the canvas saw apparently no difference in each successive note as it was put down, but those standing at the proper distance away noticed the general turn of the body appear, and the faint subtle modellings take their place, and finally, when the last delicate touch of light was laid on, the figure was seen to exist in its proper atmosphere and at its proper distance within the canvas, modelled, as Mr Whistler said, "in painter's clay", and ready to be taken up the next day and carried yet further in delicacy, and the next day further still, and so on until the end.

2.18 The advancement of art

In 1889 the Second Congress of the National Association for the Advancement of Art was held at Edinburgh. The aim of the Association was 'to foster an interest in art in the mind of the British workman, the British capitalist and the British consumer, as to lead to a sensible improvement in artistic production'. In its fifty-fourth *Annual Report* for 1890 the Art Union, which had been following similar aims through the medium of a lottery for works of art, for which members paid an annual subscription of one guinea (there were some 5,000 members), gave an account of the proceedings at Edinburgh which throws a good deal of light on the art world of Britain at the time.

The Second Congress of the National Association for the Advancement of Art was held at Edinburgh last year, and it must be

allowed that it was quite as successful as the first in regard to the interest displayed as well as the subjects discussed, and it may be said that on the whole the tendency of the papers read was more practical and less imaginative and speculative.

The strain of modern life in England, with the continually augmenting population, is so great that people need to be laid hold of and their attention forced towards the value of art by special preaching on the subject; a counteracting influence is required against the mere struggle for life and the utilitarian tendency of the day. The argument that it is to our commercial interests as a nation to make our various productions good in form, as well as in manufacture, which it has been the fashion to insist on lately, has hardly as yet resulted in any perceptible improvement.

The papers of the Congress present a great amount of thoughtful criticism on artistic subjects. Conspicuous among those which go to answer the question, What is the practical use of these gatherings? is the paper written by Mr G. F. Watts, RA, on The National Position of Art. This critical reflection by an artist of singularly high aims, and living entirely for his art, on the condition and aspect of the everyday life of his generation, serves at least to remind people how far we are, as a nation, from any real delight in life such as art can afford, and how much people need to be reminded and appealed to not to lose all consideration of the possibilities of beauty and interest in everyday life.

Mr Watts has said, 'In enterprise, in arms, in poetry, in worthy and high aims the British Nation can claim a dignified place amongst the most dignified. Can as much be said of the distinctive character of her school? Individual names will start into memory, and to these time will do justice, but I cannot think the school displays efforts worthy of the mental activity of our time. The professor of art is not called upon by the state to record the widely-reaching influence of the British Nation; of its greatness no splendid reflex is required from his hand. We want more intellectual demand made upon our artists. In the Renaissance period the celebrated artists and poets were the great men of the day – a generation or two since this was, in some degree, the case in France, where even now there is more trace of it than there is with us. Modern English art seems not less remarkable for the wide diffusion of a certain standard of technical excellence, than for the equally wide diffusion of a dead level of intellectual commonplace. The complaint against contemporary painting and sculpture, especially as illustrated at the Academy, is not so much feebleness of execution, as feebleness and commonplace

of intellectual meaning.' The higher demand on artists which Mr Watts wishes for is the most certain means of producing the higher effort; to adopt Sir F. Leighton's words 'What the people wish for they will have.' How little we do for our artists to give them either the opportunity or the stimulus to produce the highest they can, was a point forcibly touched in Mr Rathbone's able paper, also read at the Congress.

That we have not made the most of the great artists we have had and have is painfully true. We gave to Flaxman no opportunity for the display of his singularly graceful genius, and it has been lost for ever to England. We might have had in Alfred Stevens's monument to the Duke of Wellington a work of art of which the fame would have rung throughout the world, and we have thrust it away unfinished in a corner of St Paul's Cathedral, where it is impossible to see it, having worried the unfortunate artist to death before he could complete it. Future ages, when they gather up the remains of the noble and lofty genius of G. F. Watts, will not be able to repress their contemptuous scorn of the generation that gave him no opportunity of worthily displaying it.

The presidential address of Lord Lorne followed out very clearly the original idea which gave birth to the Association. That idea was strictly practical. It was the existence of the desirability, in these times of severe foreign competition, of so arousing and fostering an interest in art, in the mind of the British workman, the British capitalist, and the British consumer, as to lead to a sensible improvement in artistic production.

This was the first idea, though it should be added that the wish to retain our industrial pre-eminence was not all. There was also the desire of which Mr Ruskin, Mr Watts, and Mr Wm Morris have been conspicuous exponents, to make people's lives happier, fuller, and less mechanical, by exciting in their minds a love of their work and an admiration for beauty and perfection as such.

It is remarkable that no one was found at the Meeting to say a word for the efforts which the Art Union has been making for fifty years and more to excite in the minds of the people not only of the United Kingdom, but wherever the English-speaking race is to be found, an interest and an appreciation of the refining and ennobling effects of fine art works by the dissemination of thousands of reproductions by choice engraving, of the finest work of British artists, as well as copies of both antique and modern specimens of sculpture. There is abundant evidence to prove that these exertions have not been made in vain. The mere fact of the continued improvement in

the quality of works selected by prizeholders, year after year, proves that the influence of the Art Union's teaching has been very considerable.

Lord Lorne's earnest plea that honour should be done by the artists to our history, and our own legends, English, Scotch, Welsh, Irish, well deserves attention. So does the Lord Justice Clerk's plea for originality, enforced with an abundance of humorous illustrations. 'In the town of Leven', said the speaker, 'the houses were formerly built of soft black stone with harder white stone for the corners. Now when any one builds a house in Leven, which is not faced with stone but with plaster or cement, he has the whole front of the house painted dead black, and has the corners painted white, in order that it may look like the other houses in Leven.' This is one instance of slavish imitation of what may be called the negation of art that deserves to become classical.

Mr Hodgson, who is not only an artist of distinction, but a teacher of great experience, started a subject which, as the Chairman remarked, well deserves discussion. It was of the possible improvement – or rather of the possible radical reform – of the national art-teaching now carried on by the Science and Art Department. Mr Hodgson's watchword is 'Decentralisation'. In his opinion the teaching is too uniform and takes too little account of the needs of the different parts of the country, and the different industries which flourish there. We ought, he thinks, to have quite a distinct type of school for the potteries, from that which we have in cotton districts; ironwork and cloth-weaving require different schools and different methods of teaching. The value of such an idea, which is obvious enough in itself, clearly depends on the way in which it is worked out. Is it not the case now that at South Kensington there are separate classes for pattern designing, for wood carving, for ironwork, and all the rest? Mr Hodgson seems to lose sight of the fact that a very large amount of work must be gone through, such as that embodied in the South Kensington system, and that in all these adaptations of art-knowledge to particular industries it is absolutely necessary to begin with those principles which are equally applicable to every form of art – from ironcasting to textile industries. Equally necessary in every form of art-practice are a facility of application and imitation of form of every kind – an accurate eye and power of delineating all objects in the round, in perspective, in plan and elevation – a clear perception of the modifications undergone by natural types, whether such as human beings or inanimate objects, under varying conditions of light and shade – and all the conditions of foreshortening and

condensing, and the like. All these requisites should be well grounded in the student before he proceeds to apply them to the different processes in which they will all be more or less essential, and it is a general acquaintance and familiarity with these elementary principles that it should be the aim of all instruction in art to arrive. Having made this acquaintance the accomplished artist will experience no difficulty in applying his knowledge to any particular industry on which he may be employed, the same principles being essential whether in designing a vase or a tombstone, a muslin curtain or a teapot.

A discussion has been started in the Magazine of Art as to the desirability of having a British Artists' room in the new National Portrait Gallery. – *i.e.* a room for autograph portraits of our most eminent painters, sculptors, engravers and architects; and there appears to be a great difference of opinion on the subject amongst artists generally.

It is urged that as the Uffizi Museum of Florence has been enriched by the portraits gratuitously provided of several of our most eminent artists, the thought arises whether these artists would not prefer to endow with their portraits the country that has reared them, and is so proud of them. The French last year adopted a kindred scheme, and no room in the Louvre is more honoured than that in which are hung the portraits of the men who have taken a leading place in advancing French art.

The President of the Academy is not favourable to the scheme. He points out that the Uffizi collection contains portraits of almost all the most considerable painters of all countries over a period of more than four centuries, while our gallery would attract perhaps portraits of a certain number of eminent artists of one country or one period only; that it is open to question whether for such a small result we could stir up amongst the artists selected the necessary enthusiasm to induce them to do that which they were willing to do for such a distinction, and so cosmopolitan a result. He then alludes to the difficulty of deciding how the artists to be invited to contribute should be selected, and lastly he urges how entirely distasteful to an artist is the task of painting his own face.

On the other hand it is admitted that incompleteness in an historical collection is to be deplored, but the shortcoming that is unavoidable in every gallery, if it is to be allowed to weigh as an insuperable objection, would prevent the entertaining of such schemes at all, and the existence of even the National Portrait Gallery itself could not be justified.

Many painters now deceased would no doubt for ever remain unrepresented in such a gallery, but judging from repeated experience it is not too much to hope that many of those portraits now in private hands, would, through the public spirit that so often happily animates our collectors, ultimately reach the National Portrait Gallery.

There are at present in the National Portrait Gallery autograph portraits of 21 artists, and about 60 by fellow artists. This collection might easily be reinforced by contributions from other institutions, either as donations or loans. There is of course little hope that this collection should rival that of Florence, its conditions and its aim would be different, and infinitely more restricted, and for that very reason a great measure of success might, it is hoped, be looked for within a very short time. Its supporters believe that the experiment would yield satisfactory and complete results, and that it would be welcomed by the community of artists as well as by the public.

2.19 **The worker's share of art**

The relationship between working-class people and art had exercised many minds in the first half of the century, and taken on a greater prominence as socialism took on the mantle of the Nonconformist tradition, and became, at least partially, an ideology espoused by the better-off middle classes. The subject had its problems which at different times people as disparate as Oscar Wilde and John Berger have tried to resolve. It naturally exercised William Morris profoundly, and he addressed himself to it with particular acumen in the socialist journal *Commonweal* in April 1885.

I can imagine some of our comrades smiling bitterly at the above title, and wondering what a Socialist journal can have to do with art; so I begin by saying that I understand only too thoroughly how 'unpractical' the subject is while the present system of capital and wages lasts. Indeed that is my text.

What, however, is art? whence does it spring? Art is man's embodied expression of interest in the life of man; it springs from man's pleasure in his life; pleasure we must call it, taking all human life together, however much it may be broken by the grief and trouble of individuals; and as it is the expression of pleasure in life generally, in the memory of the deeds of the past, and the hope of those of the future, so it is especially the expression of man's pleasure in the deeds of the present; in his work.

Yes, that may well seem strange to us at present! Men today may

see the pleasure of unproductive energy – energy put forth in games and sports; but in productive energy – in the task which must be finished before we can eat, the task which will begin again tomorrow, and many a tomorrow without change or end till *we* are ended – pleasure in that?

Yet I repeat that the chief source of art is man's pleasure in his daily necessary work, which expresses itself and is embodied in that work itself; nothing else can make the common surroundings of life beautiful, and whenever they are beautiful it is a sign that men's work has pleasure in it, however they may suffer otherwise. It is the lack of this pleasure in daily work which has made our towns and habitations sordid and hideous, insults to the beauty of the earth which they disfigure, and all the accessories of life mean, trivial, ugly – in a word, *vulgar*. Terrible as this is to endure in the present, there is hope in it for the future; for surely it is but just that outward ugliness and disgrace should be the result of the slavery and misery of the people; and that slavery and misery once changed, it is but reasonable to expect that external ugliness will give place to beauty, the sign of free and happy work.

Meantime, be sure that nothing else will produce even a reasonable semblance of art; for think of it! the workers, by means of whose hands the mass of art must be made, are forced by the commercial system to live, even at the best, in places so squalid and hideous that no one could live in them and keep his sanity without losing all sense of beauty and enjoyment of life. The advance of the industrial army under its 'captains of industry' (save the mark!) is traced, like the advance of other armies, in the ruin of the peace and loveliness of earth's surface, and nature, who will have us live at any cost, compels us to *get used* to our degradation at the expense of losing our manhood, and producing children doomed to live less like men than ourselves. Men living amidst such ugliness cannot conceive of beauty, and, therefore, cannot express it.

Nor is it only the workers who feel this misery (and I rejoice over that, at any rate). The higher or more intellectual arts suffer with the industrial ones. The artists, the aim of whose lives it is to produce beauty and interest, are deprived of the materials for the works in real life, since all around them is ugly and vulgar. They are driven into seeking their materials in the imaginations of past ages, or into giving the lie to their own sense of beauty and knowledge of it by sentimentalising and falsifying the life which goes on around them; and so, in spite of all their talent, intellect, and enthusiasm, produce little which is not contemptible when matched against the works of

the non-commercial ages. Nor must we forget that whatever is produced that is worth anything is the work of men who are in rebellion against the corrupt society of today – rebellion sometimes open, sometimes veiled under cynicism, but by which in any case lives are wasted in a struggle, too often vain, against their fellow-men, which ought to be used for the exercise of special gifts for the benefit of the world.

High and low, therefore, slaveholders and slaves, we lack beauty in our lives, or, in other words, man-like pleasure. This absence of pleasure is the second gift to the world which the development of commercialism has added to its first gift of a propertyless proletariat. Nothing else but the grinding of this iron system could have reduced the civilized world to vulgarity. The theory that art is sick *because* people have turned their attention to science is without foundation. It is true that science is allowed to live because profit can be made of her, and men, who must find some outlet for their energies, turn to her, since she exists, though only as the slave (but now the rebellious slave) of capital; whereas when art is fairly in the clutch of profit-grinding she dies, and leaves behind her but her phantom of *sham* art as the futile slave of the capitalist.

Strange as it may seem, therefore, to some people, it is as true as strange, that Socialism, which has been commonly supposed to tend to mere Utilitarianism, is the only hope of the arts. It may be, indeed, that till the social revolution is fully accomplished, and perhaps for a little while afterwards, men's surroundings may go on getting plainer, grimmer, and barer; I say for a little while afterwards, because it may take men some time to shake off the habits of penury on the one hand, and inane luxury on the other, which have been forced on them by commercialism. But even in that there is hope; for it is at least possible that all the old superstitions and conventionalities of art have got to be swept away before art can be born again; that before that new birth we shall have to be left bare of everything that has been called art; that we shall have nothing left us but the materials of art, that is the human race with its aspirations and passions and its home, the earth; on which materials we shall have to use these tools, leisure, and desire.

Yet, though that may be, it is not likely that we shall quite recognise it; it is probable that it will come so gradually that it will not be obvious to our eyes. Maybe, indeed, art is sick to death even now, and nothing but its already half-dead body is left upon the earth: but also, may we not hope that we shall not have to wait for the new birth of art till we attain the peace of the realised New

Order? Is it not at least possible, on the other hand, that what will give the death-blow to the vulgarity of life which enwraps us all now will be the great tragedy of Social Revolution, and that the worker will then once more begin to have a share in art, when he begins to see his aim clear before him – his aim of a share of real life for all men – and when his struggle for that aim has begun? It is not the excitement of battling for a great and worthy end which is the foe to art, but the dead weight of sordid, unrelieved anxiety, the anxiety for the daily earning of a wretched pittance by labour degrading at once to body and mind, both by its excess and by its mechanical nature.

In any case, the leisure which Socialism above all things aims at obtaining for the worker is also the very thing that breeds desire – desire for beauty, for knowledge, for more abundant life, in short. Once more, that leasure and desire are sure to produce art, and without them nothing but sham art, void of life or reason for existence, can be produced: therefore not only the worker, but the world in general, will have no share in art till our present commercial society gives place to real society – to Socialism. I know this subject is too serious and difficult to treat properly in one short article. I will ask our readers, therefore, to consider this as an introduction to the consideration of the relations of industrial labour to art.

2.20 Bringing beauty home to the people

The evangelical fervour with which the 'social mission' of art was coming to be regarded had already been apparent in the first half of the nineteenth century, but by the second half the writings of Ruskin, of Morris and of many others had increased its intensity and widened its scope. This account of the Kyrle Society which appeared in *The Magazine of Art* in 1880 gives a very clear indication of the kind of preoccupations which were exercising the well-meaning at this time. It was named after John Kyrle (1637–1724), a philanthropist who lived very simply on his estates at Ross, and was eulogised by Pope.

The Kyrle Society, which takes its name from the 'Man of Ross' (the Howard of his age, who for his goodness to the poor deserved to be celebrated, according to Dr Warton, 'beyond any of the heroes of Pindar'), was founded about two years ago with the object 'of bringing the refining and cheering influences of natural and artistic beauty home to the people'. It numbers amongst its supporters Prince Leopold, Princess Louise, the Duke of Westminster, and Lord

Ronald Gower, besides Mr William Morris, Mr Watts, and other artists.

It was felt by its originators that hitherto, in all schemes for the benefit of the poor, the fact that beautiful and attractive objects seldom entered into their lives had been almost entirely overlooked. Much has been done in the various parishes for their bodily wants, but few people seemed to think that the poor, as well as the rich, needed something more than meat and drink to make their lives complete.

A few years ago it was thought by many earnest-minded people that beautiful things were, if not sinful, at least unnecessary, and might tend to lead our thoughts away from the higher life; but, fortunately, such mistaken ideas have given way to a growing desire to make our surroundings as harmonious and lovely as possible. When we look around us and see the harmony which pervades all nature, and how wonderful is the beauty which fills our earth, so that the tiniest flower speaks aloud to us of the supreme power of the great Father of us all, we must feel that He intended us to enjoy all His marvellous works. It would be very selfish, if those who have the means to beautify and elevate their lives did not try to bring some of this beauty home to the poor. It is in large towns, especially London, that the poor lead the saddest lives; the ugliness, monotony, and coarseness that surround them everywhere depress and weigh them down equally with their poverty. They cannot spare either the time or money to go often into the country, their visits to picture-galleries and museums can be but rare, and, as yet, little can be done to decorate their homes; they are thus debarred from the powerful and refining influences which might be derived from tasteful and harmonious surroundings.

Conscious of the difficulty of supplying this loss in the homes themselves, it was resolved by the Kyrle Society to beautify and decorate, as far as possible, by means of pictures, mural decorations, flowers, and other attractive objects, public rooms, such as hospital wards, workmen's clubs, school and mission rooms. The largest work undertaken by the Society has been the decoration of two of the wards of Westminster Hospital – the Women's Convalescent and the Bouverie Ward. The designs for the former were given by Mr William Morris, and the work was carried out under his direction. The walls are a pale green, till within about two feet of the ceiling line, where a frieze has been executed, introducing a conventional treatment of fruit and foliage. They are hung with engravings, which were given to the Society, for this special purpose, by Mr Graves, of Pall Mall.

The Bouverie Ward was decorated entirely by volunteer workers. The whole of the painting is executed upon a patent washable material, and consists of a frieze of wild flowers, symbolical of the four seasons. Immediately above this frieze, and below the ceiling, mottoes are painted in clear and distinct characters. The panels of the doors and cupboards are adorned with fruits and flowers. The fireplace is of ebonised wood, with alternate panels of American walnut and tiles, and above is a chimney-piece, with divided shelves and a looking-glass. Thus, wherever the eye turns it finds something pleasant to rest upon, and the decoration has been fully appreciated by the inmates. A lady belonging to the Society relates the following anecdote, which will show how much the poor appreciate the efforts of those who are so kindly striving to brighten and cheer their lives. When visiting the Bouverie Ward, in order to judge of the finished work, she went up to the bedside of one of the patients, who said to her, 'I knowed you directly I seed you; you painted our club.' 'Yes', the lady replied, 'I did, but I am afraid the flowers are getting dingy and dirty.' 'Oh, no, they ain't; we likes 'em, and we keeps 'em bright and clean'; and then, after some sympathetic talk about his ailments, he whispered, 'Do you know, marm, I think it is almost a blessed thing to be ill to come here in this lovely place?' Now this was not intended as a compliment, for the poor man was so impressed by the beauty, cleanliness, and kindness which he found in the Bouverie Ward that he could only whisper his thanks to his kind friend. This little anecdote will appear to most minds very touching, and is but one amongst many which might be told showing how deeply the hearts of the poor have been touched by the sight of this artistic decoration, as unexpected as it is lovely. The thought that so much trouble has been taken to cheer and please them makes them wishful to show, by the future conduct of their lives, that the good lessons they have acquired in the hospital, in which beauty, order, and cleanliness are combined, are not only not lost upon them, but are carried away to their own homes, to be copied as far as means and aptitude will permit. It may be as well to mention that the whole of the work has been arranged so that it can easily be removed without injury, and thus allow for the annual cleansing of the rooms. Similar work, though on a smaller scale, has been effected in another ward of the hospital.

Of other institutions which the Society has decorated or otherwise improved, the principal are the Mission Room in Great Ormond Yard, rooms in the Boys' Refuge, Whitechapel, the Working Boys' Home, Southwark, the Girls' Home, Charlotte Street, and the College for Working Women in Fitzroy Street.

Besides permanent mural decorations to many workmen's clubs, a good deal has been done by this Society by means of loans of pictures. When a workmen's club is first started, it is an important element in its success to make the room look as cheerful and inviting as possible. In such cases application is often made to the Kyrle Society. As it is, however, difficult to tell beforehand whether a new club will prosper or not, pictures are never *given*, but granted on loan for six months, with the understanding that they are to be returned before that time if the club be given up; if it survives, a fresh application must be made at the expiration of the six months. Should the institution then seem to be on a permanent footing, the pictures are presented to the club. This has been found to be a most useful branch of the Society's work, and the presence of interesting and nicely framed drawings or photographs on the walls often leads members to make efforts of their own to improve still futher the general appearance of the room, and to feel a pride in making it look as pretty and bright as they can.

A voluntary choir of singers has been organised, to give oratorios and concerts in churches, halls, and school-rooms situated in the poorest parts of London, where good music could hardly otherwise be heard; and believing, as we all must, that men are ennobled and raised to higher levels by lovely and harmonious sights and sounds, surely no work of this Society, which strives so earnestly to elevate the thoughts of the poor by means of such powerful influences, ought to be more supported than this. It may be that music touches the human heart more nearly than any other of the gracious gifts of Providence. How often the most callous and hardened reprobate is softened when upon his ear fall some well-remembered strains, sung perchance by his mother in his innocent childhood –

> 'Songs that have power to quiet
> The restless pulse of care.'

In teaching the poor and neglected by means of music and other beautiful things, we may hope, with some confidence, to lead them gradually away from the ignorance and vice in which so many dwell, and nearer to the pure light of knowledge and goodness.

Another aim of the Society has been the procuring and preserving of open spaces. For this purpose a special sub-committee has been formed. It was mainly owing to the representations made by the Kyrle Society, and the Commons Preservation Society, that the Corporation of the City of London were induced to purchase Burnham Beeches, and to give the ground for the use of the public

for ever. The committee are now trying to procure the opening of Lincoln's Inn Fields at stated times to the children of the neighbourhood. Efforts are also in progress to secure the site of the Horsemonger Lane Gaol for a public garden. The Society is very anxious to enlist the sympathies of landowners in the needs of the people, and to encourage the dedication of private land to public use.

2.21 Excessive sensitiveness

The relationship between illustrated magazines and painting was strikingly exemplified in the work of Frederick Walker (1840–75) who did a lot of work for *The Graphic*, but also established a reputation for himself as an artist whose work took a strong hold over the imagination of his contemporaries, a hold which was strengthened by his premature death. In his *Life and Letters of Frederick Walker* (Macmillan, 1896) his friend, and colleague on *The Graphic* John William North is quoted by the author George Marks in the following description of his technique.

Walker painted direct from nature, not from sketches. His ideal appeared to be to have suggestiveness in his work; not by leaving out, but by painting in, detail, and then partly erasing it. This was especially noticeable in his water colour landscape work, which frequently passed through a stage of extreme elaboration of drawing, to be afterwards carefully worn away, so that a suggestiveness and softness resulted – not emptiness, but veiled detail. His knowledge of nature was sufficient to disgust him with the ordinary conventions which do duty for grass, leaves, and boughs; and there is scarcely an inch of his work that has not been at one time a careful, loving study of fact. Every conscientious landscape painter will recognise in all Walker's landscape the clear evidence of direct work from nature. No trouble was excessive, no distance too great, if through trouble and travel some part of the picture might be better done. He never thought "he could do better without nature," or that "nature put him out.'

Pictorial art is a translation of a poem in the language of nature, which cannot be written in words. A delight in this unwritten language must belong to every fine painter –

To hear with eyes belongs to love's fine wit.

It was rarely that a title for his picture pleased him; in consequence his titles are of the simplest – *Spring, Autumn, Bathers, The Plough, A Fishmonger's Shop*. One exception, and that a very happy one, is *The Harbour of Refuge*, a title suggested by Mr Clayton.

Perhaps the ambitious determination to excel in art was excessive in Walker, perhaps he had some intuition of the short time granted him, and so was impatient of partial failure. Certainly he was not content with his work unless it had suggestiveness, finish, and an appearance of ease; and to the latter I sorrowfully feel that he gave rather too much weight, destroying many a lovely piece of earnest, sweetest work, because it did not appear to have been done without labour. Probably this excessive sensitiveness (to what is after all of minor importance) may have been due to a reaction from the somewhat unnatural clearness of definition in the early pictures of the Pre-Raphaelite Brotherhood.

Walker could use, and did use, his left hand equally with the right, and often worked with both hands on a picture at the same moment; as a rule, the left hand (which was the stronger) held a knife or razor, the right the brush. I think he would have missed his knife or razor more than his brush, had he lost either. The uncertain character of the paper led Walker into excessive use of Chinese white in his earlier water colours. This use of white he gradually diminshed, until in some of his later work in water colours there is scarcely a trace, and that trace only existing because of some defect in the paper.

In his oil pictures he used benzine or turpentine very freely, except with colours or mediums. He was not fastidious as to appliances; anything would do for an easel, and for maulstick a rough stick of timber about 8 feet long, weighing about 20 lbs., was used, resting one end on the ground, the other on the top of the canvas. This answered two purposes; its weight steadying the canvas, and its firmness giving real support to the wrist when (rarely indeed) Walker felt the need of such help. Painting in this rough and ready way, with no protection from wind, it was often more easy to work on a large canvas with it lying flat on the ground, and much of *The Plough* and other big pictures was painted in this way.

With a dark sealskin cap; a thick woollen comforter – his mother's or sister's work; a thick, dark overcoat; long, yellow washleather leggings; very neat, thick, Bond Street shooting boots; painting cloths sticking out of pockets; two or three pet brushes and a great oval wooden palette in one hand, and a common labourer's rush basket with colours and bottles, brushes and razors, tumbled in indiscriminately, in the other; "little Mr Walker", as the country people called him, was a type of energy. Sometimes I have known him manage to carry his large canvas on his head at the same time that his hands were employed as described, on occasion when, after

having been kept indoors by the weather until quite late in the afternoon, his usual attendant help chanced to be momentarily absent.'

2.22 An artist in black and white

Frank Holl, who died in 1888 at the age of forty-three, was a brilliantly successful portrait painter, who produced 198 exercises in that genre. He was also successful as a producer of 'problem pictures'. But above all else he was a contributor to *The Graphic*, and did much to raise the level of illustration in that, and other, magazines. His daughter, A. M. Reynolds, who wrote his biography in 1912, described his ventures into that field.

In December 1871 came one day to the studio J. D. Linton (afterwards Sir James Linton), who suggested to my father the idea of his drawing on wood; he further suggested that he (my father) should make a trial drawing on the block and submit it to a new illustrated periodical which was then just being launched into existence – 'The Graphic'. This paper had started as a rival 'illustrated' to the famous old periodical, 'The Illustrated London News', and it was gathering to itself all the rising young talent of the day – Herkomer, Fildes, Boyd-Houghton, Pinwell, Small, Caton Woodville, and many others, all of which have long ere this become household names in the world of illustration.

My father was much more attracted by the idea, and, with the instruction and help given by J. D. Linton, he executed his first drawing in the new medium, which represented a seat in a railway station, on which were a medley of nondescripts waiting for the train.

'Third-Class' I believe it was called, but has since been more popularly known by the title of 'A Seat in a Railway Station'. This he carried through in eight days, and then submitted it to Mr Thomas, the editor and owner of the 'Graphic'. The drawing was approved of and accepted, and, better still, he was forthwith appointed a regular contributor to the paper. For this drawing he received thirty guineas, and it but proved to be the precursor of many another, and additionally was the means of bringing really 'good times' to my parents. The work was regular, and the pay good and reliable. This black-and-white work continued for some five or six years. My father found that he benefited enormously by this new branch of Art, for not only did he find the work in itself fascinating and

engrossing to a degree, but it served as a corrective to a tendency which he shared in company with many another, that of a proneness to be uncertain of himself – a lack of self-confidence – a tendency to hesitate, to be dissatisfied with a design, to worry at it, pull it about, until staleness, disillusion, and a dislike for the subject would take the place of the first enthusiasm for the idea, and the design would be thrown aside, for another to take its place, only to follow the same fate: in fact, the wood-drawing came to him, just at the right moment; artistically and morally it helped him: to steady his aim, to concentrate his forces, fix his purpose, and enable him to *finish and carry right through that which he began*. The mere fact of having to have the block ready to the moment when the 'Graphic' messenger presented himself at the studio door gave him the necessary impetus. It also gave him, indirectly, stability, self-confidence, courage, and concentration – invaluable and essential assets. This discipline was the making of the man, and laid the foundation of those characteristics of his work in later life which marked him out above most of his contemporaries. That which is so essential to the portrait painter is the power of intensely and immediately realising the personality, the very 'ego' of the man before him. Many of my father's 'sitters' were men whose time was precious, and who could not afford to waste it whilst the artist 'felt about', so to speak, for his inspiration. Therefore it was necessary that an immediate, or almost immediate, decision should be arrived at as to the character and the pose most significant of the subject of the picture: so that the early training of his black-and-white work, which taught him to concentrate his ideas, which gave him the education of the inward eye, as it were, was invaluable to him. A few moments of intense observation, though apparently casual enough to the sitter himself, generally sufficed my father to discover his man; a turn of the head, a flash of the eye, the manner of raising a hand even, all served their turn, and conveyed to my father at once what he wanted to know. This gift of mental insight into the personality of his sitter was one which, in a great measure, made my father the successful portrait painter he became, since often it has been remarked by the intimate friends and relations of the sitter himself that the painter had brought to light characteristics of which they had only been latently conscious, and that the eagle eye of the painter had been keener than those of friendship, and had even opened the eyes of love.

2.23 Van Gogh on English wood engravings

Papers such as *The Graphic* and the *Illustrated London News* not only gave employment to artists and contributed to the popularisation of art, but also fostered an enhanced visual awareness among the reading public. One of the most fervent enthusiasts for this art form in its English version was Vincent Van Gogh, who during his various sojourns in England made a collection of prints, and wrote enthusiastically about them. This letter, written on 1 November 1882, dealt with Herkomer and his views.

November 1st

Dear Theo,

For the last few days I have been very much preoccupied by something which may possibly interest you also, and I think it quite worth while to write you about it in detail. In a letter from Rappard, I received the summary of a discourse by Herkomer on modern wood engravings. I cannot tell you the whole in detail; perhaps you have read the article yourself (it appeared in an English art magazine, perhaps the *Art Journal*). It dealt particularly with the drawings in the *Graphic*. Herkomer tells how he himself worked on it with great zeal and enthusiasm, and recalls especially the splendid pages of the first series. He can hardly find words to express how strongly he feels the importance of the work of those original artists. He surveys the progress in technique and *process* and the difference between the old and the modern wood engravings, etc., etc.

Then he talks about the present time, and comes to the real point of his discourse. He says that the wood engravers are more clever than ever, but I for my part see a decadence when I think of the time when the *Graphic* started. And he continued: 'In my opinion, the fault lies in two things, against which I protest. One concerns the managers and the other concerns the artists. Both make mistakes, and these will spoil the thing if they are not corrected.'

The managers, he says, ask for things that are done for effect; correct and honest drawing is no longer wanted, complete designs are no longer in demand: all that is requested is a 'bit' to cover an awkward corner of a page.

The managers declare that the public requires the representation of a public event or two, and is satisfied if it is correct and entertaining, caring nothing for the artistic qualities of the work.

I do not believe what they say. The only excuse that can be accepted is 'a shortage of good draftsmen'. (. . .)

Then he comes to the artists, and says how he regrets that nowadays it is all too often the wood engraver and not the draftsman

who makes the pages beautiful. He urges the artists not to permit this, to draw soberly and vigorously, so that the engraver remains what he should be: the interpreter of the draftsman's work, not his master. Then his conclusion follows, a strong admonition to all to put their hearts into the job, and not to allow themselves to weaken. There is a note of reproach in his voice, and he speaks with a certain melancholy, as if fighting against what he thinks unbearable indifference.

'To you – the public – art offers infinite pleasure and edification. It is really done for you. Therefore insist on good work, and you will be sure to get it', he concludes.

The whole thing is thoroughly sound, strong, honest. His manner of speaking impresses me the same way as some of Millet's letters. To me it is an inspiration, and it does my heart good to hear someone talk this way.

I say that it is a great pity there is little or no enthusiasm here for the art which is most suitable for the general public. If the painters combined to see that their work (which in my opinion is, after all, made for the people – at least I think this is the highest, noblest calling for any artist to pursue) could indeed come into the public's hands and was brought within everybody's reach, it could produce the same results as those achieved during the *Graphic's* first years.

What I appreciate in Herkomer, Fildes, Holl and the other founders of the *Graphic*, the reason why they still mean more to me than Gavarni and Daumier, and will continue to, is that while the latter seem to look on society with malice, the former – as well as men like Millet, Breton, De Groux, Israëls – chose subjects which are as true as Gavarni's or Daumier's, but have something noble and a more serious sentiment. That sentiment especially must remain, I think. An artist needn't be a clergyman or a churchwarden, but he certainly must have a warm heart for his fellow men. I think it very noble, for instance, that no winter passed without the *Graphic* doing something to arouse sympathy for the poor. For example, I have a page by Woodville representing a distribution of peat tickets in Ireland; another by Staniland called 'Help the Helpers', representing various scenes in a hospital which was short of money; 'Christmas in the Workhouse' by Herkomer; 'Homeless and Hungry' by Fildes, etc. I like them better than the drawings by Bertall, or the like, for the *Vie Elégante*.

If I am correctly informed, when it was their turn, the *Graphic's* draftsmen could always find a model at their disposal in a studio at the office. Dickens tells a few good things about the painters of *his*

time and their wrong working methods, namely, their following the model servilely, yet only halfway. He says: 'Fellows, try to understand that your model is *not* your final aim, but *the means of giving form and strength to your thought and inspiration*. Look at the French (for instance, Ary Scheffer) and see how much better they do it than you do.' It seems the English listened to him; *they* continued working with the model, but they have learned to view the model in a broader, stronger way and to use it for sounder, nobler compositions than those of the painters of Dickens's time.

In my opinion two things which remain eternally true and which complement each other are, Do not quench your inspiration and your imagination, do not become the slave of your model; and, Take the model and study it, otherwise your inspiration will never get plastic solidity.

(From *Vincent Van Gogh on England* by Dr V. W. Van Gogh, Amsterdam, 1968)

2.24 Pre-Raphaelitism and the camera

The obsessive realism which often dominated the technique of the Pre-Raphaelites, and led Holman-Hunt to excesses of verisimilitude, led some critics to complain that their works were little more than coloured photographs. Preposterous though this suggestion seems to us, it was taken seriously enough for Ruskin to have to rebut it, and in 1882 William Sharp in his book on Dante Gabriel Rossetti expanded this in a manner which throws some light on attitudes towards the camera.

Preraphaelitism is not simply another name for Photography, not what the Rev. E. Young calls it, 'a mere heartless reiteration of the model'. The absurd accusation was made against the Preraphaelites that their paintings were in reality copied photographs, a charge that Mr Ruskin effectually dissipated by challenging any one to produce a Preraphaelite picture by that process. It is strange that now that Preraphaelitism has become a phrase of the past the tradition of its synonymity with photography should still exist, for only the slightest knowledge of the latter science is required to show the wide difference there is between it and *art*. The other day I was looking at the picture of one of our most eminent sea-painters, and more than once I heard the remark 'that it was too photographic': well, this painter's method of delineation may or may not be the true way to represent the ever-changing and multiform beauty of the sea, but

one thing is certain, that it is beyond any photograph. No painter worthy of the name could paint a picture of the sea or marine coast that would not contain many more facts than any photograph could possibly do, for the limitations of the scientific method are such as to preclude more than perhaps but one truth being given at a time. If mere accumulation of facts were all that were wanted, then doubtless a series of positives would be more valuable than the picture of an artist. Suppose what is wanted is a representation of the Dover Cliffs as viewed midway in the Channel, with a fresh south-west breeze blowing through the summer day, what would the painter give us? There would be overhead the deep blue of mid-heaven, gradated into paler intensity as the eye ranged from the zenith; here and there would move northwards and eastwards (granting the wind-current to be the same at their elevation) fringed drifts of cloud whiter than snow, while down in the south-west great masses of rounded cumuli would rise above the horizon, compact, like moving alps; the sea between the painter and the cliffs would be dazzling with the sunglare, and the foam of the breaking waves constantly flashing along the glitter of the sparkling blue: here the sea would rival the sky, there it would seem as though dyed with melted amethysts, and farther on where dangerous shallows lurked pale green spaces would stretch along; outward-bound, some huge ocean steamer would pass in the distance, with a thin film of blue smoke issuing from her funnel, and, leaning over with her magnificent cloud of canvas, a great ship from Australian or Pacific ports would overtake a French lugger making for Calais, or a heavily-built coaster bound for London; dotted here and there would be the red sails of the fishing boats, quite a cloud of them far away on the right, and beyond the red sails the white cliffs, surge-washed at their bases, and at their summits green with young grass. Words can give no idea of these cliffs, however, as they would really seem to the painter – the marvellous blending of colours, the shades of delicate gray deepening to purple, the glow of minute vegetation seeming like patches of orange light, the whitest portions seeming dusky in contrast with the snowy cloud and the glitter of the sea. No painter could transfer this scene to canvas as it appeared to him in its entirety; for in cloud and sea there is an incessant and intricate changefulness defiant alike of painter and poet; but he could give a representation of it which, though not literally true, would yet in another sense *be* true, for nothing that appeared in his picture would be out of harmony with natural truth so long as it was in itself guiltless of disrelation in its parts.

And now what would the photographer give us of the same scene? In far less time than an artist's briefest sketch would occupy, we would have a representation of the sea, of the clouds, of the ships and fishing craft, of the cliffs and the cliff-formations. But in what condition? We see the cliffs clearly portrayed – even the gorges are recognisable; but to make up for this one truth the rest of the representation is falsehood. The sea is a white blank, waveless, glitterless, unbuoyant; the sky is pale and hueless, with dull, slate-coloured clouds, the whole seeming more as if permeated with wan moonlight than the glory of noonday; the blue film of the steamer's smoke is a dingy gray, and the vessel itself a black smudge, while the red sails of the fishing boats are dark and shadowless. This is what the photograph would be if a representation of the cliffs were specially desired; and the result *as a whole* would be equally unsatisfactory if only the sea and cloud effects had been wished. In this case the photographic copy would be more accurate than the sketch in retaining the actual formation of the clouds, and would also give the delicate shading beautifully, and would moreover represent well the glitter of the sea; but this would be at the sacrifice of the other constituent parts of the picture, for the vessels would be mere blotches and the cliffs irrecognisable as chalk steeps or anything else under the sun. In the first instance, in order to obtain the transference of the solid objects in the distance, the negative would have to be so long exposed to the actinic rays that decomposition would affect the more delicate sea and cloud impressions, resulting in non-gradation, and finally in a mere uniform flatness: and in the second, so very short a time would the negative have to be exposed in order to obtain true portraitures of passing cloud and sea-glitter that the cliffs and farther vessels would be left quite or almost blank. Of course, a series of photographed facts taken simultaneously, some with the negative exposed but for a very brief space, some for a sufficient time to obtain medium effects, and some so as to adequately represent the most solid objects, would produce a great many truths – in the main, might produce as many truths with more literal accuracy than any painting. But, apart from the impracticableness of this method of obtaining truth from nature, the series of photographs could never really bring before the mental vision of the spectator the scene with anything like the in one sense inaccurate and exaggerated delineation of the painter; for though an artist might be able to paint a true and beautiful painting from these photographic facts, it would entail too great an intellectual effort on the part of any one not an artist, unless indeed his or her observant powers were highly developed, both

naturally and by ceaseless usage, to comprehend the scene in its fitness of detail; and certainly the work of the landscapist is to convey a speedy impression to the onlooker of some beautiful or truthful natural scene, and not to set before him what would mainly entail a difficult labour of comprehension. Fifty artists sketching simultaneously from the same scene, each devoting the few minutes available to its ever-changing aspects, would doubtless give us an invaluable series of truthful effects; nevertheless we would get a far better idea of the scene through the literally inaccurate but harmonious rendering in the complete picture of one artist. However commonly we see people purchasing and even preferring photographs of scenery to paintings or water-colours or sketches, the enormous disadvantages of the artificial compared with the artistic method in rendering recognisable aspects are easily proved. Show a photograph of Snowdon, or Ben Lomond, or Hartfell, to some people without mentioning the mountain in question, and it is doubtful if more than one in half a dozen would really recognise it even if well acquainted with the neighbourhood; but show a sketch in water-colour, or painting in oil, and though the mountain's features may be exaggerated, the foreground of moor or woodland filled in in the studio, and an unusual effect of sunrise, noonglow, or sunset be over all, yet few who have once seen them would fail at once to recognise Hartfell, Snowdon, or Ben Lomond. And this fact arises from an apparent contradiction, namely, that nature as accurately delineated by photography is *less* truthful in the effect it produces than any good artistic representation – *because* any given natural aspect appeals not only to the sense of sight, to the mere faculties of recognition, but also, and most potently, to the imagination. The imagination does not want mere imitation, it can reduplicate sufficiently itself; what it craves is a powerful impression upon which to employ itself. But there are many persons who do not realise this – hence the common dislike to much of our most powerful modern etching, and the use of the detracting term *impressionist*. Mr Hamerton stated the matter concisely in *The Portfolio* (September 1878) in criticising the remarks of an American critic who condemned Turner's Venetian pictures on the ground of their not being imitations of nature: '*The question is not whether they are close imitations of nature, but whether they have the art power of conveying a profound impression*, and that they unquestionably have.' Mr Hamerton has also ably touched upon this necessity of exaggeration in land or sea scape art in his deeply interesting volume *Thoughts about Art*, where he also recognises what is doubtless as indubitable a

fact, an equal necessity in literature dealing as in fiction and dramatic poetry with character. I think Mr Hamerton is right in believing in this equal necessity, but only I think to a certain degree, and not to the extent he specifies, 'that no study of human character would ever be generally recognised as true which was not idealised and ex-aggerated almost to the verge of caricature'. And speaking of this very irrecognisable photographic as compared with artistic represen-tation, let the reader look at any photograph of some mountain with which he is familiar, and observe how dwarfed it seems to him, how devoid of all glory and majesty, how different from the sympathetic and imaginative work (*i.e.* poetic insight, artistic grasp) of the artist. This, of course, is very much more noticeable in the case of photo-graphs of English and Scotch hills than of the Alps, where *height* alone is sufficient to captivate the imagination in portraiture; but, as Wordsworth has pointed out, and as any observant lover of mountain scenery fully realises, mere height in itself is not alone what gives rise to emotions of grandeur and majesty, but the shadows of clouds passing overhead, the drifting of mists from crag to crag, the 'mountain gloom' and 'mountain glory'; therefore when these natural garments of the hills are not represented, or represented poorly and falsely, the results are unsatisfactory in the extreme, and the hill-range we love is metamorphosed into a dull brown band, and the moss-cragged, fir-sloped, ravined, and bouldered majesty of Helvellyn or Schehallion changed to a dark and dreary mass.

2.25 The friend or foe of art?

In 1894 *The Studio* sent a questionnaire to a number of painters – the choice is significant – to discover their attitudes towards the in-fluence of the camera, and printed the answers in its July issue. Most of the replies are, at least, judicious.

The question to which the following are replies was intended to discover:

'Whether the camera has, on the whole, been beneficial or de-trimental to art? This query was not intended to be taken in a commercial sense, but to ascertain if the conventions hitherto accepted by the painter have been modified since its introduction.'

From Sir Frederic Leighton, Bart., PRA
Dear sir,
I will confine myself on this occasion to saying that photography

may be of great use or the reverse to an artist, according as it is used with or without judgement and intelligence. I am afraid you will consider this very vague, but in reality it sums up the question.
Yours faithfully,
Fred. Leighton
7 Holland Park Road, W.

From Mr Laurence Alma Tadema, RA
Sir,
I am convinced that the camera has had a most healthy and useful influence upon art. It is of the greatest use to painters.
Yours faithfully,
L. Alma Tadema
17 Grove End Road, NW.

From Sir John Everett Millais, Bart., RA
Sir,
No doubt photography has been beneficial, and is often of value to the artist.
Faithfully yours,
J. E. Millais
2 Palace Gate, W.

From Mr W. P. Frith, RA
Dear sir,
In my opionion photography has not benefited art, and to the professors of certain branches – to wit, miniature painting and engraving – it has been so injurious as, in the form of photogravure, to have nearly destroyed the latter; and by means of coloured prints made to resemble miniatures a fatal blow has been struck at that beautiful art.
Sincerely yours,
W. P. Frith
Ashenhurst, Forest Hill, S.

From Sir John Gilbert, RA, PRWS
Sir,
I have not formed any opinion in my own mind on the subject on which you desire to know my views – viz., 'The Influence of Photography on Modern Art'. It is an important matter, but one which I am too feeble to fully consider. Therefore I hope you will excuse me,
I am, yours faithfully,
John Gilbert
Blackheath

From Sir George Reid, PRSA
Dear sir,
The question whether the influence of the camera has been on the whole beneficial or prejudicial to art is one which I have never seriously considered, and I hesitate to express an opinion offhand. It is just one of those debatable questions on which a good deal may be said on both sides.
Believe me, yours truly,
Geo. Reid
22 Royal Terrace, Edinburgh

From Mr W. B. Richmond, ARA
Dear sir,
You have asked me a question, and I am pleased to answer it.

Photography has been, no doubt, a medium of instruction and benefit to painters as well as to the public.

It has given chances to untravelled individuals of seeing, and in a measure of possessing, the masterpieces of the world in all that relates to art.

It is therefore curious that with such opportunities, the general level of taste should not have improved. Perhaps the old adage of familiarity breeding contempt may be still only too true.

If photography reproduced for us only the best, we should indeed exist in Utopia!

As it is, photography reproduces everything, good, bad, and indifferent.

So we are confounded by a plethora and a confusion. For those who know how to choose, what to take and what to reject, light is an admirable master; for others it may prove to be a stumbling-block. I do not suppose there exists in Europe an artist who would not at once admit the value of photography.

At the same time there may be some who think that modern exhibitions of pictures display an abuse of it.

Valuable, indeed, as a record of facts, mainly facts already reduced to artistic methods of thought, set photography may be used, and is, I am told, being largely used by portrait-painters who, unless I have been wrongly informed, are beginning to photograph their sitters upon their canvasses, and paint over.

If this is the case the ruin of the art of portrait-painting is certain. There is yet another danger to be apprehended. It was the custom when artists travelled for their note-books to be constantly in their hands, and every *impression* was either carefully or summarily therein registered. I have been told that the kodak has taken the place of the note-book.

If this be true the lamentable absence of interest in our annual exhibitions is to be accounted for.

Photography can never be an art, though it may be a valuable adjunct! Yes. But if it ever is used by an artist instead of his pencil where he could use his pencil, it will prove to be the destroyer of art instead of being, as it should be, *an aid*.

I would write a great deal more upon your subject, but I fear to take up space in your journal.
Yours very truly,
W. B. Richmond
Beavor Lodge, W.

From Mr Francis Bate
Sir,
It would be a long matter to consider, with anything approaching completeness, the influence that photography has had upon the arts. I know but little of the technique of photography, and should on that account more than hesitate to express an opinion on the subject you propose, were it not that my convictions are very strong that photography has affected pictorial art injuriously. Many photographers are artists, and use their camera to produce highly artistic and charming work. But it seems to me that the results possible with the camera are so different to, and inharmonious with, what I feel should be the first desire and endeavour of the picture painter, that I would deprecate, at any rate in this limited sense, any confusion or association of the two practices.
Believe me, sincerely yours,
Francis Bate
Applegarth Studio, Brook Green, W.

From Mr Wyke Bayliss, PBA
Sir,
The subject upon which you invite my opinion is one to which I have given much attention. My views are expressed in my last volume, 'The Enchanted Island and other Studies in Art'. I deal with art in its sevenfold relations – with myth, with history, with religion, with science, with daily life, with Christianity, with value. It is in the chapter entitled 'The Robe of Amethyst', that you will find what I have to say on art in relation to modern science. If there is anything there you would like to quote it is at your service,
Believe me, yours faithfully,
Wyke Bayliss
7 North Road, Clapham, SW.

The paragraph which seems to be specially applicable to this subject runs:

'The microscope adds to our knowledge, but it does not help the artist; it rather conflicts with his sense of proportion. The telescope seems to bring things nearer; but the painter loves to see the hills in blue distance. It is quite possible to see too much. It is even possible to know too much, if knowledge holds us in its meshes when we should abandon ourselves to the imagination. Already to the average sight there is more visible than can be expressed in art. To increase the intensity of the vision, therefore, or enlarge its range, is only to add to the artist's embarrassment and the difficulty of his choice, unless the increased intensity and enlarged range enable him to penetrate and to grasp the higher as distinct from the lesser truth.'

From Professor Fred. Brown
Sir,
In reply to your letter I beg to say that in my opinion photography has had no influence of any kind on the best art of to-day, though it has considerably affected a large number of painters. Its influence, however, on the appreciation of art has, I think, been prejudicial, as it has established in the mind of a large number of people a standard of mere accuracy. Judged by such a test the great works of the past would not appear remarkable. As the invention of photography has not in the least detracted from their excellences, so neither can its use or influence be of any benefit to the artist of to-day. Art and photography run on entirely different lines.
Yours truly,
Fredk. Brown
Slade School, University College

From Mr Walter Crane
Sir,
In reply to your question, I would say that I hardly think we are yet in a position to pronounce on the effect of the camera on art for good or evil on the whole, since its true use in relation to art has not yet been determined.

In painting, so far as photography has taken the place of other studies, and has induced the painter to consciously attempt photographic renderings of fact and aspect, the effect has been for evil to my mind, as the scientific registering of certain facts and accidents of aspect is one thing, and the selection, treatment, and feeling – the impression, in short, of the painter's mind – quite another.

So far as photographs are used, like all other material, as sources of

study and suggestion, they are helpful to both painter and designer alike. Photography, of course, has its own distinct and peculiar beauty, just as creative art has; and I believe, in the long run, the camera will do good service in defining the essential difference between imitative and inventive art.

Very faithfully yours,
Walter Crane
13 Holland Street, W.

From Mr G. du Maurier
Sir,
In answer to your letter I regret to say that I have been unable as yet to form any opinion on the question of the influence of photography on art. It seems to me a large question, and one requiring much thought and experience before one can have and express any opinion about it. Should one occur to me I will send it.

Faithfully yours,
G. du Maurier
New Grove House, Hampstead, NW.

From Mr Alfred East, RI
Sir,
It is doubtful if photography is of much practical advantage to the painter of landscape. If it saves him the trouble of going to Nature for the details of the foreground of his picture, it would deprive him of the knowledge he would gain of the character and colour of those details were he to go to Nature herself. The camera, having no power of selection, records with the same prominence vulgar forms as well as the refined; the aim of the artist, on the contrary, is to select only what will illustrate his theme, and the suitability of the selection is one of the greatest qualities of his art.

It is even doubtful if the instantaneous record of the movements of animals and birds and the reflections in moving water are as useful to the artist as they are interesting to the scientific, for if the pose of an animal or bird was taken by the camera at a point where the eye could not follow, the result would be, not the sense of movement, but of inanition. It is the suggestion of sustained action that the artist desires to obtain, for that suggests vitality. If the leaves of trees at a certain distance were painted rigidly against a sky, they would appear artificial, but if the artist could suggest that they were moving, he would at the same time suggest life and so be more like Nature. There is a kind of painting, which resembles photography, called 'still life'. I do not understand its meaning. It is a contradiction

of terms, for nothing is still that lives. Life is the greatest and most beautiful fact of Nature. Does the photographic camera help him here? I think not; but in different fields the camera has brought us benefits I should be the last to deny.

Yours faithfully,
Alfred East
4 Grove End Road, NW.

From Mr J. T. Nettleship
Dear Sir,

In my experience, photographs of animals in action are a pure gain in so far as they enable one to analyse the action – *i.e.*, learn how it is produced. But they are very seldom of use to copy from, because they record only a part of a movement which is perceived by the eye as a whole. In this branch of the subject convention should be the result of observation by the quickest and keenest eyes, and to these the camera can be nothing but a benefit, as helping and verifying observation; but an undiscerning use of (say) Mr Muybridge's plates would be worse than any existing convention, while faulty or careless observation needs no camera to detect it. As to animals in repose or slight action, it is needless to mention the service done by the photographs of Henry Dixon, Gambier, Bolton, and Anschutz in discrediting the artistic wild beasts of the past.

Yours faithfully,
J. T. Nettleship
58 Wigmore Street, W.

From Mr James Orrock, RI
Sir,

Photography is of great use for reference in architecture, ornamentation, designs of all kinds on wood, metals, fabrics, &c. When colour is wanted it is, of course, of no value.

Photography is also of service for reference to artistic manuscripts, signs, and signatures. Painters, especially landscape painters, sometimes use it, by the instantaneous process, for action in figures and animals, as well as for the character of skies and sea, and other rapidly moving objects. In such cases, however, only the skilled artist can apply it, as he does a few leading character lines in black and white.

Photography has been a great evil in causing mechanics in art to make laborious unartistic studies and persist in calling them pictures. Such artists, so-called, often despise and reject true art, because it does not give those photographic details which are called finish.

Photography has in no way benefited true art, the proof being that nearly all the greatest art was produced before it was discovered; the best art is that which is furthest removed from photography.
James Orrock
48 Bedford Square, W.

From Mr Joseph Pennell
Sir,
I don't think photography has had any influence upon modern art at all – that is, upon the art of men like Whistler, Degas, Chavannes, Rodin, Gilbert, and Gaudeur.
 The use of photographs by artists, however, is a very different matter, and I do not propose to give away the tricks of the trade. By refraining I have no doubt I shall receive the silent blessings of the multitude of duffers among whom I find myself.
Yours truly,
Joseph Pennell
Caen

From Mr John M. Swan
Sir,
In answer to your letter of the 9th instant, I consider photography of great value as a scientific aid to the education of the sight, but in no way related to art, which is essentially human and emotional. The instantaneous photographs of Muybridge and Anschutz reveal the truth of the Japanese in their rendering of the flight of birds produced long before photography.
 I consider one half of the pictures of modern exhibitions at home and abroad developments of photography. The photograph is the historian of light and time, and may be, like Herodotus, the father of lying – one cannot fathom the depth of it.
 The art is still with the savage, working in profound ignorance, but with the affection of a child, the pattern of his club.
I am, my dear sir, yours very truly,
John M. Swan
3 Acacia Road, NW.

From Mr Walter Sickert
Sir,
In proportion as a painter or a draughtsman works from photographs, so is he sapping his powers of observation and of expression. It is much as if a swimmer practised in a cork jacket, or a pianist by turning a barrel-organ. For drawing, which should express three

dimensions, is substituted a kind of mapping, and colour is simply non-existent. *Coelum, non cameram mutat,* as Mr Whistler recently said of a much-travelled photo-painter. It would be well if the fact that a painting was done from or on a photograph were always stated in the catalogue. A serious critic should be able to detect the most blatant cases for himself. It is extremely misleading to the public and to young students to find work of that order critically compared to works of pure craftsmanship, without a hint of the means employed. It sets false standards, and compares things that have not a common denomination. The sentence that seems to me to contain both the æsthetics and the morals of this question, I heard from the lips of Sir John Gilbert, a splendid authority. '*I think*', he said, '*an artist must do it all himself.*'

I am, sir, your obliged and obedient,

Walter Sickert

Chelsea

2.26 The camera and the connoisseur

A more rigorous approach to art history and connoisseurship was becoming increasingly apparent. Probably the best-known exponent of this new approach in the English-speaking world was Bernard Berenson, whose widely respected *Italian Painters of the Renaissance* was published in 1930. In his notebook in 1893 (14 October) he made some comments on the influence of the camera in this field (*The Bernard Berenson Treasury*, edited by Hanna Keil, London, 1964).

Printing itself scarcely could have had a greater effect on the study of the classics than photography is beginning to have on the study of the Old Masters. If most people are still incredulous about the possibility of giving a rational, systematic basis to the criticism of art, it is largely due to the fact that until very recently any accurate comparison of pictures was out of the question. The basis of connoisseurship is the assumption that an artist in his work develops steadily and gradually, and does not change his hand more capriciously or rapidly in painting than in writing. Unsigned works, therefore, are ascribed to this or that master, as are fragments of the classics when they come to light, by fancied or actual resemblances to signed or otherwise perfectly authenticated works. But the hitch in connoisseurship has always been in comparison. In the days of slow travel, when there were no photographs of old pictures to be

had, the connoisseur was obliged to depend largely upon prints. But a moment's comparison of even the best print with its original will show how utterly untrustworthy and even misleading such an aid to memory must be. No engraver, however well intentioned, can help putting a great deal of himself into his reproduction. His print has no other value than that of a copy. The connoisseurs and art historians, therefore, who had to depend on prints, no matter how good a general notion of a painter's various compositions they might have drawn from this source, could have next to no acquaintance with those subtlest elements in his style which distinguished him from the mere copyist or clever imitator.

Is it surprising then, that really accurate connoisseurship is so new a science that it has as yet scarcely found its way into general recognition? Few people are aware how completely it has changed since the days before railways and photographs, when it was more or less of a quack science, in which every practitioner, often in spite of himself, was more or less of a quack. Quackery in the criticism of art is unfortunately not less common now than it was then, but the difference is that the quack no longer has the least excuse for himself. Of the writer on art today we all expect not only that intimate acquaintance with his subject which modern means of conveyance have made possible, but also that patient comparison of a given work with all the other works by the same master which photography has rendered easy. It is not at all difficult to see at any rate nine-tenths of a great master's works (Titian's or Tintoretto's, for instance) in such rapid succession that the memory of them will be fresh enough to enable the critic to determine the place and the value of any picture. And when this continuous study of originals is supplemented by isochromatic photographs such comparison attains almost the accuracy of the physical science.

3. Buying and selling

The state of the art market

3.1 Creating a collection

Making a collection of works of art was no longer confined to the aristocracy, and Philip Hamerton gave some useful advice to both the curators of national collections, and to the aspiring tyro (*Thoughts about Art*, 1889).

In the formation of private collections, great attention ought always to be given to the *character* of the collection as a whole. Every collection ought to have a character of its own, and no work should be admitted into it which does not quite harmonize with that character. Nothing is more incongruous, nothing fatigues the eye more, than great differences of *scale* in pictures hung in the same room; and there are different kinds of art, each good separately, which arm each other very seriously when seen together. In this respect the Vernon Gallery was anything but a well-selected one. Separately, the pictures are, many of them, of great excellence; but the *collection* is brought together without any attempt at unity; and the pictures help one another no more than odd volumes on a bookstall. The Sheepshanks' collection, on the other hand, is more consistently chosen. Again, of national galleries, the Louvre is as badly ordered a collection as could well be imagined, there being no proportion whatever in the space allotted to different masters; it is a mere agglomeration, without any plan, in which the most precious things and the most worthless are stuck together like relics in some recent geological formation.

An *ideal* national collection would contain specimens of every great master, but it would necessarily limit the number of examples of each painter, which ought, in every case, to be the very finest procurable for money. In a few examples, masterpieces, carefully selected so as to illustrate the strongest period of the artist's career, a very sufficient idea might be given of all but the most versatile of painters. Each painter ought to have a room to himself, with his name inscribed over the door, and on the walls within, in great legible golden letters, so that there might be no confusion in the

minds of ordinary spectators as to whose work they were looking at. Under every picture there should be a brief account of the intention of the picture, and its history (but no attempt at criticism or pointing out of 'beauties'), engraved in legible characters on a tablet of marble as long as the frame of the picture, and on which the lower part of the frame should rest. Black marble would be the best, with the letters engraved and gilded. No catalogue whatever ought to be required, because it is wrong to put poor people to the expense of buying one. If, as is generally the case with painters, a portrait of the artist existed, there ought to be a marble bust of him, as truthful as possible, placed directly opposite the entrance, with its back to the wall, and not above six feet from the floor, nor in the middle of the room, because that would impede the sight of his pictures.

Three or four copies of a brief biography of the painter should also be accessible in different parts of the room, legibly printed and simply framed, with a glass for protection.

Every picture should be hung with its horizon on a level with the eye of a spectator of ordinary stature, and there should be a clear space of three feet at least between the larger pictures, and two feet between the smaller ones, which space should be filled up, if possible, with velvet of a dark colour. If a nation is too poor to show its pictures to the best advantage (as that poverty-stricken country, England, appears to be), a flock paper, with slight pattern and all of one colour, is the next best thing to velvet.

It is not to be expected that a nation like Great Britain should be able to afford velvet for its picture galleries; but a private speculator, who has established a permanent exhibition of pictures at Paris, was cunning enough to cover all his walls with it from top to bottom before he hung a single picture upon them, a piece of extravagance which would astonish our House of Commons if carried out, as it ought to be, in our National Gallery.

Arrangements such as these would do more to facilitate the study of painting in galleries than any one would believe possible who had not been accustomed to pass whole days and weeks in looking at pictures. The fatigue of such study, if undertaken in earnest, must always be very great, but it is now needlessly increased by a want of consideration for the convenience of the student. It is at present impossible for anyone to study seriously in any public gallery without tiring himself in seeking out works which ought never to have been separated, and straining his eyes, and stiffening his neck, in vain endeavours to see pictures which are purposely hung so high as to be out of sight. Galleries like the Louvre are an affair of mere vulgar

national ostentation: there are great treasures in them, but no sign of any supposition on the part of their guardians that the treasures can be of any use. The great Rubenses in the long gallery are, it is true, hung *together*, but they are hung at least six feet too high, the only earnest endeavour after perfect hanging and helpful association in the whole collection having been bestowed on the worst pictures in any public gallery in the world, – the hideous series of illustrations of the life of St Bruno, by Eustache Lesueur. *These* were hung in uninterrupted order, but the priceless Titians are carelessly scattered amongst other men's works, high or low, according to the caprice of the director or the convenience of the hangers.

These defects have hitherto been almost inevitable in national collections, which are accumulated gradually by successive Governments, depend largely on bequests, and are usually given over to the care of personages who have little knowledge of or interest in art. But such defects need spoil no private collection. The principle of giving a separate room to each artist may, in large houses, be carried out without inconvenience, and all the more easily if the owner has several houses. The practical difficulty of acting upon this principle is that ordinary rooms are often so badly lighted that pictures cannot be seen in them. A gallery may, therefore, be a necessary adjunct to houses which have been constructed without reference to the convenient study of art treasures. The best gallery, however, would be a suite of small rooms, all lighted from above, and of which each should be dedicated to a particular master, in the manner already suggested for national galleries. If the owner were fortunate enough to possess a few pictures of great size and importance, he ought to give a separate room to each of them, with no other furniture than a large and comfortable sofa, placed at the right distance from the picture. An ordinary exhibition, where a thousand paintings are incessantly occupied in doing each other as much harm as they possibly can, is the perfect type of what a collection ought *not* to be.

The supreme merit of any collection is U N I T Y. Every picture ought to illustrate and help the rest. And if the buyer keeps in view some great leading purpose, the unity will come of itself, but it cannot easily be reached otherwise. Mere miscellaneous buying, according to the caprice of the moment, leads to the raking together of unrelated objects, but not to that beautiful and helpful order, which multiplies the value of every particle.

Having presumed that the reader really loves art, I need scarcely hint to him the desirableness of such arrangements as will allow his pictures to be seen. If he cares for them at all, he will certainly hang

them so that he can see them. There is no better proof of the insensibility of many owners of pictures than their habit of hanging them where not a creature except the flies can ever hope to behold them. *Whenever two pictures are hung one above another, one of them is sure to be out of sight.* Pictures hung in ordinary rooms, which people inhabit regularly, should not be crowded up to the very ceiling like an exhibition, but rather carefully isolated and distributed all over the house, such pictures only being allowed to remain near each other as are naturally fitted to be companions. They ought also to be intellectually in harmony with the uses of the room. Illustrations of literature, and portraits of authors, have a greater value in libraries than in billiard rooms. I enjoy good landscapes so heartily myself that I am glad to meet with them anywhere, but they have a better chance of being seen in drawing-rooms than in dining-rooms. A landscape is half lost unless you can see its detail, which from your seat at table is often impossible in a large dining-room. But a portrait of life-size loses nothing a few yards away. At the Manchester Exhibition of Art Treasures, Gainsborough's imperious Beauty awed the crowd, with her scornful eye, twenty paces off. Nothing is nobler in a dining-room than a series of lordly portraits by Vandyke or Reynolds; but their successors of the present day have such terrible difficulties of costume to contend against that it would be a dangerous experiment to surround a scene of festivity with gentlemen in well-fitting waistcoats and highly-varnished boots. And if you have any ugly portraits that you have an affection for, as is very likely, let them be placed in your most private rooms, where no guests come. They are better there for many reasons. It is in our calmest hours that the dead come back to us in memory; it is then that we hear again their dear voices; it is then that we recall most vividly their half-forgotten looks and gestures. The ugly portrait may be precious to *us*, but it cannot touch the hearts of strangers. Alone, we may look up to it through brimming tears; but the world will not weep before it.

I think the prevalent idea that the purchasing of pictures is exclusively a luxury for very rich people who can afford *collections* is unfortunate for the art. We all of us buy books, though very few of us can afford a library; why should we not all buy pictures too? The most of us pay wine-merchants' bills; and wine, though pleasant in its way, is no more essential than pictures. I see no other reason than this, – that we like wine better. Every comfortable house ought to have three or four good pictures, at least *one* in each of its principal rooms; but such a picture as its owner will not weary of, or else he

must have more. And all good pictures are inexhaustible: some by a mysterious charm and fascination, as the melancholy portrait in the Louvre, opposite the great Veronese, or the face of the Mona Lisa; some of their mighty poetry, as the Téméraire in the Turner Gallery; some by a wonderful idea of beauty, as the Phryne; and some by fulness of matter and endless harmonies of colour, as the best works of John Lewis.

3.2 A great collection

Despite the fact that London and the provinces were now possessed of important public art collections, many of the older private accumulations of art treasures, which, as in the case of that belonging to Lord Northwick had been freely accessible to the public, were being sold for various reasons. On 30 August 1859 *The Morning Post* published an account of the collection and its dispersal.

The disposal of Lord Northwick's pictures, collected during a life extending for nearly a quarter of a century beyond the average term allotted to man, occupied 18 successive days, attracted buyers or buyers' agents from all parts of the kingdom, and realised a sum amounting in round numbers to nearly £100,000. So extensive a collection has not been sold for many years. The residents and visitors of Cheltenham knew its value, and will long lament its unfortunate dispersion. The galleries at Thirlestane House were the pride of Cheltenham. They were to that thriving town what the National Gallery is to the metropolis. They were open all the year round, without fee or charge of any kind, and their liberal owner had no greater pleasure than that of knowing that his pictures drew visitors by the hundred. In like manner, at Northwick Park, near Campden, his Lordship had built a spacious gallery, which was never closed at any hour of the day to the public, and, being the only gallery for many miles round, was greatly valued by all the neighbourhood. Until within the last year or two Lord Northwick spent much of his time every day among his pictures, and took great delight in pointing out their beauties to any intelligent visitor who might ask permission to see the collection. He had a kind way of getting into conversation with young people, and would explain the difference between one school of painting and another, and show how to discern the great points in a picture, where to look for merits, and how to distinguish between good and bad. It was a pride and pleasure to him to know that either at Cheltenham or Northwick

Park his treasures were appreciated by the public. Few men of his rank and retired habits had more public spirit. Not his pictures only, but his whole house and park were at the service of the public. Those who have frequented that lovely spot for picnics or parties of pleasure know well the hospitality with which its noble owner would send out choice fruit or other refreshment by way of welcome to his often unknown visitors. As for Thirlestane House, it was for all practical purposes a public institution, of which Cheltenham and its visitors reaped the benefit.

These splendid collections are now scattered to the winds. They were brought together in the course of a very long life, they cost immense sums of money, and repaid their owner by the gratification they afforded to his own refined taste and the pleasure they afforded to others. But they are scattered, and it may be a whole generation before another collection at all approaching to it in number, value and public usefulness shall be formed. And it is this thought that suggests these remarks. We contemplate the dispersion of these pictures with two painful reflections, which, by way of caution or suggestion to other collectors, we wish to impress upon the public. The first is the comparative uselessness of collecting works of art without some provision for their preservation. Here was a most accomplished nobleman devoted to art, especially pictures. He spent enormous sums of money in the collection of choice specimens, and was a liberal patron of young artists of ability and promise. In the course of years he had galleries of which any peer or millionaire might be proud. Now where are they? He has gone, and his pictures are scattered all over the country and the continent. They are no longer a school of art. The galleries of Thirlestane and Northwick no longer form a school for the student or a refreshment to the amateur. The purpose of a life is dissipated, and a new illustration is given to the preacher's moral '*Vanitas vanitatis et omnia vanitas*'.

It was the belief in Cheltenham, we know not on what authority, that the pictures at Thirlestane would be left for the benefit of the town, or, at least, that some provision would be made by which they would be preserved there for the use of the public. This turns out to be a mistake. Those works of art have gone to the highest bidder, and their sale is regarded as a great calamity. Undoubtedly, he who collects treasures of art in the way Lord Northwick did, and gives the public the benefit of them during his life, does a great service in his day and generation; but it is impossible not to remember how much greater a service he renders who not only forms a collection, but provides for its perpetuity. To collect pictures at great cost and

then sell them by auction is to throw to the winds a large amount of money. The difference between purchase and sale is the price of the owner's enjoyment during his lifetime, and a costly price it often is; whereas a comparatively small addition to this expense would save the labour and thought of years from the auctioneer's hammer, and, what is worse, from uselessness and oblivion. In the next place, see the duty of making a will. These collections are dispersed because they form a portion of the personality of the deceased, and there being no instructions as to their disposal, there is no choice but to sell them, and appropriate their proceeds among the heirs-at-law. Next to the mischief of making an unfair will is that of making none at all. Had Lord Northwick ordered by will the sale of his pictures, however disappointed the world might have been, it would have felt that he had a right to do as he liked. But dying intestate, the sale follows as a matter of course, and the results of a long life and large fortune devoted to works of art are just nowhere. Many of our readers are men of fortune and collectors of art treasures; we think the fate of Lord Northwick's pictures is a lesson to them. A gallery of pictures left to a family or to the public is an offering at the shrine of art; but, sold by auction and dispersed among innumerable private purchasers is sheer vanity and labour lost.

3.3 A project for a museum of art

Provincial art galleries were bursting into life all over the country, every growing city seeing in them a status symbol of urban achievement. Strangely as late as 1880 Birmingham, where several well-known painters were born, did not possess one. In that year Edward Burne-Jones, a native son, drafted a letter to John Henry Chamberlain, Chairman of the School of Art there, prompted by a visit from another local boy William Morris (in *Memorials of Edward Burne-Jones*, 1912, vol. 2).

Whilst talking to Mr Morris both before and since his visit to Birmingham, we have been much struck with the need there is in that important town for a Public Museum of Art. It is not too much to say that without one an Art School is impossible – how can students work properly without some high standard of art before their eyes, some visible authority to which reference can be made? A Museum of Art is as essential for a student of art as a library is to the student of letters. Will you allow me then to ask your attention to this subject, and let us see if anything can be done to get an Art Museum for Birmingham.

A building is the first requisite, nor would it be long wanting, I am sure, if once public interest were aroused. It should of course be large and fireproof (as far as that is possible), and in the basement should be placed casts of sculpture of the finest Greek and Florentine work – a thing easily attainable now, only needing judicious selection and advice which could be easily obtained – and then at once you would have objects that would open the eyes and the hearts of students more than hundreds of lectures and lessons on art – which of course they cannot imagine, having never seen anything of the kind.

I speak very feelingly – for I know that if there had been one cast from ancient Greek sculpture, or one faithful copy of a great Italian picture to be seen in Birmingham when I was a boy, I should have begun to paint ten years before I did; it was not till I came to London that I saw anything of the sort. In the upper rooms there should be a permanent collection of pictures, engravings and drawings, and a select library of books bearing on art. I say 'permanent' because I know that moving works of art backwards and forwards in sending them to loan collections does them great damage; especially with regard to pictures, it is evident that the shaking of many journeys does mechanical injury by loosening the paint on the surface, not to mention other and worse dangers of destruction on the railway. I have lately known of valuable work burnt in transit by rail. This being the case and also, as I think we shall agree about the desirability of establishing as many centres of education as possible in the country, my feeling is that it would be well to discourage the idea of a loan museum, and to bend all our energies towards forming a lasting collection of works of Art. And for the picture gallery which must form part of this, I should urge you to form it in the first place not from the works of contemporary artists which have not yet been submitted to the verdict of time, but of the best copies procurable of the recognised masterpieces of the world still left to us. A gallery of these would be of infinite value and help to students and the public – it would be a great thing if you could find a school of copying in Birmingham; the result would be unique, and many a young man now doing poor work of his own, which he is obliged to show to earn money by, would then be able to support himself by making faithful copies of the best pictures while carrying on his own studies privately, and gaining the best instruction by the very act of copying great art. There are numbers also who never can do original work but yet could be trained to make admirable copies.

In your library you might have illuminated MSS, old books of engravings etc, and a small nucleus would soon attract gifts – for

while I deprecate the loan, I desire the gift of works of art. I am sure the thing will thrive when once started.

Anyway, you cannot, as I said, have a School of Art without a Museum of it – there must be models and standards of excellence before the eye of learners, or they have nothing to compare their own work with, and do not know even after what they are striving.

Armed with this you will be safe from a chance to which all schools are exposed, of different teachers teaching differently, or of agitation arising from without or within owing to there being no settled authority at hand to appeal to; and in the course of time I know that even the silent presence of great works of art in your town will produce an effect on those who see them, and the next generation will, without knowing how or why, find it easier to learn than this one, whose surroundings are so unlovely.

Memorials of Edward Burne-Jones, London, 1904.

3.4 Shopping for porcelain

To some Italians, it must have seemed that the English were descending on Europe like culture-hungry locusts. In 1869 Lady Charlotte Schreiber, an omnivorous collector of china, who accumulated an impressive accumulation of fine works, which she bequeathed to the Victoria and Albert and the British Museum, recorded in her *Journals* (published in 1911) some of her activities in Italy that year.

17 June. Have been in Venice ever since and hope to stay another 10 days. Spent most of our time on the water and in hunting the curiosity shops. Most of these are filled with fine objects (qy. original) but out of our line. We have made on the whole a good many purchases, however; Guggenheim's is the largest shop. With him we only found a small enamel snuff box with a transfer printing of a girl, in black, milking, on the inside, £1 4s. Richetti is the next largest repository. He has a delightful service of Milanese ware, decorated with representations of Harlequin and Columbine; for the whole service of 80 or 90 pieces he asks £60. We bought 5 dishes of the service (2 of them marked) for £5 5s. Oval enamel, with Saviour on the Cross, printed in black, 8s. Pink enamel double inkstand, £1. A small Persian mug, £1 12s. and a pair of fine Venetian soup tureens and covers, ornamented with flowers in bold relief as a handle, £7. Of all this lot amounting to £17, only the 2 objects in enamel are English. Next in order of importance comes the shop of Favenza, in

course of moving to the banks of the Grand Canal. We found some fine old glass with him, and a few specimens of fine Venetian china, but nothing English, except 3 enamels and here again we have been tempted out of our line to the following extent. A large plaque of Smalto glass, with landscape in brown, £8, this is quite equal in size and decoration to the framed pieces in the Correr Collection. It has the extra merit of being perfect, whereas two out of the Correr pieces are sadly broken, but it falls short of them, in that the Correr pieces are decorated with views in Venice, and ours has only a fancy landscape, but very good. A pair of Smalto glass vases, painted with amorini in pink, £4. Also resembling a vase in the Correr, though of a different subject. A circular plaque in Smalto glass with representation of San Rocco, done in red, £1 12s. A pair of Trembleuses and Stands, ruby glass, with white Smalto inside, decorated with red and gold ornaments, £7. A pair of Venetian cups and saucers finely painted in landscapes and figures, £2 8s. Two similar cups without saucers, £1. Four Venetian cups, rude painting, four of them marked, £4 10s. Eleven plates and 12 soup plates Venetian, marked, with wreathes and insects in centre, £3 14s. 9d. Two pictures on glass, one done in gold, the other in silver, signed E. F. one has the arms of Cardinal Barberigo upon it, £7. A small unimportant enamel snuff box, £1 4s. A snuff box in the form of a bird, £1 10s. A small female head, enamel, black transfer-printing, 1s. 3d. An Oriental teapot, gold ground, £1 (matching some egg-shell cups I have at home). This completes a sum of £43. All, I believe, well spent. As to the glass, we got Signor Montecci, the Director of the Salviati Works, to come and give us his opinion of it. He considered the large plaque very fine indeed, as also the Trembleuses, which are of a colour very difficult to execute and still more difficult to get to stand. He pronounced these pieces undoubtedly old. About the Amorini vases he seemed rather more doubtful. It ended by our rejecting Favenza's 2 glass vases with Amorini, for on washing them we found the colouring defective. We added, however, an old metal frame and brought the lot, in settling with him, down to £40. We also made a change in our dealings with Ricchetti, exchanging the two marked Milan dishes, and two cups and saucers for a pair of Sucriers and stands (the latter both marked) to which we added a Venetian basket, bringing up the total paid him to £19. Another dealer, Rietti, principally sells figures of old Faience and Majolica, and Luca della Robbia. He has secured the whole make of the Nove works, who turn out very pretty terraglia, which he sells as old Nove pottery, and he has a quantity of Minghetti's copies of the

antique. One piece of very fine Nove china he showed us, viz: an Ecuelle, cover and stand, beautifully painted with subjects in panels. He wanted 400 francs for it. I think we have traced that it must have come direct from the proprietors of the Nove works; it is marked N.O. in the glaze. At Rietti's we found a number of old knives and forks. Twisted handles of turquoise enamel, and silver, very beautiful; but of the lot only 7 were in good order. These 7 we bought for £2 2s. as also 12 buttons of enamel with hunting subjects, in black transfer-printing, for £1 2s. This was arranged after a great deal of bargaining, more than double the price having been originally asked for them. At a little shop on the Piazza Sta. Maria dei Frari, we found a small enamel head, 1s. 6d, and a piece of Buen Retiro exactly matching the pot and cover for which we 'signed' at Bologna, and making a pair with it. At a Librarian's named Colbachini, near the Belle Arti, we got a pair of very good Oriental cups, painted with cocks for 10s., and a much broken but very interesting enamel order of Frederick the Great, for 2s. There is an officious, meddling, tiresome old man named della Rovere, who keeps a shop with very little in it in the Palazzo Berchtold, from him we got 4 printed Wedgwood cups and saucers like the Milan set, only done in black transfer instead of red, 16s. and also 4 small enamels of seasons, 12s. and 2 coloured enamel pegs, 4s. This man took us over the part of the Palace in which Mme Berchtold herself is living. She is a natural daughter of old Lord Hertford's by Lady Strachan. It is a tawdrily furnished uninteresting house, but has one fine hall in it hung with good tapestry, for which she wants some £2000. Everything in the house is for sale, but the prices asked are exorbitant. He also sent us to the Palace of a Count Albrizzi where also what little remains is to be sold. We looked at the things but liked nothing. What was then our surprise when the Count's servant brought all his china to us at our Hotel in the evening inviting us to make an offer? Of course we declined. There was a metal cast of Briot's, of a large dish. This we rather admired, but knowing nothing of this branch of the arts, we doubted of its value. To our disgust della Rovere forthwith wrote off to Cortelazzo at Vicenza telling him we wanted to consult him about it, and Cortelazzo actually came to Venice to see us on the 16th accordingly. The pertinacity of this Count Albrizzi, who would hardly take a refusal from us, was very amusing, but we did not buy anything from him. The only good della Rovere did us was in introducing us to an industrious little dealer called Ruggieri, living near the Ponte della Piavola. We paid him many visits and got a few things from him on

good terms for us, and doubtless for him also. There was a small Nove milk jug, well painted with buildings, but imperfect, 8s. A Nove écuelle, cover and stand, with a rose decorated with black spots, and signed with the star in gold, £2. A small Venetian vase, purple border and bouquet of flowers, £1 4s. A pair of Nove cups and saucers (red star) with grotesque figures, 14s. One of the oldest established (I should think) and most respectable shops in Venice is kept by an old man, with a fine venerable countenance, named Len. He is giving up business and had not many things left. It is said he had not been prosperous, owing to his having refused to fee the Laquais de Place, but this is hardly credible. From him we bought a dish, matching the plates we got from Favenza, 8s. and a pair of Battersea enamel candlesticks, exactly like those we saw at Samson's at Turin. They are a good bit injured in the sunk part near the base (where, however, they can be well repaired by a band of filigree work) and the price we gave for them was only £2. Rather a different amount from that asked by Samson! but his were perfect. An amusing incident occurred the evening before we left Venice. Ruggieri had brought us some broken vases matching the one we bought of him, and a very good 'Frederic the Great' enamel snuff box and modern enamel bracelet, which he said belonged to a lady in distress who wanted to dispose of them. The price he wanted for the snuff box was £6. We did not purchase, but in hunting about the Spadeira, on the evening of the 28th, we found all these things at the shop of a little jeweller, 'Morchio', Calle Larga S. Marco 659, and bought the Frederic the Great box for £2 16s. On the same occasion we found a small teapot, Venetian, imitating Oriental, in a rubbish shop in the Spaderia, for which we paid 3s. 6d. This exhausts the list of our Venice purchases. We went over to Murano one day with Signor Montecchi to see the glass works which interested us much and took the opportunity of going over the Museum and temporary Exhibition; the former of which contains some fine specimens of early manufacture. We also went into the Duomo, now undergoing repair, and there met the Cav. Abbate Zanetti, who is the Director of the Murano Museum, and with whom we made an appointment to visit the Museum again on the following Monday, the 21st; on that occasion Zanetti had the case opened for us, and we examined carefully the pieces of old glass. Next morning a little dealer, into whose shop we had strolled at Murano, came over to Venice with some of the goods we had looked at. They were of little value, but more from charity than anything else we bought off him 4 old Nove ware trays, 3s.; a smaller one, 1s. 6d., and an earthenware plate with

blue tracery, 2s. 6d. On a later day he came over again bringing 2 glass bottles with the arms of Murano and those of Miotto done in gold, about a century old. These we bought for £1 4s. In order to verify this 'Stemma di Miotti' he showed us a circular 'seal' of Smalto glass, having on it in relief the Miotto insignia, an ape holding an apple and inscribed 'Pusopo Miotto, Murano'. This, he said, was the trade mark put by the Miotti on their cases of manufactured articles when shipped. He was very unwilling to part with it, and for a long time refused to do so, saying that it belonged to his brother who had only lent it to him to show us, giving authority for the decoration of the bottles. But at last we persuaded him to do so, mainly by telling him we would not buy the bottles without it, and so we ultimately secured it for £1. On a subsequent visit to Murano (25th) we showed this seal to Zanetti, who was quite excited at our having obtained it, considering it a most valuable and curious specimen. There is a similar one in the Murano Museum of the Barberis who were manufacturers in 1793 at the Sign of 'Alle Nave'. This seal or stamp is impressed, 'f.b. a l l a n a v e b e t t i n a' (and a ship with 2 masts and flag at the stern). The date of our Miotto was supposed by Zanetti to be about 1723–4. I have now enumerated every purchase. As I said above, our object was rather to enjoy and benefit by the air of Venice than to devote ourselves to sight-seeing. Let us hope to become better acquainted with its wondrous treasures of art on a future occasion. Of course we made frequent visits to S. Mark's (where I think I got some ideas for the Canford Hall) and to the Bell arti, where we specially delighted in the Older Masters, Bonifaccio, Carpaccio, Gentile Bellini. Amusing ourselves by the study of the room containing the pictures of the two latter, C.S. is inclined to hope that the pictures we bought of Band on the 11th May may turn out to be one or the other of them. We went over the Ducal Palace, saw Sta. Maria della Salute, Sta. Maria dei Frari, Santi Giovanni & Paolo. Some delicious pictures of the legend of St George by Carpaccio. We went over the Pesaro and Giovanelli Palaces, the latter done up in gorgeous modern taste, and paid two long visits to the Correr Museum, being on the second occasion (Wednesday, 25 June) accompanied by one of the Directors, Sigr. Urbani, who gave us much information, and caused all the cases to be opened for our more complete examination of their contents. At Venice we became acquainted with Sir Robert and Lady Arbuthnot, who lent us Ruskin's books, and took us to see some glass (a service, not very old, decorated in gold) belonging to two old bachelor brothers, the Messrs Malcolm, who have been in trade many years.

⟨Sir Robert was the 2nd Baronet, born in 1801. He married the younger daughter of Field Marshal Sir John Forster Fitzgerald.⟩ We also made acquaintance with Mr Rawdon Brown, who is a resident of some 30 years and has made deep researches into matters relating to the Art and Literature of Venice. ⟨He worked for the English Rolls Office in the Venetian Archives and was the editor of the Venetian State papers in many volumes.⟩ He mainly supplied the materials for Mr Drake's books on Venetian China. ⟨This was a well-known collector and member of a firm of solicitors. He was knighted as Sir William Drake.⟩ Having admired our little Nove cups and saucers (bought of Rugieri) we secured a similar pair to give to him, and in return he gave us a pretty pair of Venetian cup and saucers, blue fish scale, Oriental figures in panels, probably of the Cozzi date. On Friday, 25th, we went over to Torcello, taking Murano on our way and again visiting Zanetti and the Museum, a delightful excursion. On our return went through Burano. Enquired there about lace, and found one old woman making a little, but it was very coarse bad stuff. Our enquiries were first made in a respectable, but humble dwelling (glittering, however, with brazen utensils) which we found to belong to the village tailor. His wife, a pretty young woman, who was tending twins in two cradles, not only received and directed us courteously, but insisted on our returning (after seeing the Church) to partake of coffee. The Burano people exhibit a taste I have not seen elsewhere, arranging their gaily coloured earthenware plates and dishes against the walls of their houses on racks which are constucted in pyramidical form. All the Islands seem very poor, but this is the best of them. Amongst the interesting sights of Venice I must not forget the Scuole of San Rocco, San Giovanni, and San Marco, the public Gardens (where the lime flowers were just going out of bloom) and the Lido. Also numberless excursions around the City, the Giudecca, etc. The name of our Gondolier, Luigi Moloso, No. 129. Hotel, Pension Suisse. On the morning of Saturday the 26th, we got up early and went for the day to Padua, remaining there till evening, a most charming expedition. We spent a very long time in the Giotto Chapel, and visited the Churches of S. Antonio (well remembered for the Marble Boys supporting the Candelabra, in 1838) and of Sta. Giustina. We fell in with a little antiquaire, Celin. He had nothing himself, but he took us to others. At another little shop we bought a pair of striped cups and saucers, Venetian, 4s., and a Persian pot and cover, 12s. I had been enquiring for lace at Venice and found it awfully dear. La Pompeia has the best selection. Some of it is very fine, but ex-

travagant. For a flounce like one bought last year by Ivor she wanted
£200. Of course this was out of the question. Happening to mention
lace to Celin, he took us to a draper's shop, the master of which
Barzillai, brought out a series of bundles to show us. Among them
was a flounce of nearly 20 yards, 14 inches deep (very nearly res-
embling Ivor's, for which he had given £125). To our astonishment
we were only asked £32 for it. The flounce was not to be resisted,
even in the light of an investment, at that price, so we bought it.
After this we went to the house of 'Giuseppe Bassani, San Cassiano'.
He had some very fine things which we promised to visit again;
from him we got a Venetian fruit basket and stand, 16s. From
Barzillai 4 Venetian cups and saucers, Japanese pattern, 8s. Small
pedestal of the same pattern as ours of Bow china, 4s. Four glass
heads, unimportant, 8s. A moulded cream ware tray (qy. Treviso),
£1. When we had completed our purchases, the jovial Barzillai asked
us to stay and dine with him, which diverted us vastly. The
following Monday, Lady Arbuthnot came to see our lace with Mme
Usedom and Mr Trevelyan (the latter a great judge) and they pro-
nounced it wonderful, both as to quality and price. This (Monday
28th) was our last day at Venice. We took a sorrowful farewell,
devoutly hoping ere long to return to it.
29 June. Up at 3. Left Venice at 6. . . .

3.5 Booming art sales

The market in pictures remained buoyant whatever winds of
economic change were blowing in other directions, and on 1 April
1886 *The Times* reviewed the current season in terms of undiluted
optimism.

In spite of the depression of trade, of the Royal Commission
thereon, and of all the other signs of the times, the production and
dispersion of works of art still go on. Men are no longer making
fortunes, they say; but pictures are painted in greater abundance than
ever, and if they are good ones they are bought. Never were artists
so multitudinous; never were exhibitions so constant or so rapid in
their succession. Just now, too, the sale season is beginning to
approach its height. King Street is unusually busy. The great mart
there, the momentary resting-place of so much art that is good, so
much that is mediocre, is at this moment, as it was last week, one of
the sights of London. Not now is it the happy hunting-ground of the
humble collector, in search of masterpieces which no one will dis-

cover but himself. Those chances come mostly in the dark days of November and January; while from the end of March onwards the walls are commonly given up to great collections that every one has heard of, and that attract the long purses. Such was Mr McConnel's collection, from Cressbrook, which was dispersed last Saturday; such, still more, are the wonderful possessions of the late Mr William Graham, the modern portion of which is now on view, to be followed by the old pictures next week. The Cressbrook pictures were good of their kind, and, as we have already recorded, the prices at which they were sold proved conclusively that there are buyers among us still, who are not to be restrained. The great Constable, damaged as it was, brought a high price; the best of the Turners marked an advance of one-fourth upon what it had commanded in the Bicknell sale; the pictures of Mulready, Collins, and Callcott, charming examples of the painters, sold extremely well. But the buyers reserved their great efforts for the 'Horse Fair' of Rosa Bonheur – a replica of the picture belonging to the nation – and for the three pictures of the late John Phillip. Why this painter of Spanish scenes should rank where he does with the average wealthy picture buyer we have never been able to discover; but the fact is there. If a sufficient number of people are determined to regard him as a great colourist, as a master of composition, and as a painter endowed with a sense of beauty, his canvasses will continue to bring their thousands. The fastidious must be content to stand aside and wonder.

A very different collection from the good but rather miscellaneous gathering from Cressbrook is that which is now displayed on Messrs Christie's walls. Mr William Graham was a man of great taste and knowledge, as was implied in the fact that he was a Trustee of the National Gallery. A devoted and passionate admirer of the art of the Italians of the great age, a collector of old Florentine and old Venetian pictures such as were very few of his contemporaries, he was also an eager buyer of the work of such modern English painters as seemed to him to have inherited the serious spirit of the Italians. His old pictures, as we have said, are not yet on view; next week will come the turn of Ghirlandajo and Titian. At present the rooms contain such a gathering of the works of Mr Burne-Jones, Sir Everett Millais in his early period, the late Frederick Walker, and Dante Rossetti as has never been seen there before, and as probably will never be seen there again. Visitors to the Millais exhibition have missed, among the early works, two of those which are best re-membered by the admirers of the pre-Raphaelite movement – 'Apple

Blossoms' and the exquisite 'Vale of Rest'. Had Mr Graham lived, no doubt they would have found a place there, for he was always one of the most generous of lenders; but this was not to be, and now, with 'The Blind Girl', another interesting work of 1856, they are awaiting the fall of Messrs Christie's hammer. Their fate is the subject of much speculation, but we shall be surprised indeed, if 'The Vale of Rest' does not prove to be in the estimation of the public what it surely is, one of the most precious existing works of the English school. There is sure, too, to be fierce competition for the three pictures and the numerous drawings of Frederick Walker, who, besides being one of the most admirable of our artists, happens by a curious chance to be just now one of the most fashionable. Mr Graham bought the unfinished 'Sunny Thames', 'The Vagrants' (1868), and, above all, the fine picture called 'The Bathers', which was exhibited in 1864. It was 'skied' at the Academy, but Walker soon had his revenge, and the price that will be paid on Friday for this group of lads by the pond-side will show what is thought of him now. But the feature of the sale more interesting still is the large number of the works of Rosetti and Mr Burne-Jones which will be included in it – a thing quite unprecedented in the annals of King Street. It will be curious to see whether the interest which Rosetti's art aroused when his works were exhibited two years ago is still maintained, and if there will still be found a crowd of persons anxious to possess these full-lipped, long-haired damsels, with their 'intensity' and their really lovely colour. There is no such doubt as regards the pictures of Mr Burne-Jones, some of the very noblest of which are here displayed – 'The Days of Creation', 'Le Chant d'Amour', 'Laus Veneris', besides a multitude of smaller pictures and drawings, one more beautiful in colour than another. It is sometimes said that Mr Burne-Jones is only the painter of a clique, that his fanciful allegories and somewhat sickly maidens appeal but to a few, and those not the healthiest of mankind. It may be so; but those who have watched the course of taste, even among the ordinary amateurs, during the last ten years are inclined to think differently. This sale will probably prove that a good many people who are neither critics nor sentimentalists, are anxious to possess works so sincere, so full of the spirit of beauty, and so un-approachable in colour as these.

Meantime the new pictures and statues are finding their way to Burlington House and the Grosvenor Gallery and the Water Colour Exhibitions. The rooms will be as full as ever, though it would appear that the most famous artists are likely to be represented by

less important works than usual. Perhaps we ought not to say this of the President, for a fine statue must rank quite as high as a fine picture, and if 'The Sluggard' is as good as people say, it will not cause us to regret 'Cymon and Iphigenia'. Another of Sir Frederick Leighton's works is to be the decoration of a ceiling, destined for the house of an American millionaire. Mr Burne-Jones exhibits this year for the first time as an ARA. There is to be no lack of portraits by men whose fame is established, and by newer candidates for public favour. Mr Holl is to send seven or eight to the two galleries, including Mr Chamberlain, Sir Everett Millais, and the new Head Master of Eton; while Mr Ouless, among several others, will exhibit the portrait of Mr Scharf, which, we are glad to learn, is destined for the National Portrait Gallery, which he directs so well. Mr Pettie, encouraged by his recent successes, promises two more portraits this year, as does Mr Poynter. From the hands of Mr Alma Tadema we are to have three or four pictures, one of which, called for the perplexity of the unlearned 'An Apodyterium', is among the most perfect of this artist's smaller works. Mr Watts has one picture in each gallery; Mr Gregory, the quantity of whose production never satisfies his admirers, is to exhibit only one, but that promises extremely well. Mr Briton Rivière has been industrious; the Academy is to have four of his pictures, one of them a grim and powerful rendering of the tragic story of Rizpah. For landscape we are promised some large works of Mr Peter Graham, a fine view of Dunstanborough by Mr Alfred Hunt, and, for the Grosvenor Gallery, the most important picture yet produced by the most rising of our younger landscape painters, Mr Alfred Parsons. Mr Boughton has gone to the history of New York for a pair of amusing subjects, which we may be sure that he has treated with humour and artistic skill. From Mr Marks we are to expect four pictures, from Mr Gow a Cromwellian scene, from Mr Prinsep a scene of Hindoo ritual, and from Mr Fildes two Venetian figures. The Sculpture Gallery will, as we have said, be adorned by the statue on which the President has been so long working, by a life-size figure of 'The Sower', by Mr Hamo Thornycroft, and – not to mention other and older men – by something, we hope, from the accomplished hand of Mr Alfred Gilbert. This makes altogether a respectable list, and it must be remembered that we have named but a few out of many painters and sculptors of distinction. The displays at the Royal Water Colour Society, at the Institute, and at the new Marlborough Gallery at Pall Mall are expected to be very good. A week or two hence the public will be able to judge for themselves.

3.6 The Gillott sale

Joseph Gillott, a self-made millionaire who founded the famous nib firm, did probably more than anyone else to enhance the standing, and the economic value, of contemporary British art. The account of the sale of his collection at Christie's in 1872 appeared in George Redford's *Art Sales*, 1888, vol. 1, pp. 184 *et seq.*

The most important sale in this season at Christie's, and one that first began the great rise in the price of modern pictures of the English school, was that of the collection formed during many years by Mr Joseph Gillott of Birmingham, the inventor it may be said of the modern steel pen, of which he was also the largest manufacturer in the world. The collection consisted of 525 pictures and water-colour drawings, of which 305 were works of the British school, 60 by old masters and foreign painters (2 only), and 160 water-colour drawings of which 12 were important works by Turner, 26 by William Hunt, 29 by David Cox, one of which 'Peace and War' in oils, brought the then unprecedented price of £3601 10s. Of the works of Sir Joshua Reynolds there were three, but not of great importance; of Gainsborough there were twelve, all landscapes, and some very fine examples, with one portrait, but that one of special interest being a portrait of Gainsborough himself. By William Collins there were eight, two of which were capital works, 'Barmouth Sands', the engraved picture painted for Mr Gillott, and 'Cromer Sands', exhibited at the Royal Academy, 1845, which brought the highest price ever reached for a work of this master, viz., £3,780. By Constable seven pictures, two of which were 'Weymouth Bay', and 'A View on the Stour'. Twelve by Patrick Nasmyth; several by Old Crome, of which two were 'The Windmill on Mousehold Heath', and 'A Wood Scene'. Fifteen by Müller. By Wilson thirteen, of which at least three were capital works, one being the 'Meleager'. By Landseer five pictures, three of which were of first-rate excellence – 'Waiting for the Deer to Rise', 'St Bernard Dogs', and 'The Pointers, To Ho!' one of the finest examples of his earlier time, 1821, exhibited at the British Institution, before he had gained his place as an Associate of the Royal Academy. The engraving of this picture is perhaps the masterpiece of his eldest brother, Thomas Landseer, AE. The pictures were hung chiefly in two galleries specially built in Mr Gillott's residence at Edgbaston, the west-end suburb of Birmingham, some being in the entrance hall which was lit by a top-light, others in the dining-room, and the fine Turner drawings with others in the drawing-room.

The title-page of the catalogue described the sale as of 'The renowned collection of ancient and modern pictures and water-colour drawings of that well-known patron of art, Joseph Gillott, Esq., deceased, removed from his residence at Birmingham (by order of the executors). In three portions. 1st. April 19th and 20th. Modern pictures of the late English School. 2nd. April 26th and 27th. Pictures of the early English School. 3rd. May 3rd and 4th. Old Masters (one day), water-colour drawings on the next.' A short preface preceded the list of lots, as follows:

'The noble collection of pictures brought together by the late Mr J O S E P H G I L L O T T has enjoyed so world-wide a fame, and has been so long regarded by connoisseurs – and justly so – as a complete epitome of the English School, that very little comment is necessary in bringing it before the public.

'Being the growth of many years, its formation has been the result of no hasty or indiscriminate purchase. Nearly half a century has elapsed since Mr Gillott, then a young man, first laid the foundation of it, and during the whole of that period the work – with him a very labour of love – has been steadily continued upon principles of thoughtful and judicious selection, which excluded all but first-rate productions.

'Enjoying the friendship of many of those whose names are most honoured in the roll of English art – among others, of Turner and Etty (in the works of both of whom the Gallery is especially rich) – of Linnell and Müller, of William Hunt and David Cox – and himself gifted with a refined and critical taste, and with a true artistic instinct which appears never to have been at fault, Mr Gillott was in possession of advantages rarely falling to the lot of collectors. Of these, his ample means enabled him fully to avail himself, and the result has been a collection, both in oil and water-colour, altogether unrivalled among private galleries as embracing all the highest characteristics of the English School. Of landscapes the collection boasts many among the greatest ever executed by human hand, while there is scarcely a name of note in the history of British art, to whatever branch devoted, of whom one or more first-rate and characteristic examples will not be found.'

The prices of all the important pictures will be found in the tables under the names of the artists.

The following is the statement of the amounts of each day's sale, and grand total:

1st day – Oil Pictures, English School	89	£29,718	7 0
2nd	73	44,443	0 0
3rd	76	19,556	5 0
4th	58	36,830	12 0
5th day – Old Masters.............................	58	6,559	0 0
6th day – Water Colour Drawings	160	27,423	0 0
		£164,530	4 0

Mr Gillott, a Yorkshireman, born at Sheffield, was evidently far before his time amongst the men of his class, and certainly gifted naturally with fine feeling for pictures. Although he had not had the advantages of modern education, and was entirely a self-taught man in days when there was little to be read about art matters in the newspapers, yet he acquired great practical knowledge of pictures, and his judgement and taste were generally sound. Like many lovers of pictures, he was fond of music, but not a practical musician; yet such was his native instinct, that he loved fine old violins and violoncellos as he did fine pictures, and indeed he was quite as remarkable an enthusiast in collecting these as in pictures. I have been told by Mr Cox, who was his great friend, and whom he consulted about almost all his purchases of pictures, that he delighted in simply twanging the strings of his fine fiddles and 'cellos. He used frequently after dinner to say to his friend, 'Let's have the Strad out to-night, or the "Amati"', and then he would twang the strings, while his face beamed with pleasure. His collection of violins and 'cellos, which was sold at Christie's at the same time (April 29), was the most extraordinary one ever sold, both for number of in-struments and fine quality, by the greatest makers of Italy, Germany, France and England. It was really quite a representative collection, and being myself an amateur of the 'cello, I shall never forget the interest with which this collection was viewed. There were more than a hundred instruments, some of unique excellence, by the famous Andrea and Antonius Stradvarius of Cremona, 1672; others, by Joseph Guarnerius, Nicolas Amati, and Grancino of Milan; while by Gaspar di Salo there was the grand old double bass upon which Dragonetti used to play in the Opera and Philharmonic Orhcestra. A Strad. Violin sold for £290; a Guarnerius of 1752, £275; a 'Cello, £121. – Total £4,195.

In a short biography of Mr Gillott, his artistic taste is thus spoken of:

'He could instinctively recognise the *true* in the work of young

artists, and always encouraged budding talent. Müller, a gifted genius, came in for a share of his warm support, but he scarcely repaid Gillott in a generous way. By reason of Gillott's patronage others sought the young artist, and bought at large prices the pictures which had been commissioned by his patron.' . . . Gillott was angry at this, and punished Müller severely by sending off all the pictures by him to be sold in London by auction, and without reserve. 'This step so frightened the art-world that "Müllers" became a drug in the market, and the disappointed artist went in penitence to Gillott, 'who was generous enough to restore him to favour, and give him commissions to the end of his short life, one of these being "The Chess-players", which sold in his collection at mans, 1881)

3.7 An agreement

Fostered by ambitious, enterprising and imaginative dealers, executed by astute, hard-working painters, mass produced through the medium of prints, art had become big business. The combination was seen at its most successful in the persons of Ernest Gambart, probably the most successful of English dealers in the nineteenth century (he was actually Belgian), and W. P. Frith. Their combined operations are recorded in absorbing detail in Jeremy Maas' *Gambart* (London, 1979) and from the viewpoint of one of the participants in Frith's *My Autobiography and Reminiscences* from the first volume of which (1887) the following agreement is taken.

'Memorandum of agreement made this twenth-ninth day of August, one thousand eight hundred and sixty-two, between William Powell Frith, of No. 10, Pembridge Villas, Bayswater, in the County of Middlesex, Esquire, RA, of the one part, and Ernest Gambart, of No. 120, Pall Mall, in the said County, Esquire, of the other part.

'The said William Powell Frith agrees to accept a commission to paint for the said Ernest Gambart, and the said Ernest Gambart agrees to give a commission to paint, three pictures by the said William Powell Frith, and to be called "The Streets of London" (such pictures to consist of three parts as hereafter mentioned); and the said William Powell Frith agrees to sell the copyright therein, together with the original sketches thereof, and all further sketches or drawings made or to be made in furtherance of the said pictures, for the sum of ten thousand pounds, to be paid by instalments as follows, namely: Five hundred pounds on the signing of this

agreement; five hundred pounds at the expiration of three calendar months from the commencement of the said pictures, and a like sum of five hundred pounds at the expiration of every succeeding three calendar months until the whole of the said sum of ten thousand pounds shall be paid, or until the said pictures shall be completed; in case the same shall be completed before, the said sum of ten thousand pounds shall be fully paid, in which case the balance which shall be then unpaid shall immediately, upon such completion and delivery of the said paintings and sketches, be paid.

(Signed) 'W. P. Frith,
'Ernest Gambart.'

3.8 Profits from a painting

Precisely what kind of profits a dealer could obtain from a painting is known from documentation about Holman-Hunt's *The Finding of the Saviour*, reproduced in Jeremy Maas's *Gambart* (London, 1979). In 1860 Gambart bought the painting with copyright for the unprecedented sum of £5,500. On 12 November 1860 he wrote a letter to the printseller George Pennell.

Holman-Hunt's Picture of *The Finding of the Saviour in the Temple* is now exhibiting in Bond Street at No. 168 under the charge of Mr Nutter & I propose that it remains there until a drawing which Mr Morelli is making in black chalk from it be finished – the Picture will then be free to travel all over the Provinces & the engraving will be made entirely from the Said Drawing, which, being made with the assistance of Hunt, will be in every way satisfactory to engrave from – the Engraving from the Drawing if done by either Simmonds or any other Chalk engraver will cost 1,000 guineas, and take two years; if done by Blanchard, Morelli or any other pure line engraver will cost 2,000 guineas and take four years to do.

The printing of the plate will cost about 10 guineas a hundred, including the paper, or say 1,000 guineas for 10,000 impressions – the whole future outlay will be about 3,000 guineas at most.

I trust we can reckon on receiving at least 5£ a day during four years from its exhibition alone, being only 100 visitors per diem at 1/-.

This would produce 6,000£ & would be sufficient to pay for the engraving & the printing as we go on & also Mr Nutter's Commission on all orders received & 2£ per week additional.

I propose to print from 1,000 to 2,000 artist's proofs at 15 guineas;

1,000 before letters proofs at 12 guineas, 1,000 proofs at 8 guineas & I hope 10,000 proofs at 5gns. I have now already orders which I can submit to you for verification amounting to 10,000 guineas & I have no doubt these orders will reach 50,000 guineas in 4 years.

I offer the price in the Copyright & receipts from admissions & Sale of the Engravings, deducting the charges named above for 10,000 guineas Cash down.

The picture I will reserve for six years, so as to exhibit it, also if desirable in America and other Parts.

My own labours, or those of my executors & assignees in case of death to be given gratis & I will carry this arrangement out fairly and equitably to the best of my ability.

> It is probable that this letter, though addressed to Pennell, was really intended for the eyes of the famous collector Joseph Gillott (cf. pp. 117–19). Gambart certainly sold half his rights to another Holman-Hunt painting *The Light of the World*, the details of which he recapitulated in a letter to Gillott dated 15 January 1861.

I sell half the property (in *The Light of the World*) as described in the list & as it stood on the 15th of November last for £5,875 of which sum £5,250 is now paid, and the remaining £625 will only be due to me within 18 months from this date if we have divided a Sum of £6,000, viz £3,000 each, leaving the stock in as pretty a valuable state as it is now – the point of appreciation might be taken on the value of stock in hands, the amount starting being £16,645.4.0 out of which we shall no doubt sell a considerable amount, but it will be replaced by the stock to be printed of the plates in progress, so that, if, after dividing £6,000 we have 18 months hence Stock to the value of £16,645, selling the whole of the plates in good condition, the £625 will then be due to me.

The whole of the property in which you have a Share, will be kept separate on the first floor of the house & be always ready for inspection & verification, with the list of Sales & I will, when agreeable, give you or Montaign every information on the mode of operation, so that there will be no difficulty in case of my death.

3.9 Fakers and restorers

Never before had the quest for Old Masters been so intense, and a natural consequence of this was, at best, a passion for optimistic attributions, at worst a frenzy of faking; both being stimulated by the fact that, despite the labours of men such as Crowe and

Cavalcaselli, connoisseurship still relied on instinct rather than any pragmatic technique. A contributor to *The Quarterly Review* for 1854 seized upon the much publicised exhibition of Old Master paintings held at Manchester in that year 'to instruct the public, to improve public taste, and to furnish those who are prevented visiting the great galleries of Europe with the means of judging how far illustrious painters are worthy of their name' as an occasion for exposing some of the excesses which were then occurring.

The manufacture of pictures has of late years been carried to an extraordinary extent, and is leading to very mischievous results. The demand for a certain class of pictures, as in all articles of commerce, creates the supply. As Raphaels have always been in request, so Raphaels have always been made for sale. A few years ago the Eclectic School was the fashion of the day, and enormous prices were given for the works of its masters. Carraccis, Guidos Guercinos, and Domenichinos accordingly flooded the market, and are to be found in abundance in almost every collection, small and great, in Europe. Were they all brought together, we should have to account for their number by some such miracle as that which is said to have multiplied the remains of the true cross. The work of forgery had indeed begun before many of those whose works were counterfeited had ceased to live. Some painters seem themselves to have countenanced the fraud, and it is recorded of Guido, whose paintings were much sought after, that from mere good nature and a desire to help unsuccessful artists he allowed imitations to be made of his works, to which he added one or two touches that they might be sold as his productions.

The Eclectic School has now somewhat gone out of favour, and the early Italian and Flemish schools are in demand. Our National Gallery is giving prices beyond precedent for works of this class, and collectors, public and private, English, French, and Russian, are competing with it; consequently the ingenuity and skill of the Italian artist and copyist are exerted to the utmost to furnish the required supply. The fraud is effected in two ways – by the conversion of genuine pictures by one master into spurious pictures attributed to another, and by entire forgery. The first process is the most to be deplored of the two. Picture-dealers of Rome, Florence, and other Italian cities frequented by wealthy travellers, who think that a tour of Italy cannot be conscientiously performed without the outlay of a certain sum of money in the purchase of pictures, send their agents through the length and breadth of the land to buy up every work of art, whatever may be its merits, which may be procurable. There are few Italian cities, as we have already stated, which have not had their

own school of painting, distinguished frequently by very eminent men. But as the names of these painters are little known beyond the place of their birth, and their works are consequently not talked of, their pictures, however intrinsically valuable and excellent, would meet with very little favour in the eyes of most amateurs. To render them saleable, therefore, it becomes necessary to convert them by retouching or repainting, or by imparting to them some well-known quality of colour or technical execution, into the productions of a popular master.

If the picture be inscribed and dated, the real name and date are erased, and others ingeniously substituted. It is thus that pictures of the Cremonese, Veronese, Vicentine, and Lombard schools, or of those of the March of Ancona, the Legations, and Umbria, are converted by wholesale into productions by Gian Bellini, Mantegna, Leonardo da Vinci, Luini, Pietro Perugino, and other favourite and highly prized masters. Irreparable mischief is the result, works of value and importance are destroyed, and the names of men well worthy of being preserved disappear altogether. We once asked an able Italian restorer if he had ever met with any pictures by a painter of the Lombard School, of considerable merit, whose only work with which we are acquainted is in the Louvre. 'Oh yes', he frankly replied; 'the very first job upon which I was employed was in converting one of his pictures into the Leonardo da Vinci now in a well-known gallery. Since then I have frequently repeated the operation, and I don't know of one now existing under his name.'

Pictures thus falsified retain at least some of the qualities of originals, which may deceive such as are not conversant with art and are inexperienced in picture-buying; but of the innumerable absolute forgeries which are annually 'imported', as the Manchester Catalogue has it, from Italy, the greater number are so wretched in execution, so utterly contemptible as works of art, that it is matter of astonishment how any one, even the most ignorant and most deficient in taste, can be taken in by them. There is an episode in an Italian tour which is, perhaps, familiar to some of our readers. No sooner arrived in a frequented city than you are dragged by your valet-de-place into the studio of a picture-dealer. He has, of course, received due notice of the visit from the sharer of his profits, your guide, who has probably been able in his rounds with you through churches and palaces, to form a pretty accurate idea of your knowledge of art, and of the extent to which you may be safely imposed upon. In a corner of the studio you will probably observe a number of pictures with their faces to the wall; should you inquire

what they are, you will, if an Englishman, be told, with a con-
temptuous shrug of the shoulders, that they are 'roba Americana' –
rubbish for the American Market, a compliment being adroitly
insinuated that such things would not be shown to so able and
enlightened a connoisseur as yourself. You are, of course, ignorant
that the pictures about to be submitted to your judgement are known
in the trade as 'roba da milordo' – stuff fit for an English lord – the
general title of English picture-buyers, who must be supplied with a
somewhat better quality than our transatlantic cousins. After a
careful adjustment of lights and various mysterious evolutions,
Andrea del Sartos, Fra Bartolommeos, Guidos, and Guercinos are
placed before you in succession on the easel. If your taste inclines to
early Christian art, Giottos, Gaddis, Fra Angelicos, and Ghirlandajos
are ready for you. The expression of your countenance is watched
and your criticisms carefully listened to. After you have examined a
certain number of works by these inferior masters, the dealer, who is
also a restorer, proposes to show you two invaluable pictures, one
by Raphael, the other by Leonardo da Vinci, undoubted originals, so
judged by all the professors of the Academy; not his own property,
but sent to him by the owner, for whose ancestors they were
expressly painted, to be cleaned and slightly repaired; they are going
back tomorrow, and he is fortunate in being able to submit them,
before they leave him, to so illustrious a connoisseur as his
'Eccellenza'. A black box is carefully placed on the easel. It would,
perhaps, please his Excellency to examine the old Italian wood upon
which Raphael always painted. A key, carefully labelled, unlocks the
back of the case and displays a panel of a rich brown colour, well
worm-eaten, and thickly set with seals displaying cardinals' hats and
ducal coronets, all affixed at remote epochs to testify to the authen-
ticity of the picture, of which, after such evidence, no reasonable
man can entertain a doubt. The inspection of the back having been
deemed satisfactory, a pair of folding-doors, opened with due
solemnity, display a Madonna and Child of the brightest colours and
resplendent with the most brilliant varnish. You express surprise at
the extraordinary preservation of the picture. You are assured that it
has been untouched by the restorer's brush since the day Raphael
painted it; it had become a little dirty through age, and all he, the
dealer, had considered it right to do, in his extreme conscien-
tiousness, was to 'rinfrescarla un puoco' – to refresh it a little; he sees
you are taken with the work – the box and the back have made their
due impression – the Raphael is removed with an expression of
regret that one of such knowledge and taste as yourself cannot be its

possessor, and that it must remain in the hands of a family of 'ignoranti', who have no true feeling for such masterpieces. The Leonardo in a similar box goes through the same ceremony, and you leave the studio, forgetting Guidos and Guercinos.

The following day, as you are gazing with proper enthusiasm upon a masterpiece in a church or gallery, your valet de place observes casually that he is acquainted with the 'fattore', or steward, of the marquis, the fortunate possessor of the two wonderful pictures you saw yesterday, and that he is informed by his friend that the property of the family is to be divided amongst heirs, who, to avoid litigation, might be disposed to part with these treasures. The bait takes. Your guide offers to negotiate 'as a friend'. An incredible sum in scudis is asked. You are told that the 'pretensions' of the marquis are so ridiculous that it would be well not to think any more of the affair. But you think all the more of it. Negotiations ensue, such as can be alone carried on and understood in Italy. Twenty people appear who seem to have an interest in the matter, and are ready to advise and assist you. After squabbling, cajoling, losing your temper, and ordering your post-horses twenty times – the whole sum in dispute being at length probably reduced by about five shillings – you bear off your prizes in triumph, armed with an express permission from the dogana to export one Raphael and one Leonardo da Vinci, and provided with documents signed and sealed by illustrious families, and authenticated by well-known professors of the Academy, to prove their genuineness. It need scarcely be added that the only two real personages in the whole affair – from the original painter of the pictures to the drawer-up of the documents – have been the dealer and the valet de place, who divide the spoil.

The most successful modern forger of Raphael's pictures was one Micheli, a Florentine, who succeeded in deluding some of the best judges of art. One of his counterfeits, supported by forged documents pretending to come from a convent near Foligno, was, for some time, the object of much controversy in Italy, and was so skilfully executed as to deceive even Benvenuti, the well-known painter. Although the fraud was ultimately exposed, the picture is now, we believe, in the Imperial collection at St Petersburg as a genuine Raphael. It is said that he produced the peculiar cracked and crystallised surface of old pictures by painting on the roof of a house exposed to the hottest sun. There are living Italian artists who are scarcely less successful in the manufacturing of pictures pretending to be by Giotto and other painters of the very early schools. An

ancient 'tavola' or panel, upon which are some remains of painting, is procured; figures, traced from different authentic pictures by the master to be imitated, are brought together to make up a group, and the whole is then exposed to the heat of an oven. It requires close examination and considerable knowledge to detect the spurious from the genuine parts.

The tricks of picture-dealers would alone afford matter for an amusing and instructive article. We have been assured that even in Manchester ancient paintings are manufactured to a vast extent, and at an incredibly small price, for the American market. 'You have often spoken to me of your father's gallery at New York', said an English artist to an American traveller: 'of what masters, may I ask, has he specimens?' 'My father's gallery', was the reply, 'consists almost entirely of Raphaels and Leonardos, but he has a few Correggios!'

Before leaving this subject, we would say a few words upon the restoration of pictures, of which we have many mournful examples at Manchester. This process, together with what is called 'cleaning', has done more for the destruction of pictures than time or accidental injury. It has destroyed the fame of many great painters, or has given the world a false appreciation of their works. The extent to which it has been carried can only be known to those who have carefully studied the galleries of England and the Continent, and who are capable of forming an opinion upon the true condition of a picture. This work of destruction is not of recent date: it has been going on for generations, though perhaps it was never so active or so fatal in its results as during the last few years. The large fresco in the Palazzo Pubblico at S. Gimignano, painted, in 1317, by Lippo Memmi, was restored, as is recorded by an inscription still existing, by Benozzo Gozzoli in 1467. In this instance the restorer was a greater painter than Lippo; but still a century and a half had elapsed between them, and, the feeling for art being no longer the same, the real value of the original work was much diminished. Vasari mentions pictures which had been restored by himself, and many similar instances might be quoted. But at least, in those days restorers were painters, and the work of restoration was a labour of love – not, as in these days, a mere trade for converting old pictures into new.

The restorer by profession now reigns supreme in almost every gallery in Europe, and is the arbiter of the fate of the greatest masters. An English painter, well known for his intimate acquaintance with the Italian schools, especially those of Tuscany, endeavoured some years ago, in conjunction with several artists of

Florence, to check the destruction of works of art then going on in the principal galleries of that city. Meetings were held, and it was determined to draw up a petition to the Grand Duke, pointing out the irreparable injury that was then being inflicted on the magnificent collection of the Pitti Palace, and praying that the hand of the restorer might be stayed. However, before the document could be prepared, the conspirators received a peremptory order from the police not to meddle with 'affari di stato!' One more attempt was made, by appealing to the Grand Duchess, but in vain, and the gentleman to whom we have alluded declares that he has seen almost every picture in the Pitti and other public galleries of Florence repainted almost under his own eyes; that of the celebrated picture by Raphael – the 'Madonna della Seggiola' – the head of the Virgin alone has been spared; and that the only picture which ten years ago had escaped the hand of the restorer was the well-known Venus by Titian in the Tribune.

3.10 The West-End art dealer

A writer of lively prose; a friend of Manet and other Impressionists; a realist who did for English literature what the Goncourts had done for French, George Moore poured forth a constant stream of reviews and articles about art and literature. His very successful *Modern Painting*, published in 1898, consisted of articles which had appeared in *The Speaker*, and was dedicated to Whistler's baronet, Sir William Eden. In the course of it, he addressed himself to the role played by the West-End dealer in the art world of his time.

In the eighteenth century, and the centuries that preceded it, artists were visited by their patrons, who bought what the artist had to sell, and commissioned him to paint what he was pleased to paint. But in our time the artist is visited by a showily-dressed man, who comes into the studio whistling, his hat on the back of his head. This is the West-End dealer: he throws himself into an arm-chair, and if there is nothing on the easels that appeals to the uneducated eye, the dealer lectures the artist on his folly in not considering the exigencies of public taste. On public taste – that is to say, on the uneducated eye – the dealer is a very fine authority. His father was a dealer before him, and the son was brought up on prices, he lisped in prices, and was taught to reverence prices. He cannot see the pictures for prices, and he lies back, looking round distractedly, not listening to the timid, struggling artist who is foolishly venturing an explanation. Perhaps

the public might come to his style of painting if he were to persevere. The dealer stares at the ceiling, and his lips recall his last evening at the music-hall. If the public don't like it – why, they don't like it, and the sooner the artist comes round the better. That is what he has to say on the subject, and, if sneers and sarcasm succeed in bringing the artist round to popular painting, the dealer buys; and when he begins to feel sure that the uneducated eye really hungers for the new man, he speaks about getting up a boom in the newspapers.

The Press is in truth the great dupe; the unpaid jackal that goes into the highways and byways for the dealer! The stockbroker gets the Bouguereau, the Herkomer, the Alfred East, and the Dagnan-Bouveret that his soul sighs for; but the Press gets nothing except unreadable copy, and yet season after season the Press falls into the snare. It seems only necessary for a dealer to order an artist to frame the contents of his sketch-book, and to design an invitation card – 'Scenes on the Coast of Denmark', sketches made by Mr So-and-so during the months of June, July, and August – to secure half a column of a goodly number of London and provincial papers – to put it plainly, an advertisement that Reckitts or Pears or Beecham could not get for hundreds of pounds. One side of the invitation card is filled up with a specimen design, usually such a futile little thing as we might expect to find in a young lady's sketch-book: 'Copenhagen at Low Tide', 'Copenhagen at High Tide', 'View of the Cathedral from the Mouth of the River', 'The Hills of —— as seen from off the Coast'. And this topography every art critic will chronicle, and his chronicling will be printed free of charge amongst the leading columns of the paper. Nor is this the worst case. The request to notice a collection of paintings and drawings made by the late Mr So-and-so seems even more flagrant, for then there is no question of benefiting a young artist who stands in need of encouragement or recognition; the show is simply a dealer's exhibition of his ware. True, that the ware may be so rare and excellent that it becomes a matter of public interest; if so, the critic is bound to notice the show. But the ordinary show – a collection of works by a tenth-rate French artist – why should the Press advertise such wares gratis? The public goes to theatres and to flower-shows and to race-courses, but it does not go to these dealers' shows – the dealer's friends and acquaintances go on private view day, and for the rest of the season the shop is quieter than the tobacconist's next door.

For the last month every paper I took up contained glowing accounts of Messrs Tooth & MacLean's galleries (picture dealers do not keep shops – they keep galleries), glowing accounts of a large and extensive assortment of Dagnan-Bouveret, Bouguereau, Rosa

Bonheur: very nice things in their way, just such things as I would take Alderman Samuelson to see.

These notices, taken out in the form of legitimate advertisement, would run into hundreds of pounds; and I am quite at a loss to understand why the Press abandons so large a part of its revenue. For if the Press did not notice these exhibitions, the dealers would be forced into the advertising columns, and when a little notice was published of the ware – it would be done as a little return – as a little encouragement for advertising, on the same principle as ladies' papers publish visits to dressmakers. The present system of noticing Messrs Tooth's and not noticing Messrs Pears' is to me wholly illogical; and, to use the word which makes every British heart beat quicker – unbusinesslike. But with business I have nothing to do – my concern is with art; and if the noticing of dealers' shows were not inimical to art, I should not have a word to say against the practice. Messrs Tooth & MacLean trade in Salon and Academy pictures, so the notices the Press prints are the equivalent of a subvention granted by the Press for the protection of this form of art. If I were a statistician, it would interest me to turn over the files of the newspapers for the last fifty years and calculate how much Messrs Agnew have had out of the Press in the shape of free advertisement. And when we think what sort of art this vast sum of money went to support, we cease to wonder at the decline of public taste.

My quarrel is no more with Messrs Agnew than it is with Messrs Tooth & MacLean; my quarrel – I should say, my reprimand – is addressed to the Press – to the Press that foolishly, unwittingly, not knowing what it was doing, threw such power into the hands of the dealers that our exhibitions are now little more than the tributaries of the Bond Street shop. This statement will shock many; but let them think, and they will see it could not be otherwise. Messrs Agnew have thousands and thousands of pounds invested in the Academy – that is to say, in the works of Academicians. When they buy the work of any one outside of the Academy, they talk very naturally of their new man to their friends the Academicians, and the Academicians are anxious to please their best customer. It was in some such way that Mr Burne-Jones's election was decided. For Mr Burne-Jones was held in no Academic esteem. His early pictures had been refused at Burlington House, and he resolved never to send there again. For many years he remained firm in his determination. In the meantime the public showed unmistakable signs of accepting Mr Jones, whereupon Messrs Agnew also accepted Mr Jones. Mr Jones was popular; he was better than popular, he stood on the verge

of popularity; but there was nothing like making things safe – Jones's scruples would have to be overcome; he must exhibit once in the Academy. The Academicians would be satisfied with that. Mr Jones did exhibit in the Academy; he was elected on the strength of this one exhibit. He has never exhibited since. These are the facts: confute them who may, explain them who can.

It is true that the dealer cannot be got rid of – he is a vice inherent in our civilisation; but if the Press withdrew its subvention, his monopoly would be curtailed, and art would be recruited by new talent, at present submerged. Art would gradually withdraw from the bluster and boom of an arrogant commercialism, and would attain her olden dignity – that of a quiet handicraft. And in this great reformation only two classes would suffer – the art critics and the dealers. The newspaper proprietors would profit largely, and the readers of newspapers would profit still more largely, for they would no longer be bored by the publication of dealers' catalogues expanded with insignificant comment.

3.11 A faultless passion

Private View Day at the Royal Academy (at this time still sharing the premises of the National Gallery in Trafalgar Square) was usually on 1 May and in the columns of *London Society* in 1865 one 'W.R.' broke into verse on the subject.

Shines the sun in mid-day splendour,
O'er Trafalgar's crowded Square,
O'er the basins whence the slender
Crystal stream ascends the air,
From the stately fountains flinging,
O'er the paves, sheets of spray,
Through the carriages all bringing
Those who mark the first of May.

Come the reigning Queens of fashion
To the gala day of Art
(Pictures are a faultless passion)
Their impressions to impart

To each other of the season –
Weather, artists, newest drums –
Flirt, dictate and give no reason –
This as second nature comes.

Come the 'eligibles' stalking –
Coated all *á merveille* they –
Up the steps, as if the walking
Through the rooms this first of May,
Were a labour so gigantic,
that those whiskers waving long,
May become – the thought is frantic – Limp and straggled in
the throng.

Come the beauties in the glory
Of *the* toilettes of the spring –
Beauties such as in a story
(Fresh from Mudies)* glamour fling
Over ev'rybody – gliding
By the pictures, murmuring low,
Tant peu soit their faces hiding
By their reils as to and fro.

Smiling, criticising, teasing,
Statelily they sweep along,
While, too thickly to be pleasing
Follow all the whiskered throng;
And I pause as by me streaming
Pass a tide of summer friends;
Pause, and idly fall a-dreaming
On their varied aims and ends.

* A popular bookshop and circulating library.

4. Architectural alternatives

Stylistic pressures on architects

4.1 Anti-scrape

The passion for the past which informed so much Victorian thinking, the interest in the monuments of the Middle Ages, and the whole driving force of the Gothic revival were not always as admirable as they seemed. The activities of Scott and many others were destroying the essential nature of old buildings under the pretence of restoring them. There were several outbursts against this; in the 1830s when York Minster and Durham were at risk; in the 1840s and 1850s when Southwark, and St Albans were the victims of the restorer's 'art'. William Morris first became deeply concerned in the 1870s about the fate of Lichfield, Burford Parish Church and Tewkesbury, and was responsible for founding the Society for the Preservation of Ancient Buildings, popularly known as the Anti-scrape Society, in 1878. His constant vigilance on the subject is shown in this letter published in *The Daily News* (the *Guardian* of its time) on 20 November 1885.

Sir,

I have just read your too true article on the vulgarization of Oxford, and I wish to ask if it is too late to appeal to the mercy of the 'dons' to spare the few specimens of ancient town architecture which they have not yet had time to destroy, such, for example, as the little plaster houses in front of Trinity College or the beautiful houses left on the north side of Holywell Street. These are in their way as important as the more majestic buildings to which all the world makes pilgrimage. Oxford thirty years ago, when I first knew it, was full of these treasures; but Oxford 'culture', cynically contemptuous of the knowledge which it does not know, and steeped to the lips in the commercialism of the day, has made a clean sweep of most of them; but those that are left are of infinite value, and still give some character above that of Victoria Street or Bayswater to modern Oxford. Is it impossible, Sir, to make the authorities of Oxford, town and gown, see this, and stop the destruction? The present theory of the use to which Oxford should be put appears to

be that it should be used as a huge upper public school for fitting lads of the upper and middle class for their laborious future of living on other people's labour. For my part I do not think this a lofty conception of the function of a University; but if it be the only admissible one nowadays, it is at least clear that it does not need the history and art of our forefathers which Oxford still holds to develop it. London, Manchester, Birmingham, or perhaps a rising city of Australia would be a fitter place for the experiment, which it seems to me is too rough a one for Oxford. In sober truth, what speciality has Oxford if it is not the genius loci which our modern commercial dons are doing their best to destroy? One word on the subject of Dr Hornby and Eton. Is there no appeal against a brutality of which I dare not trust myself to write further? Is it impossible that the opinions of distinguished men of all kinds might move him? Surely a memorial might be got up which would express those opinions.

4.2 The Genesis of a Goth

Although prepared to work in the 'Italianate' idiom when the client demanded it, George Gilbert Scott was seen by his contemporaries as the supreme exponent of the Gothic style. When, at the age of sixty-eight, in 1879 he sat down to write his *Personal and Professional Recollections*, he attempted to analyse what had inclined him to this particular choice.

A great deal is said, too, as to the influence on the public taste of different publications, in leading to the appreciation and the revival of mediæval architecture, and it would be unfair to ignore such influence. I believe, however, that the effect was really of a reciprocal kind. The natural current of human thought had taken a turn towards our own ancient architecture, and this led to its investigation and illustration, while such investigation and illustration in their turn reacted upon the mental feelings which had originated them; so that, by a kind of alternate action, spread over a series of years, the mind of the public was both awakened to a feeling for the beauties of the style, and instructed in its principles. So far as I was personally concerned, my love of Gothic architecture was wholly independent of books relating to it; none of which, I may say, I had seen at the time when I took to visiting and sketching Gothic churches. The first prints I had met with bearing upon the subject (for I do not think that I read the article) were in the 'Encyclopedia Edinensis', where, under the head of 'Architecture', were two or

three engravings illustrative of our style; the west front of Rheims Cathedral, an internal view of Rosslyn Chapel, and a view of an Episcopal church at Edinburgh. The latter, by the bye, must have been a very early work (as it was about 1823 that I saw this print), and it was, I fancy, rather in advance of its day. After this I saw nothing tending in the same direction, beyond one volume of Lysons' 'Magna Britannia', till after I had left home to read with my uncle in 1826, and then what I saw was very slight, Storer's 'Cathedrals' being the choicest and dearest to my memory. It must have been very long afterwards that I first became acquainted with any of Britton's works.

So far, then, as my own consciousness goes, books had little to do with the earnest stirring up to a love of the subject which I experienced. I was unconsciously subjected to the same potent influence which was acting upon the public mind, and which was rather the cause than the effect of the publications which subsequently so much aided it.

Among the books which did most to aid the revival in these early days was Pugin's (sen.) 'Specimens of Gothic Architecture'. This, though it first appeared in 1821, came out in its present more perfect form in 1825. Its great utility was that it set people measuring details, instead of merely sketching, and its practical effect was to lead architects, who attempted to build Gothic churches, to give some little attention to detail. The specimens given were mostly of late date, but the spirit of the work, rather than its actual contents, was its great value, and the several volumes of 'Examples' which followed carried on the same feeling.

There can be no doubt that it was the share taken by the younger Pugin in these works, and what he saw of their preparation, which stirred up within him that burning sentiment which has produced such extraordinary results. I should be disposed also to attribute to the first of these publications a share in the merits of Mr Barry's Islington churches, which, with all their faults and their strange commissioners' ritualisms, were for this period wonderfully advanced works. They were going on while I was in my articles (1827–30), and I doubt whether anything so good was done (excepting by Pugin) for ten years later; indeed, in their own parish nothing so good has been done since. For myself, I can hardly say too much as to the benefit derived from Pugin's 'Specimens'. I found them at Mr Edmeston's when I was first articled to him, and they at once had the effect of leading me to the most careful measuring, and laying down with scrupulous accuracy, of the details of the works I sketched. Indeed, the greater part of my holidays was spent in making

such detailed measurements. All thanks and honour then to th
Pugin, however much our *illuminati* may sneer.

So far as I was personally concerned, nearly another decade had to
pass before my studies became pratically productive. I followed up
sketching with more or less assiduity according to circumstances,
but still with little thought of its becoming practically useful; I still
pursued it solely from the love of it. Once during this period, I, for
practice sake, entered into a competition, and chose my favourite
style. I have by me also two designs for gothic churches, which I
made with an idea of submitting them, as probationer's drawings, to
the Royal Academy. They have some merit, though showing most
extraordinary notions of ritual. I have already said that church archi-
tecture during this period had gone back. Barry's Islington churches
were princely compared with those of this dark decade; and my own
awakening attempts, from 1838 to 1841, were as bad or nearly so, as
the rest, pressed down as I was on the one hand by the intensity of
the 'cheap church' mania, and on the other by an utter want of
appreciation of what a church should be.

From this darkness the subject was suddenly opened out by Au-
gustus Welby Pugin, and the Cambridge Camden Society. From
that time on to 1844 was the great period of practical awakening, and
by the end of it the revival was going on with determined and rapid
success. By this time 'shams' had been pretty generally discarded by
all architects not hopelessly in the mire. The old system of solid and
genuine construction had generally been revived, and truth, reality,
and 'true principles' were accepted as the guiding stars of archi-
tecture; while a more correct ritualism had been, so far as the
opposition of party feeling permitted, to a considerable extent
adopted. Pugin's own works were, of course, limited (or nearly so)
to the Roman Catholic Church. Their clergy had sunk fully as low as
our own in their notions of ecclesiastical arrangement and design,
and he had much the same difficulties to contend with as we had. His
success was wonderful, for, though his actual architecture was
scarcely worthy of his genius, the result of his efforts in the revival of
'true principles', as well as in the recovery of all sorts of subsidiary
arts, glass painting, carving, sculpture, works in iron, brass, the
precious metals and jewellery, painted decoration, needlework,
bookbinding, woven fabrics, encaustic tiles, and every variety of
ornamental work, was truly amazing. Amongst Anglican architects,
Carpenter and Butterfield were the apostles of the high church
school – I, of the multitude.

4.3 **Beaten out of Gothic**

The battle of styles could bring problems to architects – and indeed their families. Discussing the vagaries of taste within his own lifetime, with especial reference to the Queen Anne style, which by the late 1870s was taking over as the ideal for domestic architecture, George Gilbert Scott recounted his own experiences in his *Personal and Professional Recollections* (1879).

The course which the revival was at one time taking was first disturbed by the Italian mania, arising from Mr Ruskin's writings; then by the French rage, coming in with the Lille Cathedral competition; and later on by the revulsion against this, which might have set things right again, had not many who had been most ardently French – so much so that no moderate man could hold his own for their gallomania – become as furiously anti-Gothic; and to carry out their new views turned round in favour of seventeenth-century work, and finally of 'Queen Anne'.

I have no right to expose this frivolity, for I was myself, in a measure, carried away with some of the earlier rages; and also because when beaten out of my Gothic by Lord Palmerston in the matter of the Government Offices, I felt compelled, in the interests of my family, to succumb, and to build them in classic, for which my early training had fairly fitted me. It did, however, seem hard that the very men who had once goaded me for not being Gothic or French enough, should be the very men to forsake Gothic (for secular buildings at least) at the moment when its success was the most promising. I had always resented my classic opponents calling our mediæval enthusiasm a mere 'fashion', but this change did really appear no better than a tailor's change in the cut of a coat, and the trifles which gave rise to it seem to be evinced by the strange vagaries in dress, &c., by which it was accompanied.

When, however, one considers the results, the case is not so bad. Though many buildings may be erected in the so-called 'Queen Anne' style, which would otherwise have been Gothic, the majority of such would, no doubt, have been erected in the vernacular style of the day, and so far the change has been an unquestionable gain: we have rich colour and lively, picturesque architecture in lieu of the dull monotony of the usual street architecture, and more than this the style is half-way between Gothic and classic in its effect, and goes all the way in its use of material.

The style of Queen Anne's time was really the domestic variety of the architecture of Sir Christopher Wren, and a very good style it really was; but the style now known by that name embraces all

varieties, from the close of the Elizabethan period to the middle of the eighteenth century, with a preference for that most resembling Elizabethan, so that it really brings in very much which is highly picturesque and artistic in character such as no 'Gothic man' would fail to appreciate.

Again, it has the advantage of eluding the popular objections to Gothic, when used for secular purposes. It meets the prejudices of the modern halfway, and turns the point of his weapons. When first taken up it was really more like the true Queen Anne, than it has since become: its use of common sash windows was one of its popular points, and the difficulties, assumed to be felt in accommodating Gothic windows to modern use, were urged as an argument in its favour. Once, however, in the saddle, the Queen Anne-ites soon threw off this disguise, and freely adopted lead lights, iron casements, and all kinds of old fashions which a Gothic architect would have hardly dared to employ, so much so, indeed, that a so-called 'Queen Anne' house is now more a revival of the past than a modern Gothic house.

In my book, written about 1859, my object was to show that Gothic would admit of any degree of modernism. The aim of the Queen Anne architects now seems to be to show that nothing can be too old-fashioned for their style.

I heartily wish them all success in this, and when they have succeeded, I trust we Goths may be allowed to pick up a few crumbs of their revived old fashions, and to use them in our style, without being taunted as the revivers of obsolete customs, or with making our houses look like churches.

4.4 The evils of modern housebuilding, 1872

A tendency to decry contemporary architecture is no invention of the late twentieth century, and to a generation brought up to believe in the solidity, the craftsmanship and the elegance of Victorian domestic architecture it may come as a surprise to read this diatribe launched by the eminently influential Charles L. Eastlake, whose *Hints on Household Taste* went into three editions within the year of its publication (1872).

Perhaps the most consistent phase of modern street architecture in London is that which has appeared in connection with the West-end clubs. Yet these, as a rule, are but copies, and, not unfrequently, vitiated copies, of actual buildings illustrating an exotic school of art

which had never a footing in England until our own had been lost or degraded. The so-called Italian style – now understood to include every variety of Renaissance design which prevailed in Rome, Venice, and Florence, from the sixteenth to the eighteenth century – has its æsthetic merits and its practical advantages. But they are merits and advantages which are unsuited to the age, to the climate, and to the country in which they are reproduced. It does not require the judgement of an accomplished connoisseur to perceive that mouldings and carved enrichments which look well under the glowing effect of a Venetian sky, must appear tame and spiritless through the leaden atmosphere of London. We want in England a less refined and more nervous expression of architectural beauty – bold and sturdy features, which will hold their own against wind and rain, and defy the smoke and traffic of our busy coal-burning towns. But it is not often that we can complain with any reason of undue refinement in our imitations of Italian architecture. Even those which are confessedly copied from old examples miss, either intentionally or through inaccurate workmanship, the delicacy of the original design. And, in too many instances, where our architects have ignored the value of precedent, and struck out in a new line for themselves, the result has been hopelessly clumsy or *bizarre*. It is only by a long and careful course of study, based on naturally good and inventive taste, that these mistakes can be avoided on the part of the designer. And it is only by the well-directed and long-sustained efforts of designers that the British public will ever be brought to distinguish good from bad in modern architecture. Ignorant amateurs of the art may be divided into two classes – those who have a smattering of book lore on the subject, and who think no building worth looking at which is not based on 'authority', or, in other words, which is not copied from some existing work; and those who have a morbid craving after novelty at the expense of every other consideration, including that invaluable standard of architectural fitness which is supplied by common sense.

It is to the first of these two classes that we are indebted for the encouragement and support of the pseudo-classicism with which, in the form of churches, clubs, and public institutions, London was deluged in the early part of this century. The tide of public favour has since turned in an opposite direction; and while all must admit the laudable zeal with which Pugin and his followers endeavoured to revive old English architecture in this country, it is lamentable to reflect how many monstrous designs have been perpetrated under the general name of Gothic, which have neither in spirit nor letter

realised the character of mediæval art. In London these extraordinary ebullitions of uneducated taste generally appear in the form of meeting-houses, music-halls, and similar places of popular resort. Showy in their general effect, and usually overloaded with meretricious ornament, they are likely enough to impose upon an uninformed judgement, which is incapable of discriminating between what Mr Ruskin has called the Lamp of Sacrifice – one of the glories of ancient art – and the lust of profusion which is the bane of modern design. These extravagances are not confined to a perversion of Gothic. Some of the 'Monster' hotels, railway stations, and other buildings of a type unknown to our forefathers, but now erected in London, are decorated after a fashion which is equally novel, and which has nothing but novelty to recommend it. But then most of these buildings are six or seven stories high, make up so many hundred beds, and are managed by a host who is so important a personage that we never see him at all! These facts, doubtless, enhance our respect for an establishment which, on a smaller scale, might be open to some criticism on the ground both of personal convenience and of artistic propriety.

Some attempts at architectural display are occasionally made in the way of shop-fronts. But here a certain practical difficulty attends the designer. However elegant the superstructure may be, it has one drawback; it must rest on nothing, or, at least, apparently on nothing; the aim of every modern retail dealer being to expose his goods for sale behind a single sheet of plate glass. In accordance with this object – for which no explanation can ever be given except that it is universal – iron columns are furtively introduced, and as carefully concealed by millinery, upholstery, or sometimes by craftily-contrived mirrors, so that when all is finished the upper portion of the building seems absolutely suspended in the air. Such conditions are not exactly fitted for ordinary treatment of design; yet the shop-front architect delights in ignoring them altogether, and in loading his upper stories with pediments, columns, niches, and cornices, just as if they stood on a basement as solid as that of the Pitti Palace. It seems astonishing that the old practice of turning a sound arch or placing a real lintel over every shop-window should have fallen into such disuse. Yet so seldom is this done, and so much does the objectionable practice of using iron columns and girders in such places prevail, that a block of newly re-built shops at the west-end of Oxford-street, on the Marquis of Westminster's estate, is quite conspicuous as an exception – and in this respect a creditable exception – to the general rule.

Of the dwelling-houses in London, those which have any pretension to architectural design are few in number, and lie chiefly in the neighbourhood of the parks or of the oldest West-end squares. But the ordinary residences of fashionable life – the mansions of Belgravia, Tyburnia, and Mayfair – are mere shells of brick and stucco, which present such a dreary appearance outside that one is surprised sometimes to find them palaces of comfort within.

The Frenchman who expressed his opinion that London had ceased to be a town, and was becoming a vast province, uttered no mere hyperbole. Between the years 1800 and 1860 this metropolis not only doubled, but trebled the size which it had assumed at the close of the last century. At the present time, including the suburbs, it occupies a superficial area of at least 130 square miles. On an average, about 1,000 houses are added to it every year; and so rapidly does building go on in every direction, that no one need be surprised to find the meadow-land which he walked on in spring laid out in populous streets by Christmas. There is, however, a great difference between the gradual development of the old city and the additions which we make to our modern capital. When Bloomsbury was still a fashionable district, its inhabitants no doubt regarded it as a permanent enlargement of London, and looked forward to the time when their children's children might own the tenements which they bought or rented. That is a source of prospective pleasure in which the inhabitants of Belgravia and Tyburnia cannot indulge. According to the present system of tenure adopted for house property, the rule is to build residences which are only intended to last a certain number of years. At the end of that term they fall into the possession of the landowner on whose estate they are erected, and thus it is to the interest of his tenant (who, in nine cases out of ten, is a speculating builder) not to spend more money on their construction than is absolutely necessary.

This is an unsatisfactory state of things even in a *prima facie* view of the matter. To calculate the stability of a house so nicely that at the expiration of, say, seventy years, it shall only be fit to be pulled down and sold for old materials, is a method of reckoning which obviously involves some discomforts, not to say danger, to its latest occupant. But, unfortunately, this is not the extent of the evil. In the earnest endeavour to avoid the expense of an unnecessary stability, these economists too frequently err on the side of weakness. To speak plainly, it will be a miracle if half the houses which are now being raised in and about London do not, in the ordinary course of things, tumble down long before their allotted time. Unfortunately,

their flimsy construction is not always apparent to an inexperienced eye. The old brick mansions of the early Georgian era, although unpretentious in appearance, were at least as strong as good burnt clay and duly mixed mortar could make them; the walls were of substantial thickness; the timber was dry, sound, and of ample dimensions; the foundations were well laid; the roof was of a convenient pitch and covered with the best of slates; the doors were securely hung, and a true lintel or a real arch, with properly tapering *voussoirs* (the elements of which an arch is composed), was turned over every window. The woodwork and fittings of these houses, though modelled in a pseudo-classic taste, were excellent in workmanship, and frequently spirited in detail; while the wrought iron introduced to decorate their façades in the shape of gates and area-railings is designed in thorough accordance with the nature and properties of the material employed. The truth is, that in those days, inferior or dishonest work would soon have been detected, for there was nothing to conceal it from public view. Plaster was of course used internally, as it had been during centuries past, for the sake of convenience and cleanliness; but no one had yet conceived the idea of coating the front of a brick house with a composition which should give it the appearance of masonry. In an evil hour *stucco* was invented; and thenceforth, wherever it was employed, good and bad work were reduced, in the eyes of the general public, to one common level. It mattered little whether brick or rubble, English or Flemish bond were used; whether the courses exceeded their proper height by a dangerous preponderance of mortar; whether the openings were really arched over or only spanned by a fictitious lintel. What signified such considerations as these when the whole front was to be enveloped in a fair and specious mask of cement?

How far this detestable practice has increased in London anyone familiar with the principal surburban squares and streets can well testify. But what the general public do *not* know is that the structural deceits which it conceals are daily becoming so numerous and flagrant that they positively endanger life and property. How frequently have we heard, during the last few years, of the fall of houses which have been built even within the recollection of the rising generation? The only wonder is that these casualties do not happen every day. Of course, when an accident has occurred, the district surveyor is called in as a responsible agent to give evidence before the authorities of the state in which the house was when he last examined it. But this examination is too frequently a mere matter of form. It is the surveyor's business to arrest and remedy any

gross violation of the Building Act. But in a populous and suburban district, where houses are being run up (as the phrase is) in all directions, it is impossible for him to be in all places at once, or attempt to keep up a constant supervision. Besides, in the matter of bricklaying, as in all other concerns of life, it is very easy to keep within the letter of the law and at the same time disregard its spirit.

The Building Act itself, though framed in such a manner as to exclude many picturesque features from a London street, is on the whole rather lenient on the subject of roof-scantlings and the dimensions of a party wall. An architect who should attempt to add to the effect of his elevation by a bay-window looking into the street or by overhanging eaves (even provided with a gutter) would find himself somewhat impeded by existing legislation. Yet a heavy 'compo' cornice, barely strong enough to support itself, is allowed to project a considerable distance from the front wall, daily threatening the lives of passers-by; and a miserable lintel, composed of fragments of brick, stuck together with mortar in the weakest possible form, is often used under the name of a 'flat arch'.

These are only a few of the legalised evils of modern house building. As for those which are forgotten, overlooked, or winked at, their number is legion. Not only is plaster or cement used as a covering for inferior brickwork, but it is boldly employed for columns, parapets, and verandah balusters in place of stone. It is not at all an uncommon thing to see a would-be Doric or Corinthian shaft truncated of its base, and actually hanging to the side of a house until the pedestal (which, of course, will also be of cement) is completed. Plaster brackets support plaster pediments: stucco bas-reliefs are raised upon a stucco ground. The whole front is a sham, from the basement story to the attics. But murder will out, and by degrees this prodigious imposition begins to reveal itself. A mouldy green dampness exudes from the hastily finished walls. The ill-fated stucco blisters up and peels off in all directions. Ugly fissures appear on the house-front caused by some 'settlement', arising from bad foundations. The wretched parodies on carved work become chipped away by accident, or crumble to fragments under the influence of the weather. There is an air of shabby gentility about the whole structure which would be ludicrous if it were not pitiable. It had only a meretricious excellence when fresh from the painter's hands. A few years have made it a dingy abode: a few more years will make it a ghastly ruin.

The interior arrangements are not a whit better. Floor-boards come up unexpectedly after separating from the skirting; doors

shrink so that they cannot be securely fastened; window-sashes warp and become immovable; marble chimney-pieces are gradually detached from the wall behind them. In short, the external disorder only foreshadows internal discomfort. Of course, when houses of this class are entrusted to efficient hands, under the management of an honest builder, the case is very different; but judging from the average condition of what are called second-class dwelling-houses, I believe that I have drawn no exaggerated picture of their state.

The shop-fronts of London indicate a still greater disregard of the first principles of construction. In former days, when the British tradesman's place of business and residence were under the same roof, a modest display of goods was deemed sufficient for the ground-floor, and nowise interfered with the stability of the super-structure: but at the present time, when each draper and silversmith wants to make a greater show than his neighbour, all semblance of strength is banished from the street level. Everything is given up to plate glass. Now plate glass is an excellent material in its way, but we cannot expect it to support three or four stories of solid brickwork. To meet this requirement, therefore, iron columns and iron girders are introduced, and, as artistic effect must yield to the stern necessities of commercial life, it would be idle to urge any but practical objections to the system. Such objections, however, are not wanting. The nature and properties of iron, although well studied by scientific engineers, are but imperfectly understood by the public. In addition to the chance of a flaw in the casting, or any of those more obvious contingencies to which stone and wood are also subject, one fact stands pre-eminently forward. Every schoolboy knows that iron expands with heat and contracts with cold. Let us suppose any large mansion in Belgravia, or a West-end draper's establishment, attacked by fire; iron has been profusely introduced in its construction, and is affected in the ordinary way; the engines arrive and distribute water over the premises. Can any one doubt what the result would be? The ironwork thus suddenly cooled must, of necessity, be liable to fracture; and if the whole building tumbles to the ground, it need be no matter of surprise to those who are acquainted with the secret of its structure.

It is quite time that these evils should be remedied by legislation. It would not be difficult to strengthen my argument by artistic considerations, but I am content to leave it in a practical form. It is unpleasant to live within ugly walls; it is still more unpleasant to live within unstable walls; but to be obliged to live in a tenement which is both unstable and ugly is disagreeable in a tenfold degree. An En-

glishman's house was formerly said to be his castle. But in the hands of the speculating builder and advertising tradesman, we may be grateful that it does not oftener become his tomb.

It is true that within the last few years attempts have here and there been made to invest our street architecture – so far as shops and warehouses are concerned – with more character and stability. And this is mainly owing to the revival of a style which, however modified by the influence of climate and national habits in the various countries where it prevailed, was everywhere distinguished by a uniform honesty of constructive purpose. The Gothic Renaissance may seem a paradoxical term to use, but in a literal sense it may be fairly applied to that Reformation in the style of national architecture, which is slowly but surely taking place in this country.

The art-historian who, in a future age, shall attempt to describe the various phases of taste through which English painting and architecture have passed during this century, will have no easy task before him. If the march of science has been rapid, it has also been steady, and marked by events and discoveries which will enable posterity to distinguish between true and false theory, real progress, and futile digression. But no such landmarks exist to indicate the several roads by which we have arrived, or hope to arrive, at æsthetic greatness in the reign of Queen Victoria. The ancient highways of art are no longer traversed. Our modern geniuses have struck out new paths for themselves, which here and there cross, indeed, the course of their predecessors, but rarely coincide with it. These are so diverse in their direction that they may be said to have formed a sort of labyrinth which by and by it will be difficult to survey.

4.5 A defence of the Albert Memorial

From the moment it was unveiled till the present day the Albert Memorial in Kensington Gardens has been a source of controversy. Today its reputation is probably higher than at any time since it was built. Criticism, however, was vigorous right from the start and in his *Personal and Professional Recollections* (1879) its creator, Sir George Gilbert Scott, defended it with vigour and occasional acrimony.

I think I had stated before this interval the preliminary circumstances of the Memorial to the Prince Consort. As, for example, that I had, for my own personal satisfaction and pleasure, at the time when a monolithic obelisk, 150 feet high, was thought of, endeavoured to render that idea consistent with that of a Christian monument. This I

effected by adding to its apex, as is believed to have been done by the Egyptians, a capping of metal, that capping assuming the form of a large and magnificent cross. The (so-called) 'Iona' cross is, in fact, the Christian version of the obelisk, and though the idea of a cross of metal on a colossal obelisk is different from this in type, it is not so in idea. The faces of the obelisk I proposed to cover with incised subjects illustrative of the life, pursuits, &c., of the Prince Consort. The obelisk was to have had a bold and massive base, at the angles of which were to be placed four granite lions, couchant, after the noble Egyptian model. The whole was to be raised on an elevated platform, approached by steps from all sides. I showed the drawing to the Queen, though not till after the idea of the obelisk had been finally abandoned.

I made my design for the actual memorial also *con amore*, and before I was invited to compete for it. Though I say *con amore*, in one sense it was the reverse, for I well remember how long and painful was the effort before I struck out an idea which satisfied my mind. Why this was so I know not, but such was the effort that it made me positively ill. My revilers will say that this ought to have been the result of my success, rather than of my previous failures; be this as it may, I remember vividly the contrary fact, and the sudden relief when, after a long series of failures, I hit upon what I thought the right idea.

I do not recollect that this was derived consciously from the ciboria which canopy the altars of the Roman Basilicas, although the form is the same, but it came to me rather in the abstract as the type best suited to the object, and proved then to be an old acquaintance appearing, for the first few moments, icognito.

Having struck out the idea, which, when once conceived, I carried out rapidly, the two next thoughts which occurred to me were, first, the sculptured podium illustrating the fine arts; and secondly, the realization in an actual edifice, of the architectural designs furnished by the metal-work shrines of the middle ages. Those exquisite productions of the goldsmith and the jeweller profess in nearly every instance to be models of architectural structures, yet no such structures exist, nor, so far as we know, ever did exist. Like the charming architectural visions of the older poets, they are only in their primary idea founded upon actual architecture, and owe all their more gorgeous clothing to the inspiration of another art. They are architecture as elaborated by the mind and the hand of the jeweller; an exquisite phantasy realised only to the small scale of a model.

My notion, whether good or bad, was for once to realise this jeweller's architecture in a structure of full size, and this has furnished the key-note of my design and of its execution.

The parts in which I had it in my power most literally to carry out this thought were naturally, the roof with its gables, and the flèche. These are almost an absolute translation to the full-size of the jeweller's small-scale model. It is true that the structure of the gables with their flanking pinnacles is of stone, but the filling in of the former is of enamel mosaic, the real-size counterpart of the cloissonné enamels of the shrines, while all the carved work of both is gilded, and is thus the counterpart of the chased silver-gilt foliage of shrine-work. All above this level being of metal, is literally identical, in all but scale, with its miniature prototypes. It is simply the same thing translated from the model into reality, having the same beaten metal-work, the same filagree, the same plaques of enamel, the same jewelling, the same figure-work in metal; and each with the very same mode of artistic treatment which we find in the shrines of the Three Kings at Cologne, of Our Lady at Aix-la-Chapelle, of St Elizabeth at Marburg, of St Taurin at Evreux, and in so many other well-known specimens of the ancient jeweller's craft. For the perfect carrying out of this idea I am indebted to the skill of Mr Skidmore, the only man living, as I believe, who was capable of effecting it, and who has worked out every species of ornament in the true spirit of the ancient models.

The carving has been equally well executed by Mr Brindley.

The shrine-like character I proposed to carry out in the more massive parts of the structure by means of the preciousness of the materials. In one respect I failed. The use of marble for the arches, cornices, &c., proved to be too costly, which led me to content myself with Portland stone. The rest, however, is all of polished granite or marble from the platform upwards, while below that level unpolished granite is used.

The sculptors, with three exceptions, were not nominated by me, but by the Queen, the exceptions being Mr Armstead and Mr Philip, who have executed the sculpture of the podium and the bronze figures at the angles; and Mr Redfern, who modelled the greater part of the figures in the flèche. I must say of the latter that the models were much superior to the execution in metal. Of the sculptors of the podium, Mr Philip had long been known to me, and Mr Armstead had come under my notice during the great Exhibition of 1862 through his beautiful figure-groups on the Outram shield, and his designs for historical subjects for Eatrington Hall, Warwickshire.

Being men of less established fame than the older sculptors, they undertook the work at a far lower price than these would have done, and, as it proved, to their own cost.

In my own opinion the result places them on quite as good an artistic footing as most of their more academic companions; indeed, I am mistaken if to Mr Armstead will not be eventually awarded the palm among them all, or at least an equal position with the best.

I think I ought to have exercised a stronger influence upon the sculptors than I have done. My courage rather failed me in claiming this, and I was content to express to them my general views both in writing and *viva voce*. I should mention, however, that before the work was commenced a large model of the entire monument had been prepared under my own direction. This was made by Mr Brindley, but the sculpture was by Mr Armstead.

The sculpture had been drawn out in a general way on the first elevations, partly by Mr Clayton and partly by my eldest son. From these general ideas Mr Armstead made small-size models for the architectural model, and imparted to the groups a highly artistic feeling.

Without derogating from the merits of the sculpture as eventually carried out, it is but just to say that I doubt whether either the central figure or a single group, as executed, is superior to the miniature models furnished by Mr Armstead. They remain to speak for themselves; while the two sides of the podium and the four bronze figures on the eastern front, which he designed, give a fair idea of what his models would have proved, if carried out to the real size.

I mention this in justice both to him and to myself, as his small models were the carrying out of my original intention, and have in idea been the foundation of the actual result.

The sculpture was placed under the special direction of Sir Charles Eastlake; after his death under that of Mr Layard; and finally under that of Mr Newton, so well known as the discoverer or recoverer of the Mausoleum at Halicarnassus.

The enamel subjects were not only designed, but drawn out in full-size coloured cartoons by Mr Clayton, and from these executed by Mr Salviati, at Venice.

The structural work has been admirably carried out by Mr Kelk, and his representative, Mr Cross.

I have been the more particular in my outline of this work at the present moment, because the memorial has just now (last week) been opened by the Queen, complete (in the main), with the exception of the central figure, which has been delayed, first, by the lamented

decease of Baron Marochetti; and, since then, by the long illness of Mr Foley, contracted while correcting his model in situ.

The Queen has been graciously pleased to award me on the occasion the honour of knighthood. Oh that she were with me who I confess to have so long and so earnestly wished might live to be the beloved sharer of this honour; now in her absence but a name!

I shall have, I believe, to bear the brunt of criticisms upon this work of a character peculiar, as I fancy, to this country. I mean criticism premeditated and predetermined wholly irrespective of the merits of the case. I need not enumerate in full the various strictures which have already been made. Most of them are groundless, some wholly untrue, some merely stupid, and most of them simply malicious. I will name, however, a few.

1. That the supports of the flèche are invisible, being concealed within the haunches of the vaults: a fault, however, if such it be, which it shares with all the great flèches of the middle ages.

2. That the angle piers do not appear strong enough for their work. This is, of course, a matter of feeling: to my eye they do look strong enough, and in some points, where they have been accidentally increased, they look too bulky. I will, however, say that they did look too slight in the original drawing, a defect which I was probably the first to perceive, and which I corrected with great care.

3. That much of the height of the flèche is lost. So is it in the case of every spire that ever was erected, as they are all of necessity much higher than they appear. I will only add upon this point that the greatest fault in the design, in my own opinion, is that the flèche is too high. I was rather driven to this by a particular influence, and I now regret it.

4. That the outline of the flèche is broken. This is due to the figure-sculpture, but it was never intended to have a purely pyramidal outline like that of a shrine.

5. That the podium being of white marble weakens the structural effect.

 This is in theory true, but the difficulty was deliberately faced, inasmuch as the sculptured podium is the very soul of the design, and is well worth a minor sacrifice. The high relief of the figures will, when the first glare has gone off, relieve this whiteness, while the vast counterforts of sculpture at the angles compensate for any loss of apparent strength, and the plain massiveness of the whole of the substructure tends to the same result.

6. That the great mass of steps takes off from the height of the superstructure.

This I wholly deny; its effect is the reverse.

This being my most prominent work, those who wish to traduce me will naturally select it for their attacks. I can only say that if this work is worthy of their contempt, I am myself equally deserving of it, for it is the result of my highest and most enthusiastic efforts. I will also congratulate our art, so industriously vilified by the same party, on this, that if the Prince Consort Memorial is worthy of contempt among the works of our age, it argues favourably of the present state of the art among whose productions this is selected for vituperation.

4.6 Improving a town house

Rapid changes in taste necessitated the adjustment of homes to new ideals of interior decoration. In 1881 the architect Robert W. Edis published *Decoration and Furniture of Town Houses*, which made accessible to the owners of outmoded town houses the latest ideas on refurbishment.

Hall and staircase

Let us suppose that the street door, which should be painted in some warm, serviceable colour, either chocolate or brown, and varnished for protection against the weather and to render it easily cleaned, is opened, and we are in the hall, the antechamber of the house.

Here the walls should be painted with some good colour – not too light to show finger marks – to two thirds of their height, with some simple pattern stencilled over the surface, and the whole carefully varnished. The upper portion should be divided by a plain wood moulding which can be formed into a narrow shelf on which to place light pieces of majolica, or *grés de Flandres* or other ware. Drawings or anything hung on the walls are generally in the way and are liable to blow about and destroy the paint and decoration. The space under the cornice might be distempered; for where gas is used, this portion is likely to get dirty and discoloured in a year.

As a rule the floors of halls of most town houses are of stone, and these form very good borders for bright Persian or Indian rugs. The door mat should be sunk flat with the floor, and of large size so that little or no dirt may be carried on to the rug.

In the ordinary hall there is not much room for furniture, but there is still space for one or two high-backed chairs of plain oak, or a long deal settle, and for a small stand for wet umbrellas. If possible there

should be a cupboard with shelves arranged for coats and a sliding rack for hats.

The staircase is usually a cold and dreary approach to the living room – often a long vault, walled in with blocks of imitation marble, with cast-iron balustrading of the worst possible design, thin, poor and unsafe. Of course all this must remain, but we can make them more cheerful and less cold and dull.

As a rule the lower floors are fairly well-lighted, and the walls therefore can be hung with drawings. If possible, put here and there a piece of china, or a good figure on brackets. A carefully designed lantern light, filled with leaded and jewelled glass, a bright drugget here and there on the landings and open spaces, Persian or Indian rugs, or prayer carpets. If the landing be large, put a comfortably low couch with some bright covering, and a stand for flowers or china.

Dining room

In the dining room everything in furniture should be as comfortable as possible, and designed for use, not show. The chairs should be broad-seated and backed and strong, not narrow, high-backed and spindle-legged with knobs and irregularities to torture the back. The seats and backs stuffed and covered with strong, serviceable leather or morocco in preference to velvet, which is liable to hold dust and to drag the lace of ladies' dresses.

The table should be made so that those who are placed at angles are not made to suffer torture and misery during the long hours of dinner by projecting legs which are always in the wrong place. I can conceive nothing more suitable for an ordinary room than a round table 4 feet 8 inches in diameter, the top made expanding into almost any length so as to form, when open, an elongated oval.

Instead of the ordinary side-board with its grotesque, spider-like legs, and carved pedestals, and utterly useless mass of looking-glass back, with hideous scrolled frame and top, I would suggest a plain, but solidly handsome buffet, arranged for the reception of plate and glass, or for good pieces of china, the lower portion fitted up with a cellarette and liquor tray within a panelled cupboard on one side and a useful cupboard on the other, a few drawers for plate and other necessaries for a dinner table, and between the cluster of shelves above, a small splayed mirror might be fixed.

Perhaps, for convenience of serving, the central portion might be

made into a sliding hatch communicating with the small back parlour, or breakfast room, or a light lift from the basement might easily be made to run up in the lower portion; on either side might be repoussé copper or brass sconces for candles.

As regards the floor, the practice of covering the whole with carpets answers to no purpose but to increase the upholsterer's bill and to keep up a dust trap which is not got rid of until the time of the annual spring or autumn cleaning. Paint or stain or varnish the floor two or three feet all round in some good, hard-wearing colour, and put the money this saved into some good Persian or Indian carpet, which while warm and comfortable to the feet is grateful and pleasant to the eye.

Drawing rooms

The drawing rooms should be the rooms of all others in which good taste, both in decoration and furniture should be everywhere apparent. The walls should be pleasant objects to look upon, not cold and dreary blanks of mere one-tinted paper, varied perhaps with birds or bunches of flowers in gold, scattered here and there in monotonous array.

The furniture should essentially be comfortable, couches and chairs to lounge and really rest upon, not so called artistic monstrosities on which it is impossible to do the one or the other. The rooms should above all, look and be home-like in all their arrangements, with ornaments, books and flowers, not arranged merely for show, but for pleasant study or recreation.

But I must protest against fluffy wool mats scattered about the tables, antimacassars of lace, worsted or other work hung loosely over the backs of chairs and sofas, velvet covered brackets, with useless fringe fixed on with brass-headed nails, on which too often are placed bits of Dresden, in the shape of dogs, cats or birds. By all means have coverings to protect the chair-backs, but let them be of some good embroidered stuff, or well-designed crewel-work, fixed securely to the chair or sofabacks, so as not to be liable to be carried off as pendants to the fringe of a lady's dress or the buttons of a gentleman's coat.

The general tone of the woodwork is black, the panels of the doors and shutters being covered with gold leaf as a ground for painted decoration of flowers or birds. The general wall-surface is covered

with Morris's pomegranate pattern paper of bluish grey ground, with extremely good decorative effect in colour of fruits and flowers. The wall space is divided about three feet below the cornice with a plain flat gilt moulding, under which is placed a simple ½ inch gas pipe, also gilt, as a picture rod. Above this the wall space or frieze has been lined all round with canvas pasted on to the plaster, and on this Mr Marks has painted a decorative frieze, consisting of figures, birds and foliage.

The cabinet shown is of mahogany, ebonized, free from all mouldings and carvings, and designed specially for china and books, with drawers for photographs and prints, and the panels filled in with painted heads representing the four seasons. The floor surface is painted dark brown, and the centre space covered with an Indian carpet. The ceiling is slightly toned in colour.

Bedrooms

A bedroom should be clear of everything that can collect or hold dust in any form: should be bright and cheerful, and pleasantly furnished with light and cheeful furniture of good and simple design.

If a room can be carefully decorated, curtains are much better away, on the grounds of health as well as of decoration. If you insist of having your room quite dark at night, have double blinds or shutters.

Even as it is undesirable to cover the whole of the floor with carpet, so it is equally undesirable to cover the whole walls with paper. As a matter of health it is better to have as little material as possible that will absorb and retain the often impure air of a bedroom; as a matter of light, it is desirable to have a portion of the wall in some light tone, even if the lower portion be papered in a somewhat dark shade.

Any pattern or design which shows prominently any set pattern or spots which suggest a sum of multiplication, or which, in the half-light of night or early morning, might be likely to fix themselves upon the tired brain, suggesting all kinds of weird forms are especially to be avoided. The wood work of the doors, windows and skirting should be painted in some plain colour to harmonise or contrast with the wall decoration. . . .

Naturally chests of drawers are required, but these should stand up well from the floor, so as to allow the space underneath to be thoroughly cleaned and dusted. The dressing-table should have nests of convenient drawers on either side, while cupboards may be

arranged on either side of the swinging glass for gloves or jewellery. Now that good painted tiles can be obtained at small expense, they may be used for washing stands with good effect, or the wall above may be lined entirely with them to a height of three or four feet. In the window, plain deal boxes, fitted as ottomans, with luxuriously stuffed seats and backs would themselves suggest rest and quiet.

Childrens' nurseries

In the dreariness of town houses, nothing has struck me as so utterly cruel as the additional dreariness which generally pervades the rooms especially devoted to children – the nurseries of the house, the rooms in which our little ones spend so large a portion of their early lives – and yet I know of no rooms which should be made more cheerful and beautiful in their general appearance than these.

While the furniture should be strong and useful, it need not be prison-like. The walls need not be covered with some monotonous imitation tile paper just because it wears better than another.

In the windows of the day nursery there should be boxes of flowers in which buttercups and daisies, primroses and daffodils might be cultivated, to teach the little ones of the country, and of the nursery rhymes and fairy tales they love so well.

Let the walls be papered with some pleasant paper, in which the colours shall be bright and cheerful; distemper the upper part of the room for health's sake, and varnish the paper, if you please. But nowadays when so many good illustrations are to be found in so many of our weekly and monthly publications, why not cut them out, or better still, let the little ones do so, and paper them over the whole of the lower portion of the walls? A band of colour might be made by buying some of the Christmas books which Mr H. S. Marks, RA, Miss Kate Greenaway and Mr Walter Crane have so charmingly and artistically illustrated, and by pasting the scenes in regular order and procession, as a kind of frieze under the upper band of distemper, varnished over to protect from dirt.

4.7 An astonishing and meaningless shape

The reaction against Palladian houses, and the general architectural principles of the second half of the eighteenth century was often vehement. In *The Magazine of Art* (August 1882) Grant Allen in an article on 'The Great Classical Fallacy' described what he saw as a typical example of this style in his fictional 'Charlecombe House'.

Charlecombe House – so let me call it, lest I jar too much on the feelings of its proprietor – Charlecombe House, upon whose Italian terrace I am standing, is one of the largest, barest, and most pretentious pseudo-classical mansions in all England. It was built in the darkest period of the eighteenth century, when the classical craze was at its highest pitch of frenzy, and when people fancied that poetry consisted in talking stilted nonsense about Cynthia's pallid ray, while art was popularly believed to be synonymous with the erection of bastard facades having three storeys, representing respectively the Doric, Ionic, and Corinthian orders. Charlecombe House itself is an exquisite illustration of the ideas of the period. Warburton thought it was in vastly elegant taste; Soame Jenyns considered it chastely beautiful; and even Horace Walpole found it not amiss as a Northern echo of the Florentine palaces. From the terrace here I can get a splendid view of the house and grounds, and can wonder silently, in our nineteenth century fashion, what on earth can ever have induced a human being, a hundred years or so since, to put together so much good stone and mortar in so utterly astonishing and meaningless a shape.

In the centre, a flight of tall steps leads up to a great white portico of Bath stone, supported by big false Corinthian pillars, and decorated by stucco mouldings. On either side, a long bare arcade separates the wings from the central building, and forms a sort of covered promenade, connecting the three isolated fragments of the house with one another. At the ends, the wings themselves stand up in gaunt solitude, with doors and windows of strangely tortured design and decoration, the obvious result of a fearful struggle on the part of the architect violently to twist the stereotyped forms of a Greek temple into some remote adaptation to the needs of an English dwelling-house. In front and below me, a line of terraces, each terminated by a white stone balustrade, leads down to the little valley and the artificial lake. Platform, arcade, and niches are all adorned with very classical statuary, in dubiously classical materials, varying from marble through oolitic freestone to plaster of Paris and other like abominations. An Apollo Belvedere stretches out his empty arm on a pedestal below the portico; a Discobolus endeavours to deliver his quoit into the centre of the artificial lake; and a Laocoon under a stucco canopy closes the vista into the dingle from the Palladian bridge. The broad steps, the great symmetrical doorway, the mere mass and volume of the pile, give it still a certain grandeur of its own, as of a real ideal unattained; but its coldness, its bareness, its total want of colour, life, spontaneity, astonish and depress one.

In an age when this was vastly elegant taste, it is hardly to be wondered at that Horace Walpole should have turned to the sham mediævalism of Strawberry Hill, or that Gray should have taken refuge in that remarkable printed wall-paper which was 'almost Gothic'. The house belongs to the same terrible style as, say, Prior Park at Bath, or the unspeakable High Street façade of Queen's College, Oxford.

There are certain points, however, about the classical craze of the eighteenth century which still require, it seems to me, to be more fully pointed out. It was, I believe, not merely a mistake, but a fallacy as well; not merely an artistic blunder, but a positive historical and archæological error also. Everybody now admits that classical art is not the only nor necessarily the highest form of art; that the exclusive admiration felt for it was one-sided and ridiculous; that the slavishness of eighteenth-century copyism, the total want of originality in all decorative matters, was destructive to æsthetic feeling; that the classical craze was a pure fad, and a fad with very disastrous artistic results. Everybody recognises, too, that classical architecture is not fitted to the needs of modern life; that classical decoration is not always fitted to our climate; and that attempts to adapt classical ornament to English scenery are apt to make both look decidedly ridiculous. But beyond all this, there remains the fact, seldom sufficiently dwelt upon, that the eighteenth-century notion of Greek and Roman art was itself essentially mistaken, false, and one-sided. The thing our fathers aimed at, the model set before their eyes, the idea they had in their mind as a standard, was not Greek or Roman at all. It was entirely founded on a wrong notion of antique art, a notion derived from a very incomplete knowledge of what antique art in its totality had really been. The coldness, stateliness, and severity which to most eighteenth-century minds seemed the essence of classicism, and which to the mass of men in our own time seem its essence still, has in reality nothing to do with Greek or Roman art at all, and is merely a false idea read into the remains of that art from a study of the very incomplete relics which existed at and shortly after the epoch of the Renaissance. The classicism of the last century was a travesty of the real classicism of Athens and of Rome, with many of its most distinctive characteristics left out. We may study the various aspects of the delusion in the illustrations we have collected of the pompous front of Queen's College, of the frigid, meaningless spire of St John's, Bermondsey, and the poor circlet of the Burns monument at Edinburgh. But the Greece and Italy unfolded by modern archæology are something wholly

different from this, and something different not merely in detail, but altogether alien in kind.

White marble, bare stone, cold and naked walls, severe austerity, these are the types and symbols of classical art as most ordinary thinkers imagine it. No meretricious colouring, no gilding, no drapery, no upholstery; very little decoration, very few accessories; everything correctly simple with a Spartan simplicity; white togas and chitons, funereal Etruscan black-and-red vases, chilly marble statues, scanty tripods, hardly any furniture, and a good deal of bare floor with a profusion of Greek key-pattern or honeysuckle design; – that is about the ordinary modern English notion of an Athenian or Roman house. And the restoration of a Pompeian villa at the Crystal Palace, excellent as it is in most of its technical detail, has probably done a great deal to perpetuate this very partial and one-sided idea.

5. Virtuous design

Design and ornament take on a new complexion

5.1 Beauty, morality and design

The interplay between ideas of morality, of beauty, of functionalism was infinitely complex, and assumed many guises. The influential Christopher Dresser introduced his *Principles of Decorative Design* (1873) with the following general reflexions, which typify much contemporary thinking on these subjects.

There are many handicrafts in which a true knowledge of the true principles of ornamentation is almost essential to success, and there are few in which a knowledge of decorative laws cannot be utilised. The man who can form a bowl or a vase well is an artist, and so is the man who can make a beautiful chair or table. These are truths; but the converse of these facts is also true; for if a man be not an artist he cannot form an elegant bowl, nor make a beautiful chair.

At the very outset we must recognise the fact that the beautiful has a commercial or money value. We may even say that art can lend to an object a value greater than that of the material of which it consists, even when the object be formed of precious matter, as of rare marbles, scarce woods or silver or gold.

This being the case, it follows that the workman who can endow his productions with those qualities or beauties which give value to his works, must be more useful to his employer than the man who produces such objects devoid of such beauty, and his time must be of higher value than that of his less skilful companion. If a man who has been born and brought up as 'a son of toil', has that laudable ambition which causes him to seek to rise above his fellows by fairly becoming their superior, I would say to him that I know no means of his so readily doing as by acquainting himself with the laws of beauty, and studying till he learns to perceive the difference between the beautiful and the ugly, the graceful and the deformed, the refined and the coarse. To perceive delicate beauties is not by any means an easy task to those who have not devoted themselves to the study of the beautiful for a long period of time, and of this be assured, that

what now appears to you to be beautiful, you may shortly regard as less so, and what now fails to attract you, may ultimately become charming in your eyes. In your study of the beautiful, do not be led away by the judgement of ignorant persons who may suppose themselves possessed of good taste. It is common to assume that women have better taste than men, and some women seem to consider themselves the possessors of even authoritative taste, from which there can be no appeal. They may be right, only we must be pardoned for not accepting such authority, for should there be an overestimation of the accuracy of this good taste, serious loss of progress in art-judgement might result.

It may be taken as an invariable truth that knowledge, and knowledge alone can enable us to form an accurate judgement respecting the beauty or lack of beauty of an object, and he who has the greater knowlege of art can judge best of the ornamental qualities of an object. He who would judge rightly of art-works must have knowledge. Let him who would judge of beauty apply himself, then to earnest study, for thereby he shall have wisdom, and by his wise reasonings he will be led to perceive beauty, and thus have opened to him a new source of pleasure.

Art-knowledge is of value to the individual and to the country at large. To the individual it is riches and wealth, and to the nation it saves impoverishment. Take, for example, clay as a natural material; in the hands of one man this material becomes flower-pots, worth eighteen pence 'a cast' (a number varying from sixty to twelve according to size); in the hands of another it becomes a tazza or a vase worth five pounds, or perhaps fifty. It is the art which gives the value, and not the material. To the nation it saves impoverishment.

A wise policy induces a country to draw to itself all the wealth that it can without parting with more of its natural material than is absolutely necessary. If for every pound of clay that a country parts with, it can draw to itself that amount of gold that we value at five pounds sterling, it is obviously better to part with but little material, and yet secure wealth, than it is to part with the material at a low rate either in its native condition, or worked into coarse vessels, thereby rendering a great impoverishment of the native resources of the country necessary in order to its wealth.

Men of the lowest intelligence can dig clay, iron or copper, or quarry stone, but these materials, if bearing the impress of mind are ennobled and rendered valuable, and the more strongly the material is marked with this ennobling impress, the more valuable it becomes.

I must qualify my last statement for there are possible cases in which the impress of mind may degrade rather than exalt, and take from rather than enhance the value of a material. To ennoble a mind must be noble; if debased, it can only debase. Let the mind be refined and pure, and the more fully it impresses itself upon a material become, for thereby it has received the impress of refinement and purity; but if the mind be debased and impure, the more does the matter to which it is transferred become degraded. Let me have a simple mass of clay as a candle-holder rather than the earthen candlestick which only presents such a form as is the natural out-going of a degraded mind.

There is another reason why the material of which beautiful objects are formed should be of little intrinsic value besides that arising out of a consideration of the exhaustion of the country, and this will lead us to see that it is desirable in all cases to form beautiful objects as far as possible of an inexpensive material. Clay, wood, iron, stone are materials which may be fashioned into beautiful forms, but beware of silver, and of gold, and of precious stones. The most fragile material often endures for a long period of time, while the almost incorrosible silver and gold rarely escape the hand of the destroyer. 'Beautiful though gold and silver are, and worthy, even though they were the commonest of things, to be fashioned into the most exquisite devices, their money value makes them a perilous material for works of art. How many of the choicest relics of antiquity are lost to us because they tempted the thief to steal them, and then to hide his theft by melting them. How many unique designs in gold and silver have the vicissitudes of war reduced in fierce haste into money-lenders' nuggets? Where are Benvenuto Cellini's vases, Lorenzo Ghiberti's cups, or the silver lamps of Ghirlandaio? Gone almost as completely as Aaron's golden pot of manna, of which for another reason than that which kept St Paul silent 'we cannot now speak particular'. Nor is this only because it is a world 'where thieves break through and steal that the fine gold becomes dim, and the silver perishes.' This too is a world 'where love is as strong as death', and what has not love – love of family, love of brother, love of child, love of lover – prompted man and woman to do with the costliest things, when they could be exchanged as mere bullion for the lives of those who were beloved?'[1] Workmen, it is fortunate for us that the best vehicles for art are the least costly materials.

1. From a lecture by the late Professor George Wilson of Edinburgh University.

5.2 **Machinery not evil**

Although the consensus of 'informed' opinion had, by the latter
decades of the century, come down firmly against machine-made
objects in favour of the 'crafted,' there were those who were not
entirely convinced, and felt that sooner or later art and the machine
would have to come to terms with each other. Typical of these was
Lewis Foreman Day, who in the pages of *The Art Journal* for 1885
expressed a view which was becoming more popular.

There are two opinions upon the subject of machine-made art. The
more modern, that is to say the more scientific, school of thinkers,
are disposed to look upon machinery as the key to everything
hopeful in the future. Artists on the other hand are apt to complain
that it is a veritable Juggernaut, under whose wheels the Arts must
be crushed out of existence.

To reconcile these adverse schools of thought is perhaps imposs-
ible; both have such sufficient grounds for the faith that is in them.
But there is a standpoint between the two, in the belief namely, that
is is the abuse of the mechanical which has made artists sceptical, and
more than sceptical as to its use in Art.

There is some truth in the uncompromising assertion of artists that
the machine has done nothing for them, that there is no room in the
world for any such hybrid thing as machine-made Art; but, like
many another uncompromising assertion, it goes beyond the truth.
That the great mass of existing manufactured ornament is intolerable
need not be denied. But it is not all bad, any more than all hand-
work is good. Still less is there any inherent reason why a work of
Art, because it owes something to machinery, should be false in
taste, or unsatisfactory in effect.

The ease with which considerable enrichment such as it is, can be
cheaply produced taken in conjunction with the actual artistic superi-
ority of hand-work has led to the association of mechanical pro-
duction with cheapness, and to a corresponding nastiness. The
cheapness too of machine-work has led to its abuse. So long as
ornament represented actual labour, that was the surest guarantee of
some moderation in its use. Machinery opens the flood gates of
extravagance, and we are deluged with cheap abominations. The
deepest wrong that machinery has done to Art, is that it has made
ornament, or what is meant for ornament, so easy to get that
uncultivated persons will not be restrained from using it; and the
great majority, even of the so-called cultivated classes, happen to be
quite uncultivated in Art.

The human appettite is at all times quite keen enough for

ornament, of any kind, but the surfeit of coarse food provided by the machine sickens all who have any artistic stomach. The need is for less ornament instead of more, greater simplicity in what we do indulge in, and greater discrimination as to where we use it. The tendency of machinery is dead against this much-to-be-desired reform. So far then the machine is opposed to Art, and Art to it.

A wiser application of the machine to the purposes of the lesser arts might enable us to dispense with the intermediate 'hand' who nullifies in execution whatever of Art there may have been in the original drawing. As decorative art now stands, and seems likely to stand, the interpretation of the artist's design must be left to one of lower grade. Who that has suffered from such interpretation would not rather trust to the accuracy of the machine than the inaccuracy of the human hand? Wherever the artist's work is not autographic, he has in some degree to brutalise his design, in order that the mechanic who executes it may not brutalise it still further. He must, that is to say, deliberately make his lines harder than need be, were it not that his interpreter would otherwise be likely to go hopelessly astray, and harden them in a manner far removed from what he himself would have done. In adapting his design to mechanical reproduction he would doubtless have to be more mechanical in his execution, but not more so than would be necessary if he wished to ensure anything like accurate reproduction by the hand of another. And he would have this certainty, that, if his design were only fit, the machine would do its work with unerring accuracy. Such submission to mechanical needs may be a kind of self-murder, but one might well prefer to commit this sort of suicide at once rather than to allow oneself to be tortured to death by even the most well-intentioned burglar.

In talking about machinery, we must not leave out of account its effect upon the workman, and so, through him, upon the work he does. It is quite true, as Mr Ruskin has pointed out, that the work which gave no pleasure to the workman in the doing is not likely to afford us much pleasure either. And it would seem therefore as if mechanical work must be altogether devoid of interest, alike to him who contemplates, and to him who executes it. But this is not quite so; men of artistic temperament assume too readily that work ceases to be interesting in proportion as it is mechanical. Were they to enquire more curiously into their own feelings, they would probably find that they themselves had more enjoyment than they thought from work of a purely mechanical kind. Indeed, the alternation of mechanical with more artistic work is essential to the well-being of

the artist. The one kind of work is a relief from the other. He can no more be perpetually working his brain or pumping his emotions than he can keep up perpetual motion with his limbs.

It may not be easy for us to understand or enter into the feelings of the artisan, who is happiest when he has before him the repetition of a single form over and over again, who rejoices when it mounts to dozens of times, and is overjoyed when it reaches hundreds. Yet the prospect which nauseates us is actually soothing to him. This class of workman does exist and exists largely. His kind are more in number than the artists. We overlook this when we talk of mechanical art as degrading to the workman. The world was not made for artists only, and the artisan would, as often as not, prefer to work on the mechanical art for which he is fitted, rather than be spurred on to efforts as much out of his reach as they are beyond his ambition.

The great use of machinery of course is for the purpose of repetition. The question then occurs, to what extent is repetition desirable? Mere cheapness is not the inestimable boon it is supposed to be. It is a good thing that comfort and a measure of refinement in common things should be brought within the reach of many – and the more into whose reach they are brought the better; ornamentation of things does not add to the comfort, and certainly not to the refinement of those who are placed above want. How much more comfortable, how infinitely more refined some of our drawing-rooms would be if ornament and ornaments were only dear enough to be more scarce!

If Art cannot be reproduced by machinery, then let us have nothing to do with the machine. But it is has been abundantly proved that works of Art may be woven, printed, cast and otherwise mechanically reproduced. The *further* possibilities of the machine remain to be tested. So far as it is concerned, machinery has never been fairly tried. Machines are resorted to in order to avoid expense, and accordingly the consideration of cost determines everything in connexion with them. One cannot compare work done under such conditions with the spontaneous work of an artist done without a single thought of whether it will pay or not, or with a far-seeing faith in the ultimate success of the best and only the best. Compare machine-work with hand-work starved down to a price, and the odds are not all in favour of the handworker. The manufacturer's real chance of success lies in showing not only what the machine can do, but what it can do best, better than the craftsman who would compete with it. If capable capitalists were to be found, with sufficient knowledge alike of mechanics and Art, and belief enough

in the machine to back it at all risks, then and only then would there
be a chance of seeing what it could do, and of estimating the value of
machinery as applied to the production of works of Art. The practi-
cal and pecuniary value of machinery is obvious. The assertion that it
can have no practical value remains to be proved.

5.3 The need for self-confidence

Despite the apparent excesses of the cultivators of 'good taste' there
remained a strong, John-Bullish current of stylistic democracy, a
feeling that 'doing your own thing' was best, and that sincerity in
these matters was more important than discrimination. This was
vigorously expressed by an anonymous follower of William Morris
in the pages of *The Magazine of Art* in 1878.

Let us consider the art which people use for their own homes.

Let us fortify ourselves, and prepare for a grim and horrible sight;
let us enter the drawing-room of a fashionable lady. We need not
enumerate the whole catalogue of abominations, the appalling white
walls with the thin gold line, the fearful red silk curtains, the jingling
chandelier, the ceiling either bare with ghastly bareness, or uglified
by grinning cupids, the cornice resembling precisely the top of a
birthday cake; these are but a few of those things most of us know so
well and hate so much. Why are they there? The owners themselves
do not think them pretty; some of the things – the highly-elaborated
cornice, for instance – they have hardly ever noticed. They have
understood that decoration was necessary – was required by society,
so they bade a man decorate for them. But the real purpose of
decorating one's room is not to make it like other rooms, it is to
make it as much as possible express one's own self, and to make it for
oneself as habitable as possible. Go into the box of a pointsman at a
railway station, you will find it covered inside with bits of pictures
from the *Illustrated London News*, *The Graphic*, or any other illus-
trated journal that comes to hand. The pointsman has decorated his
little den because he feels it will be the more comfortable for him to
live in when the walls are not bare and black. No one has advised
him to put this scrap there, or the other elsewhere; he has done it as
he thought best – as it best pleased him. That pointsman is nearer a
knowledge of what art is than the lord to whom, as has been most
happily said, the silk curtains in his drawing-room are no more art
than is the powder in his footman's hair.

If you are wise you will imitate the pointsman, and make your

room habitable for yourself. As to glitter, if you are as the Orientals, and like glitter, cover your room with mirrors and bits of gleaming metal, but if you have no real love for bright things by all means avoid them. Don't put a large silver waiter on your sideboard simply to show that you have some perfectly tasteless rich relation, who was stupid enough to give you such a hideous present when you took unto yourself a wife. If you like white walls have white walls, although your neighbours prefer blue walls, and if you like dark walls don't be afraid of having them, because you hear that a drawing-room should be furnished in the French style. Be selfish, be thoroughly selfish in the matter of decoration – be as selfish in your choice of pictures. See as many as you can of what you are told are the best, and that will possibly train you to like something which is good. Perhaps it will be of the Botticelli type; much more probably of the Greuze order – no matter. When you buy pictures, big or little, engravings of photographs, or even, if you like such strange things, oleographs, or what not, buy only what you like. Choose your picture, not because you hear it is a good thing of its kind, not because it is cheap, and not because it is dear – and this is the reason for which pictures are bought by the thousand at the present day – but because it gives you real pleasure, because you think it is the sort of face, group, or landscape, you would like to see continually, that would give you always a sense of relief from the necessary uglinesses everyone has to see, a sense of repose, a sense of hope.

5.4 A year in a provincial school of design

The first annual meeting of the patrons, donors and subscribers who were responsible for the Worcester Government School of Design was held on 3 November 1852, and its report, with its admixture of subservience to the chairman, Lord Ward, brother of the Earl of Dudley, its heavy paternalism and its admirable enthusiasm presents a very good picture of the functioning of this type of school. The number of students for a town of that size is unexpectedly high, though this may be partly due to the presence of the famous porcelain factory there.

In presenting their report, your committee cannot refrain, in the first place, from acknowledging that the formation of the school was mainly owing to the encouragement it received from its noble President, who now occupies the chair; nor can they be too thankful for

the patronage and liberality which his Lordship continues to extend to it, not only by presiding this day, but that in addition to his liberal annual subscription of £25 he has given £10 to be distributed in prizes to those students who have made the most successful progress in their respective departments of Art, whose names will shortly be announced; and still further for his Lordship's kindness in allowing a selection to be made of several of the choicest paintings from his valuable collection in the metropolis, called 'the Dudley Gallery', and which he has permitted to be exhibited at the school for the improvement of the students, and the gratification of the public, to be hereafter admitted at stated hours.

His Lordship having thus at the outset excited the sympathics and roused the exertions of the public in and around our City to assist in raising those funds which were necessary to authorise the committee to call upon the Government to contribute its proffered aid in establishing the school, they lost no time in making the requisite application, which was promptly responded to, and they obtained a grant of £150 a year for the Master's salary, as well as the appointment of an efficient one to conduct the school, of whose character and qualifications your committee will hereafter speak. The Government also made its then usual liberal grant of a valuable collection of those casts of statues, busts, friezes, and antique ornaments which now adorn the schools; and they are further indebted to it for compliance with your committee's application for a collection of books upon the Fine Arts, which was speedily sent, consisting of such volumes as are seldom to be found in the generality of public and private libraries.

The provincial schools were originally under the control and direction of the masters and other officers of the London school. Under the system at present adopted, all the Schools of Design in the provinces, as well as that in the metropolis, are placed under a central authority established at Marlborough House, entitled 'The Department of Practical Art', forming a component part of the Board of Trade.

Mr Redgrave, the Superintendent, in the Department of Art at Marlborough House, has recently made a passing visit to our school and expressed his entire approbation of the general arrangements. The progress of the students in their several departments cannot show more satisfactory proofs than the following:

By desire of the Board of Trade, a selection was made by the Master from the works executed by the students and sent to the 'Department of Practical Art' at Marlborough House, in April last,

for inspection and exhibition, for which six medals were awarded. This was a greater number made to the Worcester School in the first six months of its establishment than was awarded to several other schools of some years standing. This must be highly gratifying to the subscribers.

The number of general students entered on the books, who have attended the School during the past year, is 254. The largest number who have attended in any one month is 167. The average monthly attendance during the year has been 152. Among them is a class which requires especial notice, as it has been objected that it is one which ought not to avail itself of the benefits of this school, which should rather be confined to the sole instruction of artisans and mechanics. Your committee, in reply, would observe that this class consists of many highly-respectable individuals, male and female, by whom drawing and painting are studied by way of accomplishment and pleasure, as well as for instruction. It is by the fees they pay the Institution derives much of its support, and enables the committee to give more encouragement to the other classes, and bring its advantages more within their reach than it would be in their power to do otherwise without it, and that it is impossible to foresee the future benefit these individuals may derive therefrom in the accidents to which humanity is the heir. There is a higher and more solid reason why different classes should participate in the benefits of instruction held out in Schools of Design. Both in commerce and art, employers, purchasers, and the general public must be trained to appreciate taste, so that the demand may exist before the supply can be called into full activity. The training schools should not merely produce better designers, better painters, better sculptors, but they must introduce a better taste and more liberal spirit among the community at large.

It is gratifying also to find from the Report of the Master, Mr Kyd, that all the students who have attended during the past year have conducted themselves with the strictest propriety, and shown great desire to receive the instruction afforded them; the application and anxiety of many of them to acquire proficiency, he reports, have been most exemplary, and, to use the Master's own words, 'he trusts that whatever reward they now receive for their labours, a greater awaits them, if with perseverance they continue the course of study which they have so well begun'.

And this leads your committee to speak of Mr Kyd, the Master of the school, in those terms of commendation which he so well de-serves. One more fitted for his situation could not have been selected.

In addition to a general knowledge of the principles of Art, he possesses a suavity of maner in his mode of instruction which, at the same time that it engages the attention of the students, unites them to him as their friend and companion.

It appears from the treasurers' account that the receipts for the year have been – donations, £258; subscriptions, £175 13s. 6d.; students' fees, £148 3s.; total, £581 16s. 6d. A great part of this sum has been expended in the necessary fitting up of the school, and in rent and incidentals, and after funding £150 in the names of Rev. J. Pearson, Messrs J. W. Isaac and Henry Aldrich, there is left a balance of £33 13s. 7d. in the hands of the Treasurers. The committee thought it right to make no larger apportionment than their funds would allow for prizes among the students, in addition to the £10 so liberally contributed by the noble President. That so many donations will again be made your committee cannot expect; but we have the pleasure to announce that John and William Dent, Esqrs, have kindly contributed a second donation to the same amount as they gave at the establishment of the Institution, which will be added to £150 already funded to enable the committee to carry out their intention of founding a Museum of Arts in connection with the School of Design; and we trust that other gentlemen liberally disposed will follow their example, and upon a continuance of the yearly subscriptions, to enable the students to arrive at that degree of excellence in their several departments, which will fulfil the objects of the Institution, your committee confidently rely. Many of them have already reached that stage which demands from the Master more time and attention than when he is engaged in mere elementary instruction; and it is the duty of the committee to state that the number of students who attend in the evenings, and to whom the Master is principally engaged in giving elementary instruction, is becoming greater than he can attend to without neglecting the more advanced and superior branches, there being among them a large proportion of elementary pupils. It will become necessary, therefore, that an Assistant Master should be obtained, whose salary it may be found necessary should be paid out of the annual subscriptions. Seeing, therefore, that the benefits to be derived from the instruction in the school have not yet been fully developed, your committee are sanguine in their expectations of an increase in their subscriptions instead of any diminution.

5.5 **Problems of mass-produced furniture**

It was only gradually that people were weaned away from the concept of individually designed furniture, and made to realise the changes which mass-produced furniture were producing in matters of taste. One of the first to face up to the realities of the situation was Charles L. Eastlake in his *Hints on Household Taste*, 1872.

Meanwhile there will be a large majority of the public who cannot afford to have furniture made expressly for them, but who are obliged to buy whatever articles may be 'in fashion' at the shops. Now there are degrees of excellence in all things, and as it is just possible some of these articles may be less objectionable than the rest, I venture to offer a few hints which may guide the inexperienced purchaser in choosing.

In the first place, never attach the least importance to any recommendation which the shopman may make on the score of taste. If he says that one form of chair is *stronger* than another form, or that the covering of one sofa will wear better than that which is used for another, you may believe him, because on that point he can judge, and it is to his interest that you should be correctly informed so far. But on the subject of taste his opinion is not likely to be worth more, but rather less, than that of his customers, for the plain reason that the nature of his occupation can have left him little time to form a taste at all. He neither made the furniture in his shop nor superintended its design. His business is simply to sell it, and it will generally be found that his notions of beauty are kept subservient to this object. In other words, he will praise each article in turn, exactly as he considers your attention is attracted to it with a view to purchase. If he has any guiding principles of selection, they are chiefly based on two considerations – viz. the relative price of his goods, and the social position or wealth of those customers in whose eyes they find favour.

The public are frequently misled by terms of approbation now commonly used by shopmen in a sense widely remote from their original significance. Thus, the word 'handsome' has come to mean something which is generally showy, often ponderous, and almost always encumbered with superfluous ornament; the word 'elegant' is applied to any object which is curved in form (no matter in what direction, or with what effect). If it succeeds in conveying a false idea of its purpose, and possesses the additional advantage of being unlike anything that we have ever seen before, it is not only 'elegant' but 'unique'. If an article is of simple and good design, answering its

purpose without ostentatious display of ornament, and pretending to be neither more nor less than it is, they only call it 'neat' in the shops. I will not go so far as to recommend every 'neat' article of household use which may be displayed for sale, but I strongly advise my readers to refrain from buying any article of art-manufacture which is 'handsome', 'elegant', or 'unique', in commercial slang: it is sure to be bad art.

The best and most picturesque furniture of all ages has been simple in general form. It may have been enriched by complex details of carved-work or inlay, but its main outline was always chaste and sober in design, never running into extravagant contour or unnecessary curves. Anyone who will take the trouble to examine the few specimens of Egyptian furniture which are to be seen in the British Museum, the illustrations of ancient Greek and Roman art which have been published, or the mediæval examples which still exist in many an old sacristy abroad, and in most of our English country mansions, cannot fail to be struck with two qualities which distinguish this early handiwork from our own, viz. solidity and (what we should call) rudeness of construction.

The sofa at Knole, which dates from the same period as the chair which I have already described, is an example of thoroughly good design in its class. In the first place, its general shape is rectangular, clearly indicating the construction of its wooden framework, the joints of which are properly 'tenoned' and pinned together in such a manner as to ensure its constant stability. The back is formed like that of the chair, with a horizontal tail only at its upper edge, but receives additional strength from the second rail, which is introduced at the back of the seat. By means of an iron rack attached to each end, the sides can be raised or lowered to any angle, thus enabling the sofa to be used as a couch or a settee, at pleasure. These moveable sides, like the back, are stuffed with feathers, while the seat itself is provided with two ample cushions of the same material. A more luxurious form of couch – to say nothing of the richness and elegance of its external covering – could hardly have been devised, and yet there is not a single curve in its outline. After 250 years of use, this sofa is still *comfortable*, and, with the exception that the velvet and trimmings are necessarily faded by age, remains in excellent preservation. It was introduced by Mr Marcus Stone in his very clever picture of the 'Stolen Keys', which some of my readers may remember at the Royal Academy Exhibition. Can we suppose that in the year of Grace 2122 any English artist of taste will be found willing to paint the 'elegant' *fauteuils* with which English ladies now

furnish their drawing-rooms? And if such a painter is forthcoming, where will he find such an object to depict? Possibly in some 'Chamber of Horrors' which may be devised at the South Kensington Museum to illustrate the progress of bad taste in this century, but certainly not in any private house. It is hardly too much to say that fifty years hence most of our modern upholstery will have fallen into useless lumber, only fit to be burnt for firewood.

There is a notion very prevalent among people who have given themselves but little trouble to think at all on the matter, that to ensure grace in furniture, it must be made in a flimsy and fragile manner. Thus we constantly hear the expression '*light* and elegant' applied to a set of drawing-room chairs which look as if they must sink beneath the weight of the first middle-aged gentleman who used them. Now, lightness and elegance are agreeable qualities in their way, and, under certain conditions of design, art should be aimed at. For instance, the treatment of mere surface ornament, such as painted arabesques, &c., or of details purely decorative and useless, as the filagree gold of a lady's earring, may well be of this character; but objects intended for real and daily service, such as a table which has to bear the weight of heavy books or dishes, or a sofa on which we may recline at full length, ought not to look light and elegant, but strong and comely; for comeliness, whether in nature or art, is by no means incompatible with strength. The Roman gladiator had a grace of his own, but it was not the grace of Antinous. Our modern furniture is essentially effeminate in form. How often do we see in fashionable drawing-rooms a type of couch which seems to be composed of nothing but cushions! It is really supported by a framework of wood or iron, but this internal structure is carefully concealed by the stuffing and material with which the whole is covered. I do not wish to be ungallant in my remarks, but I fear there is a large class of young ladies who look upon this sort of furniture as 'elegant'. Now, if elegance means nothing more than a milliner's idea of the beautiful, which changes every season – so that a bonnet which is pronounced 'lovely' in 1872 becomes a 'fright' in 1873 – then no doubt this sofa, as well as a score of other articles of modern manufacture which I could mention, is elegant indeed. But if elegance has anything in common with real beauty – beauty which can be estimated by a fixed and lasting standard – then I venture to submit that this eccentric combination of bad carpentry and bloated pillows is very *in*elegant, and, in fact, a piece of ugliness which we ought not to tolerate in our houses.

Most of us, who know anything of country life, have seen the

common wooden settle which forms so comfortable and snug-looking a seat by rustic hearths. No artist who ever studied the interior of a cottage would hesitate to introduce so picturesque an object in his sketch. But imagine such a sofa as I have described, in a view of the most magnificent and chastely-decorated chamber in Europe, and it would at once appear commonplace and uninteresting. Perhaps my readers may feel inclined to urge that a great deal of the interest with which we are accustomed to regard old rustic furniture is due to its age and dilapidation. It may be so; but can we expect or believe that a modern chair or couch, as they are at present manufactured, will ever, by increasing years, attain the dignified appearance of Tudor or Jacobean furniture? The truth is that our household goods become dingy under our very eyes, and the very best of them will not survive the present generation.

Now it is by no means advisable that we should fit up our drawing-rooms with cottage settles, or adopt any sort of furniture which is not perfectly consistent with ordinary notions of comfort and convenience. If our social habits differ from those of our forefathers, the fittings of our rooms must follow suit. But, in point of fact, there is a great deal of ignorant prejudice on these points. We all know, for instance, that the old low-seated chair, with its high padded back (commonly called Elizabethan), is considered awkward and uncomfortable, simply because its proportions are strange to us. We know, too, that the 'occasional' chair of modern drawing-rooms, with a moulded bar, and perhaps a knot of carving, which chafes our shoulder blades as we lean back upon it, is looked on as an article of refined luxury. As to the comparative merit of their respective designs, from an artistic point of view, there can be but little question; but if any of my readers have any doubt which is the more comfortable, I would strongly advise them to try each, after a fatiguing walk. Perhaps they will find that the art of chair-making has not improved to such an extent as they imagine since the days of good Queen Bess. But, however much opinions may vary on this point, one thing remains certain – viz., that beauty of form may be perfectly compatible with strength of material, and that good design can accommodate itself to the most fastidious notions of convenience.

A familiar and apparently very obvious distinction has been made, from time immemorial, between the useful and the ornamental, as if the abstract qualities represented by these words were completely independent of each other. It would, however, be a shortsighted philosophy which failed to recognise, even in a moral sense, many

points of contact between the two. If that which pleases the eye – if that which charms the ear – if that which appeals to the more imaginative faculties of the human mind have no direct and practical result for our benefit, then poets, painters, and musicians have, indeed, lived and wrought for us in vain. And if, on the other hand, we are unable to perceive, even in the common concerns and practical details of daily toil – in the merchant's calling, in the blacksmith's forge, and in the chemist's laboratory – the romantic side of life's modern aspect, it must be but a weakly order of sentiment with which we are inspired by songs and books and pictures.

5.6 A domestic interior *c.* 1861

With all the new intolerance of the converted, decorators and interior designers of the 1880s looked back with uncontrolled aversion to the homes of their childhood. In his *Decoration and Furniture of Town Houses* the architect Robert W. Edis described this utter want of Taste (1881).

I can conceive nothing more terrible than to be doomed to spend one's life in a house furnished after the fashion of twenty years ago. Dull monotonous walls on which garish flock papers of the vulgarest possible design stare one blankly in the face, with patches here and there of accumulated dirt and dust, or the even worse monstrosities of imitation *moiré* silk, with bunches of gilt flowers tied up in gilt ribbons, and running symmetrical lines like soldiers on parade.

Of course, if the flock of paper be red, we had red curtains hung on to a gigantic pole, like the mast of a ship, blossoming out at the ends into bunches of flowers, or turned finials, like enormous hyacinth bulbs in water. The curtains trailed some feet on the floor, and, when not taken possession of by the pet dog or cat, became the receptacle for dust and dirt, or the hiding-place of the remains of some pet's dinner.

The chairs were covered with red stuff of some kind; the table had a red cloth, printed all over with elegant designs of flowers in black, in impossible positions; the carpet was probably of some gaudy colour and pattern, covering the whole room with a sprawling pattern of gigantic flowers; the furniture of the stiffest possible kind, rows of chairs seemingly propped up against the wall in straight lines

so as not to over-task the bandy-curved legs which bore them, the so-called 'shaped' backs cut cross-grain of the wood so as to snap sharp off with any extra weight; an enormous glass over the miserably ugly mantelpiece, in a still more enormous gold frame, with bits of plaster ornament, also gilt, stuck on like bats and rats on a barn door, and, like them, showing signs of decay and decomposition; so-called sideboard, with a drawer in the middle, a cupboard on each side, and another enormous glass overhead.

In the drawing-room we had the same kind of monotony, only perhaps in a different colour; a green carpet, with peaceful lilies intertwining with each other; a hearthrug, with a Bengal tiger ill at ease, his back to the fire and his face in the lilies; and a footstool, covered with Berlin wool, representing the pet dog of the period, very much astonished at his proximity to the aforesaid tiger; green curtains, with a Greek fret or honeysuckle border in yellow or gold; a gigantic valance with deep fringe worked into knots over turned wood beads; furniture covered with work of crude colours, marriage offerings to our fathers and mothers; chairs so lightly constructed that you could never be safe upon them; couches that you could not lie comfortably upon; tables with legs twisted and turned into impossible shapes; occasional chairs, which were well named in that they would never stand for the purposes they were intended, except very occasionally indeed; and the whole arrangements of the room stiff, formal, and uninviting. . . .

If there was a bit of colour on the walls, nine times out of ten it was of the tea-tray character, a brilliant illumination of Vesuvius, as it would probably appear in a pantomime, and not in reality; a few family portraits, whose particular merits were spoilt by the painting, and everything miserable and unartistic. . . . This is no exaggeration; there are still hundreds of rooms in which this utter want of taste prevails. . . .

5.7 Deliberate, dainty decoration

In 1878 Macmillian published *The Drawing Room; its decoration and furniture* by Mrs Orrinsmith of Beckenham. Its aim was practical; its prose both whimsical and didactic; its intentions laudable. Nowhere else can we find more suitably expressed the current aesthetic complexion of the new trends in taste more admirably translated into a

form which would appeal to the sensibilities and accommodate itself to the economic limitation of housewives of the middle middle classes. The developing taste for oriental china, seen in its most advanced state in the decorative schemes of Whistler, was spreading throughout society, and the dissemination of wealth through a larger segment of the population was adding to relatively modest homes a sense of tasteful ambition which had not been seen on so large a scale before.

To an appreciative mind, not spoiled by the luxury of wealth, what keen pleasure there is in the possession of one new treasure; a Persian tile, an Algerian flower-pot, an old Flemish cup, a piece of Nankin blue, an Icelandic spoon, a Japanese cabinet, a Chinese fan; a hundred things might be named, not one being costly, yet each, in its own way, beautiful and interesting. Where to place it, for the best, is a fertile topic of conversation: then the bracket must be made; the tiny shelf designed. A delight as pure as that of a child with a fresh toy, and superior to that in its lasting power, is open to the aspirant after the beautiful in art.

Probably those whose means are limited, so that the sum to be expended in ornaments is comparatively small, have quite as much, if not more, pleasure in their occasional acquisitions than the wealthy, with whom to wish for is to have. Slow acquirers have time to dwell upon qualities of colour, to examine details of workmanship; they are not distracted by another thing until they have this one by heart, and the pleasures of anticipation and possession must surpass those of the latter alone. To be able to purchase immediately, without any doubts, without a certain preparation, does not strike one as the happier state.

Surely there are not to be found more lovely bits of ornament for a drawing-room than rare old china. It is not proposed here to give details of all the hundred pottery and porcelain marks, with all their differences as known to the connoisseur; to attempt even a list of the varied beauties in china would leave no room in this chapter for other scarcely less important items of decoration. The *disposal* of such bits of tender colour and shape will be more to the purpose, and of course they should always be placed where they can be perfectly seen, without being touched; for would not one rather fracture a limb than break a friend's old Persian or Chelsea, or Nankin?

All articles of delicate, minute work should be on a level with, or not much above or below, the range of the eyes. Cheffoniers with cupboards and shelves close to the floor, for valuable and interesting ware are unsuitable, dangerous and inaccessible.

Here a few words may be fittingly said about antique things. It is a sad and acknowledged fact, that modern decorative art, at home or abroad, cannot compare in delicacy, conscientiousness, or knowledge with that of past times; even present Persian art is not to be desired, like that of days gone by. Looking over Japanese toys, the difference between new and old is marked and marvellous. In ancient art a great knowledge of suitable decorative effect is evident, and loving toil, willing to spend any time to gain goodness at last. In modern work, attention is still paid to effect, but it must be attained by the least amount of labour possible. Perhaps other reasons for decadence need hardly be sought.

It is not that artistic power has left the world, but that a more rapid life has developed itself in it, leaving no time for deliberate dainty decoration, or labours of love; hence, all crave to possess specimens that are at present unequalled, and beauties that may possibly never be rivalled. When they are fortunely obtained, we cannot take too much care of them, or enshrine them with more than sufficient thought and heed.

Very pleasant places for tender cups, teapots, and plates, are corner cupboards, either resting upon legs or hung upon the walls, they may be small and decorative, or roomy, severe, and simple.

5.8 The seven styles of furniture

As the mid-Victorian style began to alter, and standards of taste started imperceptibly to change, a writer in *London Society* (1865) attempted to simplify the choices available to the readers of that magazine.

There are what we will call, for the sake of distinction, the dull style, the upholstery style, the rich, the architectural, the antiquarian, the luxurious and the meretricious styles.

The dull style of furnishing is, like every other form of dullness, very common. The prevailing tints are drab, oak, and a dingy red. There is much neatness about it. The highly polished round table stands universally in the middle of the room, with perhaps some wax flowers – generally water-lilies, under a glass shade in the centre; or it may be a bit of needlework, and beads for a lamp-stand at night, and a tall lanky glass for flowers by day. A few well-bound books

are placed upon the table at equal distances, all radiating from the centre. The carpet is a flowery pattern on a red ground, a few shades darker than the curtains, which are also red with stripes, or flowers of brown and drab. The sofa and armchairs have the same dull covering. There is usually a card-table, and red silk banner screens are placed like mutes on either side of the fire. One never goes into the room without feeling inclined to yawn, and a sense of depression comes over one after a few minutes. It is essentially dull and drab – respectable certainly, but painfully dull.

The upholstery style is predominantly found where riches predominate over both mind or taste. There are people who have no idea about how to set about furnishing. They think that it must be quite right if they trust it to the upholsterer, whose metier they think must be to do the right thing in proper style. So they go to some, perhaps first rate upholsterer, and tell him the sum they intend to spend, and give him *carte blanche* to do as he likes, provided he makes a good show and keeps within the specified amount. The upholsterer goes down with rule and tape, and takes all the dimensions, and he stamps himself and his shop upon the whole house. He has but one idea. The drawing room must be white and gold; the dining room red and mahogany; and the library oak and leather. In every corner you see the upholsterer's mind; in the damask ottomans and curtains, and heavy gilded cornice of the drawing room; in the elaborate oak bookcases, and table and leather sofas and chairs of the library; in the handsome(?) sideboard of the dining room. We remember being taken over a newly-furnished house which had given employment to a whole host of London upholsterers, and we were asked how we liked 'this' and 'that'; and before we could devise a suitable reply, we were assured that *carte blanche* had been given; that it had all been put into So-and-So's hands because they had done all the furnishing for the Earl of Q—. In short the house was simply a sample of what an upholsterer's ware-rooms can supply. There was no stint. There was plenty of *luxe*, but it all lacked a master-mind directing and over-ruling the whole. It smelt of the shop.

The rich style is perhaps the worst of all, because it is so insolent in its pride. It has the same defect as the upholstery style, for it is that gilded *à l'outrance*. Wealth is stamped on every corner. Heavy massive wealth overpowers it all, and the furniture is chosen not so much for its utility as for the opportunity it gives of displaying the unbounded riches of its owner. There is a surfeit of money about it all.

The architectural style of furnishing has its charms for those who

have a monomania for everything that is Gothic. To us it is especially disagreeable. The chairs are so uncomfortable and straight-backed; everything is angular and hard, suggestive of stiff discomfort. We remember a house where this style was carried to a great excess. The very bedposts were Gothic; they were made of brass, with a ribbon running round them displaying the family motto in red letters. The curtains had the arms and motto woven into them, and the papers bore the same device. When we saw it we thanked heaven we were not going to sleep in those beds. Imagine the horrors of a nightmare of griffins impaled, or lions rampant, or the ceaselessness of the motto from which one could never escape, turn which way one would. In another house an heraldic tree sprung from the centre of one of the chimneypieces, and occupied the whole of one side of the room, the ceiling resembling that of a cloister. One would gladly escape from such a room to the furthest attic, where this architectural monomania had not reached. In another the bed was hung with heavy crimson stuff, which was supported by iron rods of curious device, terminating in an exaggerated form of a bishop's pastoral staff; and the Gothic bathing machine, which was meant for a wardrobe, was suggestive of reminiscences of one's childhood that were anything but pleasant. Oh no, let us eschew this style, and be thankful that we have been preserved from it hitherto.

The antiquarian style is far more pleasing. The picturesque quaintness is far more pleasing, and the odd thing one finds here and there takes one quite by surprise. But it has its dreary side. The dark panelling, the uncomfortable chairs, whose only recommendation is their antiquity; the comfortless settee in which it was supposed some great man had sat a century or two ago; the table with its multitude of legs preventing one from ever getting near it; the scornful contempt for all the improvements of the nineteenth century, makes the house very uncomfortable, very unsuited to daily life; more adapted for lionizing than for living.

Not so the artistic style, which has great recommendations, but is objectionable inasmuch as there is a certain degree of eccentricity about it which shelters itself behind the idea that it is artistic. Odd things are done, doubtful theories are carried out as to colour and form, and the rooms themselves are often arranged more like 'studios' than living rooms for ordinary mortals.

The luxurious style speaks for itself, and the infinite variety of easy lounging chairs and sofas, the soft carpets and beautiful fabric used for curtains, make it peculiarly inviting; but it too has its faults. There is generally no solidity about it; nothing practical or

suggestive of occupation and work; no table at which you can write a letter. The whole speaks of idleness and ease, and is suited to the life of a sybarite. The *dolce far niente* is stamped upon it too plainly. It wants force, strength of character, and without great care it will drift away into the meretricious style, which is luxury in its most enervating form.

This style abounds in white and gold, and beautifully tinted walls half darkened by rose-coloured blinds, and surrounded by balconies filled with evergreens and bright flowers, and ornamented with arches of creepers. Every landing has its group of flowers and its divans; and the rooms abound in corners, which are shut off by velvet screens or trellis-work of cane covered with creepers. In the meretricious style the study is to consider the personal appearance of the occupants. There is a great amount of looking-glass; a profusion of drapery in the shape of *portières* and curtains. The effect is pretty, but it is all more or less a sham. The lace is not real, the gilding and decoration inferior, the whole of the ornamentation not even second-rate. It is pretentious, and attempts to pass itself off for something that it is not; and there is no other name for it but meretricious.

Rose-coloured blinds especially belong to this style, and strange to say, this peculiar kind of furnishing has found its way to unwonted places. We have been told that a reverend divine who has a prebendal stall, and lives under the shadow of one of our ancient cathedrals, has adopted these meretricious blinds. They must contrast strongly with the ancient walls which surround them, and more strangely with the lives of the founders of that ancient edifice.

5.9 Interior design for the lower middle classes

It is interesting that, writing in 1878, Mrs Orrinsmith in her *The Drawing Room; its decoration and furniture* can refer to people remembering 'the lower middle class drawing room of the Victorian era'. Even if it does not suggest undue pessimism about the Queen's longevity, it emphasises the mutability of taste, and the speed at which changes took place. Her ruminations on the taste of the past, and her suggestions for improving that of the future, are lively, pertinent, and significant of a new catholicism in taste in that she refers to 'good taste among comparatively uncivilised people' – a hint at a novel colonial awareness.

It is obvious that there is as much artistic consideration shown in avoidance as in execution. The first step towards improvement in taste is the perception of past and present error. We may therefore be

allowed a short review of matters as they have been – as they even now are in many places.

Who does not call to mind the ordinary lower middle-class drawing-room of the Victorian era? The very head-quarters of commonplace, with its strict symmetry of adornment and its pretentious uselessness. All things seem as if chosen on the principle of unfitness for the fulfilment of any function; everything is in pairs that possibly can be paired. The cold, hard, unfeeling white marble mantelpiece, surmounted by the inevitable mirror, varying in size only with the means of the householder, totally irrespective of any relation to the shape or proportions of the apartment; the fireplace a marvellous exhibition of the power of iron and blacklead to give discomfort to the eye. At the windows hard curtains hang in harshest folds, trimmed with rattling fringes. On the carpet vegetables are driven to frenzy in their desire to be ornamental. On a circular table (of course with pillar and claws) are placed books – too often selected for their bindings alone – arranged like the spokes of a wheel, the nave being a vase of, probably, objectionable shape and material. Add a narrow ill-curved sofa, and spider-legged chairs made to be knocked over, dangerous as seats even for a slight acquaintance, doubly dangerous for a stout friend – and all is consistently complete.

Such is the withdrawing-room to which, because of its showy discomfort, no one withdraws; wherein visitors do penance at morning calls; where the common-sense that often rules the living-rooms is left behind at the threshold, and nothing useful is allowed to enter lest it fail to be ornamental. All in the first instance being subservient to brand-new gloss, the pursuit of brightness leads to tawdry garishness. The desire after elegance begets weakness and uncomfortable inefficiency, and so-called *elegance* in fact elbows comfort from the room.

In households where means are limited, this drawing-room is a sort of appendage to the house, not quite kindred to it. It is tabooed to the children, and avoided, except on occasions, by the dwellers, who are deterred by its lack of comfort and the false tone of its general arrangements. Efforts that have been at least tolerably successful in other rooms, where a want has been felt and befittingly satisfied, seem to fail utterly in the drawing-room, where an attempt to do so much does all things ill.

If it be urged that a low type has been chosen for our illustration, it may be maintained that where good taste does not rule the house, the amount of error is but a question of degree. A higher position in the social scale, or the possession of larger means, will do little to modify

the unsatisfactory state of things, unless personal interest in the drawing-room arrangements, and an earnest effort after culture in matters of taste, are most strenuously insisted upon.

More money merely enables us to better material and more costly ornament, and thus to dispense with unsatisfactory substitutes; it will never serve instead of the wish to put the impress of our individuality, in order, beauty and grace, on our abiding places. There are plenty of errors in taste to be found in the mansions of the rich, and if wealth cannot do what we require, neither can intellect, without special culture. It seems to be often assumed that those who have attained success and a position in literature, science, or music, have acquired a right to speak with authority on such trifling matters as questions of taste in household adornment, yet we must be aware that numbers of persons of knowledge and refinement – often, too, admirers of all that is good in art – are apparently content to sit down at home surrounded by ugly form, bad colour, and conventional deformity.

Presupposing no indifference to the beautiful, nor any lack of time or inclination to take that active part in the arrangements of a house necessary to ensure a happy result, it is obvious that a peculiar kind of culture in art is requisite for decorative purposes, since examples are found of good taste in colour, proportion, and ornamentation, in comparatively uncivilised races, while we are indebted to such advanced countries as France and Germany for much in the way of *objects d'art*, in which, to say the least, the taste evidenced is of a more than doubtful character.

It is generally supposed that, after a period of decadence, popular taste in domestic art began to amend some five-and-twenty years ago; but a page or two may be occupied in an endeavour to show that there still exist sins of ugliness in our midst, amply sufficient to warrant the efforts of the writers of the 'Art-at-Home' series to bring about an altered state of things.

Here is an advertisement taken, haphazard, from a number of such published every day:

FINE ITALIAN WALNUT DRAWING-ROOM FURNITURE, comprising a luxurious lounge, lady's and gentleman's easy and six well-carved chairs upholstered in rich silk, centre table on massive carved pillar and claws, the top beautifully inlaid with marqueterie, large size chimney-glass in handsome oil-gilt frame, chiffonière with marble top, lofty plate-glass back and three doors; lady's work-table lined with silk, occasional table on spiral supports, two papier-mâché chairs and coffee-table to match, five-tier what-not, pair of hand-

some ruby lustres, and gilt and steel fender and fire-irons, with ormolu heads, &c. &c. &c.

It may be safely affirmed, without even seeing the particular furniture in question, that all the articles mentioned in the foregoing advertisement are objectionable from an æsthetic point of view.

Add to these such things as coal-scuttles, ornamented with highly-coloured views of, say, Warwick Castle; *papier-mâché* chairs inlaid or painted with natural flowers or pictures; hearthrugs with dogs after Landseer in their *proper* colours; mats and footstools of foxes startlingly life-like with glaring glass eyes; ground-glass vases of evil form and sickly pale green or blue colour; screens graced by a representation of 'Melrose Abbey by moonlight', with a mother-o'-pearl moon. Carpets riotous with bunches of realistic flowers, chintzes with bouncing bouquets, chairs with circular seats divided into quarters of black and orange, their backs composed of rollers of the same in alternate stripes; cheffoniers, with mirror-doors too low for any purpose save to reflect the carpet in violent perspective, or perchance a novel view of a visitor's boots.

All these things are still not unfrequently seen, and the catalogue might be multiplied were it desirable to be unduly iconoclastic. A critic usually has the air of a cynic, a discontented being who, uncomfortable himself, is desirous to make others equally so. It must at once be avowed that we do not enjoin contentment in matters of art: 'What next?' is a valuable motto; and 'Excelsior!' is assuredly not the cry of a contented mind.

5.10 A painter's house

In 1895 William Michael Rossetti published an edition of his brother's letters. He prefaced it with a memoir which presented a picture of his brother's house in Chelsea, which was one of the shrines of Pre-Raphaelitism.

It was called Tudor House when he became its tenant, from the tradition that Elizabeth Tudor had lived in it (the statement which I always heard as current was that the house had been used as a nursery for the children of Henry VIII; but this, if true at all, can only apply to some previous house on the same site, for the existing structure must belong to the Georgian time, or at earliest to that of Queen Anne): and it is understood to be the same that Thackeray describes in *Esmond* as the home of the old Countess of Chelsey. A large garden, which recently has been cut off for building purposes, lay at

the back, . . . dotted over with lime-trees, and enclosed by a high wall (the garden, about four-fifths of an acre in extent, was partly, but not wholly, cut off towards 1881: it contained a very prolific mulberry-tree, called Queen Elizabeth's mulberry-tree). . . . Old oak then became for a time his passion; and, in hunting it up, he rummaged the brokers' shops round London for miles, buying for trifles what would eventually (when the fashion he started grew to be general) have fetched large sums. . . . No. 16. . . seems to be the oldest house in the Walk; and the exceptional proportions of its gate-piers, and the weight and mass of its gate and railings, suggest that probably at some period it stood alone, and commanded as grounds a large part of the space now occupied by the adjoining residences. . . . Rossetti's house had to me the appearance of a plain Queen Anne's erection, much mutilated by the introduction of unsightly bay-windows (I cannot but think this rather hard on the bay-window – to me, and to my brother also, always a pleasant feature of a house to live in); the brickwork seemed to be falling into decay; the angles of the steps, and the untrodden flags of the courtyard, to be here and there overgrowm with moss and weeds. . . . The hall had a puzzling look of equal nobility and shabbiness. . . . Three doors led out of the hall, one on each side and one in front, and two corridors opened into it; but there was no sign of staircase, nor had it any light except such as was borrowed from the fan-light that looked into the porch (the door to the right led into the small dining-room; that to the left, into the sitting-room first used by Mr Swinburne, and ultimately by Mr Caine himself; the one in front, into the studio, which, for an ordinary tenant, would have been the dining-room). . . . The changes which the building must have undergone since the period of its erection had so filled it with crooks and corners as to bewilder the most ingenious observer to account for its peculiarities. . . . The studio was a large room, probably measuring thirty feet by twenty, and structurally as puzzling as the other parts of the house. A series of columns and arches on one side suggested that the room had almost certainly been at some period the site of an important staircase with a wide well; and on the other side a broad mullioned window, reaching to the ceiling, seemed certainly to bear record of the occupant's own contribution to the peculiarities of the edifice (this window had been enlarged, but not constructed, at Rossetti's instance some while after he entered the house). . . . (Also) a window at the side, which was heavily darkened by the thick foliage of the trees that grew in the garden beyond. . . . (Rossetti's bedroom, which was on the first floor) was entered from

another and smaller room which he said that he used as a breakfast-room (many a breakfast have I eaten in it, but almost invariably without the company of my brother, who rose much later than I did). The outer room was made fairly bright and cheerful by a glittering (coloured porcelain) chandelier (the property once, he told me, of David Garrick), and, from the rustle of trees against the windowpane, one perceived that it overlooked the garden; but the inner room was dark with heavy hangings, around the walls as well as the bed, and thick velvet curtains before the windows. . . . An enormous black-oak chimney-piece of curious design (it was Rossetti's own design, and constructed out of decorated slabs, etc., picked up here and there by himself), having an ivory crucifix on the largest of its ledges, covered a part of one side, and reached to the ceiling. . . . When I reached the room that I was to occupy during the night (it is on a landing between the ground-floor and first-floor), I found it, like Rossetti's bedroom, heavy with hangings, and black with antique picture-panels, with a ceiling (unlike that of the other rooms in the house) out of all reach or sight; and so dark from various causes that the candle seemed only to glimmer in it. . . . I strolled through the large garden at the back of the house. . . . A beautiful avenue of lime-trees opened into a grass-plot of nearly an acre in extent (it is the grass-plot which, allowing for a small strip retained, was afterwards built over; the avenue continues to be attached to the house). The trees were just as Nature made them, and so was the grass, which in places was lying long, dry, and withered, under the sun – weeds creeping up in damp places, and the gravel of the pathway scattered upon the verges.

5.11 The artistic coal-scuttle

A concern with every aspect of domestic decoration for the endlessly growing numbers of houses built in the latter half of the century was characteristic of the period. In *The Magazine of Art* for January 1882 Percy Fitzgerald applied himself to applying principles of utility and simplicity to the design of coal-scuttles.

It is a familiar necessary implement enough, yet, in an artistic sense, it is harshly if not barbarously dealt with. Charles Lamb says happily of a new cheap edition, issued by Tegg, of his fine old favourite 'Burton's Anatomy', which he was accustomed to read in a 'good tall copy' of the seventeenth century, 'I know nothing more heartless.' And so of the Birmingham coal-scuttles issued in the

glory of japanning, gilding, and general clattering magnificence, it may be said that there is nothing so pitiable. The sight of one, meant to be handsome and ornamental, laid like a mortar beside your fire, with its shiny sticky blackness, fluted sides, and oval gilt lid, is an ugliness and a sorrow for ever. Rather than endure it one would almost go without coals altogether. It is inconvenient and unsuited for its purpose, as every inartistic thing is certain to be. As it gapes at us it may indeed boast that it holds the coals; but how hard it is to extract them! The problem, in truth, is of some difficulty. The jaws are held apart by a sort of prop between, with a view to keep the coals from straying over the carpet, as, if the utensil were at a level, they would surely do; but the tube-shape hinders this, and keeps all the coal at the bottom, whence it has to be dug out. The very look of the thing is an offence. At best it has but a dirty if an honest function; and the black dusty coal has to be made tolerable in a drawing-room. The makers have felt this, and tried to beautify their work with gold and lacquer, and with a lid which moves on a very weak hinge, flaps down with a noisy jar, and flaps back to be often broken off. Sometimes there are wheels below. Often, too, a photograph of some antique statue, or a painting of flowers on a white ground, is introduced by way of decoration – a painful association with the black and coarse blocks within. As a change, we sometimes find a combination of wood and brass employed with even worse effect, coal in a wooden box being altogether out of keeping. Novel and strange shapes have been devised and 'brought out': among others one of a ponderous basket, with sloping lids on each side. The meaning of these fantastic freaks it is impossible to divine, unless it is that they are perpetrated with a view to introducing a 'novelty' for the drawing-room.

Now all these results – so many gropings in the dark – proceed from false principles, and are therefore unsatisfactory. The idea is to furnish a small coal store for the drawing-room – that is, a magazine in which coal may be kept to save the trouble of bringing it from below. Now the practice of keeping a stock of coals in a drawing-room is fatal to furniture and hangings; it is also the *raison d'être* of this glorified coal-bunker of ours, the principal function of which is altogether to refuse to yield up its contents, or so to yield them as inevitably to scatter them over the carpet. No more fuel should ever be kept in the room than just enough to renew the expiring fire; and there is nothing better for this than the old familiar coal-scuttle or coal-box. It contains a small reserve, and when exhausted it is carried below and replenished. It is analogous to a water-jug in a washhand-

stand, which is a different thing from a pail or a water-butt. With what labour and trouble the magazines in vogue are re-filled many of us have seen; and a melancholy sight it is. An overburdened servant struggling with both hands to lift the ponderous thing appears as a kind of inglorious martyr – to duties that are unnecessary, to a taste that is absolutely false.

What we want is something that shall be light, handy, and inconspicuous, for it is not suitable that so coarse a matter as coal should thrust itself upon public notice. We must select a material, too, which shall not be inappropriate and out of key. China, pottery, and glass are accepted for holding water; combinations of metal and wood we feel to be strange and improper in themselves. It should be a homely metal – genuine, stout, and serviceable: not spick and span like brass, which shows black marks and is cleaned with difficulty; not iron, which savours of the kitchen; nothing japanned or painted, for all things painted or japanned are odious. What, however, of copper – of copper lightly decorated with brass? It has a relation to the fire, it keeps a genuine glow, it has a respectable and handsome air. Nothing, then, is better than the old open-mouthed coal-box that 'John brings up'. It is carried lightly, and shoots its contents on the fire deftly and conveniently; it honestly shows what it contains; it is, in short, a sort of enlarged ladle or spoon, and as such is it used. However, as it is a primitive and rather wasteful contrivance, we may accept a compromise, and let our coal-box become a sort of bowl, standing open-mouthed and ready by the fire, whence with a light scoop a small supply may dexterously be drawn. Here, however, we get into trouble with strict aesthetic principles; for we cannot do without a stand, and something like the stem and 'foot' of a glass are added below, so that a most awkward-looking composition is the result. It is like putting a stand under a spoon, which instantly becomes another article with another function. Again, the two handles to a coal-box, which should be boldly emphasised, protest loudly against the stand below, which says as loudly, 'It does not want you, but me.' To be nicely accurate, these handles should modestly proclaim themselves as only meant for transporting the body attached to them from cellar to drawing-room; they should therefore be one at each side, while the scoop should be developed into the leading feature of the whole. It should, that is to say, instead of being the mean, 'skimpy', inefficient thing it is, become a really handsome, capacious, and boldly-treated article. Being large, well balanced, and conspicuous, it, rather than what it carries, should attract the eye. But, indeed, all this theorising is more or less false, as

the coal-scuttle proper is made for a stately and effective entrance into the drawing-room, with a prompt withdrawal; and for the coal-scuttle proper it would be quite conceivable that a real artist should produce a really artistic design. Something of the kind has been attempted: as witness the thin things, brass-embossed and having an air of *repoussé* work, we know. But these are so slight and mean that their pretention is seen through; they look as if they would bend, and the *repoussé* indentures and hollows are actually an added weakness. But then if our scuttle be of solid and substantial brass, we have to reckon with the element of expense. Better, therefore, plainness and simple strength. Copper, as before noted, seems the material best in keeping. It is rude, plain, effective, though it only lends itself to simple lines; it always looks well, with an honest warmth akin to the glow of the embers. What is chiefly wanted is the artist. Let him only appear, and keep in view the principles I have shadowed forth, and he will be a benefactor to his kind.

5.12 Advice on wallpapers

One of the dominant figures in the Arts and Crafts movement, Charles Annesley Voysey the architect, was remarkable for the width of his interests, and his readiness to see the totality of design. He contributed to the 1896 issue of *The Studio* an interview in which he gave his views on wallpaper and decorative wall painting in the ordinary house. It was illustrated with several of his own designs.

I think that a wall-paper, even if more pleasing in an all-over pattern, is less disturbing when a more determined and simple expression of one or two ideas, unless of course you are one of those unhappy mortals who never notice a design except to count its repetition. A wall-paper is of course only a background, and were your furniture good in form and colour a very simple or quite undecorated treatment of the walls would be preferable; but as most modern furniture is vulgar or bad in every way, elaborate papers of many colours help to disguise its ugliness. Although elaboration makes confusion more confounded, yet if you have but enough confusion the ugliness of modern life becomes bearable. Mr Morris is credited with the axiom 'the smaller your room the larger the pattern you may put on your walls.' There is no doubt that it is better to have large and bold than small and timid patterns, both in papers and printed or stencilled friezes. If you wish to reduce the effect of its scale and force, these can be modified in the colouring.

Do not think that I place wall-papers first. Wooden panelling, whether polished or hand-stained, is best of all; next to that comes painted panelling, but as papers wear better than the plain wall, we must permit them to exist on this ground. If, however, the room be a well-proportioned one and the furniture good, even if pictures are absent, the need for wall-papers is not apparent on æsthetic grounds; but in such a case the frieze may be treated with a pattern either printed or stencilled, not too engrossing, but yet sufficiently important. If stencilling be employed, I would insist on the importance of preserving the ties which the work imposes, so that it is obviously a stencilled and not a painted pattern.

You do not consider the ornament on a paper should be limited to strictly conventional foliage and purely ornamental motives?'

No, I do not see why the forms of birds, for instance, may not be used, provided they are reduced to mere symbols. Decorators complain of small repeats and simple patterns, because they are apt to show the joints, and because the figures may be mutilated, in turning a corner for instance. If the form be sufficiently conventionalised the mutilation is not felt; a real bird with his head cut off is an unpleasant sight, so is a rose that has lost half an inch of its petals; but if the bird is a crude symbol and his facsimile occurs complete within ten and a half inches' distance, although one may have lost a portion of his body, it does not violate my feelings. To go to Nature is, of course, to approach the fountain-head, but a literal transcript will not result in good ornament; before a living plant a man must go through an elaborate process of selection and analysis, and think of the balance, repetition, and many other qualities of his design, thereby calling his individual taste into play and adding a human interest to his work. If he does this, although he has gone directly to Nature, his work will not resemble any of his predecessors; he has become an inventor. The ordinary practice is to paraphrase a popular design, one that has sold well. 'We want something in this style', the manufacturers cry; and so, instead of inventing a new pattern, the artist is called to translate one already popular, and re-adapt its essential qualities in a more or less novel fashion.

It seems to me that to produce any satisfactory work of art, we must acquire a complete knowledge of our material, and be thorough masters of the craft to be employed in its production. Then, working always reasonably, with a sense of fitness, the result will be at least healthy, natural, and vital; even if it be ugly and in a way unpleasing, it will yet give some hope. The danger to-day lies in over-decoration; we lack simplicity and have forgotten repose, and

so the relative value of beautiful things is confounded. In most modern drawing-rooms confusion is the first thing that strikes one. Nowhere is there breadth, dignity, repose, or true richness of effect, but a symbolism of money alone. Hoarding pretty things together is more often a sign of vanity and vain-glory than of good taste.

Instead of painting boughs of apple-trees on our door panels and covering every shelf with petticoats of silk, let us begin by discarding the mass of useless ornaments and banishing the millinery that degrades our furniture and fittings. Reduce the variety of patterns and colours in a room. Eschew all imitations, and have each thing the best of its sort, so that the decorative value of each will stand forth with increased power and charm, and concentrated richness will be more apparent with its simple neighbours.

To produce healthy art one must have healthy surroundings; the first effort an artist should make is to sweep ugliness from him.

The habit of being merely tenants, on short leases, of our homes has fostered the vice which crowds foolish and useless objects, bad in proportion and colour, into rooms ugly and uncomfortable in themselves. We pitch ornamentation in our rooms with no restraint. We have a language of ornament and yet nothing to say – charmed by its sound, we have let vanity feed on its own creations, and forgotten that the expression of deep and noble feelings would make decorative art once again full of life and vigour.

It is not necessary for artists to be bound merely to tradition and precedent, or to be crammed to overflowing with the knowledge of the products of foreign nations. They should each use their God-given faculties, and if they have thoughts worth expressing, the means to express them sufficiently are, and always will be, at hand. Not that we need shut our eyes to all human efforts, but we should go to Nature direct for inspiration and guidance. Then we are at once relieved from restrictions of style or period, and can live and work in the present with laws revealing always fresh possibilities.

5.13 Problems of framing

The widening concern with interior decoration, and cheaper methods of reproduction gave a new importance to questions about actually framing pictures. In his *Thoughts about Art* (1889) Philip Hamerton gave anxious attention to the subject.

The force of routine, in all matters which concern the working of the common trades, offers such a steady resistance to innovation, that it

is almost useless to suggest any reform which would involve the practical abandonment of a trade already learned and in the full tide of an assured prosperity. Picture-frames are made admirably well, and they succeed admirably in the object for which they are intended; that is to say, they show a picture to the best possible advantage. They have two faults; but these faults,, instead of diminishing the prosperity of the trade, positively go far to increase it, whilst they injuriously affect only the pocket of the man who buys the picture, or that of the unsuccessful or partially successful artist, who often has pictures left upon his hands.

These two faults are costliness and fragility. A picture-frame of any magnitude is an expensive thing, and, at the same time, one of the very worst investments of money that it is possible to imagine. The ornaments are made in a kind of paste glued upon a wooden framework, and then gilt. A very slight shock is sufficient to break them off, for the paste becomes exceedingly brittle with time; and if there is any extra heat – as, for instance, if you hang a picture over a chimney-piece – the mouldings are apt to curl up and detach themselves without the help of any shock whatever. Then the gilding, though extremely pretty when perfectly new and fresh, loses its beauty very rapidly; so that, even in galleries possessed by the very wealthiest owners, the idea of keeping picture-frames always perfectly clean and beautiful has to be abandoned as impracticable. In the country, it is possible to keep them decent a little longer; but even there it is difficult, if the climate produce abundance of troublesome flies: in an English town, however, especially a manufacturing town (such as Manchester or Leeds), the only way of keeping your frames decent without extravagantly frequent regilding, is by covering them with gauze, which, so long as it remains there, spoils both the frame and the picture. Works of fine art are not like things whose use is independent of appearances. For example, you may put a cover on an easy-chair without diminishing its usefulness as a thing to sit comfortably in; but as the only usefulness of a picture-frame is one of appearance, you absolutely arrest the performance of its function in the world when once you have hidden it. If picture-frames are to have gauze over them, we might as well begin by simply painting them a dull yellow.

The inconveniences to owners of pictures which result from the prevalent system of frame-making are, that an amount of dirt has to be tolerated in frames which would never be tolerated in any other piece of furniture, whilst a constant drain of expense has to be going forward, which, if it could be more wisely administered, might give

results of higher and more permanent beauty. Considering, however, that the purchaser of many pictures is of necessity either a rich man who has money to throw away, or an extravagant one, who throws it away without troubling himself about questions of economy, he does not feel the perishableness of frames as a matter seriously affecting him. On the other hand, the successful painter gets rid of his pictures so quickly that a frame has not time to lose its freshness whilst it remains upon his hands; besides which, he can easily stipulate, and often does so, that the frame shall be a separate transaction between the purchaser and the frame-maker. And in any case, if a successful painter has to keep a few old frames in his studio, they serve him to paint other pictures in; and it matters little, when they are used for that purpose, whether an ornament be chipped off here and there, or the general tone of the gilding be somewhat dimmed by ineradicable dust. Those who suffer most from the extreme perishableness of the frames commonly in use are the ordinary crowd of artists, whose pictures are frequently refused at the exhibitions, and are sent from one exhibition to another, till one out of three or four is sold, and the rest come back to their author. The frames of pictures declined at the Academy are *always* damaged; sometimes they come back in a state so extremely unlike their splendour in the month of March, that the comparison which suggests itself the most readily is that of a spruce and brilliant soldier at a review, and the same soldier ragged and dirty after a disastrous battle. All artists complain of this, but the fault lies with the system of frame-making, not with the authorities of the Academy. The pictures are knocked about by agents of artists who go to seek for refused works; and as the ornaments are as fragile as porcelain, a considerable amount of damage is quite inevitable.

A system of frame-making is needed, by which it might be possible to preserve the good appearance of our present frames when they are new, whilst giving greater strength and durability. Some attempts in this direction have been made of late years which may be alluded to. The reader will probably remember the massive frames of carved wood which surrounded Bierstadt's great landscapes when they were exhibited in this country. These were much stronger, no doubt, than the ordinary frames of paste, and were handsome things in themselves. As a cornice for some room, richly furnished in carved wood, they would have been very noble and appropriate; as picture-frames, they had the radical vice of not showing the picture to advantage. In our schemes of reform we must not lose sight of the fact that the function of a picture-frame is purely auxiliary, and that

if it fail to be an efficient auxiliary to the work of art it does not signify how beautiful it may be in itself. Many experiments have been tried, but nothing answers so well as gilding. No carved wood helps the appearance of paint as gilding does. The metallic lustre of gold saves it from injuring the tones of paint which might dangerously resemble it, so that there is never any struggle between them; whilst, on the other hand, there is a pleasant warmth in the colour of gold which silver does not possess. An immensely important collateral advantage is, that gold adds to the *splendour* of a work of art more than any other surrounding. The frames of Bierstadt's pictures, though they were magnificent things, were not splendid things; and a picture-frame ought to be splendid. On the other hand, we have had the pre-Raphaelite experiment in frames – a flat margin, often of solid oak, gilded so as to leave the grain visible. In Mr Hunt's Temple picture a margin of ivory intervened, which, though useful as adding to the peculiarity of the work (which was an essential part of the pre-calculated effect on the public mind), and useful farther in conveying the idea of sacrifice to the spectator, did not add anything to the artistic effect of the picture, except by separating the painted gilding of the Temple from the rivalry of the real gilding of the frame. The ivory, in short, though more expensive, had only the effect of so much paper of the same tint of white; and it has long been a settled question amongst artists, that oil-paintings are better helped by having gilding close to them than any kind of white or cream-coloured or black margin. The chief defect, however, of the pre-Raphaelite frame was its want of illusory effect, owing to its flatness. The preliminary idea of all picture-frames is the open window, or the bevelled boards that surround the diorama. Although we know that the *trompe-l'œil* is not the object of art, still a certain concession is made to the infantine or instinctive desire to be deceived. The frame, by the recession of its sloping sides, leads us first to the foreground, and then to the successive distances of the picture, preventing the perpendicular lines on each side of the *canvas-stretcher* (or stretching frame) from contradicting the pictorial distances, and so helping to produce the degree of illusion which is right and necessary even in the most elevated art. A flat frame does not sufficiently achieve this (though it achieves it partly), and consequently it misses much of the utility of the typical picture-frame. For the typical picture-frame is not only a margin, but much more. It is to the action or scenery in the picture what the walls and side-scenes of the theatre are to the acting and scenery upon the stage.

The American carved-wood frame and the English pre-Raphaelite frame, though both much more durable than the frames we are usually accustomed to, could not, therefore, be considered as a satisfactory solution of the difficulty. What we want is a kind of frame which shall show a picture as well as the best frames of the ordinary kind, and yet be sufficiently durable to bear dust and coal-smoke, and even a little occasional hard usage in the exhibitions. I have no pretension to be able to suggest any satisfactory solution of this difficulty; indeed, I do not proffer, but ask for a solution. Something, however, may be said as to the direction in which the solution will have to be sought.

5.14 The Arts and Crafts exhibitions

On the occasion of the fourth Arts and Crafts Society exhibition in 1893, an article in the October issue of *The Studio* set about assessing the achievements of the movement over the five years of its existence. This protest against the modern industrial system, with its high standards, and its emphasis on the notion that beauty is not to be found merely in ornament, had an indubitable influence on the development of middle-class taste and fashion.

Now that after an interval of two years the Arts and Crafts Exhibition Society has gathered together material for a fourth show, it may be well before discussing the present display to turn to the preface to the catalogue of its first exhibition in 1888. Therein we find a protest against the modern industrial system which has thrust the personal element further and further into the background until the production of ornament instead of growing out of organic necessities has become a marketable affair controlled by the salesman and the advertiser, and at the mercy of every passing fashion. To proclaim that the true root and basis of all art lies in the handicrafts, and to give visible expression to such belief, were the objects for which the Society was started; coupled with a determination to give full prominence to the individuality of each designer and craftsman engaged in the production of its exhibits. In place of attributing them vaguely to the various firms, whether manufacturers or vendors, as had hitherto been the rule, a list of all persons engaged upon any essential features of the works was to be added to the catalogue description. That in 1893 the Society abides by its first programme the present catalogue will suffice to prove. Through good and evil report its members have stuck to their guns, and are not to be cajoled

or threatened into abating the severity of their programme; the many rejections this year indicate that they have a fixed standard and judge accordingly.

Before considering the fourth show, it is but a truism to say that as a whole it must needs lack the allurement of novelty which is always an important attraction to the public, quite apart from any intrinsic merit. Even if the works of each artist who made the first year a success showed an immeasurable advance, the evanescent glamour of the first impression cannot be recaptured. Again, it is obvious that the primal exhibition of a newly formed society, despite the drawback of immaturity, has, like an author for his first novel or his first play, an indefinite past behind it from which to pick and choose the best ideas of silent years, and can garner the choicest fruit of many seasons in one harvest.

Probably the difficulty of finding an annual succession of good things, led to the temporary suspension of the exhibitions. These, so far as the catalogues assist one's memory, relied for their chief attraction on a few prominent artists who each contributed very many exhibits. Among these were no small number of memorable works – memorable, that is to say, to those technically interested in decorative art – some from their exceptional costliness, others for the new vitality they showed in arts that had slumbered long; this year, save always Mr Morris's tapestries, the exhibition is more noticeable for its high level than for any one or two *tours de force*. To say that it has no epoch-making work, is by no means a reproach; it is far better to produce a number of objects fine indeed in their way, but not too fine for ordinary use, than a few masterpieces fit only for private or public museums.

There are two questions one would like to put as a test; one, whether the level of commercial design has advanced since 1888, and how far the exhibition may be taken as a representative sampling of the market to-day?

To the first no certain affirmative is ready. Nor could the warmest supporter of the Society claim that it was entirely catholic and representative. For the more you examine them you feel that although the industrial exhibits represent (as they should do) the individual art of many clever designers and makers, they do not represent (as one hoped they might) the average of commercial products made directly for public sale in the ordinary way. This is not the fault of the Society; the shop-windows to-day give evidence that the standard of design has not risen appreciably since 1888, so we are compelled to own that the beautiful things inside the New

Gallery represent the work of a few for the few, and that the taste of the masses is not shown, nor will be raised directly thereby. But – and here is surely the reason which justifies its existence as an exhibition – for artists in design and as a show which attracts the classes rather than the masses, its influence is certain to be felt sooner or later by those who at present scarce know of its existence.

Outside, the ruling fashion of the hour is as reckless of all restraint as ever. Now it inclines to sobriety and good design, then it veers round to the inane vulgarity of a bastard rococo when it is to be feared the vulgar novelty chokes to death the seedlings that looked so vigorous. Yet, despite open attack, despite trade jealousies, and despite honest divergences of taste, it cannot but be good that a body of art-lovers should unite to set up a fixed standard, above caprice, even though it be more limited in its choice of styles, and more severe in their employment, than a cosmopolitan would demand. For the exhibits are unmistakably English; even a nation so nearly allied in custom and taste as America has not influenced a single example. Modern French art is hardly more felt, and although old Italian, old German, and old Dutch may be traced, yet these inspirations, however obvious, have been expressed in native idiom, proclaiming a desire for fine craft allied to good art, regardless of the taste of the man in the street. The so-called æsthetic movement which is irrevocably mixed up with the 'Arts and Crafts' by the average person, has always had two classes of enemies: those who protested against it in public and straightway accepted its productions with gratitude in private, and those who openly applauded it, and by indiscreet imitation showed their praise to be the most vulgar form of flattery. But the art-items of the furnishing catalogue which appeal to this latter class are noticeably absent in the New Gallery; and that its judges have not modified their notions of beauty and fitness to accept work out of sympathy with their ideal will be found an easy and not unfounded taunt to hurl at them. Hard words, however, are helpful to a movement, and the rejected smarting with what they deem unmerited disapproval can hardly be unbiassed in their criticism. Yet it is as well to remember that the Society is neither a State-endowed body, nor one that asks alms of the public, but an association which possesses a perfect right to manage its own affairs in its own way. Therefore, if it prove consistent to its self-set ideal, to criticise it fairly, it should be studied not so much with one eye on outsiders and one on its collection, but as all art should be studied, on its own merits. 'Who shall say which of us is text, which of us is sermon?' One person may find its art narrow-minded, in the

style of a certain set, and another that it attempts worthily all he holds worth attempting. It is not incumbent to side with the extreme views of either, for both alike are most probably largely imbued with personal taste and purely arbitrary likes and dislikes.

Fine work in the crafts has been done outside the Society, and good work of various styles that, judging by the governing ideal here, would be distinctly unpleasing to the taste of the judges, is not unknown in other places; but that fact does not detract from the merit of the things now on view in the New Gallery. To say that these exhibits by English craftsmen during a few years are not worth considering because they do not surpass, nor even equal, a carefully selected group of the world's masterpieces, were as wise as saying that the poetry of a similar period was absolutely contemptible because it is not above or equal to the works of Dante and Shakespeare, Goethe and Victor Hugo. Your superior person finds the art of the New Gallery inferior to his vague memories of the treasures of continental museums; your commonplace person decries its costliness, and says, 'Why not turn out similar things in bulk, and so lessen the price?' As an American manufacturer said to the present writer at a previous exhibition: 'Well, sir, these things don't interest me any. I could turn out a thousand copies of each of them by machinery. Look at that copper dish – if I wanted to, I should just make a die and stamp 'em by the gross.' There spoke the soul of the bourgeois; and unless we happen to enjoy the evidence of personal thought and care expended on one piece of work for its own sake, the very best thing shown will only provoke similar, though possibly more elegantly expressed, criticism from the modern economist with his machine-made opinions. Of course there is half a very important truth in an objection to artistic works that are by their cost removed from the masses – for one would fain see the common pottery, the ordinary furniture and every-day objects of the houses as beautiful as possible. But the lesson the 'Arts and Crafts' aims to teach – that beauty is not to be found merely in ornament – is not yet learned by those who can afford expensive products, and has been long ago forgotten by the poorer classes, who take now their ideas of beauty from richer folk. Simplicity, in short, is unpopular to-day when the average advice, if given frankly, would be, 'If you cannot afford a well-made piece of furniture discreetly ornamented, choose one badly designed, badly made, with plenty of meretricious ornament, so long as it *looks its cost.*' In the last phrase one discovers the real objection to much excellent work; not because its design is good and its work lasting; Philistia with its theories of worldly

probity will approve of both, if only it proclaim to the world at large the high price paid for it.

5.15 Artistic tiles

Partly as a result of the interest in medieval art, which relied heavily on tiles for decorative effects, that medium became very popular, and presented an ideal form for that combination of art and industry which had become such an overriding preoccupation by the second half of the nineteenth century. In his *Great Industries of Great Britain* (vol. 3, p. 73, 1875), James Francis McCarthy described the painting shop in the Minton factory.

With the evidence of the fact so constantly before us, it is almost unnecessary to say that the decoration and ornamentation of tiles have in these days reached such perfection as to come within the region of high art. While there is much meritous decoration produced by the printing process, it is in painting on china tiles, used for various purposes of ornamentation, and on fancy hearth-tiles, that the most artistic effect is realised. The delicate and chaste painting on slabs of china is almost invariably performed by ladies with a skill that compares favourably with similar, and much more pretentious work on canvas. The painting of costly tiles – tiles which form bright pictures of the hearth that do not readily face – is always effected in their biscuit state. These tiles are passed into the department of the artists, and these gentlemen place them upon their easels, and with the colours which have been so carefully prepared transform the plain squares of clay into lovely pictures. The firing necessary to indelibly fix the colours lasts many hours. The tiles, after firing, are returned to the artists, who in putting the several pieces together can observe the general effect of their work, and very pleasing it is. For instance at one end of the long room, sacred to the artist's fancy, may be found a series of tiles illustrative of horses' and dogs' heads. They are drawn with such breadth, vigour, faithfulness, and animation, as to recall the skill of Rosa Bonheur (an animal painter who enjoyed a considerable reputation ⟨born 1822⟩). Further on may be seen tiles representing birds of many-hued plumage, which testify to the marked care with which the painter has portrayed these bright-winged creatures. At the other end of the room there are tiles treated in a conventional manner; whilst in the middle of the place there may be noticed a large number of pieces, perhaps more than forty, of tile-work, which when they are fitted up

in the destined fireplace will indeed beautify that hearth. The central design is a group of rose leaves – every blushing petal being minutely figured – with a border of dead leaves, the flowers being painted as only true artists can render them. When finished, the tiles are taken to the large warehouses, and there they are stacked in their tens of thousands.

5.16 Shakespeare in porcelain

In 1850 the Worcester Porcelain works, which had achieved a considerable reputation in the previous century, were taken over by W. H. Kerr of Dublin, who was anxious to give them a new vitality. The firm had always had a strong Irish connection, and in 1853 it was decided to produce a *chef d'oeuvre* for display at the Dublin Exhibition, one of the many progeny of the Crystal Palace exhibition. The subject chosen was a Shakespeare play, *A Midsummer Night's Dream*, and the artist responsible was W. B. Kirk, son of a Dublin sculptor. A special edition of the play was produced, which contained the following 'explanatory preface'; itself a model of the type of design appreciation popular at the time. The entire service consisted of a suite of plates and comports for twenty-four persons, and was acquired by 'an Irish nobleman'.

A Midsummer Night's Dream, being the play selected, is chosen, not only from its varied, light, and ideal character, but from its Grecian locality, which latter directly suggests the use of those charming forms and elegant decorations peculiar to classic art; and again, the difficulty of introducing with propriety so many figures of various sizes, which are absolutely requisite to suit the different pieces in the service, could not possibly have been overcome in the choice of any other of the plays.

We are fully aware of the difficulties with which we must contend in attempting to illustrate so charming a conception as *The Dream*, and to the designer there is nothing more trying or capricious than public criticism, – the more particularly so as each lover of Shakespeare will, no doubt, have already formed to his own fancy the characters introduced.

The figure of Shakespeare, as represented sleeping on the bank whilst in the act of planning his comedy, is much larger than any of his characters. The ass's head, with Puck flying through the tree, as well as the fairy heads proceeding from each branch, indicate how the poet's thoughts are passing. The beings, therefore, created by his fanciful imagination may, with all due license, be represented smaller, as fleeting visions of a dream.

The proportion of the Apotheosis has likewise been idealised, there being no given rule for the magnitude of allegorical figures.

The deification of the bard is illustrated by a female with out-stretched wings, holding his image graven on a star, emblematic of his immortality; whilst trumpeting his praises she bounds from the pinnacle, where she has

"—— Left his lofty name,
A light, a landmark, on the cliffs of Fame."

The Comedy and Tragedy are made largest of all, as presiding geniuses over the whole.

Having said so much in justification of the various proportions introduced, it is desirable to make a few remarks upon the different characters, and expression of each class of subject.

The groups of Athenian mechanics who are represented as re-hearsing and acting the *Lamentable Comedy* of Pyramus and Thisbe, have many points of expression and individuality, which it is only fair, in justice to the artist, not to pass over without some enlighten-ing comment for those criticisers of art who look for faults or beauties merely in the finish or formation of a limb, and thereby lose sight altogether of that which should be principally regarded; namely, the character of attitude and expression of countenance, which alone are the existing proofs that an artist can feel what he illustrates.

In the group of Sweet Bully Bottom and Wall, the self-satisfied, earnest, and clownish manner in which Bottom is engaged in look-ing through the fingers of Wall, may first serve as an example of what we have just asserted; whilst he who plays the stony part has fixed himself straight, stiff and immovable as that which he enacts, with his dull eye turned from his window/turret on the Duke and friends, to watch the effect produced by their inimitable perform-ance.

Moonshine is represented by a thick, short, stout man, with a very full, round face and bullet head, wearing a belt of stars around his moonship – his whole appearance bearing the aspect as if selected from amongst his compeers for a remarkable resemblance to that planet, which resemblance he endeavours to increase by standing in as circular a position as possible, with eyes upturned and face of comic gravity, making him appear still more ludicrous and ridicu-lous; the dog (which by a string he holds), well suited to his master, is engaged earnestly watching a worm that has fallen from the faggots held by the Moon, and utterly regardless of the fair This be,

who is put into a great disorder from the imagined danger, and is taking to her heels in a most inelegant and unladylike manner.

In another group we have Quince and Flute. Quince is an elderly, bony, skinny man, awkwardly standing in a position with his scroll of names, which evidently indicates, from his timid attitude, that reading is not an every-day task with him. Whilst Flute, the bellows mender, or the future Thisbe, is very naturally pointing out the budding hairs of puberty which are likely to incapacitate him from playing so fair a part.

'The Weaver is again introduced into another group, where he is represented in the wood with the ass's head. He stands in *his* most dignified attitude, to show his utter contempt for any fear of danger, whilst he turns round to address the wondering Snout with as much scurrility of countenance as the head of an ass is likely to assume. The Tinker is one of those that previously ran away frightened at the transformation, but he returns soon afterwards as if for the purpose of convincing his eyesight of the startling fact; his face and phrenological development are just the class where ignorance, with wonder and incredulous amazement, would most naturally reside.

The centre piece is entirely devoted to fairy ground; it is, there-fore, of no order of architecture, but simply a fanciful construction; it is divided into three classes; namely, the Jealousy, the Revenge, and the Reconciliation.

'It might be considered useless, perhaps, to enter into any further details concerning these ideal beings, as imagination may form them as it best pleases; still, however, it is as well to draw the attention to one or two points which may appear rather open to criticism; such, for instance, as Puck pulling the flower, being of a different size and shape from where he is represented on the salt-cellar. This may seem, to many, erroneous; but when we consider the variety of forms he assumes, – in his own words, 'sometimes a horse I'll be, sometimes a hound', &c., – having the power to do all this, we can just as well fancy him changing his shape in other ways, as if suitable for his several occupations.

Higher up in the same piece we find Titania awake, whilst the fairy behind her is supposed to be repeating the words, 'Hence, away', &c. It may be said she should be sleeping at that moment, but we are not to suppose her asleep till all the fairies are gone; and to strengthen the propriety of her wakeful moment, Mr Kirk has introduced "the clamorous owl" in the act of retreating from the bank, the noise of which may have startled her from a more easy attitude of repose. It is in order to have a variety of composition that

recourse to these little inventions is requisite. In the group adjoining, Titania is sleeping, whilst Oberon squeezes the flower on her eyelids; it would therefore, show great want of judgement were she to be represented twice in the same somniferous state.

5.17 Designing a funeral car

Death and its trappings were a major Victorian concern, and became incentives to a great deal of art and design. The death of the Duke of Wellington in 1853 was the occasion for a special effort by the newly emergent art bureaucracy in the Department of Trade, intended to be as much of a public relations exercise as an actual tribute to the dead hero. Richard Redgrave, who despite some counter-claims by others considered himself responsible for its design, recorded the various stages in its genesis in his diary (*Richard Redgrave, C.B. R.A. A Memoir*, by F. M. Redgrave, Cassell, 1861).

Although the great Duke had been dead some time, and Banting had shown the Prince Consort several designs for the car, made by a Frenchman, it was only on Thursday, Oct. 22nd, that our Department was called upon for suggestions. I well recollect that, as Cole and I walked home together, we talked over the sort of carriage it should be (since a carriage was required), and we settled that the coffin should be upon a bier, and that this bier should be mounted on a suitable vehicle; no sham, such as the upholstery ones already alluded to, but a real substantial work; and we decided that it ought to be of bronze. I made two pen-and-ink sketches on half a sheet of letter-paper, and showed them to Cole in the morning. They were for a solid six-wheeled carriage, with a design for a pall, the whole thoroughly simple, as was the character of the Duke, the only decorations being the pall, the armorial bearings of the deceased, his coronet and arms, and the names of his great battles. Cole thought the sketches satisfactory, and set Semper to make two more complete yet hasty designs from mine, during the day (Friday), as he proposed we should go to Windsor in the evening of Saturday, in order that no time might be lost. I was going out to our chess-meeting on Friday evening, but, in thinking over the changes which Semper had introduced into my idea during the day, I felt it was not improved, or, rather, that my idea of the matter was partially lost. As soon as I had dined, therefore, I gave up my party, and, setting to work, I made a larger sketch on tinted paper, which I still have, completing it by about eleven o'clock. During Saturday, Semper finished up his two sketches, and mounted them, and Cole and I took them with mine to Windsor, about 5.30 on Saturday afternoon.

Cole told the Prince that he thought the finest thing would have been, to have carried the Duke up from Walmer by soldiers, making several days' march of it; but he then showed first Semper's two sketches. The Prince looked at them, talked of those he had already seen (Banting's), and listened attentively to our idea of making the car a solid, substantial thing, rather than a piece of upholstery. I then unrolled my little sketch, and the Prince at once said, 'This is the thing!'

He then talked over the canopy, and about making it removable, suggesting various modes of doing so, and finally said my sketch was to be carried out. This was on Saturday evening, the 24th October. The funeral was to take place on the 19th November; thus we had little more than three weeks to model, cast, and complete a work of this magnitude, with all the added difficulties arising out of cross-interests and cross-jurisdictions – Lord Chamberlain, State upholsterers, Board of Works, Board of Trade, War Office – all with something to say. The Board of Trade treated the matter as the private affair of its officers.

This *mêlée* of interests makes the completion of the car in the time a perfect wonder. To render it at all possible it was necessary to prepare the work so that it might be placed in the hands of several metal founders at the same time. Bramah and Robinson, of Pimlico, had part; Tyler, of Warwick Lane, had the six wheels; Stuart and Smith, of Sheffield, the figures; Messenger, of Birmingham, the lions' head. The carriage was made in Chandos Street, Covent Garden. Now it was that Semper's great talent came into action; he was incessantly employed, night and day, until the completion of the car, and he ought to have every credit for the details and the carrying out. Cole's energy was very great, and I may fairly say that for three weeks we had no rest. There was all the embroidery to prepare, designed by Hudson from my suggestions, and carried out, at least much of it, by the ladies of the School of Art. I proposed a mode of hiding our unsightly mourning-coaches which were to be used on the occasion, and it was adopted; but this greatly added to the work, as there were eighteen or twenty carriages, each with four scutcheons, besides those for the twelve car horses, and the work for the pall.

At ten o'clock the night before, I saw to the last of the preparations, and rising at five, I started before six the next morning for Marlborough House. When I arrived there, I at once made for the tent in front of the Horse Guards, to which the car had been removed. They were still at work upon it, though several of the men

were dead-beat; some of them had been at work seventy or eighty hours without rest. Their food had been brought to them, and they snatched an hour's sleep at the workshops. Several of them, when I arrived, were asleep under the car. It had been raining heavily, but as day broke the clouds lifted like a veil, and the sun gilded everything with his golden rays. We wanted to remove the canopy, as it was not needed, but Lord Hardinge would have nothing more done. I felt there was too much added frippery – real laurels, arms, and cuirasses, but it was too late to make any change. Some errors in the make of the carriage had obliged the workmen to cut and change the spandrels over the wheels just at the last, and the haste in which the whole had been done, caused the starting to be an anxious moment.

As eight o'clock struck, a gun was fired. The curtains of the immense ordnance tent that shrouded the car were removed, and the car, with the coffin of the Iron Duke upon the bier, was displayed to the crowds of soldiers drawn up on the parade. The word was given to move. Each groom stood at his horse's head – they were twelve noble beasts (lent by Sir Felix Booth) – and like a ship launched from the slips, as they started with a burst, the car rolled majestically forth.

All went well until they crossed the road opposite the Duke of York's column. Here, some weeks before, the ground had been opened to lay down gas-pipes, and at this spot the massive wheels went in up to their naves. Here was a mishap! Had not the coffin been fixed on the bier with copper wire, it must have slipped off in the lurch it made. As it was, a foolish aide-de-camp galloped forward speeding the news of the misfortune; but a remedy had been prepared. The grooms whipped the gigantic brutes, which, with their feathers and trappings, reared and plunged fruitlessly, but a strong cable was quickly fastened to rings fixed along the timbers, sixty policemen ran out with one such cable on each side, the horses were again urged, and, rising steadily to its right position, the car proceeded safely on its way. I walked with it to Charing Cross, but was far too tired to proceed to St Paul's. I returned home very happy to think that my labours were so far at an end. I had had little rest, and some anxiety, as I was specially told I was not to undertake the work officially, which made me the more anxious. I received, however, £50 as a fee from the Lord Chamberlain.

5.18 Taste and ornament

The growing interest in 'applied art' was reflected in all kinds of ways; dress and jewellery were being influenced by current stylistic trends just as much as pottery or furniture. In the February issue of *The Magazine of Art* for 1879 Lewis. F. Day, one of the most influential writers on the subject, considered the implications, the dangers and the ambiguities of the conflict between taste and fashion in these matters.

The low condition to which ornament had fallen until within the last twenty or thirty years accounts fully for the slight esteem in which it has come to be held, and there is little doubt that the success of modern design will in time restore to decoration the prestige that attached to it as a matter of course in days when art and handicraft were scarcely distinguishable, and easel pictures were not supposed to be the be-all and end-all of art. Already there is a wave of reaction in this respect, and perhaps even a danger that the cause of decorative art may be swamped in a wave of fashion, to be left presently high and dry beyond the reach of public sympathy. However that may be, the interest in applied art is growing; people are beginning to realise that art is not altogether a matter of painting and sculpture. It is beyond dispute that the influence of our everyday surroundings must affect us, and I believe that they influence us much more powerfully than we are accustomed to suspect. It may be un-avoidable (but it is by no means beyond doubt) that some of us should have to live without beauty – and in that case it may be a relief to deaden the senses that take delight in what is beautiful – but, for all that, it is not just the same thing whether we live in the midst of beauty or of ugliness. Æsthetic culture is not the high-road to all the virtues, and, indeed, certain of the vices may be found as often in its train as elsewhere. Neither, on the other hand, is there any special grace in ugliness. Art is only utterance. It must express something; and the vital question is, what does it express? the daily association with honest, manly, real work, with graceful fancy, individual character, and refined art, must do one morally as well as in-tellectually, perhaps even physically good; and to live in the midst of false pretence and flimsy affectation, of heartless workmanship and dead monotony, must be equally demoralising. The fact that we may be wholly unconscious of the influence about us does not des-troy its effect. The fresh air is a tonic, whether we feel it to be so or not; and the germs of disease that emanate from a foul atmosphere are none the less fatal though our nostrils may not be sufficiently delicate to make us aware of the poison we breathe.

It becomes essential, then, seeing that we cannot do without decoration, and therefore cannot escape its influence either for good or bad, that we should make ourselves at least so far acquainted with the subject as to keep within the bounds of taste. The first difficulty in the way of the acquirement of this limited amount of knowledge is the assumption that every educated man or woman is *de facto* already possessed of the faculty of taste. So firmly is this infatuation rooted in men's minds that it amounts to an insult to question their taste. This is owing in part to a confusion of the different senses in which the word is used. Bad taste may mean bad breeding, and no one cares to be accused of that. Again, taste may be understood to signify liking, and in respect to liking every man must be a law to himself. But in reference to art there should be no mistake about the meaning of the word. Liking is one thing, and taste quite another. One may heartily dislike a thing, and yet acknowledge that it is good; and the faculty that enables us to realise that fact in art is taste. A competent critic, if he is honest, admits in calmer moments that his judgement is biassed by personal predilection, and that he is not unerring. It is reserved for the average English gentleman to assume calmly that his likes and dislikes constitute good and bad in art – only in art. In other respects he is sane enough. He does not argue with his solicitor or pretend to prescribe to his physician. He goes to them for advice, and whether he acts upon it or not, the fact that he is prepared to pay for it argues that he attaches some value to it. It is true that society does not insist that a man should be versed in the law or in medicine, and that it does demand that he should be able to converse about art. But society appears to be quite innocent of what nonsense he talks when he begins. If for a moment he could but see himself as artists see him!

The expression of a man's honest preference without prejudice and without affectation is valuable in proportion to his experience and character, and there is no particular reason why he should keep it to himself; but the cool way in which those who never held a brush since the days of their childhood pretend to determine what is good and bad, 'well painted', or 'out of drawing', would be amusing if it did not stand in the way of all true appreciation of what they are talking about. Lookers-on see the best of the game, it is true, but not unless they know its rules. For every fault that the mere *dilettante* really discovers in a work of art there are possibly a dozen merits that he fails to detect; and if he flatters himself that he has detected precious qualities in a work unrecognised by the profession, the probable reason for its neglect, if it has indeed the merit he sees, is

that it is marred by grave faults of execution of which he has no
suspicion. It would be only decently modest in him to assume that,
whenever he differs from a painter as to a matter of fact which he has
himself not particularly studied, he is in the wrong, for the painter
probably has studied it.

The difficulty is in proving the excellence of any work of art,
owing partly to the intangible nature of its highest qualities, partly to
the vagueness of the common terms in use. But there is a good and
bad – whether in poetry or in painting, or in the arts of design. If in
his own art a man does not know better than others what is well
done, he ought to. It may be admitted that there are qualities con-
cerning which a critic from the outside is perhaps the better judge –
the poetry in a painting, for instance, would be more truly
appreciated by a poet than by a prosaic brother brush – but these are
qualities that are not to be taught. The excuse for discussing chiefly
what may be called *technique* is that it is the only discussion which is
profitable. The grammar of art is not the end in view, but it is the
only road to it; and if any one fancies that he has genius, let him
make haste to learn the ABC of his profession, for without it he will
not compete successfully with rivals who know the alphabet and
nothing more.

Were proof wanting of the absence of cultivated judgement
among us, it would be enough to point to the omnipotence of
fashion. So little does 'the education of a gentleman' teach him about
taste, design, or workmanship, that he is at the mercy of the latest
novelty. And it is not too much to say that the higher a lady's
station, and presumably the more 'polite' her education, the more
imperative it seems in her eyes that she should keep pace with
custom, and march to the tune of the fashion-mongers. A stupid
jingle it may be, but it is artful enough to make the world forget that
the fashions are furnished in the interest of their providers only,
regardless altogether both of art and of economy. The habit of
referring to the shifting fashion rather than any fixed principles of
taste as a standard is not only proof of our ignorance, but provo-
cation of half the hideousness with which we are oppressed. How
meek we are! How we resign all individual preference of form or
colour or design, and obediently produce our purses to the magic
formulæ, 'the last new thing, sir', 'the latest fashion, madam'!
Fashion is a comedy in which taste plays quite a small part. So
persistently have we followed in the false track that the very sense of
what is appropriate, becoming, or beautiful grows dull. Even vanity
succumbs. What art there may be in dress consists, obviously, in the

skilful adaptation of costume to the form and features of the wearer, in diverting attention from bodily defects and setting off beauties to advantage. But fashion pulls the wires, and we answer to them. No matter whether we be short or tall, stout or thin, we wear a greatcoat that reaches down to our heels, if only the tailor so determine. Ladies wear their hair in bands or ringlets, crimped or padded, all down their backs, or tied up tight like the tail of a cart-horse, always *à la mode*, and usually without reference to their own particular style of beauty. Fashion, who crept into the service of vanity as her slave, well content to make herself generally useful, is mistress now, and lords over us despotically; humbly we disfigure ourselves; without a murmur we distort our solitary grace or beauty, and expose our very deformities at her bidding – and we fancy we have taste!

Look at the jewellery we wear. There, if anywhere, is an opportunity for the exercise of refined and delicate appreciation of what is beautiful, for in most cases beauty is the only excuse for its existence. If we cannot afford to wear intrinsically beautiful trinketry, we can do very well without it. Not that there is any reason why it should be costly. The jewellery until recently worn by the peasant women of Normandy, Norway, Switzerland, and other European countries, now in imminent danger of being altogether superseded by the attractions of more modern, showier, and altogether worthless Parisian and Viennese manufactures, was strictly peasant-jewellery – the metal chiefly silver, and the stones chiefly garnets; but it was good work and well designed, worth transmitting from mother to daughter, and not fit only to be flung under when the fashion had passed by. Men of taste have been collecting and buying up the old examples of this kind of work. Will any one be likely to buy up the flimsy trumpery that has superseded it?

Even the costly work now found in our best shops will be chiefly valuable for the weight of its gold and the water of its diamonds. There is this to be said of the better class of modern English goldsmith's work, that a certain honesty characterises it. It suggests 'value received'. But this very character shows how little the artistic element in design is considered or sought after. The Indian jeweller, according to Dr Birdwood, thinks nothing of the intrinsic value of the precious stones he employs. He is an artist, and to him the value is in their colour, sheen, effect; he cares as much for them as a painter cares for his pigments, and no more. They are simply a means to his decorative end. The consequence is that he is able to use rich emeralds and rubies as lavishly as if they were enamel, and

wherever he wants a point of light, bits of diamond are at hand, commercially of no value, but artistically as valuable as though they were priceless.

Our idea of jewellery is altogether the reverse of this. We must have fine and flawless stones, and thick masses of heavy gold. At great cost we succeed in producing poor, cold, lifeless rings of gold, more like gilded fetters, studded with isolated stones; or we throw rare diamonds together *en masse,* producing, at fabulous cost, an effect far less gorgeous than the comparatively inexpensive Eastern work. The art among us appears almost to decrease in proportion to the increase of the value of the materials. Sometimes we see a gem that a collector might envy, more often a diamond that is not ill-set, but never a ring that Holbein or Cellini might have been proud to have designed. With regard to diamonds, the greater the quantity of precious stones, the more closely they seem to have been put together, after the pattern of the flaring illuminations which draw attention to the entrances of the London theatres.

The root of all evil here, and in so many other arts, is the innate and seemingly irrepressible passion for display, which finds vent among the poorer classes in Brummagem jewellery, and shows itself in rich ones in the choice of watch-chains, necklets, tiaras, and bracelets, whose sole value and sole interest consist in the number of rare diamonds and the weight of gold. Only in so far as they are beautiful do such things deserve the slightest attention from a decorative point of view. Diamonds may be a valuable investment, a convenient form of settling money on one's wife, a ready means of advertising one's wealth; but this has nothing to do with art. The Indian craftsman is altogether in the right, and every artist among us must sympathise with him. Those who do not, those to whom money value is more than beauty, can lay no claim to any feeling for art. The clumsy ornaments so much in vogue with us are none the less blunders that the blundering is peculiarly British. It is always dangerous to dogmatise, but I dare to say that, in pure luxuries like jewellery, the value of the art expended on an object should invariably be in excess of that of the mere matter on which it is expended. The fact that a thousand pounds' worth of diamonds are thrown together without a thousand pennies' worth of art is conclusive proof in itself that the wearer does not put on jewels for the sake of ornament. The love of show which is here so unpleasantly prominent steps in everywhere in decorative and domestic art, and leads us astray from the simplicity and modesty that are at the bottom of all good work, and that should especially characterise the art that we live with every day.

5.19 **Decorative art for women**

In *The Magazine of Art* for 1881 Lewis F. Day criticised the dilettantism which marked female forays into decorative art in an article entitled 'The Woman's Part in Interior Decoration'.

It is the fault of the education of ladies that they realise so little what goes to make proficiency in decorative art. . . . Their time has been spent in acquiring accomplishments which accomplish nothing. . . . The lamentable outcome of this unkind kindness is that when a lady, as so often happens, is reduced to want employment, she fancies that the half-developed faculties which have been wont to win the praise of friends will enable her to earn a livelihood. . . . It is one of the pressing questions of our time – How shall poor gentlewomen support themselves? – and many imagine that the career of art, and of decorative art especially, is open to them. So it is – or would be if they had been trained to it. . . . The real source of their distress and trouble is in the prejudice which men hug to themselves with more than feminine infatuation, that a man is degraded by allowing his daughters to work for their own living. . . . When a young woman is all at once thrown upon her own resources, with a *necessity* of earning immediately her own living, those resources seldom prove adequate, and that necessity of at once earning an income makes impossible the study that should by rights have preceded the exercise of a profession. . . . When one has arrived at a certain proficiency in one's craft these accomplishments begin to be valuable, but till then they are sometimes even a hindrance.

5.20 **Dress as an art form**

Lucy Crane, sister of the famous Walter and an influential lecturer of the time, was one of the first commentators to develop a consistent approach to dress and fashion. Her *Art and the Formation of Taste*, published in 1882, with illustrations by Walter, and the less well-known Thomas, consisted of six lectures, delivered at a variety of places, predominantly in the north of England. They cover a wide range of themes, but consistently attempt to apply 'fine' art to the more humdrum things of everyday life. Although her thinking was clearly influenced very much by William Morris, her application of these ideas, expressed in clear and ungushing prose, was generally stimulating.

That dress becomes an Art from the moment it ceases to be merely a covering and a protection from weather, – need not be doubted. We

often read of the dress of savages, which consists frequently more of decoration than of anything else; and we read of the fine linen in which Joseph was arrayed by the hands of Pharaoh.

So does needlework become an Art from the moment that it is more than merely a drawing of the edges of skins together with a fish-bone needle, which was probably the earliest kind of sewing; and in the fifteenth century before Christ we read of embroidery in blue and in purple, in scarlet and in fine linen.

Both these Arts in their various departments and branches fill in some way or other so large a part in the lives of women now, and have done so in all past time, that it cannot but be well to learn to think clearly and reasonably of them – practising the Art of Needlework with pleasure and intelligence, fulfilling the requirements both of beauty and use, and in the Art of Dress, which we must all of us practise whether we will or no, still fulfilling the same requirements, conforming to fashion to a certain extent, but not blindfold and with too great confidence, always reserving the right of private judgement, and with it the charm of individuality – style in its true sense. The greatest objection to the despotism of fashion is the uniformity it leads to. It is surprising how willing people are to forsake their own rights in this matter, and seriously aim at looking like every one else; the fringe of hair worn, however becoming it may be to some young faces, however piquant in effect it may sometimes be in itself, has the tendency to make every young lady look alike, and destroy the effect of individual attractions. There are no doubt good principles, good customs, lying at the root of some of the prevailing fashions of the day, which those who decry them are apt to ignore; as, for instance, when a fashion for short dresses lasts for any length of time, we may be sure that a healthy custom of walking much in the open air prevails among women.

Those parts of the fashions that originate in reasonable requirements, habits, customs, hours, – these are always rightly to be followed; but those other parts that have their origin in a mere thirst for novelty or love of display, should be looked at with suspicion, and not too hastily adopted. The fashion of the garments of the last few years has had this advantage, that it has offered plenty of freedom for individual taste, whenever people were willing to take advantage of that freedom, besides possessing in itself many elements of grace and comfort, of beauty and use. But there always seems to be the danger of spoiling a good idea in costume by exaggeration. Not content, a few years ago, with the stateliness and dignity of ample flowing skirts, we distended and stiffened them

with wire cages; and in later years, not content with scantier and more graceful drapery, expressing the harmonious lines of the figure, we bound our dresses tightly round us, almost abolishing falling folds, and scarcely allowing ourselves room to move. I suppose that the height of the fashion now is a happy combination of both the tightness and the crinoline. Some fashionable milliner invents a bead trimming, and we clothe ourselves in beads from head to foot. Some fashionable lady, with a brilliantly clear complexion, finds black lace becoming, and instantly white frills, collars, and cuffs vanish from the scene, to the detriment of many a less dazzling bloom. There are also useless and ugly superfluities attending the fashion of the day, respecting which we should do well to question ourselves. All kinds of things added on after the dress itself is assumed should be looked on with suspicion. A modern writer estimates the number of articles of clothing and adornment that a woman has on by the time she is fully dressed at forty-nine. Out of these surely some may be superfluous. A year or two ago I used frequently to notice that a young lady would wear round her neck, in morning dress, a collar, a lace tie, a tight velvet, a ribbon, a brooch, and a chain and locket, – that would make seven out of forty-nine. But I think that now more simplicity prevails.

And before I leave this part of the subject, I must ask you to bear with me if I join my feeble protest to the many powerful and able ones raised against a fashion – an epidemic, rather – which has arisen, subsided, only again to reappear at different periods of modern history. I have reason to think that it is raging at present with some severity; and its victims are supposed, not without reason, to yearly swell the bills of mortality. I mean the epidemic of tight-lacing. Those who wilfully incur the consequences of this practice must have strangely incredulous minds; they disbelieve all doctors, as a matter of course, and, what is more to my purpose, they disbelieve artists; and the verdict of all the ages as to the beauty of antique statues has, for them, been given in vain. The Venus of Melos and all the goddesses of Olympus are to them as nothing. Instead of a gently undulating line from the shoulder to the hip, they prefer a sudden sharp bend like the narrow part of an hour-glass. In times when figures of the hour-glass contour are admired, there can be no good sculpture; for there is scarcely any natural beauty of figure, or ease and grace of movement, left for the artist to admire, to learn and study from.

In a discourse delivered, more than a hundred years ago, by Sir Joshua Reynolds to the students of the Royal Academy, he says, after

some allusions to the taste of that day in dress: 'All these fashions are very innocent; neither worth disquisition, nor any endeavour to alter them; as the change would, in all probability, be equally distant from Nature. The only circumstance against which indignation may reasonably be moved is where the operation is painful, or destructive to health, such as some of the practices at Otaheite, and the strait-lacing of the English ladies, – of the last of which practices, how destructive it must be to health and long life the Professor of Anatomy took an opportunity of proving a few days since in this Academy.'

This was spoken by Sir Joshua on December 10, 1776. It is sad to think that so many of the English ladies are still unconvinced, though many professors of anatomy since that day have said the same thing.

'I believe true nobleness in dress', says Mr Ruskin, 'to be an important means of education, as it certainly is a necessity to any nation which wishes to possess living art, concerned with portraiture of human nature. No good historical painting ever yet existed, or ever can exist, where the dresses of the people of the time are not beautiful; and had it not been for the lovely and fantastic dressing of the thirteenth to the sixteenth centuries, neither French nor Florentine nor Venetian art could have risen to anything like the rank it reached. Still, even then, the best dressing was never the costliest; and its effect depended much more on its beautiful – and, in early times, modest – arrangement, and on the simple and lovely masses of its colour, than on gorgeousness of clasp or embroidery.

'The splendour and fantasy even of dress, which in these days we pretend to despise, or in which if we even indulge it is only for the sake of vanity, and therefore to our infinite harm, were in those early days studied for love of their true beauty and honourableness, and became one of the main helps to dignity of character and courtesy of bearing. Look back to what we have been told of the dress of the early Venetians, that it was so invented "that in clothing themselves with it they might clothe themselves also with modesty and hon-our"; consider what nobleness of expression there is in the dress of any of the portrait figures of the great times; nay, what perfect beauty, and more than beauty, there is in the folding of the robe round the imagined form even of the saint or of the angel; and then consider whether the grace of vesture be indeed a thing to be des-pised. We cannot despise it if we would, and in all our highest poetry and happiest thought we cling to the magnificence which in daily life we disregard. . . . I do not merely mean magnificence; the most

splendid time was not the best time. It was still in the thirteenth century, when simplicity and gorgeousness were justly mingled, and the leathern girdle and the clasp of bone were worn, as well as the embroidered mantle, that the manner of dress seems to have been the noblest. The chain mail of the knight, flowing and falling over his form in lapping waves of gloomy strength, was worn under full robes of one colour in the ground, his crest quartered on them, and their borders enriched with subtle illumination. The women wore first a dress close to the form in like manner, and their long and flowing robes veiling them up to the neck, and delicately embroidered round the hem, the sleeves, and the girdle. The use of plate armour gradually introduced more fantastic types, – the nobleness of the form was lost beneath the steel; the gradually increasing luxury and vanity of the age strove for continual excitement in more quaint and extravagant devices; and, in the fifteenth century, dress reached its point of utmost splendour and fancy, being in many cases still exquisitely graceful, but now, in its morbid magnificence, devoid of all wholesome influence on manners. From this point, like architecture, it was rapidly degraded, and sank through the buff coat and lace collar and jack boot, to the bagwig, tailed coat, and high-heeled shoe, and so to what it is now.'

I suppose Mr Ruskin would not allow us to think that there is any good thing in modern dress; but, rather than sink into utter depression and hopelessness, let us consider what good there is and seek to increase it. I know that in these days some intelligent ladies have learned the art of dressmaking on purpose to modify and improve the form and constuction of our garments, and I am in hopes that the reform may be complete and lasting. Few women who have work to do in life, their living to make, or families to care for, can take the trouble to set fashion at defiance and wear a self-devised costume, – the opposition to established rule; the difficulty of getting original ideas satisfactorily carried out; the becoming an object of special remark and comment to one's friends and the general public; these things seem to hinder such an enterprise, and make one feel that more is lost than gained by the attempt. All that, I think, we can clearly see our way to is, by observing reason and simplicity in moderately fashionable attire, to gradually lead the way to improvement.

As to form of garments, speaking generally, soft, long, flowing lines must always be the most graceful: they add to the apparent height when it is desirable to do so, while lines and folds across the figure shorten it. Any tightness *across* any part of the form is a

discord, and must destroy the gracefulness of the whole. Any shape that *seems* to fetter and confine, and any that *really* does so, is defective; if a garment interferes with freedom of action there must be something wrong with it. And as to the laying on of trimming, rows and rows of buttons never meant to button, sham button-holes actually constructed of bits of silk and cord laid on, bows of ribbon never meant to tie, immovable lattice-work of cords or laces, sham pockets where none exist in reality, – there can be no possible use or beauty in these. If the material of a gown is rich and soft, and if it is well cut and fits well, every piece of superadded trimming goes to spoil the effect. I except, of course, lace, which softens and harmonises the general effect, and fringe, when its origin is not too hopelessly lost sight of, – that it was first the fraying out and knotting of the edge of the stuff in certain quantity. And if the material is plain and ordinary, and intended for ordinary occasions, there is all the greater reason to keep the dress simple, and to avoid an elaborate and over-studied appearance. A rigid inquiry as to the use and beauty of every piece of added trimming and adornment we often mechanically wear, would lead, I am sure, to many details being discarded, to the manifest improvement of the general effect.

5.21 Rational dress

Never before had dress been so closely allied to aesthetic beliefs, often associated with vaguely ethical considerations. Organisations such as the Rational Society and the Healthy and Artistic Dress Union were strenuous in their activities; ardent in their beliefs. Inevitably *Punch* took notice (1882, p. 254).

<div align="center">

The Rational Dress show
(By Our Fair Correspondent)

</div>

In the Hall of the Prince is a Show – stuffs and chintzes –
 (O Maidens of England, pray list to my song!)
For all there displayed is a warning that Ladies,
 In matters of dressing, are terribly wrong!
I thought my new bonnet, with roses upon it,
 And tasteful costume, was complete, I confess;
But now I'm reminded my eyes have been blinded
 To all the requirements of Rational Dress!

We look at the models – they puzzle our noddles –
 Regarding them all with alarm and surprise!
Each artful costumer revives Mrs BLOOMER,
 And often produces an army of guys.
The costume elastic, the dresses gymnastic,
 The wonderful suits for the tricycle-ess –
Though skirts be divided, I'm clearly decided,
 It isn't my notion of Rational Dress!

See gowns hygienic, and frocks calisthenic,
 And dresses quite worthy a modern burlesque;
With garments for walking, and tennis, and talking,
 All terribly manful and too trouseresque!
And habits for riding, for skating, or sliding,
 With 'rational' features they claim to possess;
The thought I can't banish, they're somewhat *too* mannish,
 And not quite the thing for a Rational Dress!

Note robes there for rinking, and gowns for tea-drinking,
 For yachting, for climbing, for cricketing too;
The dresses for boating, the new petticoating,
 The tunics in brown and the trousers in blue.
The fabrics for frockings, the shoes and the stockings,
 And corsets that ne'er will the figure compress:
But in the whole placeful there's little that's graceful
 And girlish enough for a Rational Dress!

'Tis hardy and boyish, not girlful and coyish –
 We think, as we stroll round the gaily-dight room –
A masculine coldness, a brusqueness, a boldness,
 Appears to pervade all this novel costume!
In ribbons and laces, and feminine graces,
 And soft flowing robes, there's a charm more or less –
I don't think I'll venture on dual garmenture,
 I fancy my own is the Rational Dress!

5.22 Colour in dress

Aesthetic dress and all its subsidiaries, such as 'rational dress',
greatly preoccupied many minds, and emphasised the universality of
stylistic standards which were beginning to apply to most aspects of
life. In the February issue of *The Magazine of Art* for 1882 Lucy
Hemingham discussed with some seriousness some of the problems.

It is not known whether she was a member of that influential body, the Healthy and Artistic Dress Union.

There seems to be a prevailing impression that if womenkind dress themselves in olive-greens and *teints dégradés*, their garments will immediately become pleasing to the lover of the beautiful. It takes more than this to make dress attractive. Decided colours are to be unhesitatingly preferred to demi-tones and drabs and mixtures. If we can give people pleasure with no more trouble to ourselves than wearing a colour wholesome to the eyes, we may as well do so. But by decided colours I would not be thought to mean crude colours and coarse dyes. In this climate Nature teaches us to use colours in rich but subdued tones, especially when they are presented in any mass. Grass is not really emerald-green; look carefully at the brightest green field, and you will see that it is toned with a delicate bloom of grey, purple, or reddish. The reds and yellows of sunset are nowhere without hints and suggestions of purple. The brilliancy of flowers we can scarcely emulate; and if we could, the mass of bright colour would be too large. The right use of very bright colours is to adorn our dress as flowers adorn the landscape.

In choosing colours, then, those are best which suggest a toning down of brilliancy – in which there seems to be a sort of bloom over the dominant shade, or where another colour mingles with it subordinately: as blues which suggest green, reds which suggest purple, purple that suggests russet, and effects of that sort. The suggested colour may often be used in accessories to the dress, or the embroidery upon it; but to do so requires great care and a good eye for colour. Green-blues, for instance, harmonise with blue-greens; as we may see in peacock's feathers. Red and blue purples are sometimes exceedingly beautiful together; as witness many an autumn landscape. In the Canariensis is displayed an exquisite combination of yellow and yellowish-green. Autumn, again, gives us beautiful harmonies of yellow-browns and olive-greens. It is quite impossible to particularise all the pleasing combinations of colour that are possible, even if I limit myself to two colours in each; if I take three colours in each, the number of possible combinations becomes far larger. A flower, a brilliant jewel, a rich embroidery, may be used to give point when two or more subdued colours are already used. It must not be forgotten that many and totally different effects are producible by the use of two same colours, as the one or the other is employed in larger proportion. It is frequently admissible to use them in one key only. Thus, a small quantity of bright red may be used with a large quantity of subdued blue; a small

quantity of blue with red would not look well at all. Green trims dark blue better than dark blue trims green, but light blue can be used to trim dark green. I have seen very pretty dark blue dresses with lighter trimmings of green in smocking and embroidery, and a dress of green satin delicately embroidered with blue of a lighter shade than its own.

There are many ways of introducing harmonising colours into dresses. Most people have the one method – a not particularly pleasant one – of throwing in bows of tinted ribbon. Bows are all very well in their place – when they tie, or may be supposed to tie, something; but one does not want a gown to be a mere opportunity for bows. Dainty needlework, in colours chosen carefully to suit the groundwork of the dress, is one of the aptest vehicles for the intro-duction of colour. Sometimes a portion of the dress may be lined, or the neck and wrists may be bound over, with velvet of a harmonis-ing tint; as russet-brown on olive-green, or dark green velvet upon peacock-blue, and so on. Sashes chosen in the same way, not to match the dress, but to introduce a rich half-tone, are often very attractive indeed.

The complexion, hair, and eyes of the wearer must always be considered. People with reddish-gold hair and light blue or grey eyes look wonderfully well in rich warm browns, and sometimes in yellow; but they would probably look ridiculous in peacock-blue or scarlet. Dark people with clear skins and rich complexions can often wear warm, deep colours, but do not look at all well in light blues and faint exquisite pinks. Golden hair inclining to flaxen is greatly enhanced in beauty by greens toned with yellow, and by peachy purples. There are people with a grey look about them who never look better than in quaker hues, and others with a delicate bloom of pink and a clear skin with blue veins, who look equally well in either pale blue or pale pink. These combinations of complexion and colour might be varied *ad infinitum*. It is ridiculous to see people of all complexions donning the 'colour of the season', in obedience to the dictates of fashion, without the slightest regard to fitness or propriety. I am constantly told that some lovely colour is old-fashioned. Fortuntely there are some shops yet – as Burnet's and Liberty's – where you can buy old-fashioned colours; so that you may still practise in your own garments a refreshing change from the general livery.

6. Divisions of taste

Opposing factions in art; Aestheticism, Impressionism and after

6.1 Prosaic pictures

Lucy Crane, sister of Walter, and author of *Art and the Formation of Taste* (cf. also p. 387), tackled the problem, apparent to many of her contemporaries, of the difference between 'high' art and the sort of pictures which appeared in such profusion at the exhibitions of the Royal Academy and countless other institutions. The most obvious thing which comes out of her reflections is the deep sense which many of her contemporaries possessed of what they saw as the ugliness of late-nineteenth-century life. 'Little beauty of form or colour can be found in groups or assemblages of ordinary English people'; contemporary fashions are awful; chimney-pot hats an abomination and so on. It was this flight from reality – very different from the attitude which informed the work of a Courbet or a Manet, which was responsible for both the derision and the support which the aesthetic movement generally attracted.

Every year, with the flowers of spring, bloom some hundreds, nay, thousands of pictures, in the London exhibitions; in other places they appear later in the summer or the autumn. They flourish for a month or two, weathering the cold blast of criticism, or basking in the sunshine of public favour, or withering under the general neglect. At the end of the season they are gathered by purchasers to be transplanted into private collections, or they return into the hands of their originators; in any case, for the most part, they disappear, forgotten by the world at large, and their successors year after year bloom and pass away in like manner. Every one would feel a strange want if the season brought no show of pictures; it would seem like an interruption of the course of nature. They are a necessity of social life, a safe theme for discussion, a fruitful subject of small-talk. And these assemblages of pictures – but for about a score or two, which *do* possess some originality of treatment or some remarkable power of execution – might consist of the very same pictures year after year, such is the similarity of their subject, the constant repetition of the same manner, the same ideal. Who does not know of old the portrait

of a lady in red velvet or white satin, on a terrace; the official gentleman with his arm-chair and inkstand; the flower-pieces; the fruit-pieces; the cottage interiors; scenes of domestic happiness or affliction? There must be a large demand for these things, or there could not be so abundant a supply. In all of them the artist, it seems to me, makes himself into a sort of shopman. The public wants these articles, and he supplies them accordingly: every year, so many baskets of fruit and flowers, so many acres of Welsh or Scotch or Swiss scenery, so many yards of satin and lace, so much fashionable attire, and so much sentiment and domestic affection.

If people must have these things to cover their walls with, simply as part of the furniture of a room, let them by all means; but they are not worthy the name of pictures, and should be judged of by a different standard – that of the picture dealer – and treated as articles of commerce. They are not pictures in the sense that Raphael's 'Sacrament' or Titian's 'Flora' are pictures. The painters of them stoop to supply the wants of the age; the true artist raises the age up to his level. He shows us different aspects of persons and things, new facts about them, new ideas; he makes us see what we have never seen before, feel what we have never felt before. If any picture we know has done something of this kind for us, we may be sure that it is a real work of art.

It is not that the *subjects* of such pictures as I have described are in fault, but the *ideas*, or rather *want* of ideas, expressed in them. That very portrait of a lady, with meaningless, simpering face and over-gorgeous attire, might have been an interesting and graceful subject if the artist had set himself to discover, to express the interesting side of her character and the subtler graces of her demeanour, instead of caring so much about her jewels and her velvet gown, as to make them the most prominent things; it seems, too, as if the lady must have cared about them unduly too.

So with the portrait of a gentleman. There *must* be something in his character, his powers, his brains, that is more interesting than the shininess of his coat, his inkstand, his arm-chair. Very likely it is a good likeness as regards shape and size of features; but the painter should do something more. Sir Joshua Reynolds seems to have had the power of discovering in faces and figures – that often, no doubt, seemed sufficiently commonplace to the rest of the world – some nobility of expression, some grace of form or tenderness of colouring; so that in all his portraits the subject has the air of being somebody, distinguished by some gifts of mind or person that the painter knew how to seize and avail himself of, – at the same time,

we may be sure, passing over defects, and ignoring the disagreeable and the positively unbeautiful. For these reasons have his pictures been treasured and handed down, their beauties explained, commented upon, and praised afresh by each succeeding generation of the family to whom the original subject belonged; so that it has become a distinction highly prized, a kind of patent of gentility (in a good sense), to have a Sir Joshua in the family. This is what the art of portrait-painting may be, and what in one or two modern painters' hands it still is. A coloured photograph is just as valuable as the average portrait. Of course it is faithful, but we want something more; we want to be made to feel the application of the human mind to the subject; we want some idealising, some transforming power. The same with landscape. The true painter, in choosing a natural scene for his subject, does not seek to get everything that he sees into his picture, but to get what makes the beauty of that scene, and to leave out what does not. There is often something jarring, something incongruous, in a real scene or that would be so if it were put into the picture.

In a landscape, or in some accidental grouping of real figures, Nature is so complex, and crowded, so full of infinite details of form and tint, that it would be a life-long and fruitless labour for a painter to set himself to reproduce even a very small part.

This should not be difficult for any one to understand who has practised in any degree the art of drawing. I do not mean copying other drawings – that is merely, as Hogarth said, 'pouring water from one vessel into another', – but really drawing something from nature, say, a flowering branch. The very outline itself is a bold stretch of imagination. There is no outline in Nature. There are masses of colour and light and shade relieved against other masses of colour and light and shade, and the outline is a device for defining the exact point where they begin and end. And, beside the outline, there is much more: when we think we have it correctly, – and that is not easy, for people are so apt to draw a thing as they think it ought to be, not what it really is, – then come light and shade, colour, projection, space; our difficulties are multiplied a thousand-fold; we very soon find that some details, some irregularities of form and surface, some lights, some shadows must be left out, – they are too infinite and crowded for us; we begin to feel that the thing for us to study is the inmost character of the object we are drawing, and our business must be to express that, leaving many details alone. So must it be on a larger scale: the artist must penetrate the innermost spirit of the person or scene he paints, and show it to us no longer obscured

by the commonness of the detail of every-day life and appearance – but this is asking a great deal; – and the painter's aim, his thought, his motive must be distinct and clear in his own mind, in order to appeal to ours; and, besides this, great technical knowledge and mastery are needed in order to paint the simplest subject worthily.

It is impossible to refuse to see that the England of to-day does not afford a favourable soil for the growth of Art. Science, Commerce, Literature, flourish; but Art, considered in its relation to the world at large, languishes. All the social or public scenes of modern life lend themselves more readily to caricature than as subjects for great pictures. Little beauty of form or colour can be found in groups or assemblages of ordinary English people; we have no leisure to culti-vate such things; we are too full of cares, of pleasures; we are for ever busied in the making of money, or else the spending of it; there is too much to do, too much luxury, too little simplicity. This is expressed in the costume of the day, of men and women too; it is too tight-fitting, too crowded with mean detail. Think how the golden copes, the jewelled mitres, the armour of steel inlaid with gold and silver, and plumed and crested head-gear of a former age, compare in pictorial effect with the black-silk gown, the lawn sleeves, the pad-ded coat and chimney-pot hat of this. The degeneracy of costume in modern times is a great hindrance to all but exceptionally gifted painters. Pictures of incidents of modern life, in which the figures are clothed in the height of this year's fashion, are sure to look quite out of date and dowdy in a year or two. Compositions representing weddings, and picnics, and such-like scenes, in which the chimney-pot hat flourishes in great perfection, are to be found in every exhibition. The life they depict has no pictorial aspects; the painter has no thought to express, no beauty to reveal, – only a little sentimentality, a little feeble moralising. Still there are English pain-ters of the present time, of much higher aims, whose works range from poetical interpretation of Nature in landscape, from noble portraiture up to paintings of a higher order, still aiming at ideal beauty, and appealing almost exclusively to poetical ideas. It is not possible for me now to enumerate these artists, or to describe their pictures; they can be easily singled out by those who truly care for art in its highest sense.

6.2 The Aesthetic ideal

Underneath a good deal of aesthetic theorising there existed a hard core of pragmatism. In the conclusion to *The Renaissance*, published

in 1873, Walter Pater provided a classic statement of the idea of sensation, which gave the book an immense popularity, despite the fact that he removed it from the second edition in 1877, but restored it, with slight alterations, to the third in 1888. He feared, at one point, it would seem, in case it had a bad effect on the young. Despite the luscious prose, it is not as removed from actuality as some have supposed.

To regard all things and principles of things as inconstant modes or fashions has more and more become the tendency of modern thought. Let us begin with that which is without – our physical life. Fix upon it one of its most exquisite intervals, the moment, for instance of recoil from the flood of water in summer heat. What is the whole physical life in that moment but a combination of natural elements to which science gives their names? But these elements, phosphorous and lime and delicate fibres, are present not in the human body alone; we detect them in places most remote from it. Our physical life is a perpetual motion of them – the passage of the blood, the wasting and repairing of the lenses of the eye, the modification of the tissues of the brain by every ray of light and sound – processes which science reduces to simpler and more elementary forces. Like the elements of which we are composed, the action of these forces extend beyond us; it rusts iron and ripens corn. Far out on every side of us those elements are broadcast, driven by many forces; and birth, and gesture and death and the springing of violets from the grave are but a few of ten thousand resultant combinations. That clear, perpetual outline of face and limb is but an image of ours, under which we group them – a design in a web, the actual threads of which pass out beyond it. This at least of flame-like our life has, that it is but the concurrence, renewed from moment to moment, of forces parting sooner or later on their ways.

Or, if we begin with the inward world of thought and feeling, the whirlpool is still more rapid, the flame more eager and devouring. There is no longer the darkening of the eye, and fading of colour from the wall – the movement of the shore side, where the water flows down indeed, though in apparent rest, but the race of the midstream, a drift of momentary acts of sight and passion and thought. At first sight experience seems to bury us under a flood of external objects, pressing in on us with a sharp and importunate reality, calling us out of ourselves in a thousand forms of action. But when reflection comes to act upon those, they are dissipated under its influence; the cohesive force seems suspended like a trick of magic; each object is loosed into a group of impressions – colour,

odour, texture – in the mind of the observer. And if we continue to dwell in thought upon this world, not of objects in the solidity with which language invests them, but of impressions, unstable, inconsistent, flickering, which burn and are extinguished with our consciousness of them, it contracts still further; the whole scope of observation is dwarfed to the narrow chamber of the individual mind. Experience, already reduced to a swarm of impressions, is ringed round for each of us by that thick wall of personality, through which no real voice has pierced on its way to us, or from us to that which we can only conjecture is without. Every one of these impressions is the impression of the individual in his isolation, each mind keeping as a solitary prisoner, its own dream of a world. Analysis goes a step further still, and assures us that those impressions of the individual mind to which, for each of us experience dwindles down are in perpetual flight; that each of them is limited by time, and that as time is infinitely divisible also; all that is actual in it being a single moment, gone while we try to apprehend it, of which it may ever be more truly said that it has ceased to be than that it is. To such a tremulous whisp constantly reforming itself on the stream, to a single sharp impression, with a sense in it, a relic more or less fleeting of such moments gone by, what is real in our own life fines itself down. It is with this movement, with the passage and dissolution of impressions, images and sensations, that analysis leaves off – that continual vanishing away, that strange perpetual weaving and unweaving of ourselves.

'Philosophieren' says Novalis 'ist dephlegmatisieren, vivificeren' (Philosophy is dephlegmatisation, the act of bringing to life). The service of philosophy, of speculative culture, towards the human spirit is to rouse, to startle it into sharp and eager observation. Every moment some form grows perfect in hand or face; some tone on the hills or sea is choicer than the rest; some mood of passion or insight or intellectual excitement is irresistibly real and attractive for us – for that moment only. Not the fruit of experience, but experience itself is the end. A counted number of pulses only is given to us of a variegated, dramatic life. How many we see in them all that is to be seen by the finest senses? How shall we pass most swiftly from point to point, and be present always at the focus where the greatest number of vital forces unite in their purest energy?

To burn always with this hard, gem-like flame, to maintain this ecstasy, is success in life. In a sense it might even be said that our failure is to form habits; for, after all, habit is relative to a stereotyped world, and meantime it is only roughness of the eye that makes any

two persons, things, situations seem alike. While all melts under our feet, we may catch at any exquisite passion, or any contribution to knowledge that seems by a lifted horizon to set the spirit free for a moment, or any stirring of the senses, strange dyes, strange colours, and curious odours, or work of the artist's hands, or the face of one's friend. Not to discriminate every moment some passionate attitude in those about us, and in the brilliancy of their gifts some tragic dividing of forces on their ways, is, on this short day of frost and sun to sleep before evening. With this sense of the splendour of our experience, and its awful brevity, gathering all we are into one desperate attempt to see and touch, we shall hardly have time to make theories about the things we see and touch. What we have to do is to be forever curiously testing new opinions and courting new impressions, never acquiescing in the facile orthodoxy of Comte or Hegel, or of our own. Philosophical theories or ideas as points of view, instruments of criticism may help us to gather up what might otherwise pass unregarded by us. 'Philosophy is the microscope of thought.' The theory or idea or system which requires of us the sacrifice of any part of this experience, in consideration of some interest into which we cannot enter, or some abstract theory we have not identified with ourselves, or what is only conventional has no claim upon us.

One of the most beautiful passages in the writings of Rousseau is that in the sixth book of *The Confessions*, where he describes the wakening in him of the literary sense. An undefinable taint of death had always clung about him, and now in early manhood he believed himself smitten by a mortal disease. He asked himself how he might make as much as possible of the interval that remained and he was not biased by anything in his previous life when he decided that it may be by intellectual excitement, which he found just then in the clear, fresh writings of Voltaire. Well! we are all *condamnés* as Victor Hugo says; we are all under sentence of death, but with a sort of infinite reprieve; we have an interval and then our place knows us no more. Some spend this interval in listlessness, some in high passion, the wisest at least among 'the children of this world' in art and song. For our one chance lies in expanding that interval, in getting as many pulsations as possible into the given time. Great passions may give us this quickened sense of life, ecstasy and sorrow of love, the various forms of enthusiastic activity, disinterested or otherwise which come naturally to many of us. Only be sure it is passion – that it does yield you the fruit of a multiplied, quickened consciousness. Of this wisdom, the poetic passion, the desire of beauty, the love of art for

art's sake, has most; for art comes to you professing frankly to give nothing but the highest qualities to your moments as they pass, and simply for those moments' sake.

6.3 Art talk

The language of criticism had become more complex as literary comment on art increased in quanitity, and in quality. Social success too could often depend very largely on an ability to converse, with varying degrees of feeling, but uniform sophistication, about the current art scene. In 1881 a writer in *The Magazine of Art*, signing himself *Philostrate*, examined new aspects of this burgeoning vocabulary.

A well-known proverb suggests the propriety of doing what the Romans do when you are at Rome. Supposing, however, that a Roman comes to you, are you still to think of him as a Roman, or are you to give him a chance of following your own precept, and doing as Londoners do, now that he is in London? Are you to say to him, 'What a fine city Rome is!' or 'What sort of cabs do you have in Rome?' or are you to sail on another tack, and to ask him how he likes London hansoms and four-wheelers? The Roman will probably be grateful to you, if you will occasionally ignore the fact that he is a foreigner, and talk to him as you would to any one else – that is to say, to a fellow-Englishman. Now, there is the same question about professional men. Is it necessary to talk to professional men about their profession, continually and invariably?

This question people seem to answer differently in different cases. When they meet a stockbroker at dinner, or a doctor at a party, they do not ask at once what the price of Consols may be, or what has been lately found to be the best remedy for the measles. But with an artist the thing is different. Given an artist, and most people will open fire on him by some remark about pictures or painting. Has he not noticed that the Academy gets worse and worse every year? Doesn't he think no one paints portraits like Velasquez and Mr Lordslupho? Has there ever been any one since Sir Joshua who understood the expression of children's faces so wonderfully as dear Mr Duccadilly? The poor artist solemnly answers that he thinks there is much to be said for all these opinions, but that it is imposs- ible to say absolutely yes or no off-hand. 'No, I suppose not', says the questioner; and then he proceeds to pour on the unhappy painter a new volley of perplexing interrogatories.

Art-talk of another kind is to be heard when the dilettante goes to a studio. Here, of course, being so to speak at Rome, it is proper to do as the Romans do; not being able to do – that is, to paint – one can at least talk, though, to continue the metaphor, one talks a very queer sort of Italian. Once it was the custom in visiting a studio to use nothing but interjectionary phrases. You went up to a picture, looked at it for a time in absolute silence, then sighed, threw up your head, sighed again, and solemnly spoke as follows: 'Well, well!' 'What a picture!' 'What go! what life! what expression!' This was a very easy sort of language, which any one could acquire after once or twice seeing, or rather hearing, professors in the art. It admitted of little variety as far as words themselves went, but a skilled master of this school would by inflections of tone imply different degrees of superlative. It need scarcely be said that the consummation of the art consists in bringing an ever-increasing amount of interjectionary agony to bear on each succeeding picture, and to keep the final outpouring of frenzied admiration for the last work to which one was taken up. You begin PIANO, you go on to MEZZO-FORTE, and with carefully planned CRESCENDO pursue the theme until the time has arrived for FORTISSIMO.

This sort of criticism is now dropping out of fashion, but it is not yet quite gone. Few professors of it remain, but it has still many professoresses. It is, in fact, the criticism which comes still most frequently from the lips of young ladies. Some vary it slightly, and prefer to prefix adjectives to substantives. Instead of 'What go! what life!' etc., the line they pursue is to apostrophise the pictures with those choice words which are equally applicable – so, at least, we presume from the frequency with which they are applied – to novels, balls, partners, or lawn-tennis: 'How awfully jolly!' 'How quite too much more than most awfully nice!' Or pictures are praised in exactly the same tone as though they were strawberry ices, and then we get, 'Dear! how delicious!' or some modulation of the phrase.

But all things advance, or change, at least, and the art-criticism of studio loungers has changed too. The old phraseology has gone, and a very wonderful one has taken its place in the mouths of all those who want to pass as persons of real artistic sensibilities. To begin with, you don't now call a picture a picture, any more than you call a spade a spade. You call it a THING. Rather a vague word, perhaps, but then remark what familiarity it shows with the object spoken of. 'That THING of the sharp profile on the grey background was the thing I liked best of all your THINGS last year.' What artist does not hear phrases of this kind every time an amateur visits his studio? But

that is only the beginning. To proceed: you must make up your mind what to single out and praise in every picture you see. This you do, of course, before you go to the studio – what you say has really nothing whatever to do with what you see. You are going to see portraits – then you say, 'It's not only as a portrait that I like that, it's such a delightful THING' (not picture, remember) 'of itself.' Or, 'How happy you always are in catching a man's expression!' Remark how safe this is. If you praise the nose, the artist will tell you that he or the sitter thought it was just that which was wrong; and if you say the mouth is to the life, you will be told that the mouth is going to be altered, as at present it is not absolutely right. When you go up to a group of figures, no matter if the subject be historical, religious, or domestic, you use a remark for the invention of which the new school of criticism deserves great praise, as it is infallibly gratifying to the artist: 'What I like is the TOUT-ENSEMBLE.' Is this not ingenious? In praising thus you seem to be praising no single bit of the picture, and yet it will invariably make the artist think with joy of the particular inches of his canvas with which he is especially in love.

Change the scene. Let us turn to a landscape. The new school of art-criticism can give you a splendid hint as regards landscape. Don't say you never saw such a lovely oak, because the painter may have meant it for a fir-tree; don't praise the hill in the background, perhaps it was meant for a pond. No; there is a much safer and a much more knowing remark to be made. You simply say, 'WHAT WONDERFUL ATMOSPHERIC EFFECTS!' If any one looks puzzled, you can add, 'The thing shows one what sort of a day it is.' You will then carefully ask what month the artist had in mind when he painted the picture, and if he says July, you will say, 'How hot it all looks!' – if December, 'Why, one shivers as one looks at that grey, angry sky.' This is a policy which never fails to win the heart of the artist, and the amazed admiration of by-standers.

This school of art-criticism, which we might call the vague school, is one which has always plenty of disciples. Anyone who takes the trouble to listen to the remarks made by visitors to the two great annual Exhibitions will not have to wait long before he hears plenty of examples. Critic number one is standing in the Royal Academy, along with critic number two, before Mr Calthrop's 'Attempted Assassination of William the Silent'. 'Capital', says critic number one, whom we will call Davus. 'Excellent', says number two, whom let us entitle Geta. Davus now looks at Geta, and Geta at Davus, for a remark which is to betray the professional critic, for we all might say CAPITAL or EXCELLENT, you know. 'THE TONE IS A

SUCCESS', says Davus. Geta nods his head, and adds in solemn voice, 'And how well the whole thing is PUT ON THE CANVAS'. They pass on to Mrs Butler's admirable 'Remnants of an Army', and say it is 'realistic and very solid'; and, looking below it, descry Mr Nettleship's 'Golden Age'. Davus kneels down, and pokes his face right on to the canvas; Geta follows suit, and seems to rub his nose up and down it – nothing the professional critic likes better than peering into a minute canvas. 'Clever', says Geta. 'Oh, yes', says Davus, 'treatment is nice'. 'Just conventional enough', says Geta. 'Not a bit strained', says Davus, craning his neck down again. At the Grosvenor they hear four phrases, which are used indiscriminately for all the pictures – poetic, imaginative, creative, and decorative. The last is the pet word, and the amount of pathos to be obtained by gazing long at Mr Burne-Jones' Pygmalion series, and then sighing, 'How decorative', is really astonishing.

Our readers may possibly like to know what kind of persons they will find Davus and Geta to be if they should be so fortunate as to make their acquaintance. They will find both Geta and Davus exceedingly affable, and most willing to give any information that is desired. Only let our readers beware of one thing – one slight thing we had nearly said, but it is not a slight thing. Let them not ask, 'What do you think of that picture?' because to a question put in such every-day language the art-critic would vouchsafe no answer. Let them say, 'What do you think are the TECHNICAL QUALITIES of that work?'

There is yet another tack on which to sail – by no means an easy one, but invariably effective. It might be called the musical tack. It consists in applying – cautiously at first, and, when you have warmed up to your subject, vigorously – the terms of music to painting. Some people think that Mr James Whistler taught the critics this mode of expression from his habit of calling his works harmonies and nocturnes, which are EN RÈGLE musical terms; but Mr Whistler himself would be the first to declare that he desired to teach the critics – a race of men whom, if report be true, he neither loves nor reverences – nothing, and that they have developed their new phrases, as their old ones, from their own ingenuity. And HARMONY and NOCTURNE give little notion of the new vocabulary's infinite richness and none of its surpassing peculiarity. Some examples of it will show that we are not throwing away our own terms of wonder in calling it by such terms.

Given a picture of an Italian lake with a mountain as background, and a bench, with a lover and his lass sitting on it, as foreground, and

a gipsy standing near, about to tell the fortunes of the youth and maiden; sky red; sea ditto by reflection. Now hear the critics who delight to revel in the new musical vocabulary. First, the figures: 'Curious STACCATO face, that gipsy,' says musical critic number one. 'I like the lovers,' says number two; 'their very pose is ADAGIO. 'As for the lake,' says number one again, 'it's just loud enough; its little waves are beating a sort of march, and its whole look gives you the sort of notion of MOLTO CANTABILE.' 'And do look at the sky,' chimes in number two; 'how I like that noisy treble red; how those laughing clouds up in that left-hand corner are playing a sort of ALLEGRO leap- frog!' 'But now as to the tone of the whole thing,' inquires number one, 'would you call it ANDANTE or ALLEGRETTO?' 'Oh, neither,' says number two; 'I should call it ANDANTINO E MOLTO CANTABILE; IL TEMPO BEN MARCATO'; and then the two agree that this exactly describes the picture before them. For our own part, we believe the description will sound exceedingly well if applied to most pictures, and it is with great confidence that we recommend it to our readers for general use at the Royal Academy, at the Grosvenor Gallery, and at all other art collections which they may chance to visit.

6.4 Good claret and sermons

The dandified image which artists now tended to present of themselves is convincingly demonstrated by the engaging affectation of Aubrey Beardsley's replies to the questions put to him by Arthur H. Lawrence in an interview published in *Tomorrow* in January 1897.

'I don't really know,' remarks Mr Beardsley, in reply to another question, 'whether I am a quick worker or not. I have got through as many as twenty chapter headings in an afternoon, but this particular sketch', showing me a drawing with a great deal of fine work in it, 'took me nearly a fortnight to do.'

'This interviewing is a wonderful and terrible business,' my host exclaims suddenly, 'and I suppose I ought to make something in the nature of a confession. Well, I think I am about equally fond of good books, good furniture, and good claret. By-the-way, I have got hold of a claret which you must sample, and I think you will act on my advice and lay down a few dozen of it while there is a chance of getting hold of it,' Mr Beardsley interjects with a childlike heedlessness of the fact that interviewers do not, as a rule, receive princely salaries from publishers, while very often their credit is none of the best. But Mr Beardsley is not to be denied on these

matters, and refuses to say anything more about himself until I have sufficiently admired a goodly collection of Chippendale furniture – two rare old settees in particular, which he assures me are almost priceless – while he rapidly goes over the titles and dates of some of his rare editions, making up a collection sufficient to cause a biblophile's eyes to bulge with envy.

'My opinion on my own work?' my host exclaims, as I bring him back to the main point of our chat. 'Well, I don't know in what sort of way you want me to answer a question so inane – I mean so comprehensive. Of course, I think it's marvellously good; but if you won't think me beating about the bush, I may claim it as a proud boast that, although I have had to earn my bread and cheese by my work' – ('together with the Château-Latour of 1865', I murmured) – 'I have always done my sketches, as people would say, "for the fun of the thing". No one had prescribed the lines on which I should work, or set any sort of limits on what I should do. I have worked to amuse myself, and if it has amused the public as well, so much the better for me! Of course, I have one aim – the grotesque. If I am not grotesque I am nothing. Apart from the grotesque I suppose I may say that people like my decorative work, and that I may claim to have some command of line. I try to get as much as possible out of a single curve or straight line.'

Then Mr Beardsley goes on to tell me, amongst other things, how much he loves the big cities, and smilingly points out, that when a year ago his doctor ordered him to the Ardennes, he had obeyed his directions by going over to Brussels, following his stay there by a sojourn in Paris. 'How can a man die better than by doing just what he wants to do most!' he adds with a laugh. 'It is bad enough to be an invalid, but to be a slave to one's lungs and to be found wintering in some unearthly place and sniffing sea-breezes or pine-breezes, with the mistaken idea that it will prolong one's existence, seems to me utter foolishness.'

A well-known publisher having described Mr Beardsley to me as 'the most widely-read man' he had ever met, I questioned my host on the subject. 'I am an omnivorous reader,' he replies, modestly, 'but I have no respect for classics as classics. My reading has been mainly confined to English, French, and Latin literature. I am very interested just now in the works of French Catholic divines, and have just received a copy of Bourdaloue's sermons from my publisher. I suppose my favourite authors are Balzac, Voltaire, and Beardsley. By the way,' he continues, 'the goody-goody taste of the British public is somewhat peculiar. The very work that they expect

from a French artist or author will only excite indignation if it emanates from the pencil or pen of an Englishman.'

'But in matters of taste we go to extremes', I suggest.

'Yes, you are right', my host replies.

'We first of all reach the high-water mark of narrow-minded bigotry, and then follows the reaction. Rabid Puritanism comes in like a high wave and is immediately followed by a steady ebb-tide of brutal coarseness. This again is succeeded by the finicking censorship of the present day, which I hope will be followed by a little more tolerance and breadth of opinion. . . .'

'Do you know, I think that the attempts of modern artists to go back to the methods and formulae of the primitive workmen are as foolish as would be the attempts of a fully-matured man to go back to the dress, manner, and infantile conversation of his babyhood. To my mind,' Mr Beardsley remarks confidentially, 'there is nothing so depressing as a Gothic cathedral. I hate to have the sun shut out by saints.'

. . . To my intense horror, my host remarks of Turner that 'he is only a rhetorician in paint. That is why Ruskin understood and liked him.'

'I love decorative work,' Mr Beardsley tells me, as I glance at the hour indicated by a Louis Quatorze clock on the mantelpiece and determine to wind up my merciless interrogatories; 'and wherever I have gone I have always brought away some little decorative scheme with me. In fact, I think you could always guess where I am working from the work in my sketches. But have you never noticed that it is the realism of one age which becomes the decorative work of the next?'

6.5 A unique exuberance

Considered the most typical 'decadent' artist of his period, Aubrey Beardsley became a touchstone for determining attitudes towards art. On the publication of his *Fifty Drawings* in 1896 Max Beerbohm published a review in *Tomorrow* (January 1897) which typified a whole, fashionable and witty approach to questions of taste.

I do not suppose that I have ever written one honest word in praise or blame of anyone. I am, personally, capable of the strongest reverence and of the strongest contempt, and, when I am talking, I can give a quite straightforward expression to these feelings. But, when I sit down to write, lo! my honesty does desert me, leaving me

1. Frank Reynolds, *Gazers at paintings few appreciate and fewer understand,*
Illustrated London News, December 3rd 1910. (Courtesy of The Illustrated
London News Picture Library.)

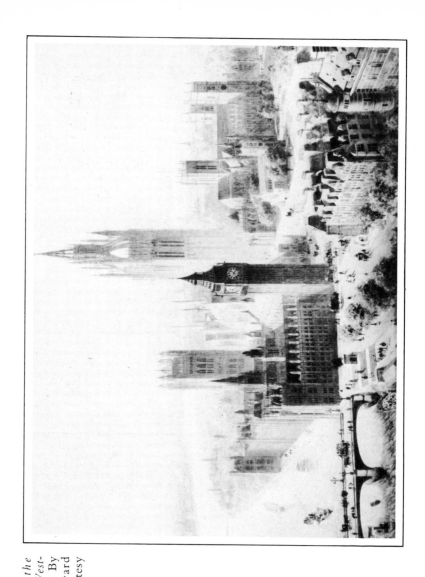

2. *Design for the Monumental Halls, Westminster, London, 1890.* By J.P. Seddon & Edward Beckitt Lamb. (Courtesy R.I.B.A.)

3. *Trafalgar Square showing the National Gallery.* By John Filleylove, 1883.

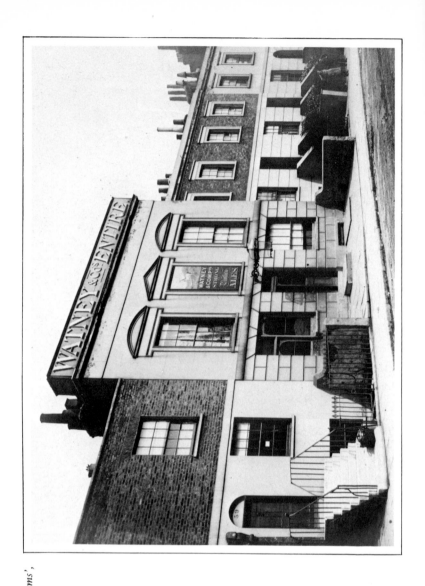

4. The 'Gloucester Arms', Kentish Town, c. 1870.

5. *Upper corridor, Balmoral, c. 1875–1880. This was designed by Prince Albert. (Reproduced by kind permission of Her Majesty the Queen.)*

7. Max Beerbohm, 'Rossetti just having had a consignment of 'stunning fabrics' from that shop in Regent Street . . .'. (Reproduced by courtesy of Eva Reichmann.)

6. Drawing by Du Maurier entitled *The Six-Mark Teapot*, Punch, October 30th 1880.

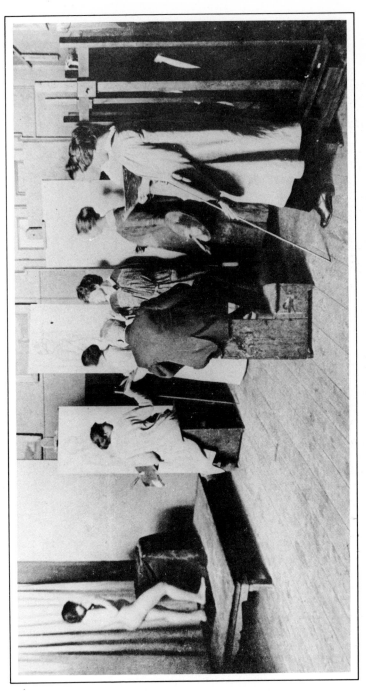

8. *A Life class for female students, c. 1905.* (Courtesy I.L.E.A.)

9. *Design for the main door of the Natural History Museum, London.* By Alfred Waterhouse, 1872. (Courtesy R.I.B.A.)

10. *Design for the facade of The Fine Art Society.* By E.W. Godwin, July 28th 1881. (Courtesy of The Fine Art Society.)

11. *William Frith R.A.* His *Ramsgate Sands* was bought by Queen Victoria for 1,000 guineas on a private view day at the Royal Academy in 1854.

London Showrooms of the
Burmantofts Works
16 Charterhouse Street E.C.

12. *The London Showroom of the Burmantofts pottery, c.* 1890.

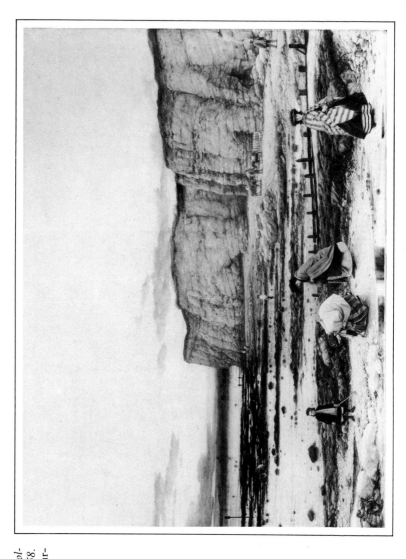

13. *Pegwell Bay: A Recollection of October 5th, 1858.* By William Dyce. (Courtesy of Tate Gallery.)

a prey to irony and poses. Would I extol, all the defects of my subject stand out most suddenly in a scheme of lurid colour, and I must needs proclaim them till they become, at length, the basis of an ironic eulogy. Would I denounce, my harsh humour soon vanishes in sweet irony. Thus has my own temperament ever baulked itself of right expression. I have loaded my blunderbuss with incense, and dropped grains of gunpowder into my swaying censor. Insomuch that, all being over, my victim lives, my god is frowning, and I am in a very false position.

I, therefore, having a real admiration for Mr Beardsley's genius, am rather loth to write of it. There is no knowing what may not happen before I have finished. But, possibly, the fact that I am a personal friend of Mr Beardsley may suffice to guide my pen in reverence and in truth. For do not imagine that friendship can generally discount the value of praise given! If it be (it should be) the critic's aim to appreciate all that is good in the work that he has selected, and if that work be (it is) the expression of the artist's own temperament, then has that critic, who is also the personal friend, a high advantage over the other critics, though they be, for the rest, his equals. Stevenson has said, admirably, in one of his dedications, that all his books contained that which none but his own friends could love fully. A very pregnant plea for log-rolling! The finest criticism is not that which lingers over blemishes, and friendship is the very touchstone of genius, for this reason, that it can ignore the blemishes and find fuller appreciation of the beauties. It is always 'they of his own country and of his own people' who gain the prophet his tardy hearing. But why am I thus paltering on the threshold of Mr Beardsley's temple? I suppose that I cannot quite trust myself to behave seemly under the dome. Moreover, I feel that I, not an initiated art-critic, am rather presumptuous in venturing there. Were I even a book-reviewer for a newspaper, I should feel no diffidence at all. I remember that the late Mr Hamerton having called Beardsley a 'young genius', was severely taken to task by a person who writes an article on Sport for a weekly paper. 'Genius! A man who draws a woman with a neck like a giraffe! Oh fie, Mr Hamerton!' Indeed, I think that every great artist should follow Mr Whistler's example and publish an anthology of his press-cuttings, for the public good. Mr Beardsley's anthology would be splendid reading. But I should advise him to wait still for a short time, till his critics have passed through the whole process of insult, doubt and servility. At present, these dull dogs are in the doubtful stage. They have taken their teeth out of Mr Beardsley's calves, but they have not yet fastened them in his coat-tails. They soon will.

For Mr Beardsley's genius is so swift that his critics' process must be strangely congested. At a time when most artists are still throwing about for ideals, and cursing their ineffectual fingers, he is – Aubrey Beardsley. What strikes one first in his book of drawings is his unique exuberance. I had seen most of his drawings, as they were done in swift succession, but not until I read Mr Vallance's iconography printed at the end of the book, did I realise how many, many hundreds he had achieved in the span of three short years. A mere few examples of his originality and technical accomplishment would have sufficed to make him the marvel of London and of Paris; the terror whose name has passed into every English household, and is used for frightening naughty children; the pervasive influence which has filled all the United States, from Frisco to N'York, with a horde of abominable imitators. But Mr Beardsley's work is not the careful, slender outcome of a merely exquisite mind. It is a thing of utterly colossal bulk. Three short years! When we know that this artist hardly drew a line before he was fourteen years of age, that he has never had one tittle of instruction, and that he has been always the prey of physical delicacy, which prostrates him only too often and makes activity of any kind impossible, what can we do but throw up our hands and wonder at the miracles which Nature is still working in this flat world? Mr Beardsley forces us to readjust all our ordinary scale of judgement. He is most comparable, perhaps, with the painter-children of the Renaissance. Like them, *in varias artes distulit ingenium*. At the age of nine, he was already a musician of great skill. He has written delicate prose and verses. He has read vastly and is most learned in all the French and English literature of the eighteenth century. Yet, for all this, he has ever gadded restless through all the drawing-rooms where young lions are asked to roar. None of his friends has ever seen him working. Five or six new pictures would always be evident on a side-table, but no one ever knew how they came there. He had none of the artist's paraphernalia, none of the artist's habits. He was always a preposterous mystery.

This book can but deepen that mystery. Through it, for the first time, I may form some synthetic notion of Mr Beardsley's work. Of course, in this selection of fifty from so many drawings, I am bound to miss some that especially delighted me. Perhaps Mr Beardsley will make a fuller selection hereafter. For the present, this one is generally satisfying. I do not complain that nothing has been printed from the early 'Scrap-Book', which is in the enviable possession of Mr Robert Ross. That volume, curious and delightful though it is,

must be regarded as a precedent, rather than a presage, of Mr Beardsley's sudden genius. But I am sorry that we have not the 'Birthday of Madam Cigale', a pretty drawing done under the direct influence of Japanese art. And I am inclined to think that there are too many of the illustrations to the *Morte D'Arthur*. True, each is a proof of versatility, technical accomplishment, a rich fancy. But Mr Beardsley would never have undertaken, of his own bent, to illustrate this book, and his drawings are obviously not the outcome of his own peculiar being. Their plenteous inclusion is a compliment to Sir Edward Burne-Jones, but it robs us of many examples of Mr Beardsley's later work. In the drawings of Salomé, the first influences had been assimilated. Jones and Japan were there, but blent and metamorphosed. It was not until the *Yellow Book* was thrown at the heads of an angry public, that Beardsleyism was seen, for the first time, absolute. Can one wonder at the sensation made by those drawings, with their simple ordering of black blots and cobweb lines, so flawless in their accomplishment, so very decorative, so very strange? All the criticasters were furious. The word 'ugly', which ever serves them for new things, came spouting from all their pens. To the work of new painters, this word is applied in virtue of *technique*. Corot's fields, and Turner's sea, and Whistler's ladies were not ugly subjects, but it was long before the criticasters were shamed even into a pretence of admiring the beauty of these things, as newly rendered. Even if Mr Beardsley had drawn the prettiest subjects, the criticasters would have been very angry, and, as a matter of fact, his subjects were then far from pretty, for the most part. The criticasters like, above all, to be reminded of something they are fond of, in a manner that is easy for them to understand. If one of Mr Beardsley's extraordinary women could be materialised, no criticaster would propose to her. Thus was there a twofold barrier between the artist and their praise. They will never realise that, in art, subject is the least important of all things. Even if they were really to like the 'Lady Archibald Campbell' and the 'Lady Meux', you could hardly explain to them the beauty of that canvas which Mr Whistler has covered with a most venomous caricature of a certain art-pattern. Mr Beardsley's 'Fat Woman' is beautiful in draughtsmanship, in decoration; artistically a beautiful creature, though one might not care to meet her. 'She is not like life!' cries the criticaster. She was not meant to be. Utomaro's women were not meant to be. 'She is hideous!' cries the criticaster, running away to contemplate a paving-stone on which black eyelashes curl over carmine cheeks.

But, perhaps, the favourite charge against Mr Beardsley's work

was the charge of indecency. Some professed to see actual indecency in the drawings, others declared it was rather the spirit of them that was indecent. I have no wish to enter into a discussion on this point. I would merely have suggested to the indignant that they should not look at the drawings, nor talk about them. If they supposed that they could cure Mr Beardsley by newspaper diatribes, they were much mistaken. An artist may alter his method, but the impulse is always within himself. Critical anger tends, if anything, to make him more strenuous in his own method. If he be not quite indifferent, he probably retaliates by a wilful exaggeration of what offends. I think there is some evidence, in the *Savoy* especially, that Mr Beardsley tried, now and again, in a spirit of sheer mischief, to scandalise the public. An artist should not do that.

6.6 The new art criticism; a Philistine's Remonstrance

The kind of divisions which were becoming apparent in the art world were interestingly demonstrated in an article by J. A. Spender, given considerable prominence in the issue of *The Westminster Gazette* for 8 March 1893.

We, and I am one, who count ourselves ordinary people, have stood a great deal in times past from the superior person, and especially the superior critic. But even the worm will turn, and I confess that for me the turning point seemed to have come when I read the following in the art criticism of *The Spectator* the other day.[1] '*L'Absinthe* by Degas is the inexhaustible picture, the one that draws you back and back again. It sets a standard by which too many of the would-be 'decorative' paintings in the exhibition are cruelly judged. It is what they call a 'repulsive' subject, two rather sodden people drinking in a café. There is a picture hung in the place of honour in the large room by Mr Stott of Oldham, which represents Tristram and Iseult drinking a love-philtre on a fairy ship. Mr Stott thinks his people are beautiful and heroic, means them to be so, puts them forth as such. They are really the disagreeable prettiness of a Christmas card. It is a disastrous failure by a painter, who elsewhere has done good work. He has maltreated what, if you like, *before he made it his subject* was a beautiful picture. M. Degas understands his people perfectly; there is

* The article appeared in *The Spectator* on 25 February 1893. The writer was D. S. Maccoll.

no false note of an imposed and blundering sentiment, but exactly as a man with a just eye, and comprehending mind and power of speech could set up for us that scene in the fit words, whose mysterious relations of idea and sound should affect us as beauty, so does this master of character, of form, of colour, watch till the café table-tops and the mirror and the water-bottle and the features yield up to him their mysterious affecting note. The subject, if you like, was repulsive as you would have seen it, *before* Degas made it his. If it appears so still, you may make up your mind that the confusion and affliction from which you suffer are incurable.'

How strange, one thinks, that our old friend *The Spectator*, so moral and respectable in all other relations of life, should lend itself to this threnody over a picture of 'two rather sodden people drinking in a café'! Critics have in the past talked a great deal of rhapsodical nonsense about pictures that, in spite of it all remain classic and beautiful; but is there anything in the whole history of the subject quite to touch this about 'the mysteriously affecting note' of table-tops, mirrors, water-bottles and drinks?

'It sets a standard'. This is really the point, but for which we might be content to let alone the affecting qualities of table-tops and drinks. But 'it sets a standard' – a standard apparently of beauty, of decorativeness, of skill. And that, we must suppose, is the last word of the 'new criticism'. For the 'new critics' are in possession of the weekly, and several of the daily papers, and with one accord they tell us the same thing. These two sodden people are their ideal; it is for this the world has been waiting; and if you refuse to hail it with joy for ever, your affliction is incurable.

The wise have warned us not to dispute about matters of taste, and within certain limits it is a counsel of prudence. But when a new critic comes along to set a new standard, and commends what the world has hitherto called repulsive as a sort of touchstone of the beautiful, we are entitled to ask for his credentials. D.S.M. has written under his own initials in *The Spectator* for several years, and it is bare justice to say that he often writes with ability and skill. He is not so much a critic as an advocate – the frankly partisan advocate of the young English imitators of French impressionists who call themselves The New English Art Club. There is no deception about it. 'Academic' is in D.S.M.'s vocabulary a term of derision; hardly anything worse can be said about a man than to insinuate that he is an RA, or might some day desire to become one. Secondly it is, in D.S.M.'s opinion, a presumption against a picture that it makes its appeal (like a Raphael, a Velasquez or a Reynolds) to people of

ordinary understanding. Another maxim seems to be that the subject is nothing; the use of paint, the handling everything. Then again the painter is under no obligation to make his subject resemble in paint what it seems to ordinary people in life.

6.7 The role of *The Studio*

Founded in 1883, *The Studio* was probably the most influential art magazine which had ever been published in Britain. Its influence in promoting both art nouveau, the related Arts and Crafts movement, and 'artistic' photography not only in Britain but throughout Europe was incalculable. One of its earliest contributors, Walter Shaw Sparrow, a prolific and lively writer, estimated its role in his *Memories of Life and Art* published in 1925 when he was in his late seventies.

As I wish to give a correct estimate of the great work done by *The Studio* for the arts and crafts, I must relate what our country's needs were when Charles Holme began to publish his magazine in May 1893.

His attitude towards architecture is the first thing to be considered, because architecture is the parent, chief and standard of all the other arts. Easel-painters began to rebel against this fact as soon as the Renaissance ended, though good pictures and other costly decorations would never transform any ill-planned house into a convenient home fit to be adorned by suitable easel-paintings. Besides, it was irrational to paint pictures at random for rooms unknown; and this irrationality would be certain to react against artists by placing their work, very often, on dimly lighted walls, and by encouraging them to produce, age after age, a great many more paintings than any public could afford to buy. These reactions began very soon to cause trouble; then painters everywhere, striving to defend their interests against evils caused by themselves, became more and more hostile to architecture and the household crafts. Thus our Royal Academy, though founded by George the Third for the protection of *all* good art, became mainly a custodian of the social and financial interests of easel-painters. Sculptors occupied a second place; and architects were banished into a dull and small room at the annual show. Charles Holme made up his mind that he would oppose this bad routine; and never did he swerve from this decision. You will find in his magazine many attacks on the baneful glut of oil-paintings, and also on that bad citizenship which undervalued continually the domestic handicrafts and architecture.

The Studio's policy, in brief, was to proclaim the urgent need of re-uniting the arts and crafts to daily life among all classes. For nearly a hundred years, reformers with a taste for history had brooded over those early times when daily life employed in its customs and changes every handicraft that was practised in a thinly-populated England. In those days, every county had craftsmen who knew how to hand on developing methods of building work, which retained particular ways of handling chosen materials; so that county after county had manor houses and cottages, and farms and inns, more or less racy of an attractive dialect, not only honest and beautiful, but free also from the control of professional architects. And young craftsmen were not cramped by inherited craft methods, being as free to show their originality in dialects of building as they were to express their own views in dialects of everyday talk. They did not make much ado about 'style' and 'taste', their motive power towards art being a desire to turn out good jobs, pleasing to look at, friendly to live with. But as soon as mechanical trades grew strong, converting farms by the dozen into industrial districts and slums, arts and crafts were divorced from the people, and handed to the protection of wealthy patrons. Then artists of every sort became more and more conscious that they were at variance with their type of society, which became uglier year by year. Groups of reformers tried very hard to bring about a gradual improvement, Gothic revivalists undertaking the first efforts, and passing on their zeal to Ruskin, and to William Morris and his colleagues.

This was the position when Charles Holme founded his magazine. Six years later, when I joined his staff, the Morris movement was fading away in England, but not in Germany, where it was passing through many interesting transformations, by which German industries were gaining a great and sinister advantage over our own. Apathy was descending once more on our country's attitude towards many vital things, ranging from design and handicraft to that political negligence which, fifteen years later, obliged our Empire to enter a long-threatened war without even a reserve of rifles. So there was nothing strange in the fact that *The Studio's* circulation, the largest an art magazine has ever won, was international, not British only. There was a French edition, an American edition, and the sales in Germany and Austria were larger than in France, Belgium, Holland and Italy, and Russia. Japan, too, bought many copies every year.

It says much for Charles Holme that he was never depressed by the rather lethargic movement of reform in his own country. He continued always to regard Art, not as Art for Art's sake, a creed for

cliques, but – as Art for the sake of everyday life among all classes. Research and experiments of every sort, if they had anything in them of permanent value, would enter little by little into the common stock of knowledge, from which persons of genius would collect what they could employ, as naturally as big rivers received tributaries. The useful and necessary thing in the policy of *The Studio* was to keep always before readers the firm conviction that Art should be Shakespearian, a friend to all mankind, and not sectarian.

Though Charles Holme published a vast amount of modern enterprise, there were phases that he refused to help, because they had not enough correspondence to design or to the needs of current life. There was a risk in this part of his policy, no doubt. An art magazine that fails to mirror all that is being done resembles a newspaper that suppresses news; it runs the risk of losing rank and authority. This explains why so many art magazines, after a period of success, have declined rapidly and disappeared, like *The Art Journal*, *The Portfolio*, *The Artist*, and several others.

Once there was a bad hitch over some early work by Augustus John, who had then a studio in Fitzroy Street, where he fought his way through a very stern ordeal. Among a host of young painters, he had a reputation that put a hushed voice into spoken praise. I called to see Mr John, visited some of the pictures that he had sold, and got half-a-dozen photographs taken, though fearing that Holme would not publish them. He didn't; and my position was unpleasant. Still, there's nothing easier than to make mistakes as an editor-in-chief. To Charles Holme, Mr John was going too fast, because his revolt against the old 'laws of beauty' – laws dangled too long or too limply by academic routine – had advanced into an ugliness that normal persons would never like. But similar remarks were made about Francois Millet, about Monet and Degas, Legros, and many others. There are talents that seem like enchanted corks; for no storm-tide of criticism can keep them under water. Augustus John was among those talents; and surely Mr Holme should have been the first to publish his work.

6.8 The Academy attacked

The great divide in art between the traditionalists and the avant-garde, which had already been apparent in France since the 1850s, did not really materialise in England till some thirty years later, when institutions such as the New English Art Club, and galleries such as the Grafton offered the more aesthetically venturesome

exhibition space. In the first year of its existence *The Studio* (June 1893) emphasised these points in an article by Arthur Tomson.

To charge the Academy with commercialism is by this time become a commonplace of the streets, but even the average sensual man has come to recognise that the Forty, immortals though they be, are not beyond criticism or reproach. The Clapham Miss has been heard to whisper her own opinions on Mr Dicksee and Sir Frederick Leighton. Still, the charge is a grave one against a body which is specially constituted for the guardianship of art, and may not be made without responsibility. The question comes to this – Is it true or false? Let us take the exhibition just opened in Burlington House and consider the facts of the case. Regard it collectively or individually and you will find scarcely one canvas that would perplex the soul of the most ultra Philistine. Compare the walls with those of the Grafton Gallery, the New Gallery, or the New English Art Club. They are discordant because, except to provide the members with prominent places, the only object is to crowd the wall with pictures. But withal, there is a strange unity of purpose in all these works. But few canvases have been left because the painter has said all he wanted to say, but because he has attained, in every particular, the public standard of a finished painted picture, and therefore the chief qualification that will commend his work to the goodwill of the Royal Academician. Now, although a picture need not necessarily mystify the person unacquainted with art, it is certain that a good many excellent pictures do, seeing that he is accustomed to find in a picture no suggestion or information that has not its counterpart in his own mind. It must be remembered that the average visitor to the Royal Academy is not like the frequenter of concert rooms, or the student of literature; he judges a picture not by his knowledge of other pictures but by his own remembrances of Nature, not recognising that to see intelligently requires as much training as the comprehension of a chord in music.

It is, therefore, no wonder that the collection at Burlington House is not very notable and is not in any way representative of the art of this country.

The more an artist relies upon an intelligent use of his pigment to the exclusion of the literary interest, the more he will vex those who are unable to follow him. Everybody can comprehend the illustration of a story, but subtleties of tone, of handling, and of line, and the numerous other mysteries that go to compose the painter's art (as distinguished from the literary art) are qualities which can only be appreciated by persistent study. To this fact the Academicians are

alive. A glance at the Royal Academy reveals the fact that this Society lives and has its being by reason of its careful consideration of the public tastes. It is a constant complaint that it is 'no good' sending anything artistic to the Royal Academy. Here, then, is a set of men in the enjoyment of a royal grant for the promotion of an art which they make no effort to promote. For a work of art must be artistic, or nothing. And so we find on examining the pictures this year that the art for the most part (where there is any) has been kept well in the background. The prime consideration has been the necessity of setting forth the object painted in such a manner that the imagination of the spectator should never be troubled, whatever discredit this may throw upon the intelligence of our public. Neither the art of this country is represented nor the art of any other country to any appreciable extent. With but few exceptions, canvases dealing with the problems that are interesting all other representative art societies, are rigorously excluded. Certainly Mr Sargent and Mr Clausen have been granted hanging space; but even they have been obliged to consider, to some extent, the peculiar tenets of the Society with which they have elected to exhibit. Two more brilliant portraits by the former are to be seen at the New Gallery, and one better than all three was hung at the last winter exhibition of the New English Art Club; while it is safe to say that Mr Clausen has possibilities, of which we shall never be made aware in works destined for the big yearly show.

A striking example of the Academical point of view is the fact that the place of honour in the entire exhibition is given to a large subject-picture by Mr Frank Dicksee. This work, *The Funeral of a Viking*, is trivial in sentiment and in workmanship; its drama is pure melodrama, worthy of the Adelphi or the Britannia; and as to its accomplishment – well, the sentiment of paint and of colour has been entirely overlooked in the painter's vain struggle with his colossal subject. But, after all, Mr Dicksee is to be congratulated from his point of view: if his picture lacks many other things it lacks also imagination, and imagination is an ingredient to be avoided in the compilation of a popular picture.

At the left-hand corner of Mr Dicksee's frame, rather high up, of course, may be found a small landscape by Mr Leslie Thomson, wherein that very same quality wanting in Mr Dicksee's picture may be immediately recognised. Mr Thomson's tones and technique have, indeed real poetry.

A certain just observation and breezy freedom of handling always characterises the marines of Mr Hook, whose work here is as good as

ever. The President also shows no falling off from his customary standard. His is the work of an accomplished gentleman rather than a painter. The *Rizpah* is nicely arranged on the canvas, but one feels, instinctively, to how much more admirable an effect such a man as Mr Swan might have treated the subject. For Mr Swan, with his vast abilities and strong poetic vision, would have given the motive exactly what the President's version lacks – life and poetry.

A sentiment that is peculiarly his own always gives interest to the pictures of Mr Orchardson. His small subject-work, of a girl sitting at a harpsichord, is delicate and refined, but not distinguished, nor does his portrait of Lord Rookwood leave any very distinct impression. But then every portrait in the exhibition suffers more or less by comparison with Mr Sargent's. What power of laying on paint can be compared to his? What realisation of character, what style or faculty of rendering a momentary impression, will stand the test of being studied after Sargent's?

Mr Waterhouse sends some decorative work, ably painted, but depending, this time, upon line rather than on colour for effect. While for an absolute harmony of colour one has to turn to Mr Albert Moore's canvas, with its white tones and its delightfully disposed orange accents. Add half a dozen pictures to these and you have practically all that is artistic in an otherwise barren 'show'. Surely the charge of commercialism is proven by the most cursory visit to Burlington House.

6.9 Monstrosities on canvas

English hostility to new art styles has become a cliché of the history of taste. In April 1881 the sixth group show of the Société des Artistes Indépendants was held at 35, Boulevard des Capucines, with works by Pissarro, Degas, Gauguin, Renoir and others on the walls. In the following month one of *The Artist*'s anonymous 'Lady Correspondents' contributed the following to its columns (1 May).

The group of artists calling themselves 'Indépendant' has migrated this year to the Boulevard des Capucines, where we find a suite of rooms, whose walls are covered with calicos, and hung with many-coloured pictures. The group changes its name as often as its quarters; it has been 'Intransigeant' and 'Impressionist' and certainly might become 'Extravagant'.

One's first impression in walking round these rooms is that the artists are making fun of us, or that these violent lakes, cadmiums,

cobalts, emerald greens, and violets are put upon canvases by a blind man with a large palette knife, and that by some extraordinary hazard they emerge from his unguided hands as portraits, landscapes or still-lifes. True this colouring reminds one somewhat of the most extravagant of the Pre-Raphaelites some thirty years ago; but the sentiment, which as with their ancestors, the Florentine was their principal charm is here wanting. In the one the aim was pure and holy, in the other the reverse – an aim, one must admit, successfully attained. It is of course arbitrary to say that any effect of nature which we have not ourselves seen is false; nature sometimes showing us eccentricities of colour that one would not have believed in, had one not seen them. Still there can be no doubt that, given a sky towards sunset of all colours of the rainbow, the river reflecting the same, the bridge crossing this blaze of light and the barges opposed to it must necessarily be a dark mass. Yet in the pictures of M. Guillaumin of river scenery, the bridges and barges partake of the same hues, and are formed of the same material as the sky and water; they are not one whit more solid. These effects are not 'impressions', if 'indépendant'. Again looking at the portraits, who can honestly say – unless he is colour-blind – that a face is made up of rank emerald green, crude cobalt, raw violet and pure carmine or scarlet? Mlle Morisot is the greatest and Mlle Cassatt the least offender in this way, and the latter's *Automne* has even a certain charm about it, but her *Jardin*, a woman knitting, sitting in a cane chair on a path along which runs a border of red leaves (one of which, blown onto her dress has become metamorphosised into a ribbon) is extravagant and false. It all jars! it is all on one plane, and the background is crude to a degree. The same lady's *Mère et Enfant* deserves praise from its intense feeling; both faces are almost invisible, but one feels the love and intensity of the embrace; it is a pity more care was not put into the drawing of the hand, which is large, coarse and ill shapen.

Another, and not the least fault of these 'Indépendants' is their admiration for the ugly and the vulgar. These titles show it as much as the pictures *Physionomie de criminel, Déclassés, Loge d'Actrice, Chiffoniers, Blanchisseuses*. It is not, mind you, the best side of common life treated sympathetically and poetically, but crudely in all its lowness and vulgarity. M. Räffaelli's *Déclassés* is a picture of two men reduced to the lowest state of misery brought on by intoxication, boozing over glasses of absinthe, and betting with their last sous. None of the details of parched lips, red noses and worn cheeks are omitted. Such subjects were by no means uncommon amongst the old Dutchmen; but then they were redeemed by the

excellence of their treatment, and I opine no one admires a Jan Steen simply for the 'story'. Take away the exquisite execution from a Teniers, and who would care to possess one of his drunken boors? But here we have all the horror of the drunkenness, and nothing to redeem it, not even well-painted accessories. Only turn to M. Degas' *Statuette en cire*. A ballet girl, fondly called in the catalogue *Petite danseuse de 14 ans*, a semi-idiot, the head and expression of an Aztec, dressed in real tulle petticoats, and her hair tied up with emerald green ribbons, is in the act of dancing. Her hair and skin are coloured to life, and her feet are shod in pink satin shoes and sandals. Can art descend lower? Can anyone calling himself an artist more hopelessly degrade what he ought to reverence and love? This is 'Realism' so called; this is, in art, what M. Zola is in literature. Such being the case, let us make a big hole and bury all our ideals; do not let us drag them through the mire till they become sufficiently soiled to suit the new schools. Even the Italian sculptors, with their *Dirty Boy* and *Children under an Umbrella*, have not descended as low as M. Degas. But these people teach us many things; and having demonstrated that the province of art is to perpetuate the vile rather than the beautiful, to paint *déclassés* in mind and body, we may soon expect to see a gallery of monstrosities equal to the collection at the Jardin des Plantes.

6.10 On buying Impressionists for the nation

By the beginning of the new century the Impressionist lobby was gaining strength and confidence. Reviewing the large Impressionist exhibition (some 300 works) exhibited at the Grafton Gallery by Durand-Ruel, Frank Rutter made a strong plea for an Impressionist presence in the national collections (*Sunday Times*, 22 January 1905).

Thanks to the munificence of the late Mr Ionides, the nation possesses at South Kensington a Degas, and a very characteristic example of Degas. But with this solitary exception there is not in any of our public galleries a single example of a work by a member of that great group of painters known as the French Impressionists. Even those who are still hostile to the theory and practice of Impressionist painting must admit that the absence of any work by Manet or Monet leaves a serious gap in our records of the history of painting. Moreover many who are yet unable to perceive the beauty of the results obtained by the Impressionists are bound to admit the beauty and originality of their methods, and also the indisputable

fact that their discoveries in the field of light and colour have had an incalculable influence on modern painting. On historic and scientific grounds, then as well as on purely artistic, I venture to appeal to the generosity of art patrons of all shades of opinion to give such assistance as they can to the securing for the nation at least one work by Manet and Monet, and I hope, by Sisley and Camille Pissarro. It is of course perfectly open to the Chantrey Trustees to purchase works by Monet, or Pissarro or Sisley, for all three worked in England, and Sisley, if born in France, was of British parentage. But, despite the recent enquiry, there is I fear, but a small chance that even a small portion of this 'Academy prize fund' will be devoted to the purchase of a painting by an 'outsider' however distinguished. In the circumstances, if we are to take advantage of an unprecedented collection of Impressionist paintings, it seems clear that the initiative must come from some private person. I cannot hope that the proceeds of my lecture will form more than the nucleus of a fund for the purchase of a single work. The days are gone when one could secure a masterpiece for a few francs. At the present moment quite a small painting by Monet will fetch anything from four hundred guineas upwards. I am well aware also that among the unrivalled series of works now on view at the Grafton Galleries are quite a few works which M. Durand-Ruel could never be persuaded to let pass out of his hands. But on the other hand there are several fine works which could be purchased, and I have reason to believe that their price could not only be reasonable but even moderate if it were known that they were being purchased for one of our national collections. Among my readers too, I know, are many who have purchased, and are still able to purchase such masterpieces for their own private collections. To these especially I now look for that generous support which alone can make my own humble efforts successful.

6.11 The last phase of Impressionism

In February 1908 *The Burlington Magazine* published an editorial on an exhibition at the New Gallery of post-Impressionist paintings. Roger Fry replied in a letter published in the March issue outlining some of his attitudes.

As a constant reader and frequent admirer of your editorials on matters of art I should like to enter a protest against a tendency, which I have noticed, to treat modern art in a less serious and sympathetic spirit than that which you adopt towards the work of

the older masters. This tendency I find particularly marked in an article with the above heading. The movement which is there condemned, not without a certain complacency which to me savours of Pharisaism, is one that surely merits more sympathetic study. Whatever we may think of its aims, it is the work of perfectly serious and capable artists. There is, so far as I can see, no reason to doubt the genuineness of their conviction, nor their technical efficiency. Moreover in your condemnation you have, I think, hit upon an unfortunate parallel. You liken the pure Impressionists, of whom we may take Monet as a type, to the naturalists of the fifteenth century in Italy, and these neo-Impressionists to the 'now-forgotten Flemish and Italian eclectics'. Now the eclectic school did not follow on the school of naturalism; there intervened first the great classic masters who used the materials of naturalism for the production of works marked by an intense feeling for style, and second, the Mannerists, in whom the styles of particular masters were exaggerated and caricatured. The eclectics set themselves the task of modifying this exaggeration by imbibing doses of all the different manners.

Now these neo-Impressionists follow straight upon the heels of the true Impressionists. There has intervened no period of great and then of exaggerated stylistic art. Nor has Impressionism any true analogy with naturalism, since the naturalism of the fifteenth century was concerned with form, and Impressionism with that aspect of appearance in which separate forms are lost in the whole continuum of sensation.

There is, I believe, a much truer analogy which might lead to a different judgement. Impressionism has existed before, in the Roman art of the Empire, and it too was followed, as I believe inevitably, by a movement similar to that observable in the neo-Impressionists – we may call it for convenience Byzantinism. In the mosaics of Sta Maria Maggiore as elucidated by Richter and Taylor (*The Golden Age of Classic Christian Art*) one can see something of this transformation from Impressionism in the original work to Byzantinism in subsequent restorations. It is probably a mistake to suppose, as is usually done, that Byzantinism was due to a loss of the technical ability to be realistic, consequent upon barbarian invasions. In the Eastern Empire there was never any loss of technical skill; indeed, nothing could surpass the perfection of some Byzantine craftsmanship. Byzantinism was the necessary outcome of Impressionism, a necessary and inevitable reaction from it.

Impressionism accepts the totality of appearances and shows how to render that; but thus to say everything amounts to saying nothing

– there is left no power to express the personal attitude and emotional conviction. The organs of expression – line, mass, colour – have become so fused together, so lost in the flux of appearance, that they cease to deliver any intelligible message, and the next step that is taken must be to re-assert these. The first thing the neo-Impressionist must do is to recover the long obliterated contour and to fill it with simple undifferentiated masses.

I should like to consider in this light some of the most characteristic painters of this movement. Of these M. Signac is the only one to whom the title neo-Impressionist properly applies. Here is a man feeling in a vague, unconscious way a dissatisfaction at the total licence of Impressionism and he deliberately invents for himself a restraining formula – that of rectangular blobs of paint. He puts himself deliberately where more fortunate circumstances placed the mosaic artist, and then he lets himself go as far in the direction of realistic Impressionism as his formula will allow. I do not defend this, in spite of the subtle powers of observation and the ingenuity which M. Signac displays, because I do not think it is ever worthwhile to imitate in one medium the effects of another, but his case is interesting as a tribute to the need of the artist to recover some constraint; to escape, at whatever cost, from the anarchic licence of Impressionism.

Two other artists, MM. Cézanne and Paul Gaugin, are not really Impressionists at all. They are proto-Byzantines rather than neo-Impressionists. They have already attained to the contour, and assert its value with keen emphasis. They fill the contour with wilfully simplified and unmodulated masses, and rely for their whole effect upon a well-considered co-ordination of the simplest elements. There is no need for me to praise Cézanne – his position is already assured – but if one compares his still-life in the International Exhibition with Monet's, I think it will be admitted that it marks a great advance in intellectual content. It leaves far less to the casual dictation of natural appearance. The relations of every tone and colour are deliberately chosen and stated in unmistakable terms. In the placing of objects, in the relation of one form to another, in the values of colour which indicate mass, and in the purely decorative elements of design, Cézanne's work seems to me to betray a finer, more scrupulous artistic sense.

In Gaugin's work you admit that 'some trace of design and some feeling for the decorative arrangement of colour may still be found', but I cannot think that the author of so severely grandiose, so strict a design as the *Femmes Maories* or of so splendidly symbolic a decor-

ation as the *Te Arti Vahiné* deserves the fate of so contemptuous a recognition. Here is an artist of striking talent who, in spite of occasional boutades, has seriously set himself to rediscover some of the essential elements of design without throwing away what his immediate predecessors had taught him.

And herein lies a great distinction between French and English art (I am speaking only of the serious art in either case), namely, that the French artist never quite loses hold of the thread of tradition. However vehement his pursuit of new aims, he takes over what his predecessors have handed to him as part of the material of his new formula, whereas we in England, with our ingrained habits of Protestantism and non-conformity, the moment we find ourselves out of sympathy with our immediate past, go off at a tangent, or revert to some imagined pristine purity.

The difference is one upon which we need not altogether flatter ourselves; for the result is that French art has a certain continuity and that at each point the artist is working with some surely ascertained and clearly grasped principles. Thus Cézanne and Gauguin, even though they have disentangled the simplest elements of design from the complex of Impressionism, are not archaisers; and the flaw in all archaism is, I take it, that it endeavours to attain results by methods which it can only guess at, and of which it has no practical and immediate experience.

Two other artists seen at the International deserve consideration in this connection: Maurice Denis and Simon Bussy. Against the former it might be possible to bring the charge of archaism, but he, too, has taken over the colour-schemes of the Impressionists, and in his design shows how much he has learned from Puvis de Chavannes. His pictures here are not perhaps the most satisfactory examples of his art, but any one who has observed his work during the past five years will recognize how spontaneous is his sense of the significance of gesture; how fresh and genuine his decorative invention.

M. Bussy is well known already in England for his singularly poetical interpretation of landscape, and though at first sight his picture at the International may strike one as a wilful caprice, a little consideration shows, I think, that he has endeavoured to express, by odd means perhaps, but those which appeal to him, a sincerely felt poetical mood, and that the painting shows throughout a perfectly conscientious and deliberate artistic purpose. Here again the discoveries of Impressionism are taken over, but applied with quite a new feeling for their imaginative appeal.

I do not wish for a moment to make out that the works I have

named are great masterpieces, or that the artists who executed them are possessed of great genius. What I do want to protest against is the facile assumption that an attitude to art which is strange, as all new attitudes are at first, is the result of wilful mystification and caprice on the artists' part. It was thus that we greeted the now classic Whistler; it was thus that we expressed ourselves towards Monet, who is already canonised in order to damn the 'neo-Impressionists'. Much as I admire Monet's directness and honesty of purpose, I confess that I see greater possibilities of the expression of imaginative truth in the tradition which his successors are creating.

I am Sir, etc
Roger E. Fry

Biographical index

Abbey, Edwin (1852–1911) An American-born painter, who worked for much of his life in England, producing a large number of mural paintings.

Agnew, Sir William (1825–1910) One of the most successful art dealers of his time. In 1876 he bought Gainsborough's *Duchess of Devonshire* for a record price of 10,000 guineas. A benefactor of the National Gallery, he was part owner of *Punch*.

Allen, Grant (1849–99) Born in Canada, educated at Oxford, he became professor of Moral Philosophy in Jamaica in a college for the education of the local population. In 1876 he returned to England and became a successful novelist and writer on various subjects.

Alma-Tadema, Sir Lawrence (1836–1912) Born in Holland, studied art at Antwerp, settled in England in 1870, where he had a great success as a painter of classical scenes, executed with great archaeological exactitude.

Armstead, Henry Hugh (1828–1905) A sculptor mainly known for his work on the Albert Memorial. He studied design at Somerset House, and worked in metal for Messrs Hunt & Roskell. He became an ARA in 1875, an RA in 1879 and taught at the Royal Academy Schools.

Barry, Sir Charles (1795–1860) Architect who designed the Houses of Parliament, the Travellers' and Reform Clubs. Predominantly a classicist, he was adept at Gothic variations.

Bayliss, Sir Wyke (1835–1906) A painter who specialised in arthitectural subjects. President of the Royal Society of British Artists.

Beardsley, Aubrey Vincent (1872–98) A prolific draughtsman, with great imaginative powers. He was art editor of *The Yellow Book* and later *The Savoy*.

Beerbohm, Sir Henry Maximillian (1872–1956) Wit, critic, cartoonist, essayist, he touched lightly and amusingly on every aspect

of the life of his time. In 1910 he married an American actress, and spent the rest of his life in Rapallo.

Berenson, Bernard (1865–1969) Born in Latvia and migrating to the USA he was taken up by a series of patrons and collectors, who often influenced his judgements, as a critic and historian of art. He developed an aesthetic based on the concept of 'tactile values'. Much of his life was spent in Italy.

Bicknell, Elahan (1788–1861) An enthusiastic collector of contemporary British art, of which he built up a large collection at his great house in Herne Hill.

Bierstadt, Albert (1830–1902) A German-born landscape painter who migrated to America and established a reputation for large panoramic landscapes, and is known as the founder of the Rocky Mountain School.

Birdwood, Sir Christopher Molesworth (1832–1917) A prolific writer about Indian art, he was an Anglo-Indian, who after starting as a doctor joined the Statistics and Commerce Department of the India Office in 1878.

Bonheur, Rosa (1822–99) The most famous French animal painter of the nineteenth century and the first woman to become an officer of the Legion of Honour. Affected male attire.

Booth, Charles (1833–1916) A Liverpool shipowner, who interested himself in social questions. His magisterial *Life and Labour of the People of London* (1891–1903) was largely responsible for the passing of the Old Age Pensions Act of 1908.

Booth, Sir Felix (1775–1850) Promotor of Arctic exploration; distiller and successful businessman. Sheriff of London.

Boughton, George Henry (1833–1905) Painter and illustrator, who concentrated on Breton, Dutch and American themes.

Bouguerau, Adolphe William (1825–1905) A painter of mainly mythological subjects, whose richly sensuous manner came to be seen as typifying the French academic tradition at its most extravagant.

Bourdaloue, Louis (1632–1704) A famous French preacher, renowned for the severity of his morals.

Brindley, William (–) Stone carver of the firm of Farmer and Brindley. He did a great deal of work for George Gilbert Scott, including work on the Albert Memorial. Scott said of him 'he is the best carver I have met with'.

Britton, John (1771–1857) Antiquary and topographer whose many publications described and eulogised the antiquities of Britain.

Brown, Frederick (1851–1941) Painter; head of the Westminster School of Art, and then of the Slade, which he transformed into the leading art college in Britain, attracting many famous pupils.

Brown, Rawdon Lubbock (1803–83) An English scholar who spent practically all his life in Venice, editing for the Stationery Office the *Calendar of State Papers (Venetian)*.

Bussy, Simon Albert (1870–1954) A French painter, whose work was admired by Degas, and who spent much of his life in England in the ambiance of the Bloomsbury Group.

Butler, Lady Elizabeth (1846–1933) A painter who successfully specialised in battle scenes and other military subjects. Her *The Roll Call*, bought by Queen Victoria, was one of the most popular paintings of the age.

Butterfield, William (1814–1900) An architect who, having made a very careful study of Gothic architecture, became one of the leading lights of its revival, designing, *inter alia*, Balliol Chapel, Keble College, the new buildings at Merton, and All Saints, Margaret Street, London.

Calderon, Philip Hermogenes (1833–98) Born at Poitiers, apprenticed to a civil engineer in London, and then studied art in Paris. He became the acknowledged leader of the St John's Wood School, and had great success with his historical paintings.

Carpenter, Richard Cromwell (1812–50) Architect and member of the Royal Academy, who designed many churches and was an associate of Scott.

Cassat, Mary (1845–1926) An American-born painter who was a close friend of Degas and other Impressionists. She specialised in the paintings of mother-and-children subjects, and did much to spread the popularity of Impressionism in the United States.

Clausen, Sir George (1852–1944) A painter, predominantly of landscape and agricultural scenes, greatly influenced by Bastien-Lepage.

Clayton, John (d. 1861) Architectural draughtsman and writer on architecture. A native of Hereford, he moved to London in 1839.

Colbert, Jean-Baptiste (1619–83) The great minister of Louis XIV, who was not only a skilled politician and able economist, but created the state system of patronage of the arts in France.

Collins, William (1788–1847) A popular painter of landscapes and genre subjects. Father of the novelist Wilkie Collins.

Cook, Sir Edward (1857–1919). Editor first of *The Pall Mall Gazette*, and then of *The Westminster Gazette*, he wrote several biographies, and edited the complete works of Ruskin in a definitive edition of 38 volumes (1903–11).

Corot, Jean-Baptiste Camille (1796–1875) French landscape painter, whose lyrical and misty landscapes had a great influence on many painters, including Whistler.

Courbet, Gustave (1819–77) The robustly original protagonist of a kind of realism with political undercurrents which was in direct opposition to the official art of his time in France. At the Paris exhibition of 1855, dissatisfied with the hanging of his *The Painter's Studio; an allegory of realism*, he opened a personal exhibition nearby.

Cox, David (1783–1859) Birmingham-born son of a blacksmith, his great merits were largely unrecognised in his time. He was a close friend of the collector Joseph Gillott, with whom he shared a passion for music.

Crane, Lucy (1842–82) Daughter of Thomas Crane of Liverpool, and sister of Walter, she was a musician, lecturer and compiler of fairy tales.

Crane, Walter (1845–1915) Artist, craftsman and writer. Closely associated with William Morris, he exercised a great influence, especially after becoming in 1898 Principal of the Royal College of Art.

Crowe, Sir Joseph Arthur (1825–96) Journalist, diplomat and art critic, he published, in collaboration with the Italian artist Cavalcasseli, a history of Italian painting which for the first time applied criticial standards of comparison to the verification of authenticity.

Dagnan-Bouvert, Pascal Adolphe Jean (1852–1929) A French realist painter, specialising in scenes of contemporary life, close in style to Millet and Bastien-Lepage.

Day, Lewis Foreman (1845–1910) A decorative artist who taught at the Royal College, and exerted a great influence through his two books *Nature and Ornament* (1908) and *Lettering and Ornament* (1902).

Denis, Maurice (1870–1943) French painter and writer; a member of the Nabis he formulated one of the main aesthetic doctrines of his age in saying that; 'Remember that a picture, before being a war horse, a nude woman or an anecdote is fundamentally a flat surface covered with colours assembled in a certain order.'

Dicksee, Sir Francis Bernard (1853–1926) A fashionable portrait painter, who also produced romantic and historical painting. He became President of the Royal Academy in 1924.

Du Maurier, George Louis Palmella Busson (1834–96) Cartoonist and novelist. Born in Paris where he studied art, he joined the staff of *Punch* in 1866, and became famous as a satirist of middle-class life. His novel *Trilby* published in 1894 was a great success.

Duran, Carolus (1837–1917) A very successful French society portrait painter.

East, Sir Alfred (1849–1913) A landscape artist who was also well known for his etchings. He became President of the Royal Society of British Artists.

Eastlake, Charles Locke (1836–1906) Keeper of the National Gallery from 1878 till 1898, where he rearranged the hanging of the paintings. His most successful works were *A History of the Gothic Revival* (1870) and *Hints on Household Taste* (1872).

Edis, Robert W. (date unknown) A successful architect, who specialised as an interior decorator. In 1879 he gave a series of lectures at the Royal Society of Arts on the subject, and these were subsequently published in book form.

Egg, Augustus Leopold (1816–63) A painter of sentimental scenes from contemporary life which became very popular.

Fantin-Latour, Ignace Henri Jean (1836–1904) A friend of the Impressionists, though less experimental in his technique. He was an adept portraitist, and became popular through his flower-pieces. He spent some time in England where his works had a considerable success.

Fildes, Sir Samuel Luke (1844–1927) A painter, who having commenced his career as a purveyor of successful genre paintings went on to build up a reputation as an official portrait painter.

Foley, John Henry (1818–74) Sculptor who studied at the Royal Dublin Schools, ARA 1849, RA 1858. He was responsible for many famous pieces of sculpture, of O'Connell, Goldsmith and Burke in Dublin.

Frith, William Powell (1819–1909) After commencing his career as a historical painter, he went on to produce those remarkable scenes of contemporary life on which his success was built. The father of some twenty children, he wrote an interesting series of reminiscences.

Fry, Roger Eliot (1866–1934) Art critic and artist. An assiduous promoter of contemporary art, and the most influential writer on the subject of his generation. In the Omega Workshops he ventured into the field of decorative design.

Gambart, Jean Joseph Ernest Théodore (1814–1902) Born in Belgium, he came to London in 1840, and quickly built up for himself a reputation as a shrewd, informed and imaginative dealer, who did much to enhance the reputation of the artists whom he represented.

Gauguin, Paul (1848–1903) French painter noted originally for his development of a folk-based style of painting in Brittany, and then for pushing this still further in the course of his life in Tahiti into great simplification of colour and drawing, a lack of concern for perspective and the pursuit of monumental qualities.

Gilbert, Alfred (1854–1934) Sculptor whose finest work was done during the final decades of the nineteenth and the early ones of the twentieth century, mainly 'Eros' in Piccadilly, and the tomb of the Duke of Clarence at Windsor. He led a turbulent life, much of it in economic exile in Bruges (1901–26) but he was knighted in 1932.

Gilbert, Sir John (1817–97) A painter of historical subjects, but also a sought-after wood-engraver who was closely associated with the *Illustrated London News*. He became President of the Old Water-Colour Society.

Gillott, Joseph (1799–1873) A Sheffield-born steel worker who made a fortune out of adapting the techniques for making buttons into the mass production of steel nibs. He became an enthusiastic collector. On his death his English paintings fetched a record sum of £170,000.

Gogh, Vincent Van (1853–90) Post-impressionist painter. In 1873 he was an assistant at Goupil's London branch at a salary of £90 a year. He spent some three years here before returning to Holland in 1877. He was greatly impressed by the work of English illustrators.

Gray, Thomas (1716–71) Poet and writer, deeply concerned with matters of taste; a close friend of Horace Walpole.

Greenaway, Catherine (known as 'Kate') (1846–1901) Studied art at Heatherley's School, South Kensington and the Slade. A writer and illustrator of children's books.

Gregory, Edward John (1850–1909) Studied at Royal Academy Schools, became a frequent and important contributor to *The Graphic*, and President of the Royal Society of Painters in Water-colour. Although a portrait painter, his best works are of scenes of contemporary life.

Guillaumin, Armand (1841–1927) French painter, one of the participants in the first Impressionist exhibition, and always close to Monet, Pissarro, Signac and Cézanne, his works came to have a greater lyrical freedom which brought them close to the ideas of the Fauves.

Hamerton, Philip Gilbert (1834–94) Writer and artist, he founded the influential *Portfolio* magazine, and was art critic of *The Saturday Review*. His *Autobiography* was completed by his widow in 1897.

Helleu, Paul César (1859–1927) A successful French etcher and engraver, who specialised in society scenes, and was well known in London, where he had many friends.

Herkomer, Sir Hubert Von (1849–1914) Born in Bavaria, he came to England as a child, and studied art at South Kensington. He first achieved fame with his *The Last Muster* of 1875. He was Slade Professor at Oxford from 1885 to 1894.

Hodgson, John Evan (1831–95) Educated at Rugby and Royal Academy Schools; painter; RA 1879 Professor of Painting and Librarian at the Royal Academy from 1882 until his death.

Holl, Francis Montague (1845–88) Son of William, he was an active and successful portrait painter, and produced a number of genre paintings which became popular in their engraved versions.

Holl, William (1807–71) The son of an engraver of the same name, he became famous for his line and stipple work, being especially successful in his versions of Frith's paintings.

Holme, Charles (1848–1923) Founder and editor of *The Studio* which set new standards of art criticism, and built up an international reputation for its articles on design.

Hook, James Clarke (1819–1907) Originally a genre painter he became known from 1854 onwards as a painter of coastal scenes; much praised by Ruskin.

Hornby, Charles Harry St John (1867–1946) Book collector, printer, founder of Ashendene Press; a partner in W. H. Smith.

Hornby, James John (1826–1909) Theologian, Headmaster and Provost of Eton, pioneer of Alpine climbing and deeply involved in the anti-scrape controversy.

Houghton, Arthur Boyd (1836–75) Book illustrator and painter, he did much work for the *Illustrated London News*. Among the books which he illustrated were *Don Quixote* (1865) and *The Arabian Nights* (1866).

Hunt, Alfred William (1830–96) Landscape painter, who worked in a Turneresque style, and exhibited at the Royal Academy, the Old Water-Colour Society and the Liverpool Academy.

Hunt, William Holman (1827–1910) Son of a warehouseman, he studied at the Royal Academy, and in 1848 was one of the founders of the Pre-Raphaelite Brotherhood. Associated with Morris in the manufacture of furniture.

Ionides, Constantin Alexander (1833–1900) A Greek businessman, who entered the London Stock Exchange in 1864. He became an ardent collector, supporting contemporary art and leaving an important bequest to the Victoria and Albert Museum.

Israels, Jozef (1824–1911) A Dutch artist, and leading member of the Hague School. He was renowned for his paintings of fisherfolk in their original surroundings.

Jenyns, Soame (1704–87) A minor politician and leading social figure who wrote extensively about religious and philosophical subjects.

John, Augustus Edwin (1878–1961) A student at the Slade under Tonks, a brilliant draughtsman, a prolific, but uneven portraitist, a devotee of gypsy life, he was the very epitome of the successful Bohemian.

Kirk, William Boynton (1824–1900) A member of a family of Irish sculptors, who came to England in 1845, and while living at Worcester designed a famous dessert service. In 1860 he entered the church, and held livings at Birkenhead and Ashton-under-Edge.

Layard, Sir Austen Henry (1817–94) Politician, diplomat, critic, collector, author, he was most widely known as the excavator of Nineveh, his account of it being published in 1849–50. He was involved in intelligence work and collected old master paintings on an impressive scale.

Legros, Alphonse (1837–1911) Born at Dijon, he established a reputation in Paris as a realist painter, until in 1863 he was persuaded by Whistler to come to London. He had an important influence on English art through his teaching at the Slade School of Art over which he presided from 1875 till 1892.

Leighton, Frederick Baron (1830–96) Spectacularly successful as a painter and a public figure, as well as being a sculptor, he became President of the Royal Academy, and the only British artist to be raised to the peerage.

Leopold, Prince George Duncan Albert, Duke of Albany, Earl of Clarence (1853–84) Fourth and youngest son of Queen Victoria, an air of mystery surrounds his life, much of which was spent abroad. He was deeply interested in art.

Leslie, Charles Robert (1794–1859) Born in London of American parents, he went to teach drawing at West Point, then returned to London where he had a successful career as a painter, and was the author of several books on art, including a biography of Constable (1845).

Le Sueur, Eustache (1616–55) A French painter, who typified the classical approach to art, and who was deeply influenced by Poussin.

Lewis, John Frederick (1805–76) Painter of Italian, Spanish and Oriental subjects currently enjoying a great vogue. He was elected an RA in 1865. Ruskin hailed him as a Pre-Raphaelite, although he had no links with that movement.

Linnell, John (1792–1822) Portrait and landscape artist, who maintained a running feud with the Royal Academy, and was in close touch with Blake and Samuel Palmer.

Linton, William James (1812–98) Engraver, poet and political reformer. He published and edited a number of radical periodicals. An intimate friend of Mazzini, he was well known for his fine engravings. In 1866 he migrated to America, and published an authoritative *History of Wood-engraving in America*.

Lorne, John Douglas Sutherland, Marquess of Lorne, later 9th Duke of Argyll (1845–1914) Husband of Queen Victoria's daughter Louise, who stimulated his interest in art.

Louise, Princess Caroline Alberta (1848–1939) The sixth child of Queen Victoria; married the Marquess of Lorne, who became the Duke of Argyll. A gifted sculptress and patron of the arts, whe wrote about art under the pseudonym of 'Myrna Fontenoy', and became President of the National Union for the Higher Education of Women.

Lysons, Daniel (1762–1834) Topographer, whose works on medieval architecture greatly contributed to the spread of the Gothic Revival.

Maccoll, Douglas Sutherland (1859–1948) Art critic and painter, who was one of the main protagonists of modern art in both its French and English versions. Keeper of the Tate Gallery in 1906, and of The Wallace Collection 1911–24.

Maclise, Daniel (1806–70) An Irish painter, predominantly of historical subjects, and also a prolific book illustrator. He was active in fresco painting.

Marks, Henry Stacy (1829–98) Began his career as an apprentice in his father's coach-building business. Then after attending the Royal Academy Schools had a successful career as a painter of literary subjects and landscapes.

Marochetti, Baron Carlo (1805–67) A sculptor who, having worked in Paris and Rome, settled in England in the 1840s and was much patronised by the Queen. He executed many public works, and was an exponent of the use of colour in sculpture.

Millais, Sir John Everett (1829–76) One of the founders of the Pre-Raphaelite movement, he married Ruskin's ex-wife, and became a successful portrait painter, and President of the Royal Academy.

Millet, Jean-François (1814–75) A French landscape painter, whose realistic, but emotional pictures of peasants within their environment had a great vogue in late-nineteenth-century England.

Moore, Albert Joseph (1841–93) A painter of predominantly classical subjects, noted for his treatment of diaphanous draperies. His work was greatly admired by Whistler and many younger painters.

Moore, George Augustus (1852–1933) Novelist. He introduced the realism of writers such as the Goncourts into England; he was a collector and critic of art, having spent much of his early life in an Impressionist milieu in Paris.

Morisot, Berthe(1841–95) An Impressionist painter, who was Manet's sister-in-law, and influenced his style quite considerably. She was one of the first exponents of plein-air painting.

Morris, William (1834–96) Poet, painter, craftsman, socialist, designer, manufacturer, political polemicist, he endeavoured to revivify the arts and crafts by a combination of medieval revivalism and practical socialism. One of the most influential figures in the history of art and design.

Müller, William John (1812–45) A Bristol artist, who tavelled in Europe and the Middle East, producing in the course of a short career some remarkable water-colour and oil paintings.

Mulready, William (1786–1863) A genre painter, who taught drawing, illustrated books and designed the first postage stamp. His *Choosing the Wedding Gown* (1846) was reknowned for its rendition of textures.

Nasmyth, Patrick Alexander (1758–1840) A Scottish portrait and landscape painter who began his career as a coach painter. He was a friend of Robert Burns.

Nettleship, John Trivett (1841–1902) An animal painter, who did a lot of work in India. He was a fervent admirer of Browning, about whom he wrote a book.

Newton, Sir Charles Thomas (1816–94) Assistant in the Department of Antiquities in the British Museum. Taking up a diplomatic post in Greece, he excavated many sites, the most famous of which was the mausoleum at Halicarnassus. In 1880 he became Professor of Archaeology at University College, London.

Northwick, John Rushout; 2nd Lord Northwick (1769–1859) After spending his early life studying art in Rome, he became a discriminating and scholarly collector. Several of the paintings in his collection were sold in 1956 for £2,000,000.

Orchardson, Sir William Quiller (1832–1910) A successful painter of historical subjects who studied in Scotland, and became an RA in 1877.

Ouless, Walter William (1848–1933) A Jersey-born painter, who was highly successful as a portraitist, and became an academician in 1881.

Parsons, Alfred William (1847–1920) Painter and illustrator who became President of the Royal Society of Painters in Water-colours.

Pater, Walter Horatio (1839–94) Classical scholar and Fellow of Brasenose College, he became an associate of the Pre-Raphaelites and Swinburne. Both as a critic, and the writer of luscious prose, he had a great influence on the aesthetic movement.

Pettie, John (1839–93) Pupil of Robert Scott Lauder, he first exhibited at the Royal Academy in 1860, becoming a member 13 years later. He specialised in historical genre painting.

Philip, John Birnie (1824–75) Trained at the Government School of Design, he was first employed on ornamental sculpture for the Houses of Parliament, and became one of the most popular and prolific sculptors of his time, his most famous work being the 87 figures on the podium of the Albert Memorial. One of his daughters married Whistler.

Phillip, John (1817–67) Subject and portrait painter, who specialised in Spanish scenes. He became an RA in 1853.

Pinwell, George John (1842–75) Started his artistic career as a wood engraver working for the Dalziel brothers, but later he specialised in water-colours.

Poynter, Sir Edward John (1836–1919) First Slade Professor at University College; Director of the National Art Training School 1875–81. Director of the National Gallery 1894–1904; President of the Royal Academy 1896–1918. Introduced French techniques into art teaching.

Prinsep, Valentine Cameron (1834–1904) Painter, whose works were strongly influenced by those of G. F. Watts and Lord Leighton.

Pugin, Augustus Charles (1762–1832) Artist, architect and archaeologist, whose studies of medieval architecture had a great deal to do with putting the Gothic Revival on a serious footing. He greatly influenced his son Augustus Welby.

Pugin, Augustus Welby (1812–52) Architect and writer, he became the dominant figure in the early part of the Gothic Revival thanks very largely to his *Contrasts* (1836) and *True Principles of Pointed or Christian Architecture* (1841). A fervent Catholic, he died insane.

Raffaelli, Jean François (1850–1924) An associate of the Impressionists and a friend of Degas, he specialised in realistic urban scenes.

Redgrave, Richard (1804–88) Subject and landscape painter, who in 1857 became Inspector-General for Art in the School of Design. He was also Surveyor of the Royal Pictures.

Richmond, Sir William Blake (1842–1921) Son of William Blake's friend and disciple. He studied in Italy, after being at the Royal Academy Schools, and became a successful painter, mainly of mythological scenes. He designed the mosaics in St Paul's.

Riviere, Briton (1840–1920) Descended from a family of artists and bookbinders, he started exhibiting at the Royal Academy after leaving Oxford.

Rossetti, Dante Gabriel (1828–82) Poet and painter; son of an Italian refugee, he was taught by Cotman, and at the age of 21 painted the successful and revolutionary *The Childhood of the Virgin Mary*. Although closely connected with the Pre-Raphaelite movement, he had no political or social concerns, and was in effect a highly personal romantic escapist.

Rossetti, William Michael (1829–1919) Brother of Dante Gabriel, critic and man of letters, who wrote extensively about his family. He was an official of the Inland Revenue Board.

Rothenstein, Sir William (1872–1945) Painter and Principal of the Royal College of Art. Lived and worked in his youth in Paris, where he met most of the leading figures in the art world. His memoirs are a rich source of information and gossip.

Ruskin, John (1819–1900) Son of a London sherry merchant, he learnt drawing from Copley Fielding, and in 1843 published *Modern Painters*, the final volume being published in 1856. A prolific writer of fine, if purple prose, and the most influential writer on art of his time, he interested himself in social questions, design, education and little girls.

Rutter, Frank (1876–1937) Art critic of *The Sunday Times*; curator of the Leeds Art Gallery, and a strenuous supporter of contemporary art.

Samuelson, Sir Bernard (1820–1905) Ironmaster and promotor of elementary and technical education. An MP from 1859 till 1895, he was very involved in things connected with art.

Sargent, John Singer (1856–1925) Born in Florence of American parents, he first made his reputation in Paris as a portrait painter, but settled in England in 1885. He was made an RA in 1897; one of the most successful society portrait painters of his time.

Scheffer, Ary (1795–1858) A Dutch painter, engraver and illustrator, best known for his religious paintings, as well as for illustrations to the works of Byron and Goethe.

Schreiber, Lady Charlotte Elizabeth (1812–95) Scholar, linguist, businesswoman, collector and traveller, she was the first person to bring scholarship to the collecting of china, playing cards and old lace.

Scott, Sir George Gilbert (1811–78) His first success as an architect was winning a competition for the design of Hamburg Cathedral. An energetic, if misguided restorer, his works include the Albert Memorial, St Pancras Station and countless churches and offices.

Sharp, William (1855–1905) A prolific writer on literary matters, whose life of Rossetti was published in 1880. He also wrote mystical prose and verse under the pseudonym of Fiona Macleod.

Shee, Sir Martin Arthur (1769–1850) Portrait painter, and President of the Royal Academy, who had a fatal gift for writing prose and verse.

Sheepshanks, John (1787–1863) A successful industrialist who collected works by living British artists, and left them to the nation. They are now on view as a unity in the Victoria and Albert Museum.

Sickert, Walter Richard (1860–1942) Painter of Danish parentage. One of the founders of the New English Art Club, he was the most forceful artistic personality of his generation.

Simmons, William Henry (1811–82) Line engraver who produced plates after the works of Millais, Frith, Landseer and others.

Skidmore, F. A. (date unknown) A Coventry-based metal worker employer by Scott on the flèche of the Albert Memorial and other projects. About him Scott said: 'No nobler work in metal for architectural purposes has so far as I know, been produced in our own or probably – considering its scale and extent – in any other age, nor do I think that any man living but Mr Skidmore could have produced such a work.'

Smirke, Robert (1752–1854) A painter who made his reputation as an illustrator for Boydell's Shakespeare and other works.

Spender, John Alfred (1862–1942) Journalist and author; a protagonist of rugged Liberalism, he was in close contact with influential politicians. For many years he was editor of *The Westminster Gazette*, probably the most important periodical of the time.

Steer, Philip Wilson (1860–1942) Portrait and landscape painter, influenced by both Manet and Whistler. He taught at the Slade, and was an influential member of the New English Art Club.

Stephens, Frederick George (1828–1907) Though a founder member of the Pre-Raphaelite Brotherhood, he was better known as a critic than a painter. He appears as Christ in Ford Madox-Brown's *Christ Washing the Feet of St Peter*.

Stevens, Alfred (1818–75) Son of a house-painter, he studied sculpture in Rome under Thorwaldsen, and then became a teacher in the School of Design. He was extensively employed by Hoole & Co., the Sheffield founders. His best known works are the Wellington Monument in St Paul's and the vases and lions on the British Museum.

Stone, Marcus (1840–1921) A genre painter, whose works were sentimental, full of incident, and highly popular.

Stott, William (1857–1900) Known as Stott of Oldham, a painter of landscape and figure subjects, who was considerably influenced by Whistler. A prominent member of the New English Art Club.

Swan, John Macallan (1847–1910) Painter and sculptor famed for his representation of animals. He designed eight colossal lions for the Rhodes Memorial in Cape Town.

Tegg, Thomas (1776–1845) A bookseller, who made a reputation and a fortune by publishing cheap reprints and abridgements of famous works.

Thomas, William Luson (1830–1900) Founder and editor of *The Graphic*, he began his career as wood engraver in Paris, and in 1864 opened his own business in London. He founded *The Graphic* in 1869, and was closely involved in perfecting the application of photography to reproduction techniques.

Thornycroft, Sir William Hamo (1850–1925) Sculptor; RA 1888; knighted 1917. He was responsible for many public works.

Tomson, Arthur (1859–1905) A landscape painter and writer, who championed the Barbizon School in England, and wrote a book about Millet.

Vernon, Robert (1774–1849) Having made his fortune as a contractor to the army during the Napoleonic Wars, he became a leading art patron, especially of works by living English artists. His collection is now in the Victoria and Albert Museum.

Voysey, Charles Annesley (1857–1941) Architect who specialised in the design of small houses, which greatly influenced architectual thinking both here and in Germany. He was a designer of wallpapers, textiles and furniture in simple styles which contrasted with the taste of earlier decades. He was largely responsible for the revival of vernacular styles in architecture and design.

Walker, Frederick (1840–75) Commencing his career as an architect's clerk, he became first an art student, and then an engraver. He rapidly achieved fame for his brilliant book illustrations and paintings.

Walpole, Horace, 4th Earl of Orford (1717–97) Son of Robert, a prolific letter-writer and one of the founders of art history in England. He was a noted protagonist of the early Gothic Revival in England, his home at Strawberry Hill being a prime example of its style.

Ward, James (1769–1859) A painter and engraver, who specialised in animal subjects. The landscape backgrounds in some of his works are remarkably fine.

Warton, Dr Joseph (1722–1800) Literary critic and poet, a member of Dr Johnson's entourage. His successful *Odes* was first published in 1744.

Waterhouse, Alfred (1830–1905) Known chiefly as a prolific architect, responsible among other projects, for the Natural History Museum, and the Prudential Offices in Holborn, he was also a gifted water-colourist, exhibiting at the Royal Academy and elsewhere.

Watts, George Frederick (1817–1904) A prolific painter and sculptor, who combined much of the traditional academic approach with leavenings of more recent developments.

Webster, Thomas (1800–86) A painter who specialised in scenes of village life, and made a considerable reputation for himself as a sculptor.

Westminster, 1st Duke of (Hugh Lupus Grosvenor) (1825–99) An active politician, philanthropist, and the owner of vast London estates. He was much interested in art and literature, as well as horses.

Wheatley, Francis (1747–1801) Painter of portraits and genre works. Strongly influenced by Greuze, he spent much of his life in Dublin.

Whistler, James, Abbot McNeill (1834–1903) Born at Lowell, Massachusetts; educated at West Point. Studied painting in Paris under Gleyre. He came to London in 1859, and established a reputation as an etcher, and painter of pictures which combined oriental and Impressionist influences. Litigious, witty and amusing, he aroused extremes of admiration and dislike.

Wilde, Oscar O'Flahertie Wills (1856–1900) Son of a Dublin physician. Famous for many reasons, not the least being that in his verse, prose and drama he seemed the very epitome of the aesthetic movement.

Wilson, George (1818–59) Having studied medicine at Edinburgh he became a chemist, a preacher, Professor of Technology at Edinburgh University, President of the Royal Scottish Society of Arts, and Director of the Scottish Industrial Museum. He wrote about a bewildering variety of subjects.

Index